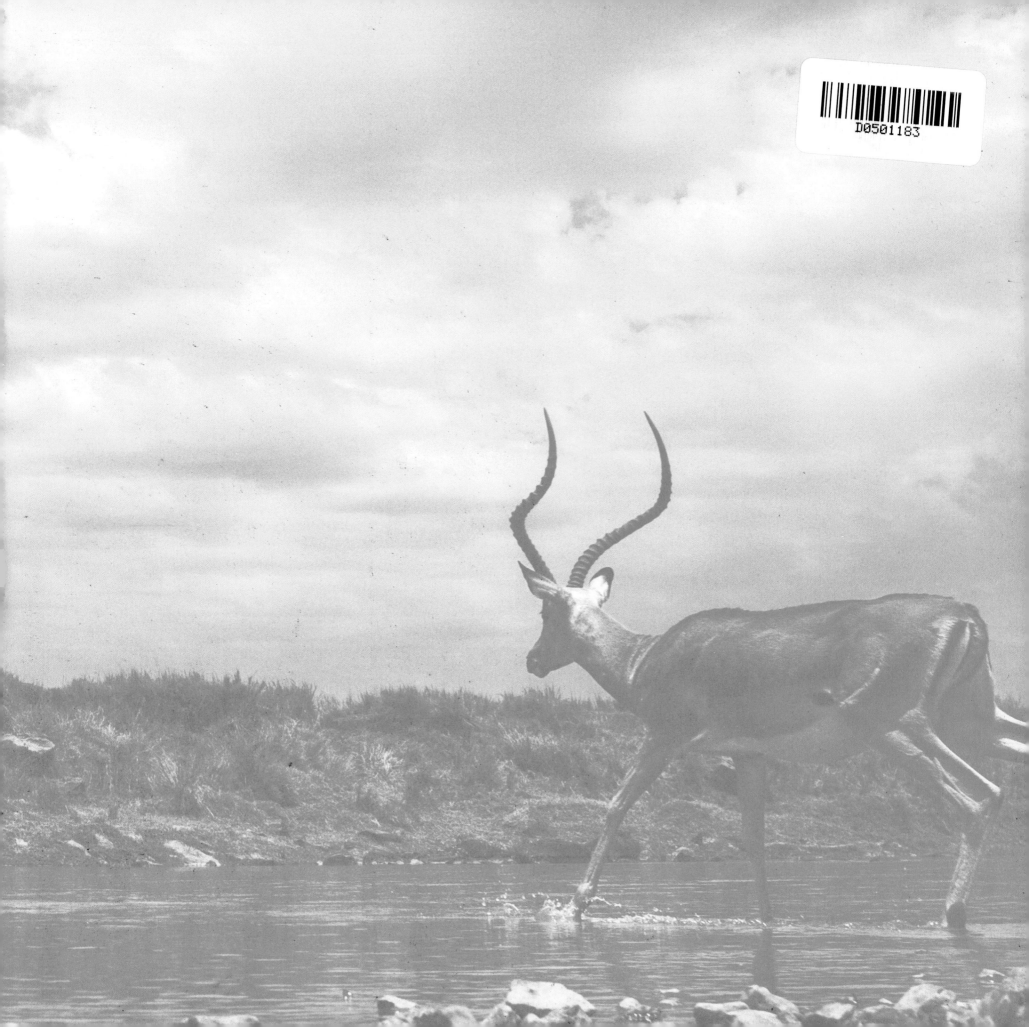

D0501183

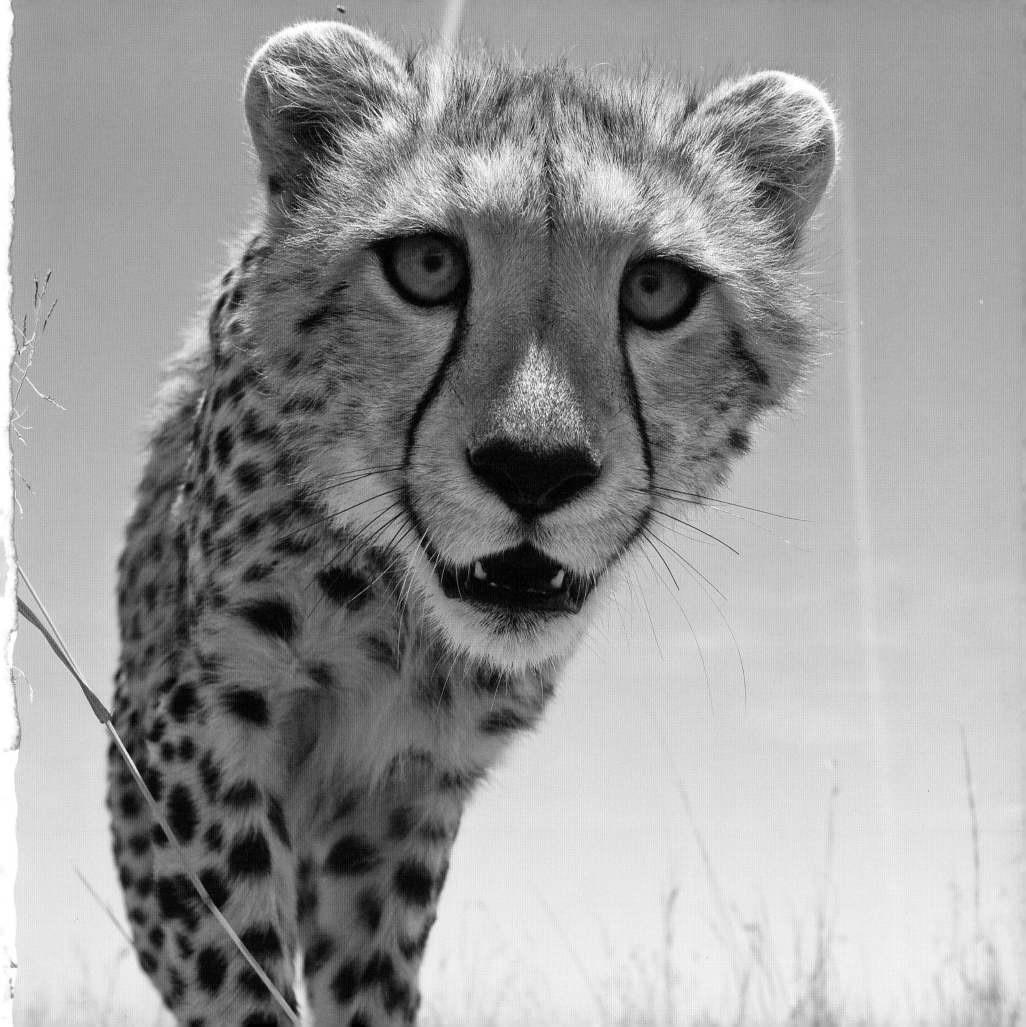

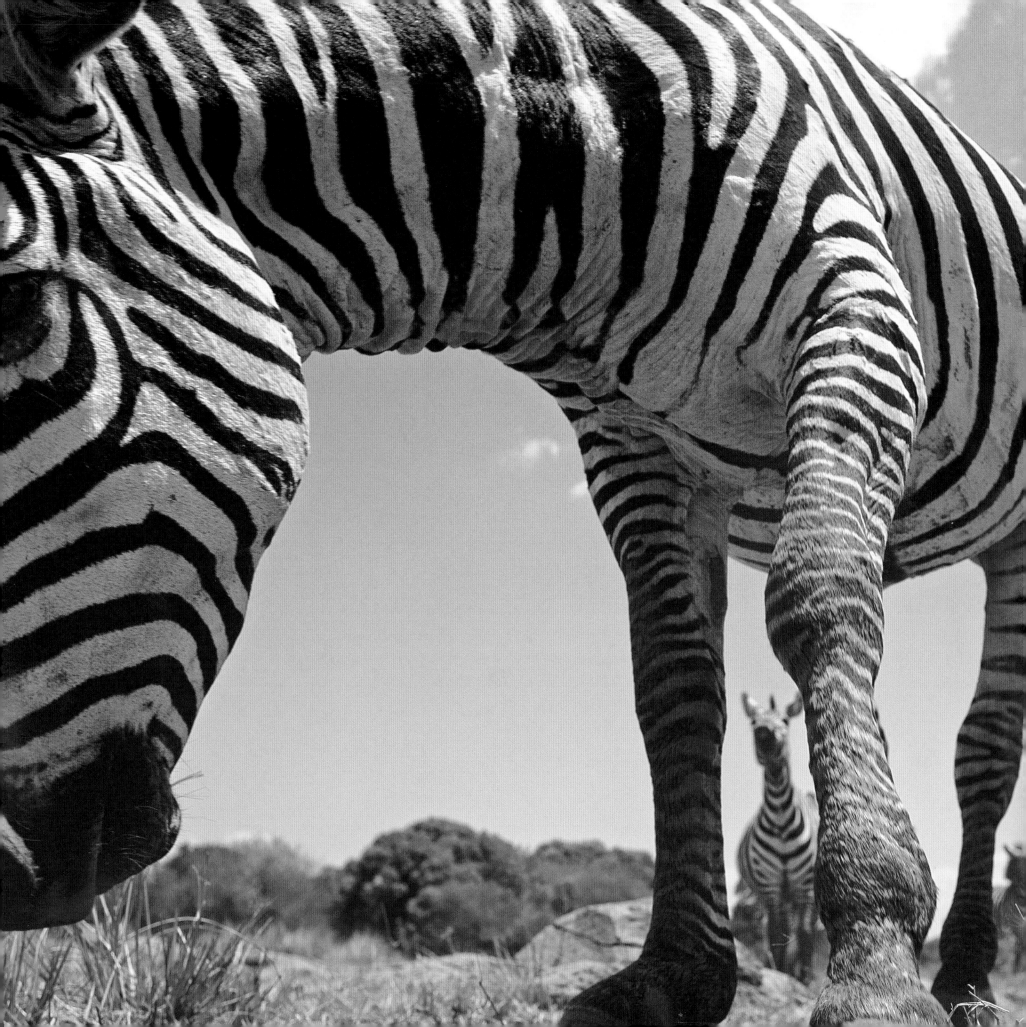

Sah, Anup
Serengeti spy : views
from a hidden camera on
c2012.
33305227759978
cu 04/09/13

Serengeti SPY

Views from a Hidden Camera on the
Plains of East Africa

ANUP SHAH

ABRAMS, NEW YORK

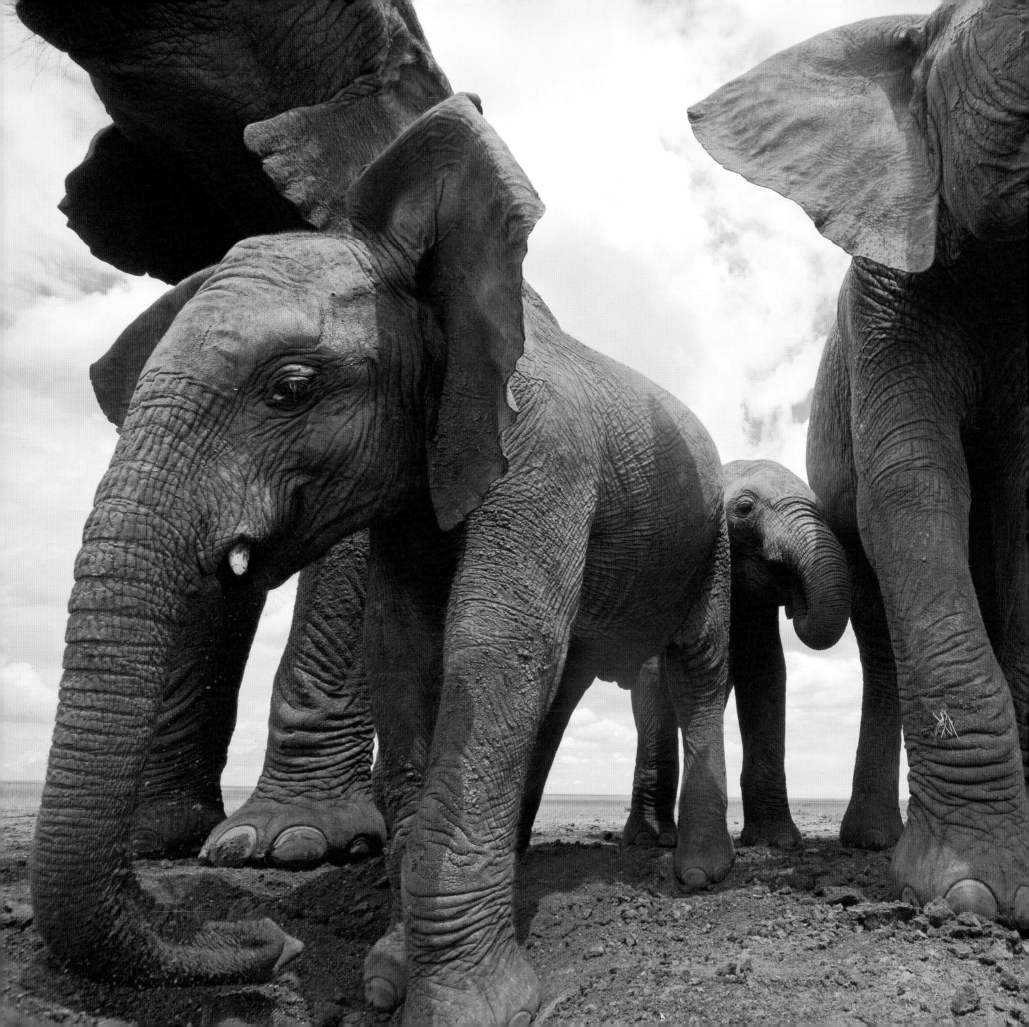

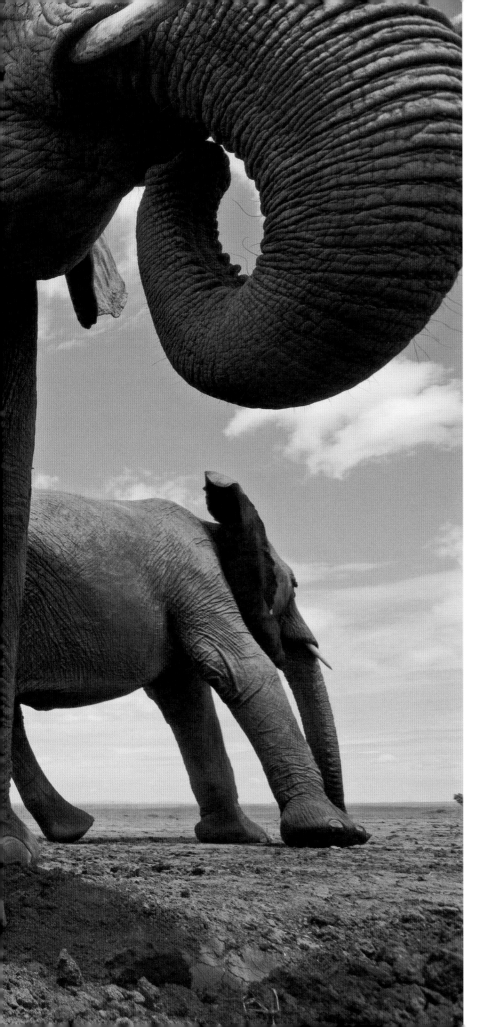

An entire ecosystem of parasites exists in the many deep wrinkles and creases of an elephant's skin, which is one of the reasons they love bathing and plastering their bodies with mud.

By February, many pools of water have evaporated, and the expansion of yellow, shriveled grass is gathering pace. Primarily nocturnal creatures, hyenas either sleep out the daytime heat around their den sites, or immerse themselves in muddy water.

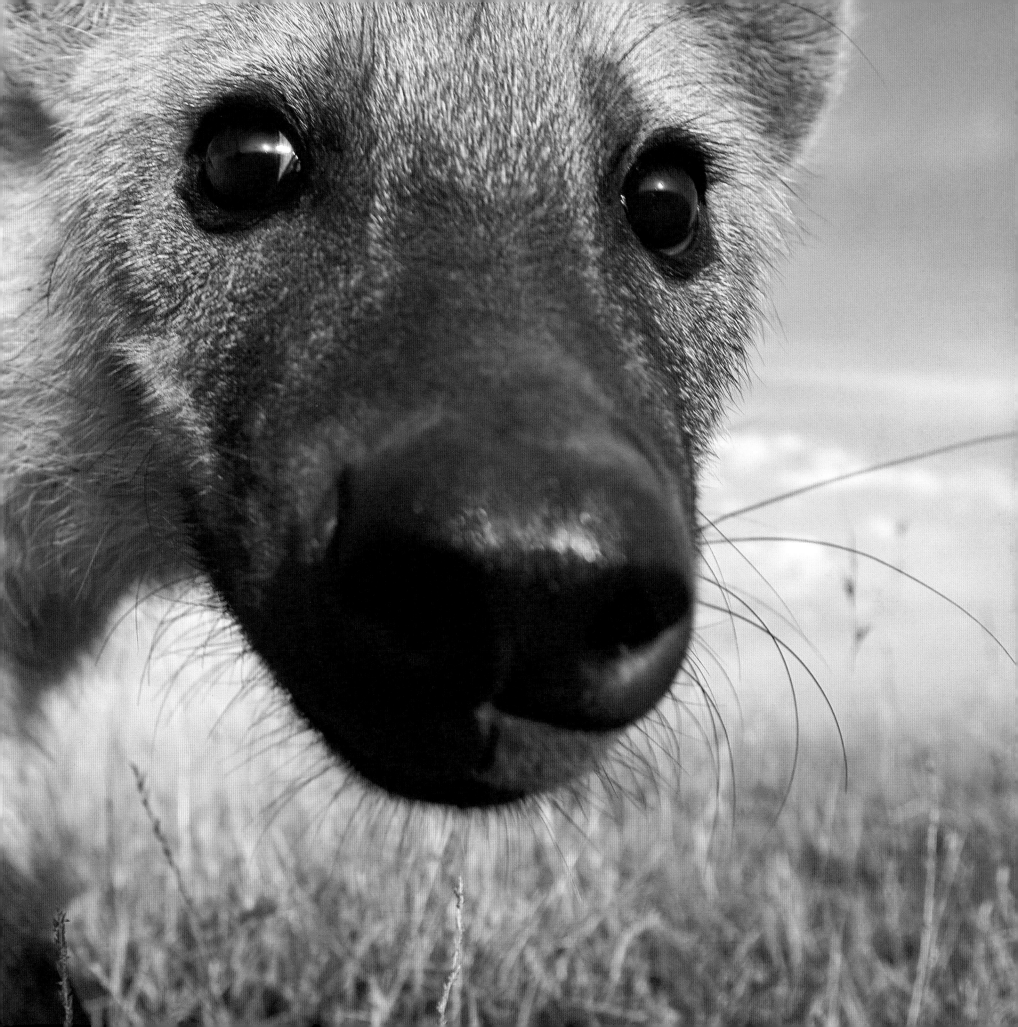

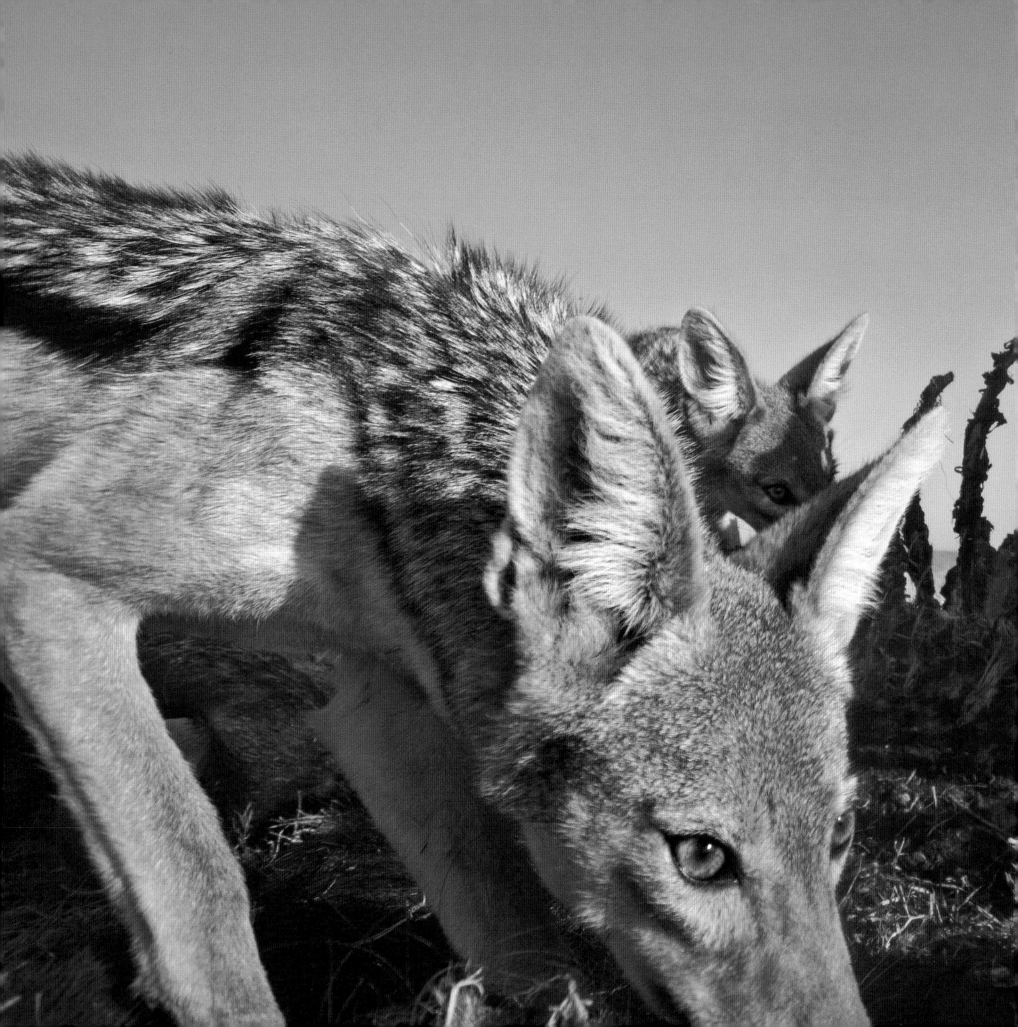

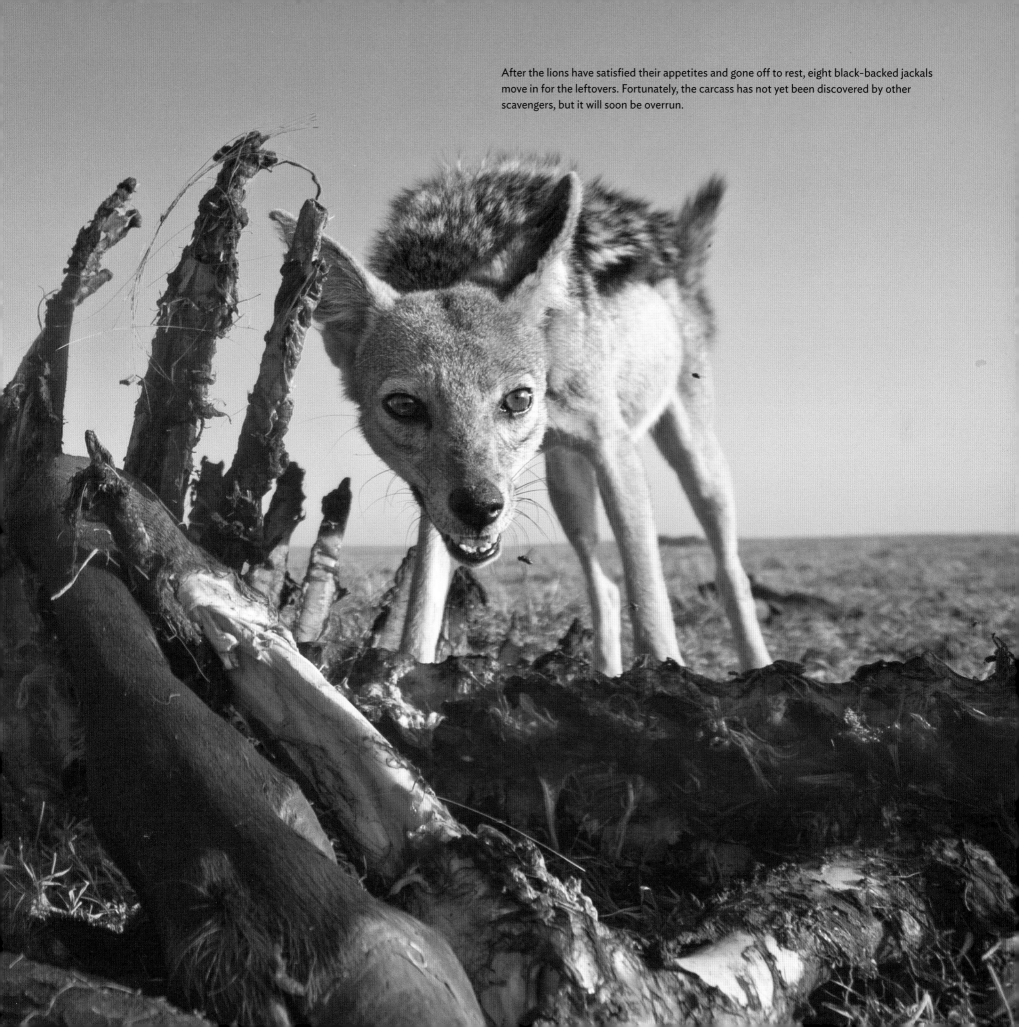

After the lions have satisfied their appetites and gone off to rest, eight black-backed jackals move in for the leftovers. Fortunately, the carcass has not yet been discovered by other scavengers, but it will soon be overrun.

On a cloudy morning, a pride rests after a night of feasting. One of the adolescent cubs notices the remote camera and, driven by curiousity, moves closer, watching it all the time, in case it turns out to be dangerous. He circles it and paws at it, then hisses a warning when the shutter makes a clicking sound.

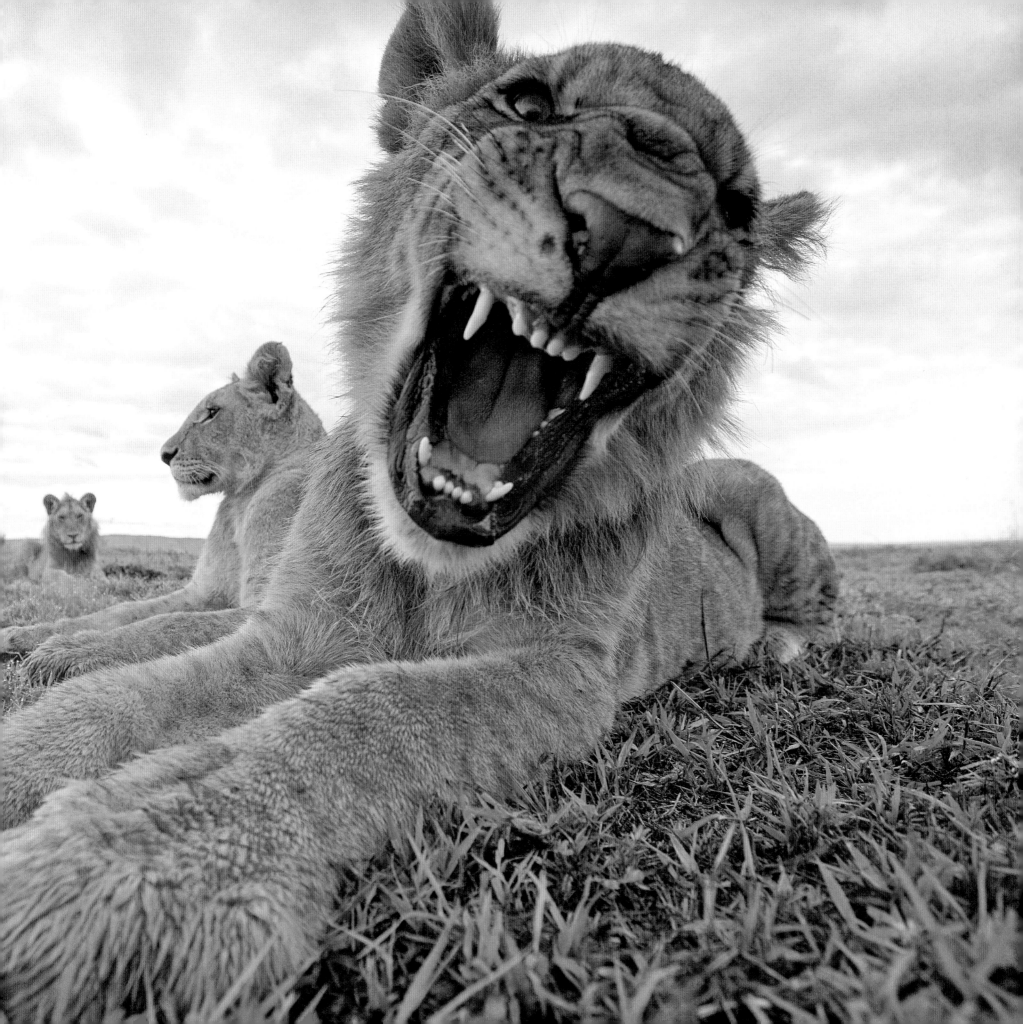

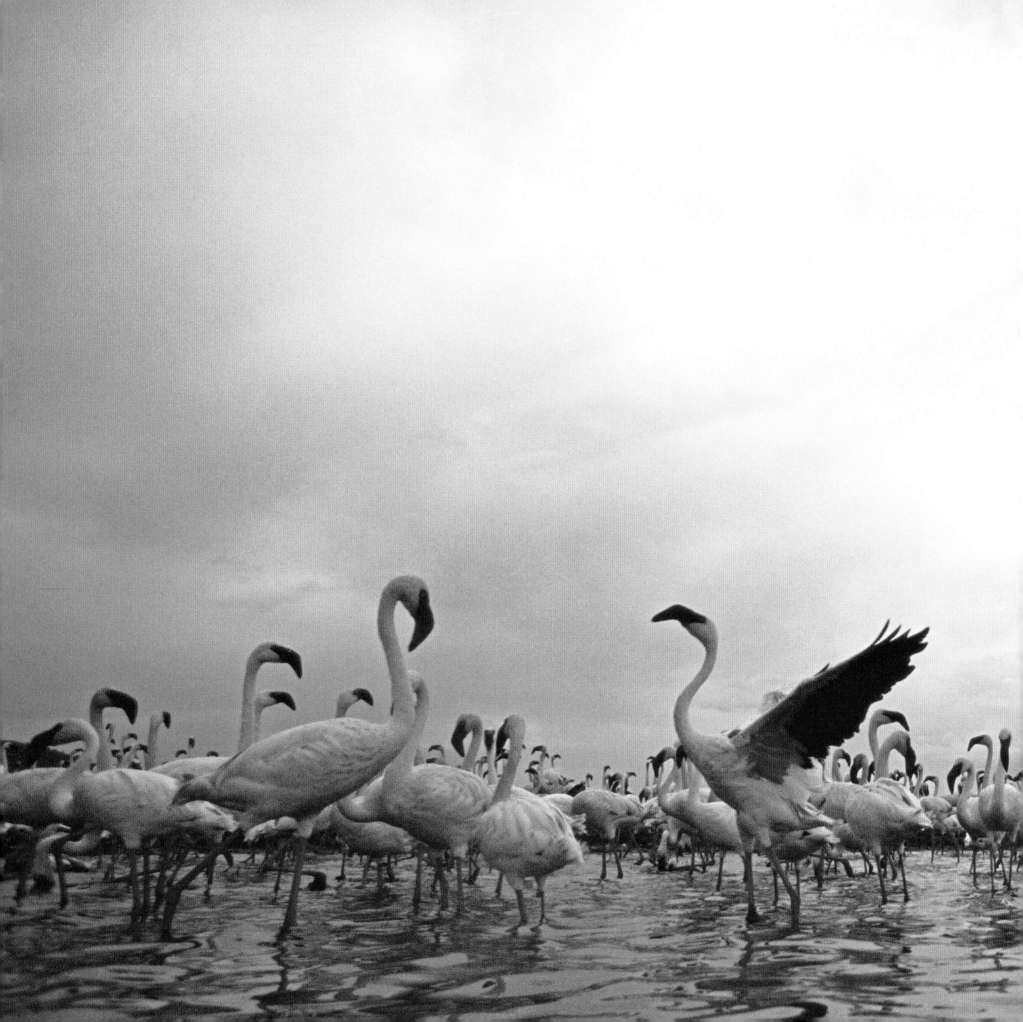

FOR PANNA

INTRODUCTION

For the past fifteen years, I have spent a few months out of every year photographing wildlife from a four-wheel-drive vehicle on the plains of East Africa. Fortunately for me, these plains, in particular the vast Greater Serengeti–Mara ecosystem that encompasses many protected areas, including Serengeti National Park and the Maasai Mara National Reserve, provides a never-ending wealth of photo opportunities.

A few years ago, it occurred to me to try to imagine what I might see if I were a hunter-gatherer on foot—a man who had spent his entire life in the wild and who relied on it to live. This was a revelation to me. Imagine you are that hunter, that you have crept to within yards of a Thomson's gazelle and are hiding in a crouched position in the tall grass. From that angle, the small gazelle looks almost imposing. Now imagine that you are a gazelle fawn looking up at Mom, from which vantage point you can see the details of her muzzle, eyes, hide, belly; you are in her private world, on her terms. This hunter-gatherer perspective is a strange one to the urban dweller, but a fuller range of emotions opens up when you enter the world of a wild animal in its private space.

Considered from another perspective, photojournalists and street photographers spend all their time trying to get close to their subjects— why not do the same in the wild? Why not shoot from the streets, so to speak, out in the wild where the animals roam?

This is what I have tried to do in my photography for this book: to get as close as possible to these wild animals, to actually enter their world on their terms and without disturbing them, to become one of them, free of all man-made intrusions, of even the space between the animal and the camera itself. The result is, hopefully, that you see the animals as they see one another, or as a hunter-gatherer on foot, living with them in their world, would see them.

What does their world look and feel like, and how do I re-create that world, as though no camera was in place? To put this train of thought into action, I had to overcome many difficulties, but one in particular stands out: the size difference. I was going to have to get the camera low down and go wide. Another related difficulty was figuring out how to bring the camera close enough to the animals—in their faces, inside the herd—to

achieve the "street photography" effect. It was here that technology came to my aid in the form of a remote camera. I invented a bespoke housing that looked rather like a tiny tortoise, which I placed in optimal locations across the plains, usually on the ground. Camera placement—wherever I thought the animals would travel—was the hardest part of the shoot and where my fifteen years' worth of knowledge of animal behavior became important. Built into the camera unit was also a video link that connected to a portable television screen inside my truck. I would park the truck fifty to a hundred yards from the remote camera, and with my eye on the screen, I was able to trip the shutter at the moment of my choosing.

Viewing the resulting image of, say, a wildebeest herd that has just crossed a river and is ascending a gully on the bank with hooves flying, the whites of their eyes flashing and water dripping from their straining bodies, it is easy to imagine the tense concentration of a lone lioness who might be crouched nearby, her body taut and ready to spring at any opportunity to bring down a vulnerable wildebeest. Hopefully, the viewer can feel that tension as if he or she were right there in the middle of it all. At least, that was my intention when I hid the camera in that particular gully. Looking at another view of a lion staring straight into the camera, you can almost feel the very essence of this feline predator. By following a pride of lions and learning their habits, I was able to place the camera at their favorite resting spot and wait for the right moment to capture the innate power reflected in their eyes.

Although the camera was well disguised with mud, grass, elephant dung, and other materials, I could not fool the lions. If one of them spotted the camera, usually by first hearing the clicking of the shutter, it was the animal most likely to approach and investigate. Monkeys, inquisitive creatures that they are, tended to react the same way to the camera, once it was spotted. The herds ignored it, but their hooves destroyed five of my cameras. Female elephants typically ignored the camera, but male elephants seemed more tempted to extend their trunks to investigate it.

The larger context in which this idea took seed was something that had been churning away in the back of my mind for some time. Our ancestors traveled on foot, depended on wild fruits, nuts, and meat for sustenance, slept under the stars, stayed away from the burning sun, took shelter when

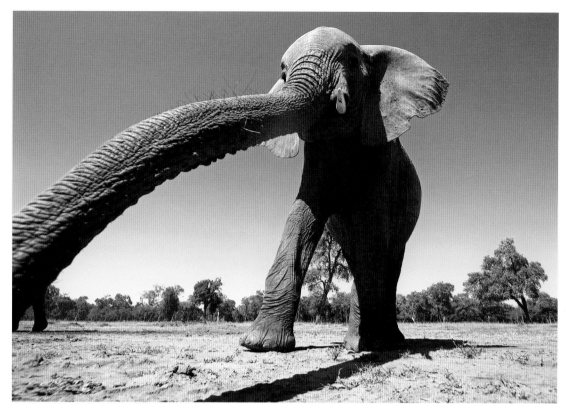

This elephant has spotted the remote camera and is examining it very gently with its trunk. Satisfied that it is both harmless and uninteresting, the elephant moved on.

it rained, and generally adapted to the vagaries of the land and the elements. It is impossible to know what they saw and felt, but we can safely assume that it was very different from what we see and feel in our urban cocoons, which have become a barrier between us and nature. Our hunter-gatherer ancestors, by constantly having to adapt to the land and the elements, by living in raw and wild nature without the protection and comfort afforded by an urban setting, naturally forged a significant relationship with nature.

The animals, too, have adapted to the land and seasons and are very much shaped by these forces. The images in this book are organized by the seasons in the Maasai Mara and the Serengeti, of which there are four: the short dry season (mid-December to mid-March), the long rains (mid-March to the end of May), the long dry season (June to October), and the short rains (November to mid-December). The story of being wild is more complex than these photographs alone can convey, so I have added captions, not to point out what you see, but to suggest the larger environment and to help you imagine yourself there.

Once I noticed a Cape buffalo drift into a thicket. Shortly thereafter, a car pulled up next to the thicket, and a tourist alighted and went behind a bush. She must have come eye to eye with that buffalo, because she came running back to the safety of the car in a hysterical state. She may have felt terror or some other emotion she had rarely, if ever, experienced in her life. In the Kalahari, there was an incident where a lion invaded a field researcher's tent that had been situated in the heart of lion territory. The lion seemed to have been motivated by curiosity (lions are like that when they're not sleeping). The trapped individual had no choice but to exit the tent quickly, flashlight in hand, but for a split second, before the lion backed off, the two came face to face. Later on, the researcher struggled to describe the incredible emotions she had felt in the presence of that big cat. In the end, she came to perceive it as a spiritual experience.

Obviously, nothing can replace a personal face-to-face encounter with one of these animals in the wild, on their own terms, but with these photographs, I've made an attempt to come close. I hope it enables you to see, imagine, feel, and think in a new and different way.

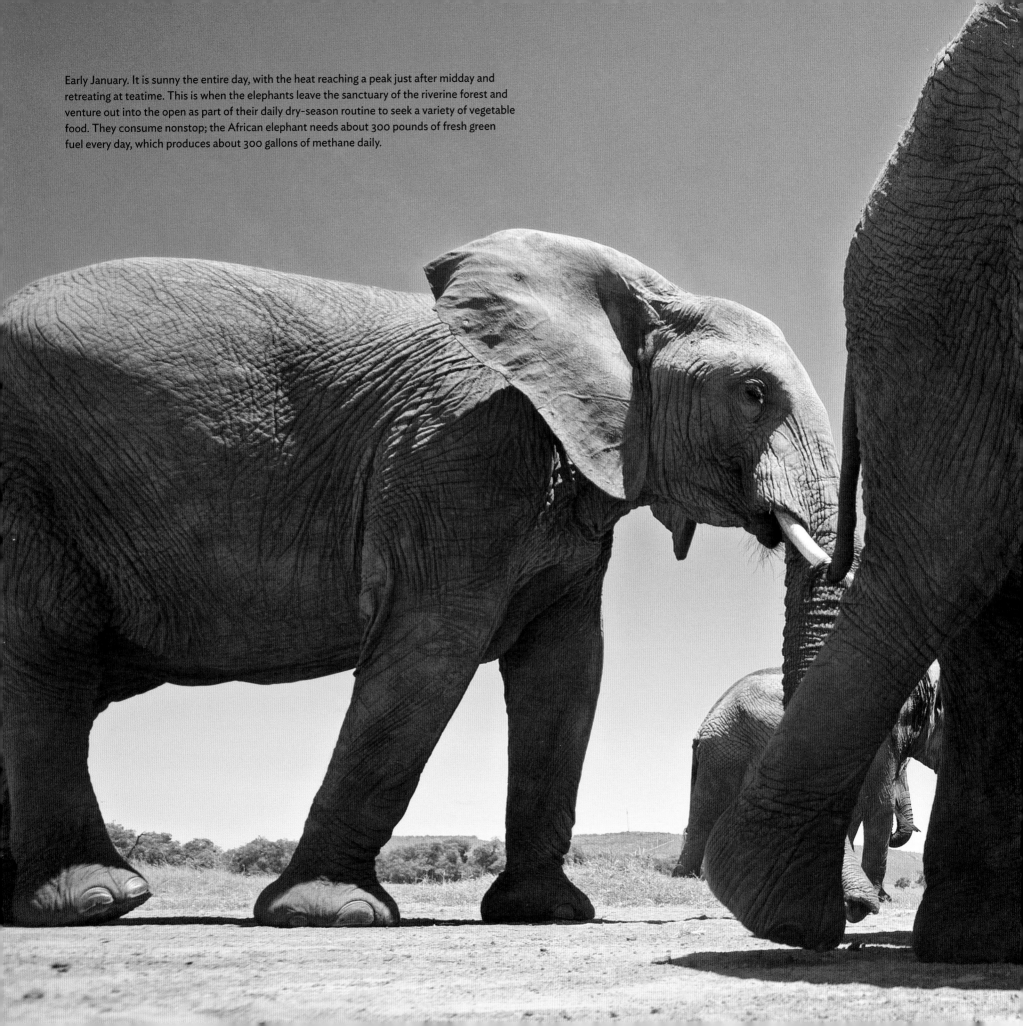

Early January. It is sunny the entire day, with the heat reaching a peak just after midday and retreating at teatime. This is when the elephants leave the sanctuary of the riverine forest and venture out into the open as part of their daily dry-season routine to seek a variety of vegetable food. They consume nonstop; the African elephant needs about 300 pounds of fresh green fuel every day, which produces about 300 gallons of methane daily.

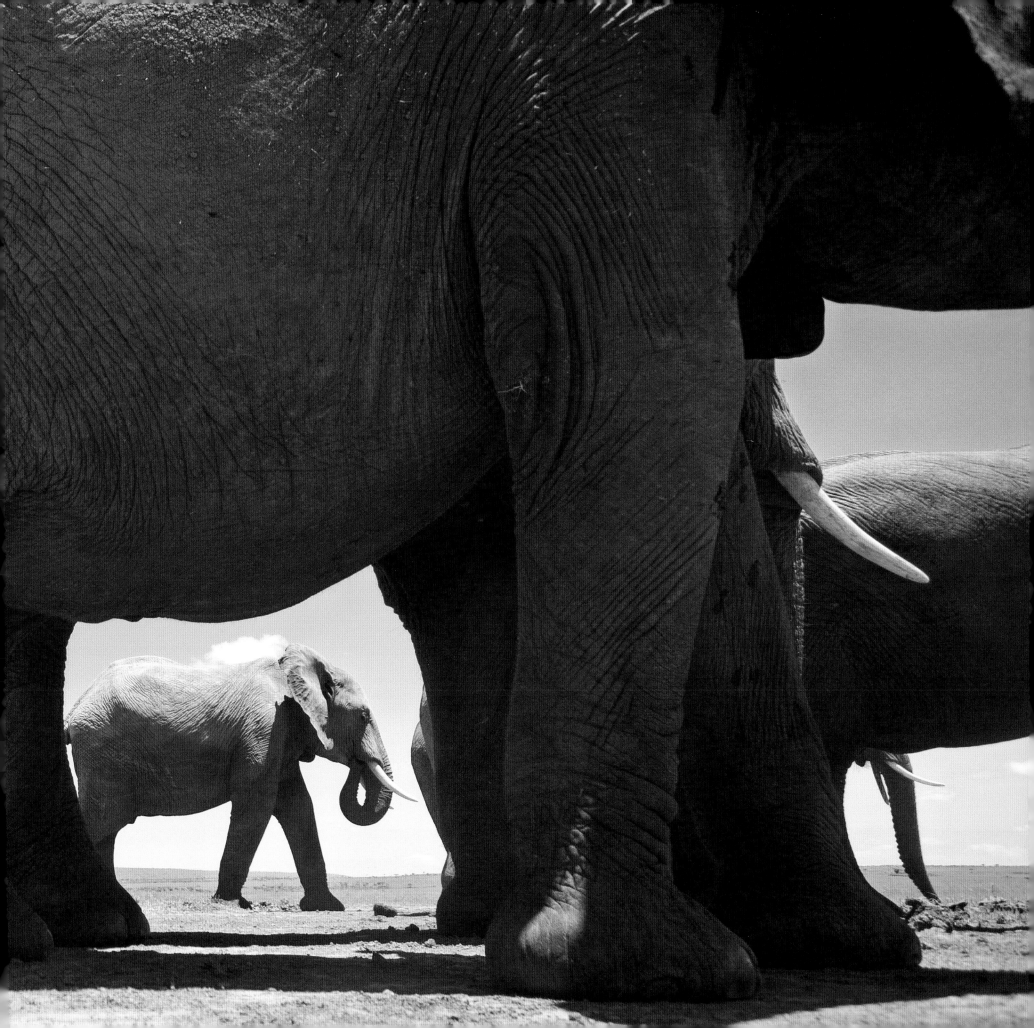

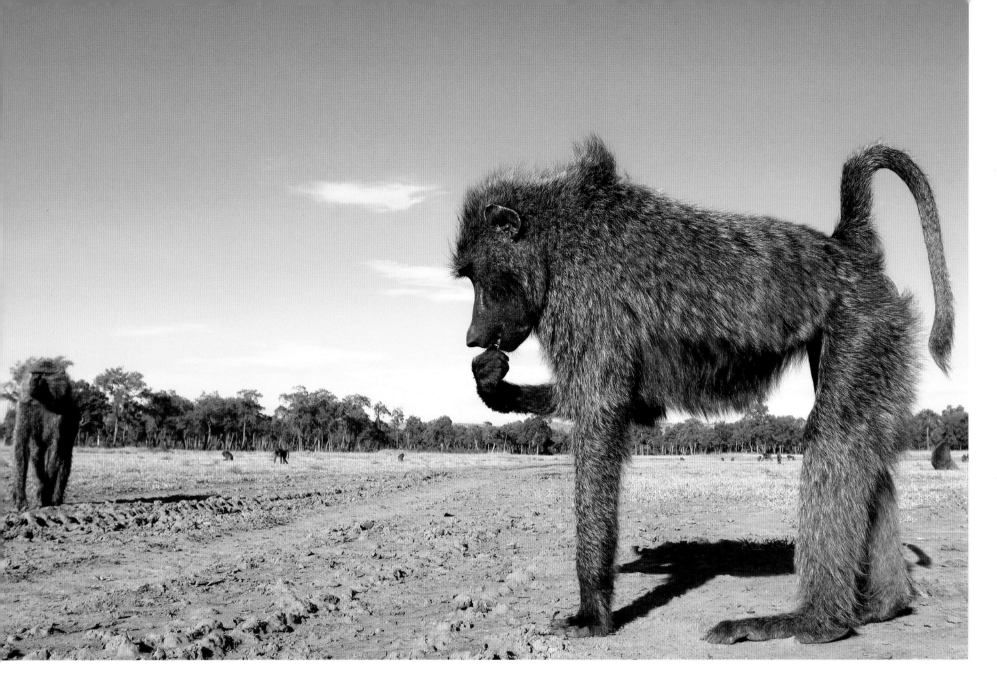

A baboon troop spreads out to forage. While looking for food, each baboon is in either visual or auditory contact with every other member of its troop. One key to the survival success of baboons is their willingness to consume anything that is remotely edible.

OPPOSITE: Before the heat of the day settles in, baboons forage on the plains adjacent to the patches of forest, looking for leaves, herbs, and seeds. Baboon hands, very much like human hands, are capable of gripping very fine objects between the thumb and forefinger, including very small seeds no larger than those of an apple.

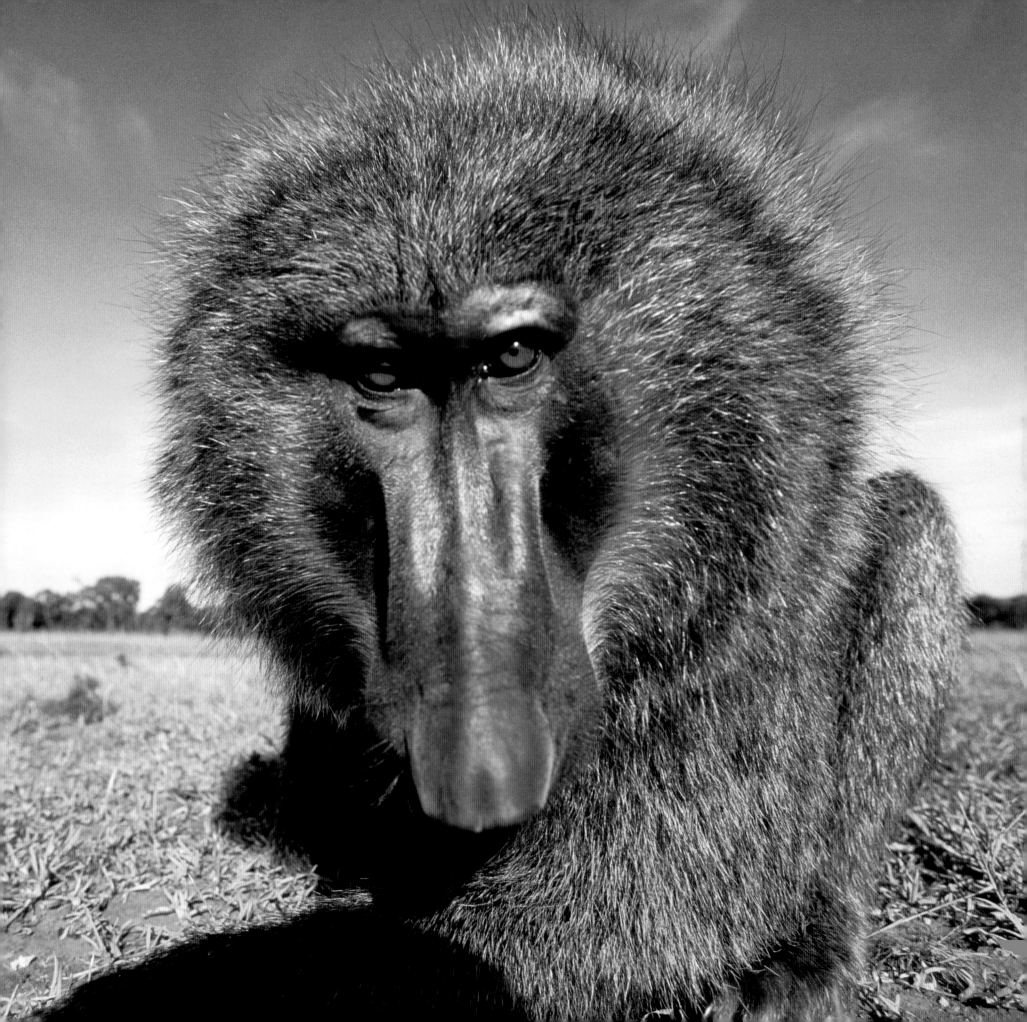

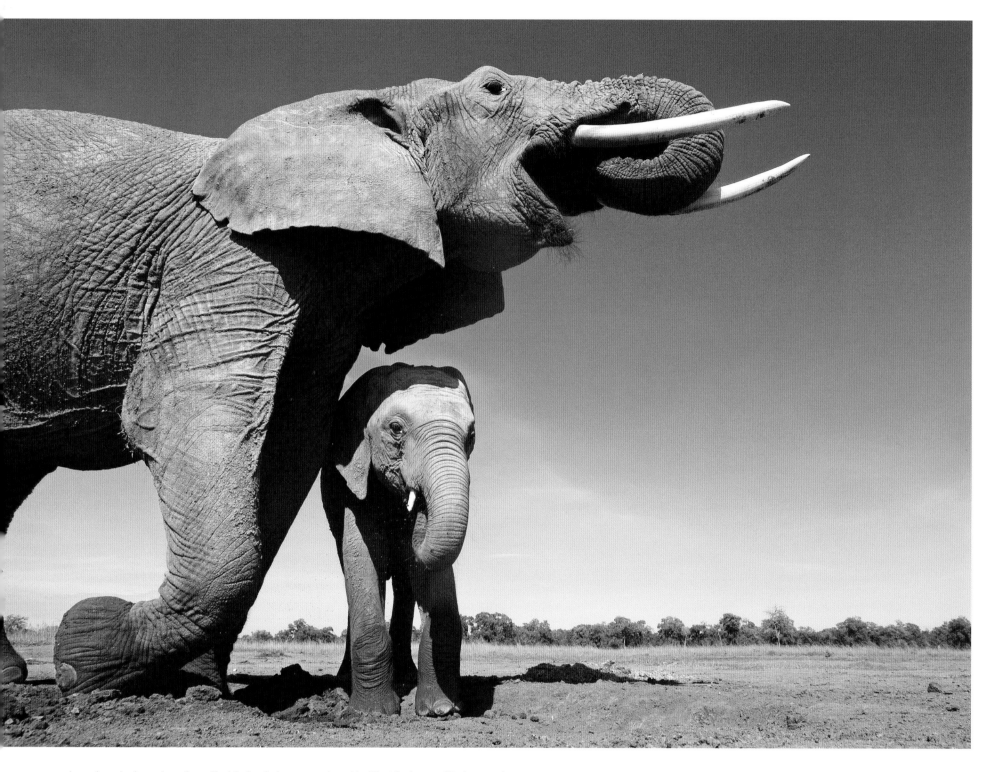

A mother elephant dusts herself while her baby stays at her side. The elephant calf is born with about 35 percent of its adult brain size potential; a human baby's brain at birth is about 29 percent of its adult size. Like in humans, a considerable amount of development occurs as the baby elephant grows to adulthood.

OPPOSITE: Even with good visibility, it is surprising how easily elephants can creep up on you without your noticing them. Despite their size, they are quiet mammals by habit and make hardly a sound when walking.

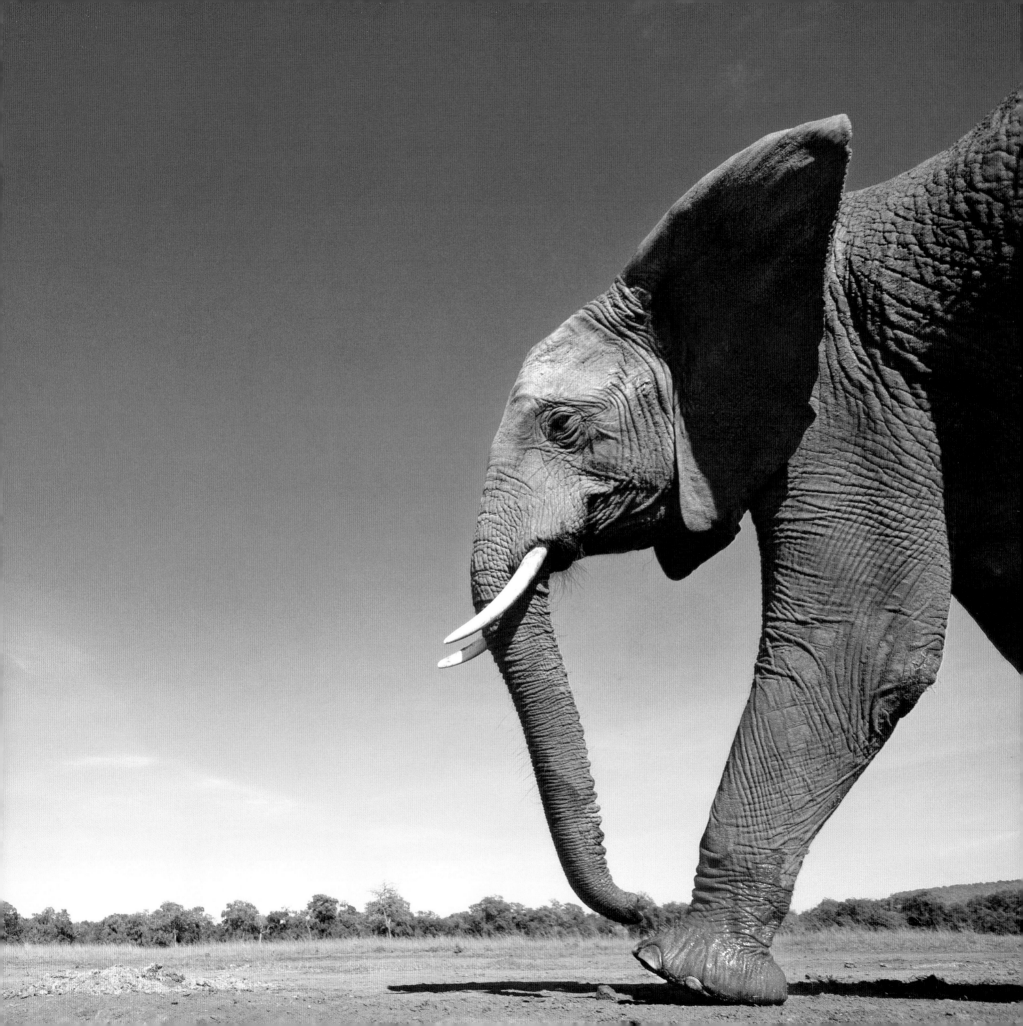

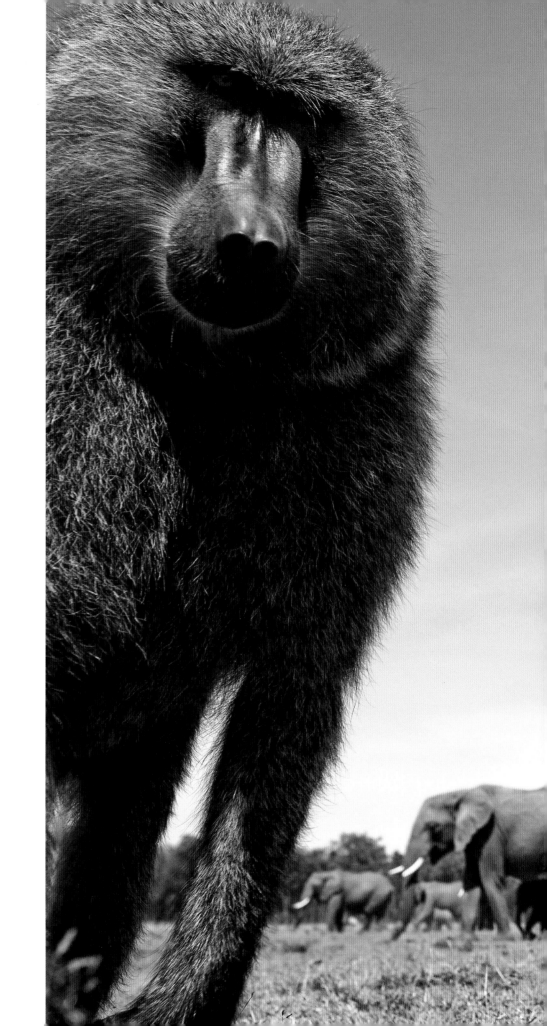

Another reason for the baboon's survival success is their ability to withstand extremes of temperature and rainfall. In this respect, they are similar to elephants. In the distant past, both species ranged over all of Africa. Sadly, due to human expansion, this is no longer the case.

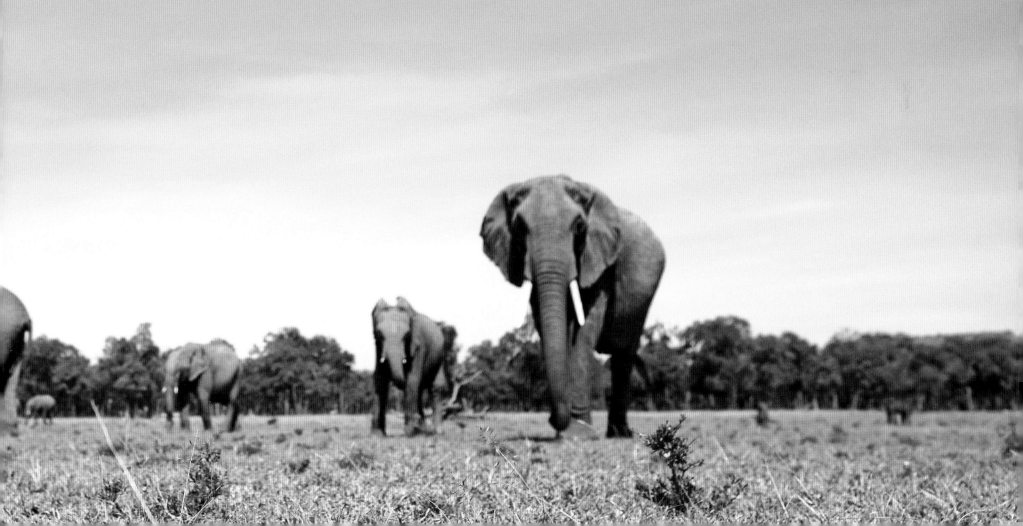

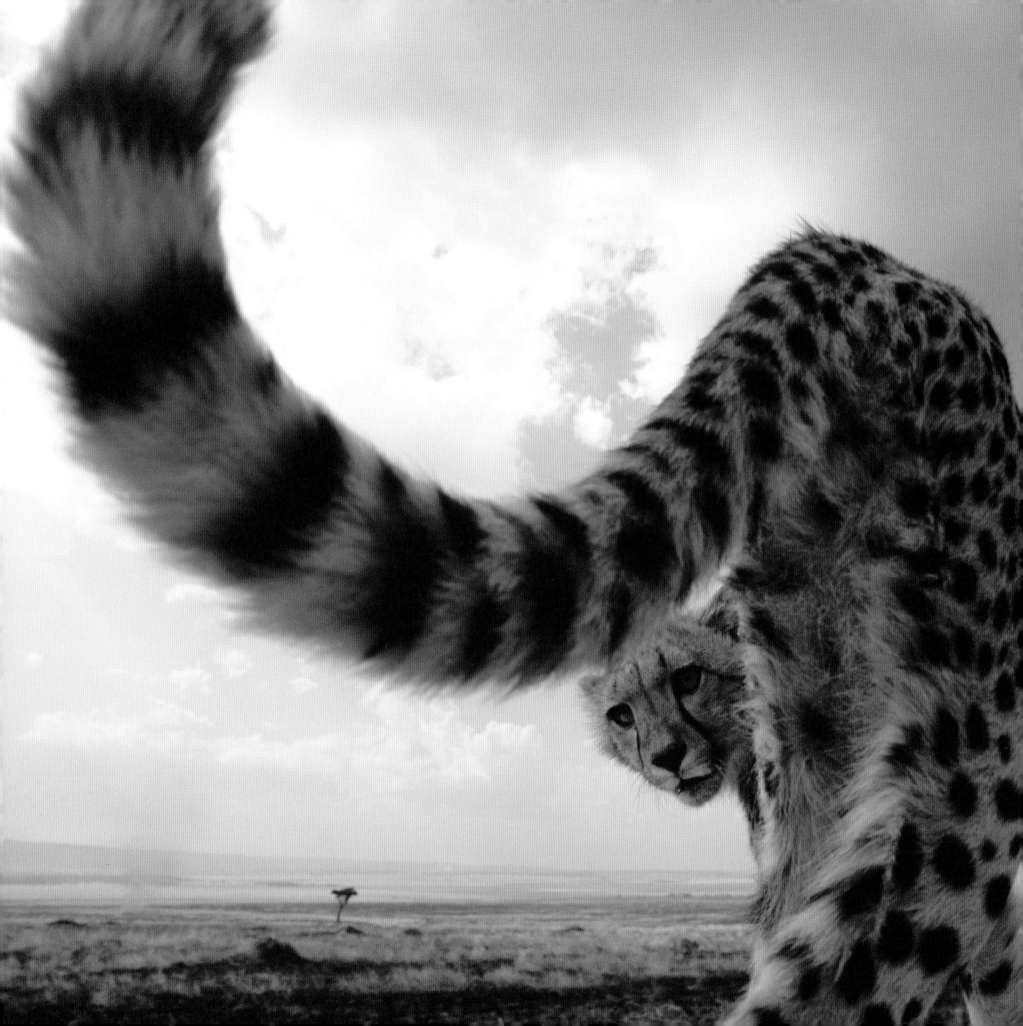

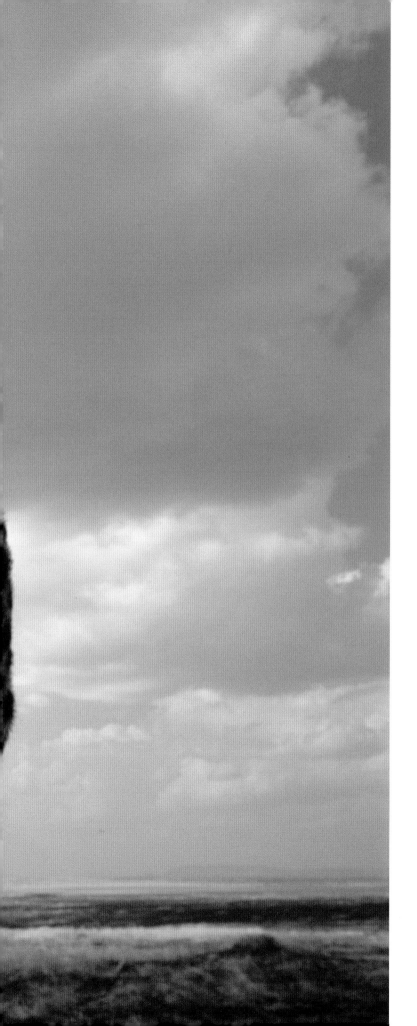

This fourteen-month-old male cheetah turns his head back to glance at the camera; he is bolder and more inquisitive than his sisters.

In the early months of the year, newborn Thomson's gazelles start appearing on the plains. During their first couple of weeks, they are helpless against predators and are easy to catch once detected.

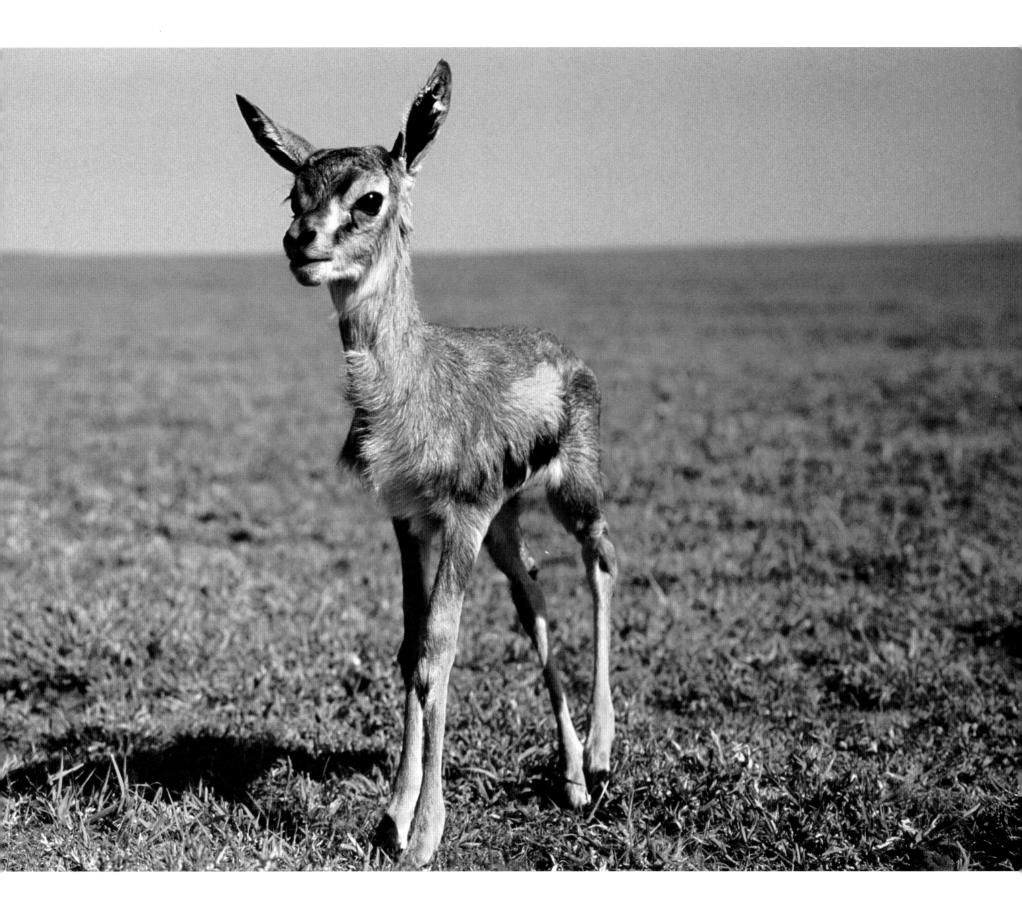

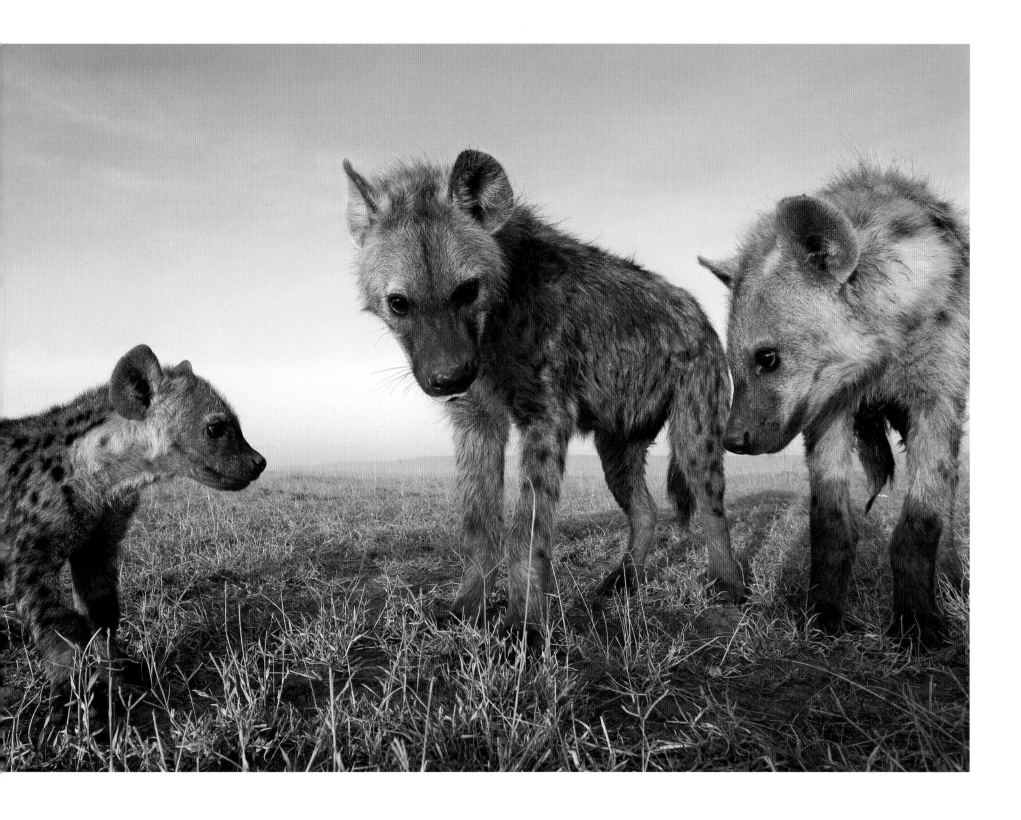

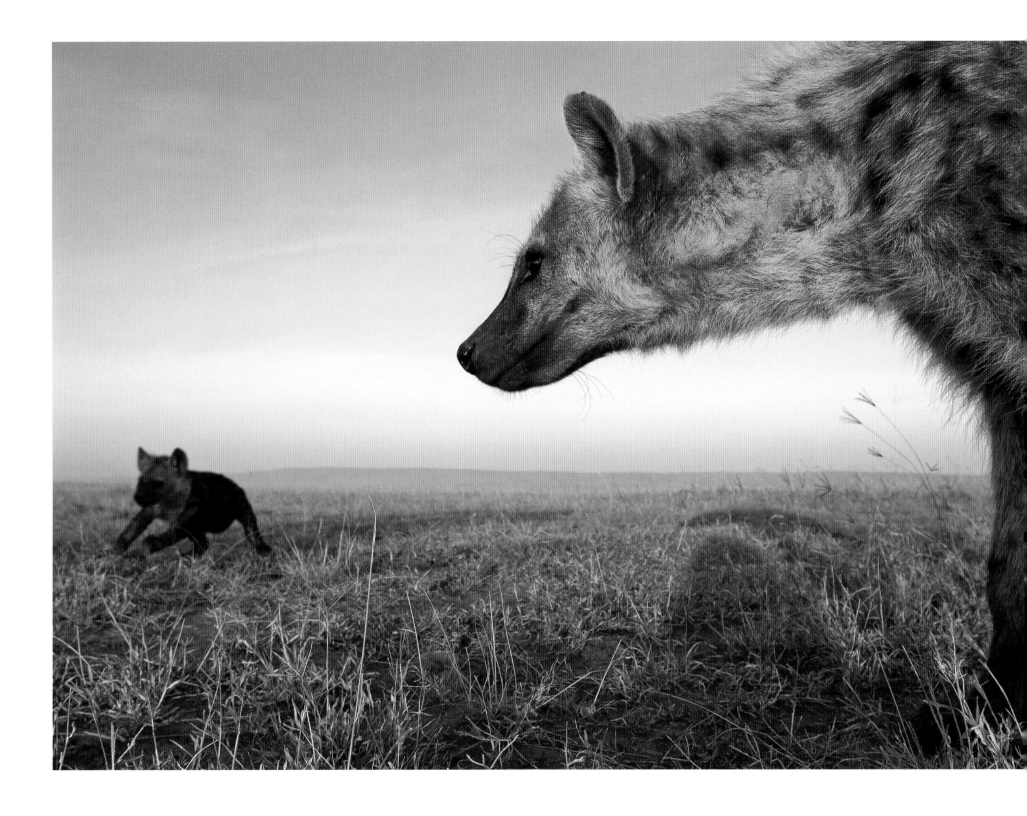

Activity around a hyena den in the cool hour after daybreak. The pups greet each adult returning from the night's excursion, carry off a piece of the carcass brought for them, and dash into the den opening at the slightest hint of danger. Hyenas are highly tolerant of the pups, and females are considered to have excellent mothering skills.

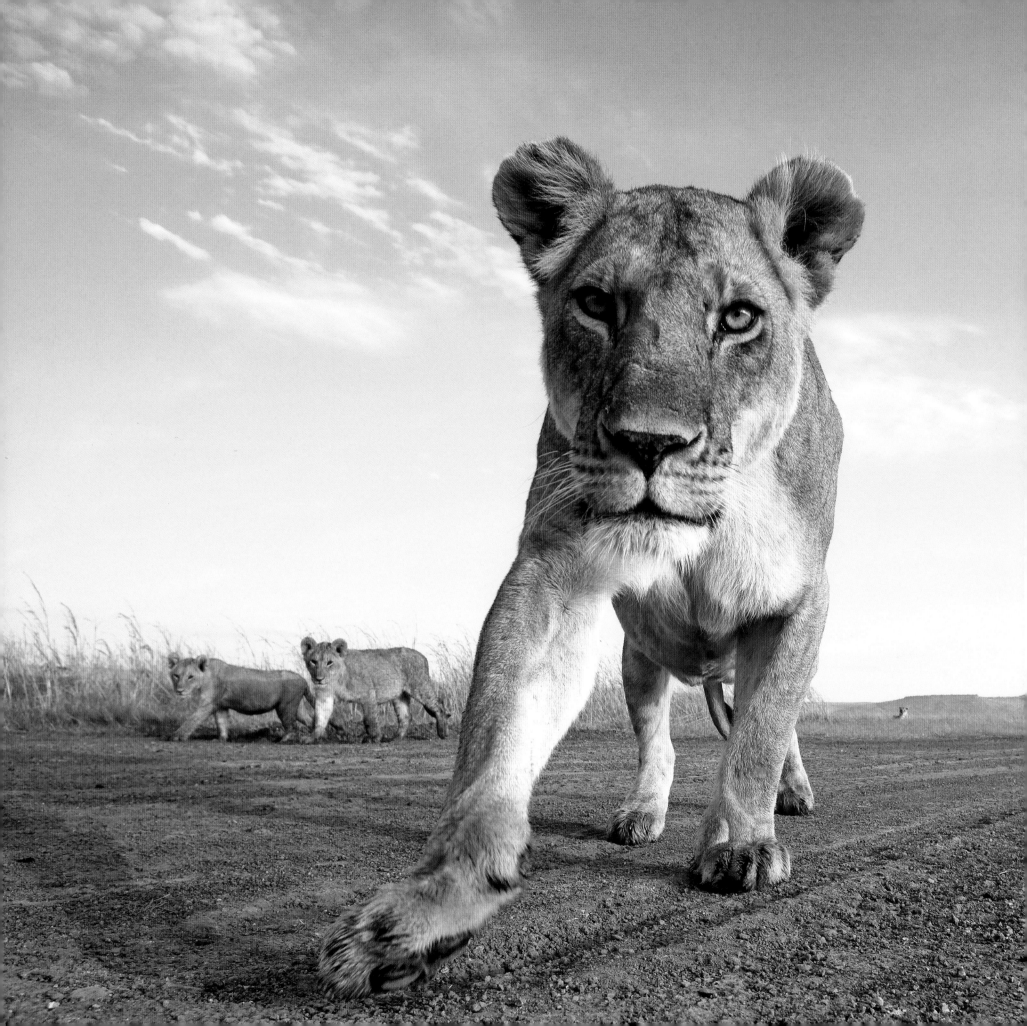

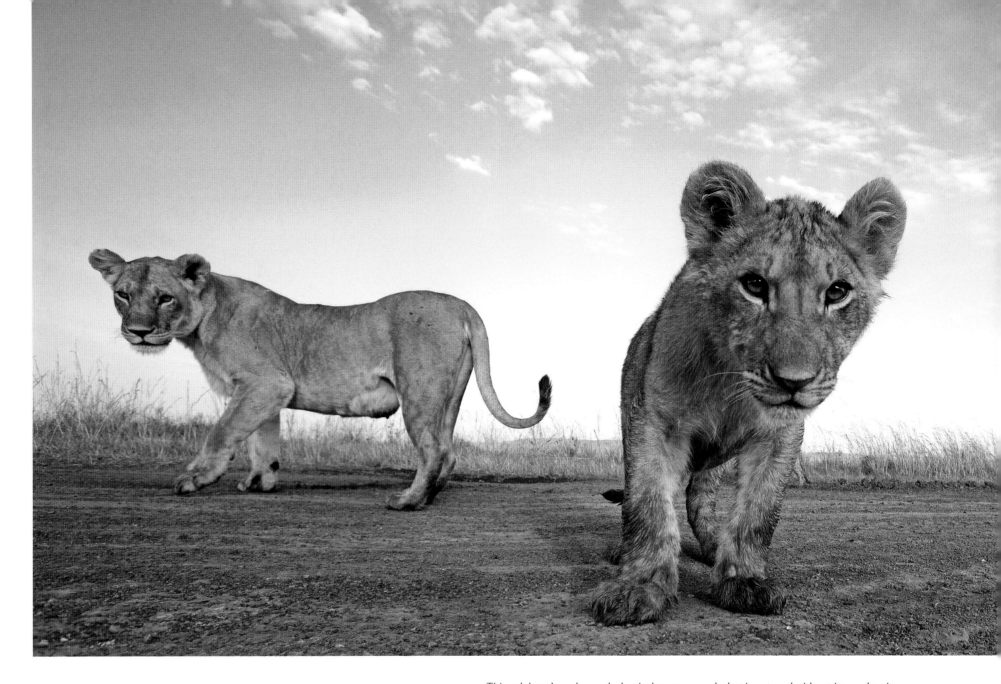

This cub hasn't yet learned what is dangerous and what is not, and without its mother, it could easily blunder into danger: Cape buffalo are known to trample lion cubs, and given the opportunity, hyenas, leopards, and jackals would not hesitate to kill and eat them.

OPPOSITE: This lioness is taking her cubs to rejoin her pride. While her cubs are this young, she prefers to keep them away from the older cubs, who would torment them mercilessly. At the same time, she is driven to keep in touch with her sisters; they need to become familiar with her cubs sooner rather than later.

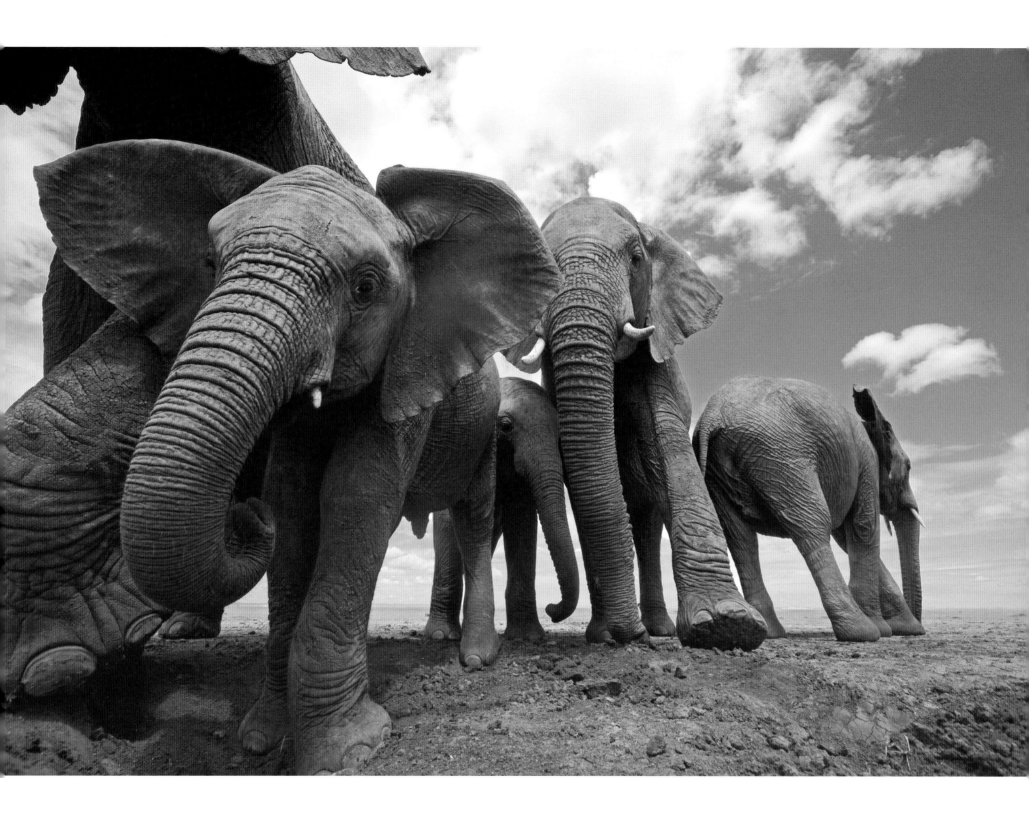

These elephants have emerged from the forest in search of water, mud, and dirt. After slaking their thirst, they will dig into the cool mud and spray it over their bodies; the young adopt all kinds of contorted postures to maneuver their tusks in the soil.

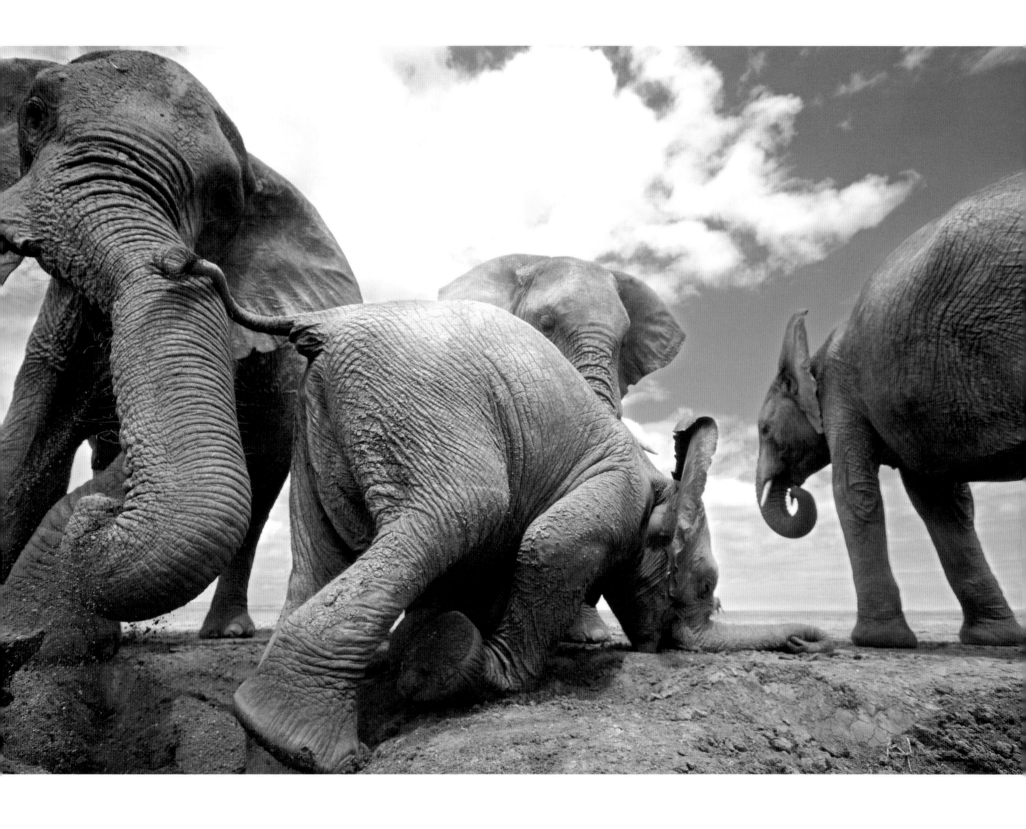

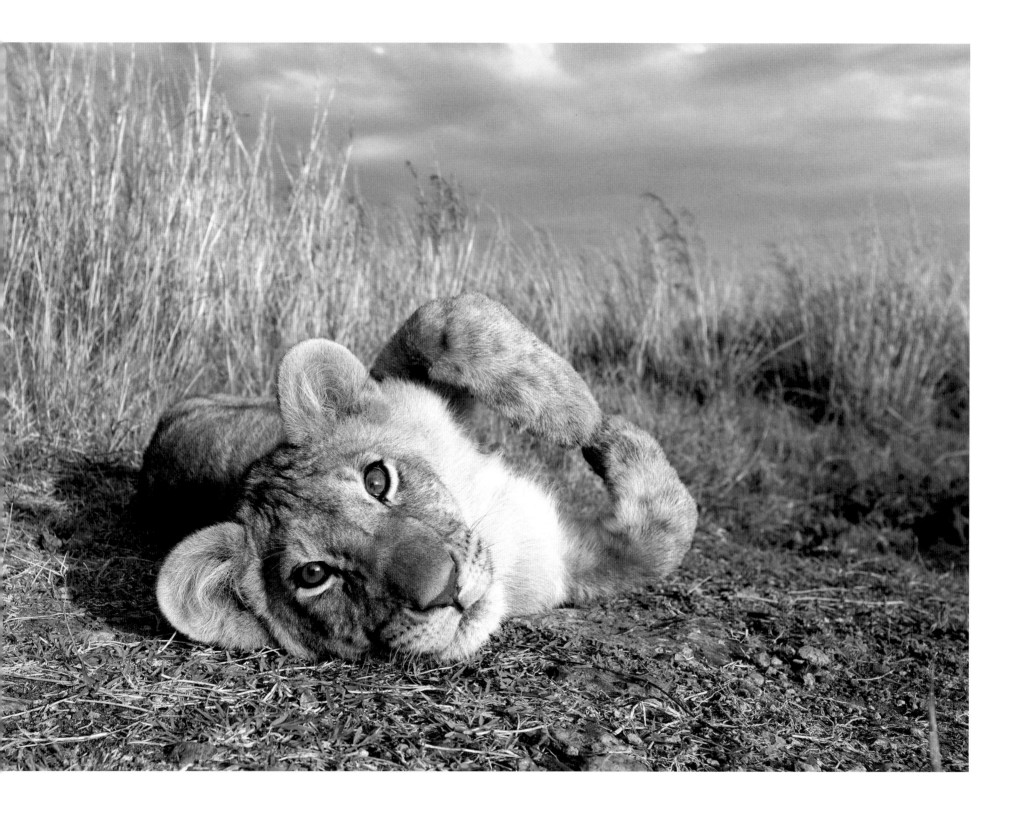

Lions have a longer period of development than any other African cat—more than two years.
During the early part of this phase, cubs seem to live at only two speeds: overdrive and collapse.

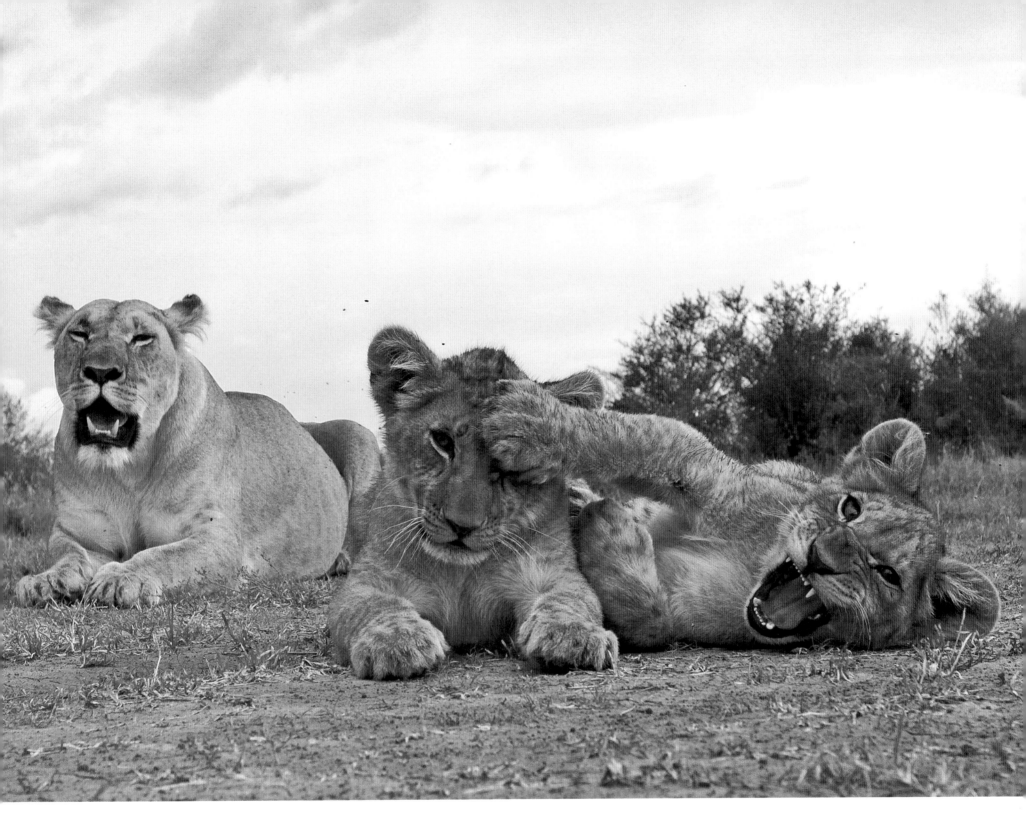

Having suckled, two lion cubs get up to mischief under the watchful eye of their resting mother. The cubs are less than six months old, so the mother still keeps them away from the pride most of the time.

February is the calving period of wildebeests. This newborn calf was born with deformed legs and has been abandoned. Its mother tried to cajole it into following her, but to no avail.

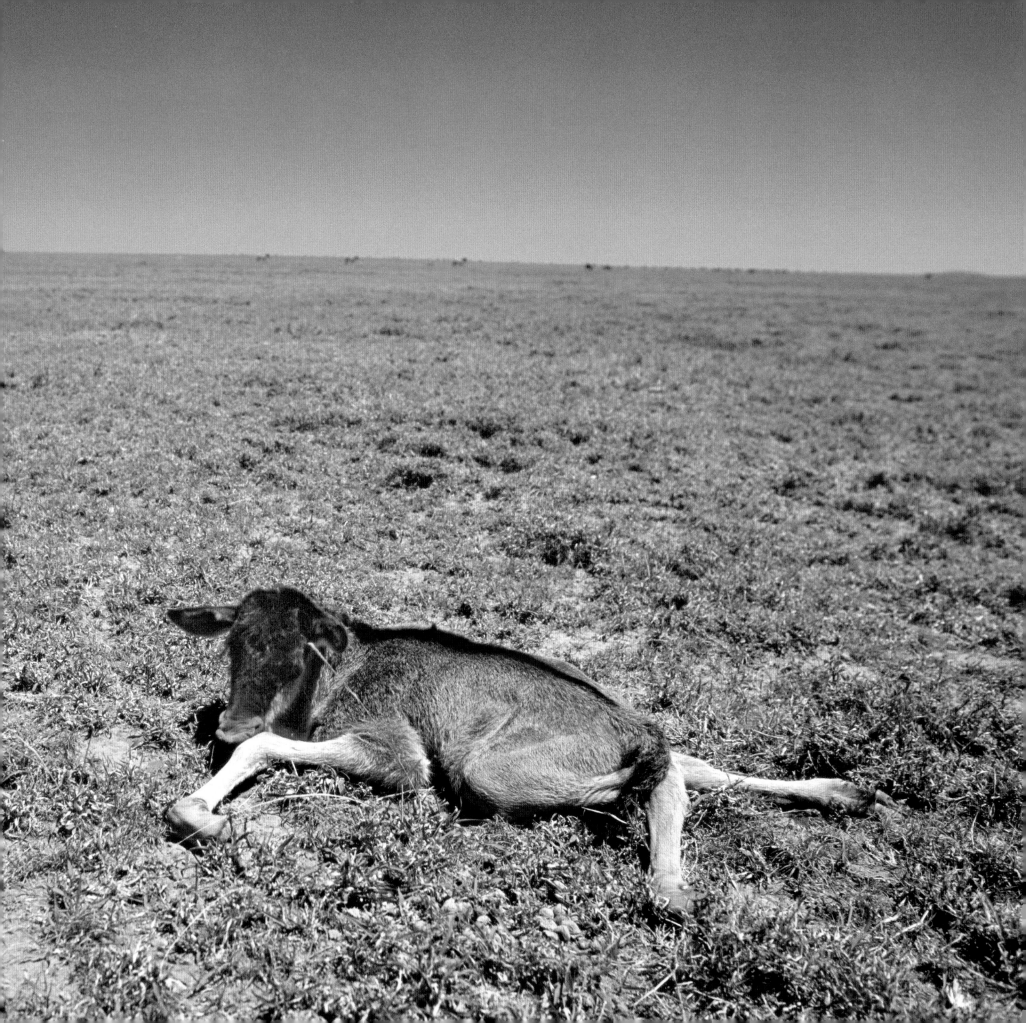

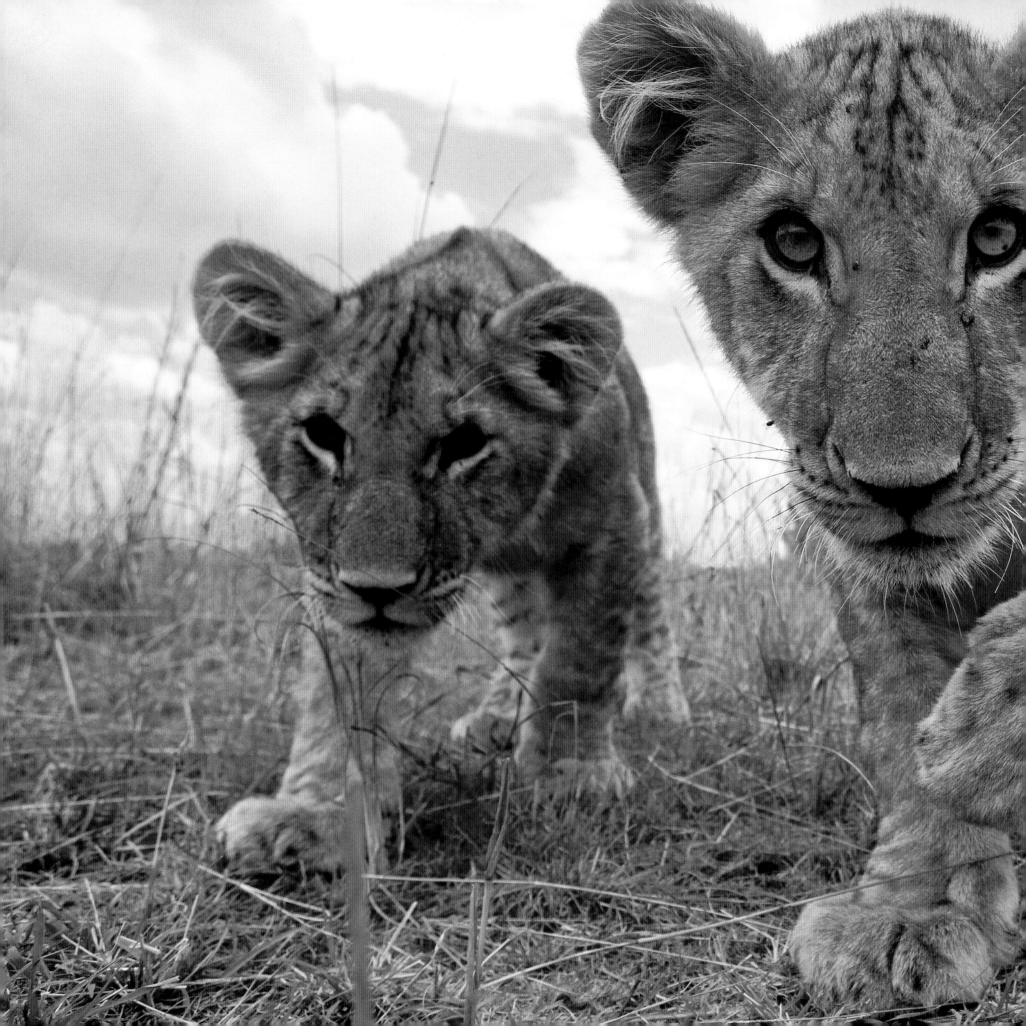

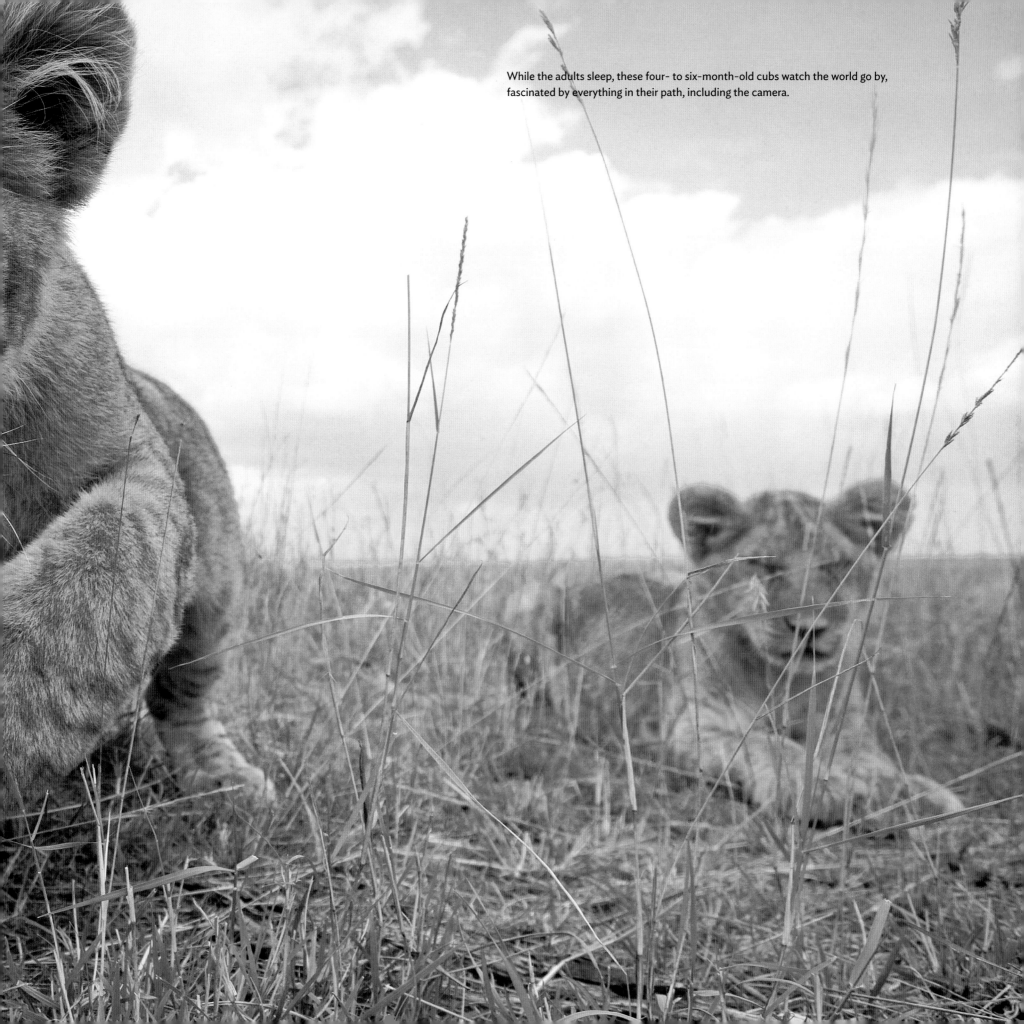

While the adults sleep, these four- to six-month-old cubs watch the world go by, fascinated by everything in their path, including the camera.

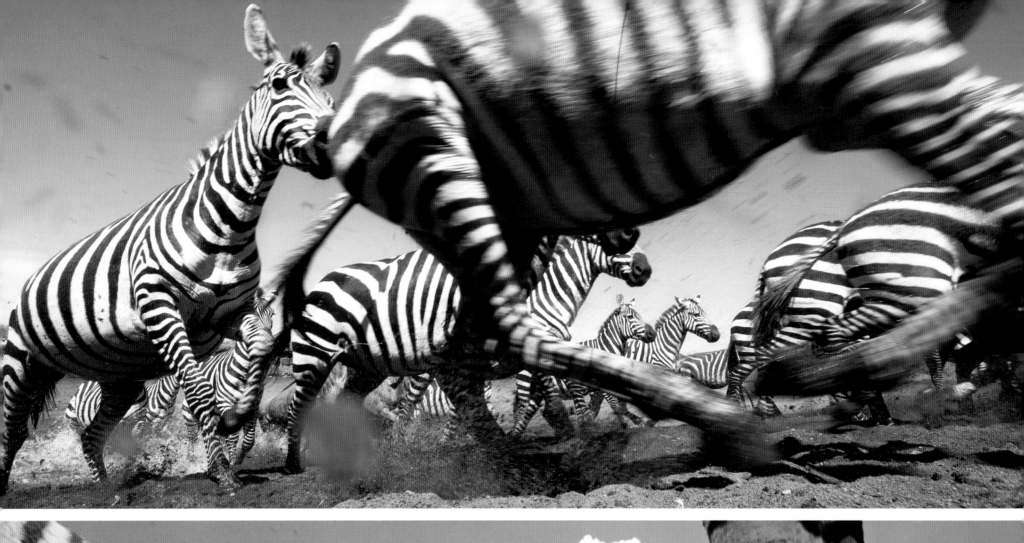
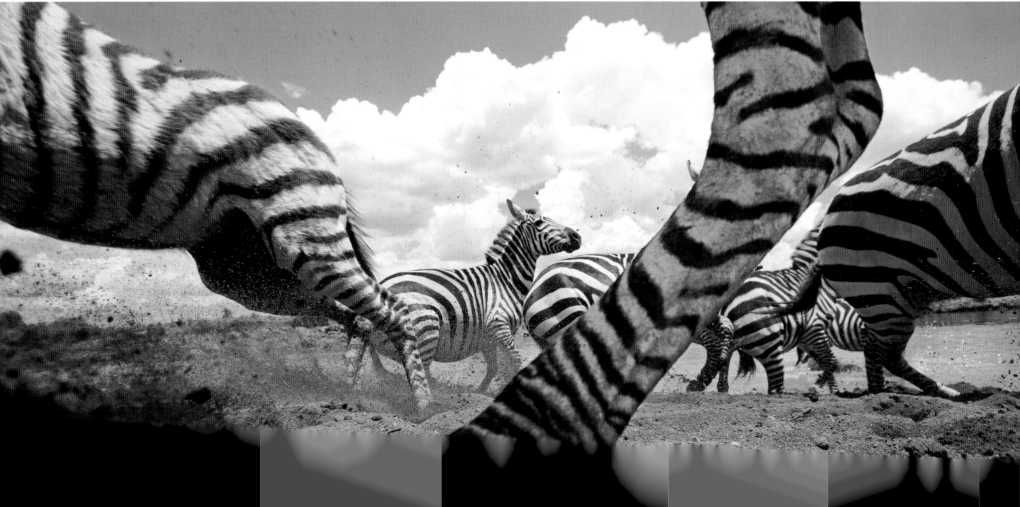

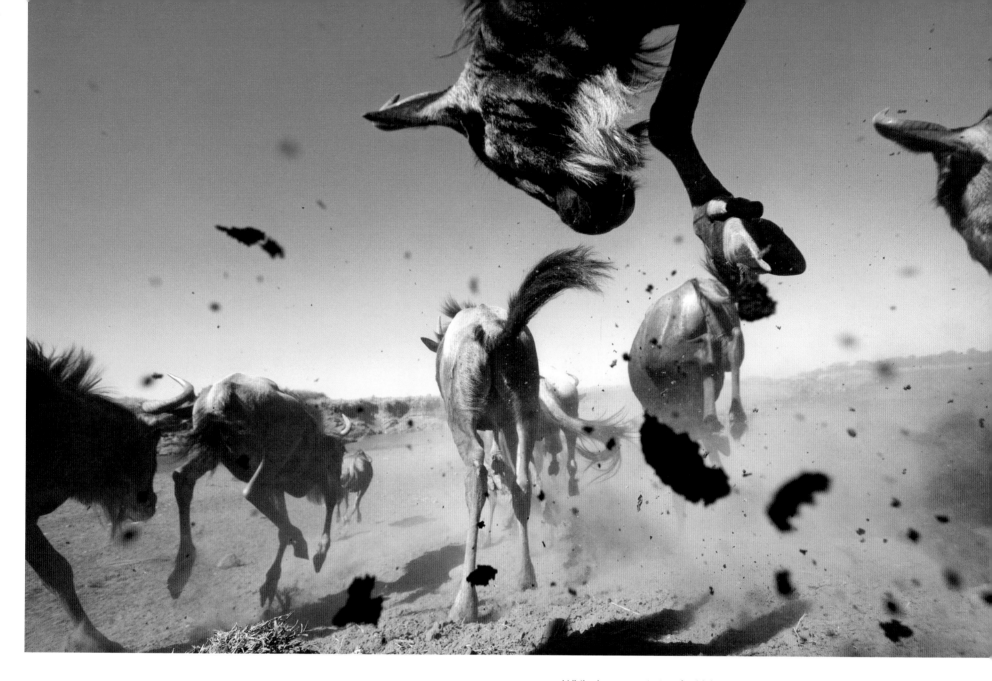

ABOVE AND OVERLEAF: While the vast majority of wildebeests living on the East African plains migrate over the greater Serengeti ecosystem, a small minority migrates locally between an area called Loita Plains and the Maasai Mara. Yet another tiny minority, too exhausted to keep up with the migrating herds, stays in the Mara year-round.

OPPOSITE: During the months of January, February, and March, zebras are drawn to the Maasai Mara National Reserve for its water. The Mara River is a permanent source of water in the region, though by March, the end of the short dry season, huge rocks are exposed in the riverbed. At this time of year, one can cross by scrambling from rock to rock and arrive on the other side with dry feet. The zebras come to this river nearly every day to drink.

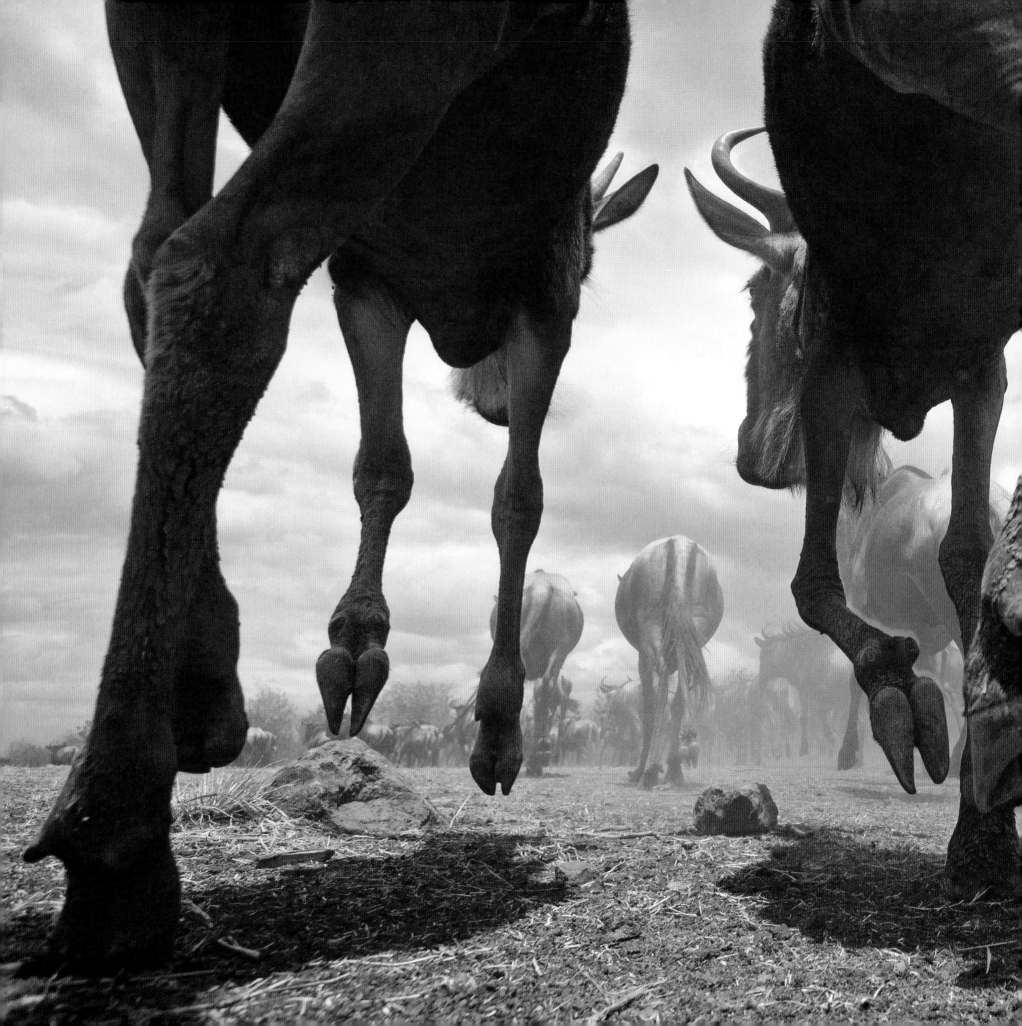

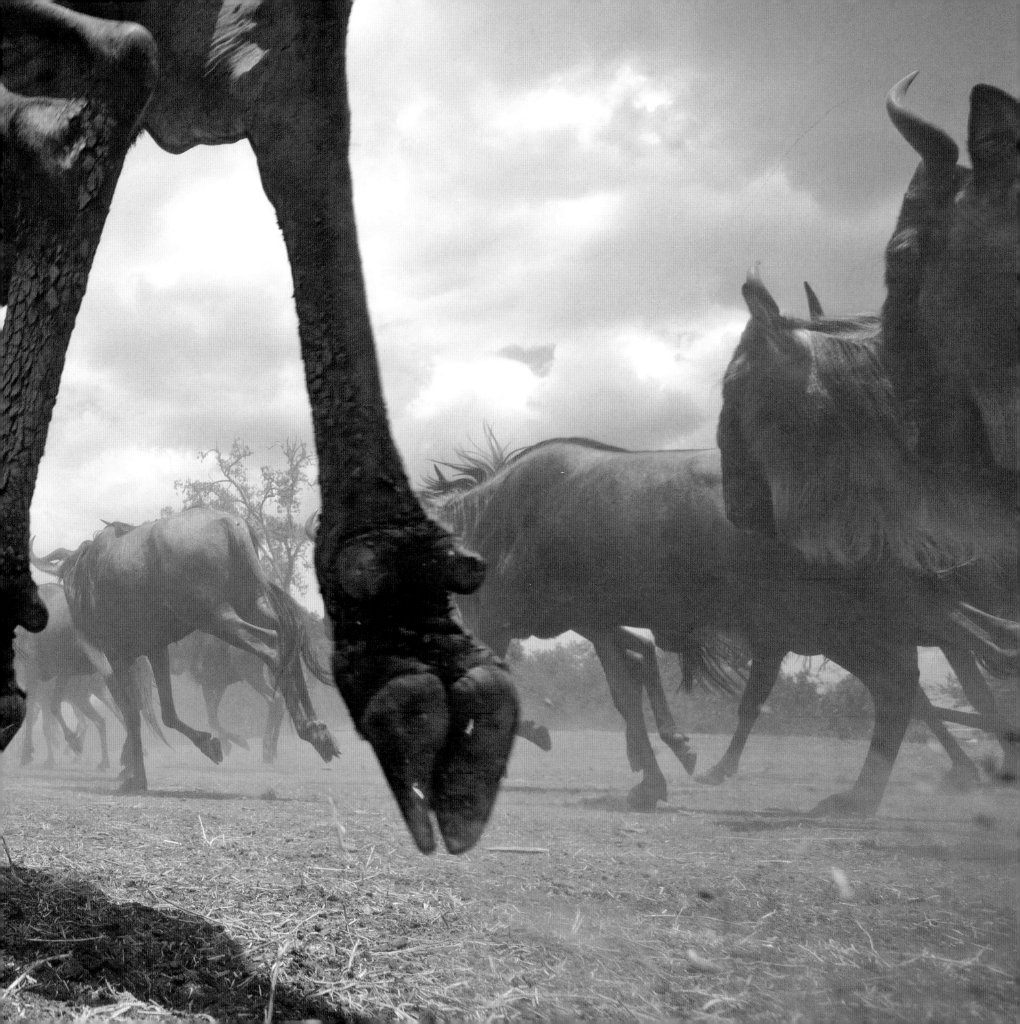

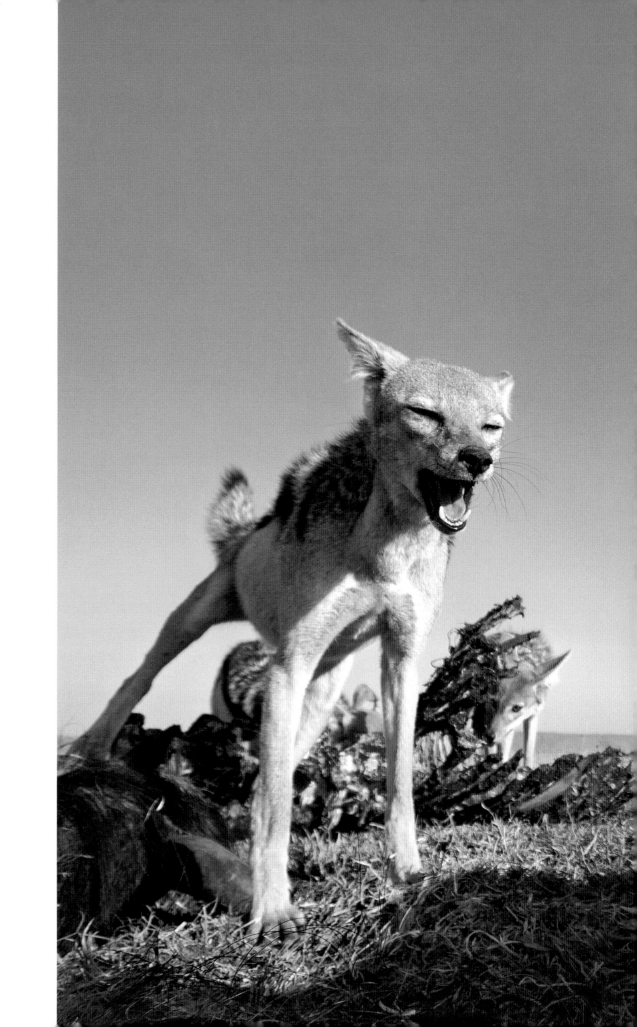

The Marsh lion pride made this kill during the night and after eating its fill has moved off to a shady, dry riverbed. There are eight black-backed jackals in contention for the leftovers, but only one male controls access to the kill. Fortunately for them, the carcass has not yet been discovered by either vultures or hyenas, so every jackal gets at least a mouthful.

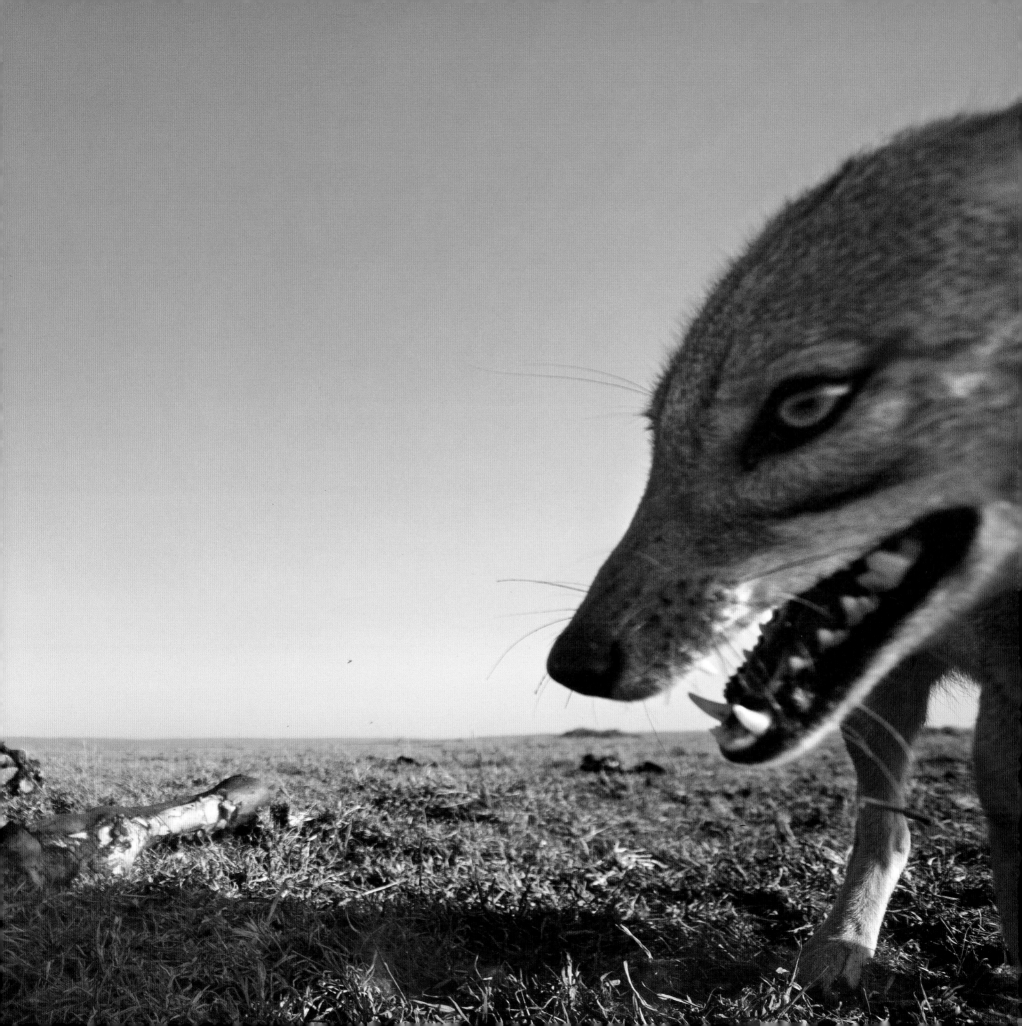

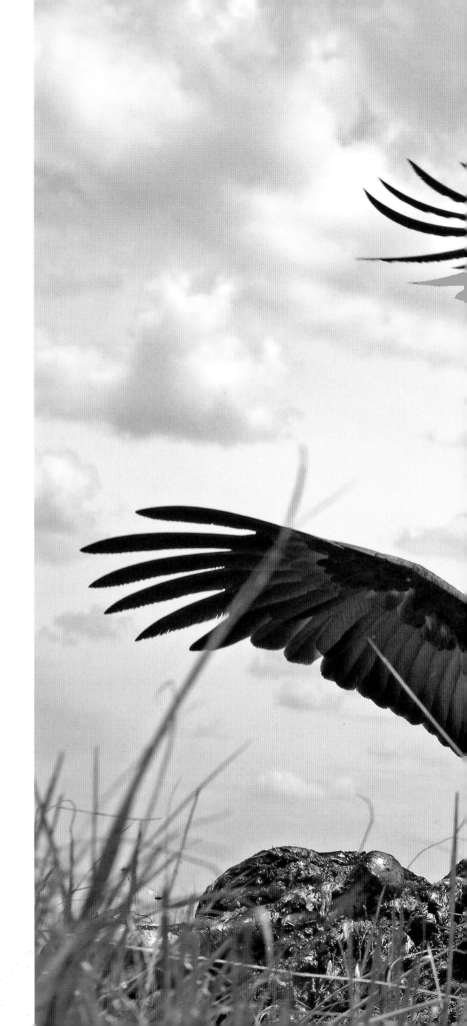

The vultures are the next set of scavengers, after the jackals, to arrive at the kill. Flying in one after another, they land near the carcass, where they join a group waiting for the coast to clear. When the predators have moved on from the kill, the vultures rush in, not unlike humans trying to board a crowded flight.

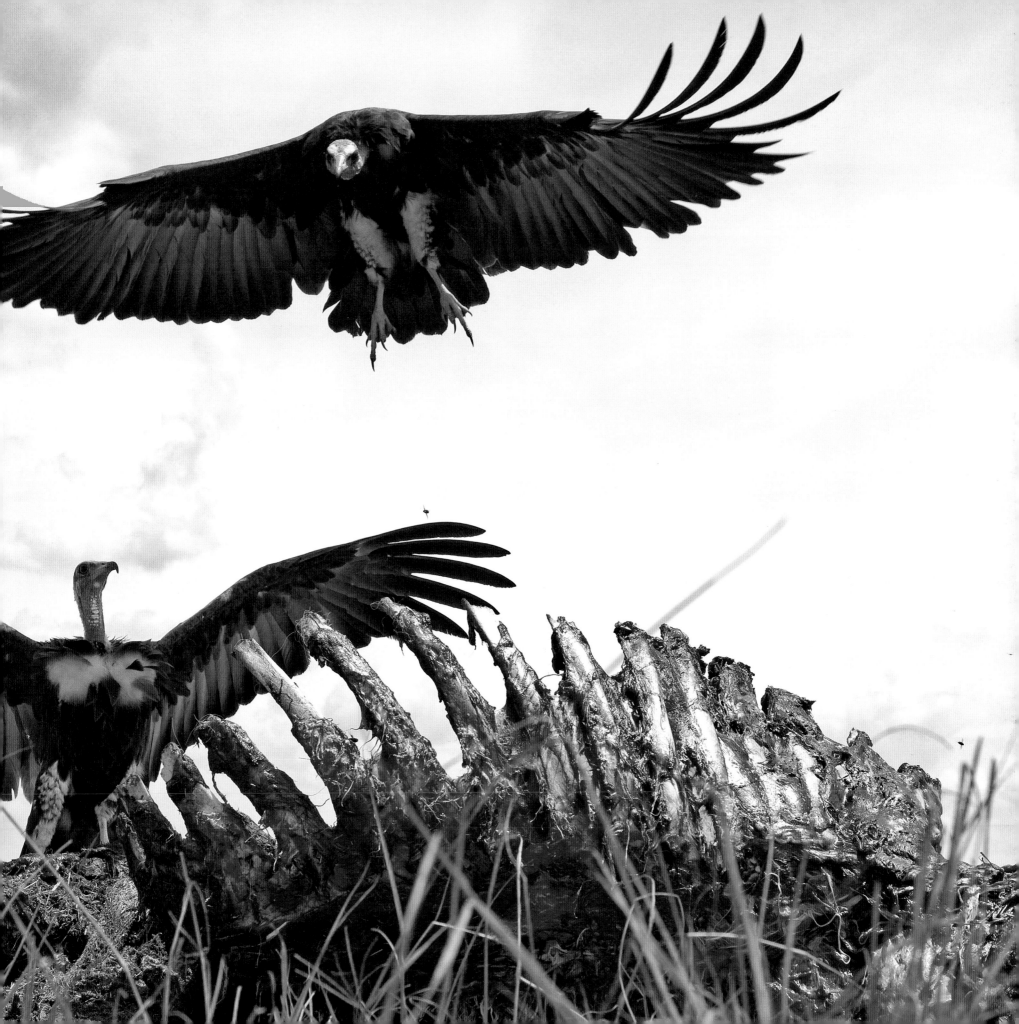

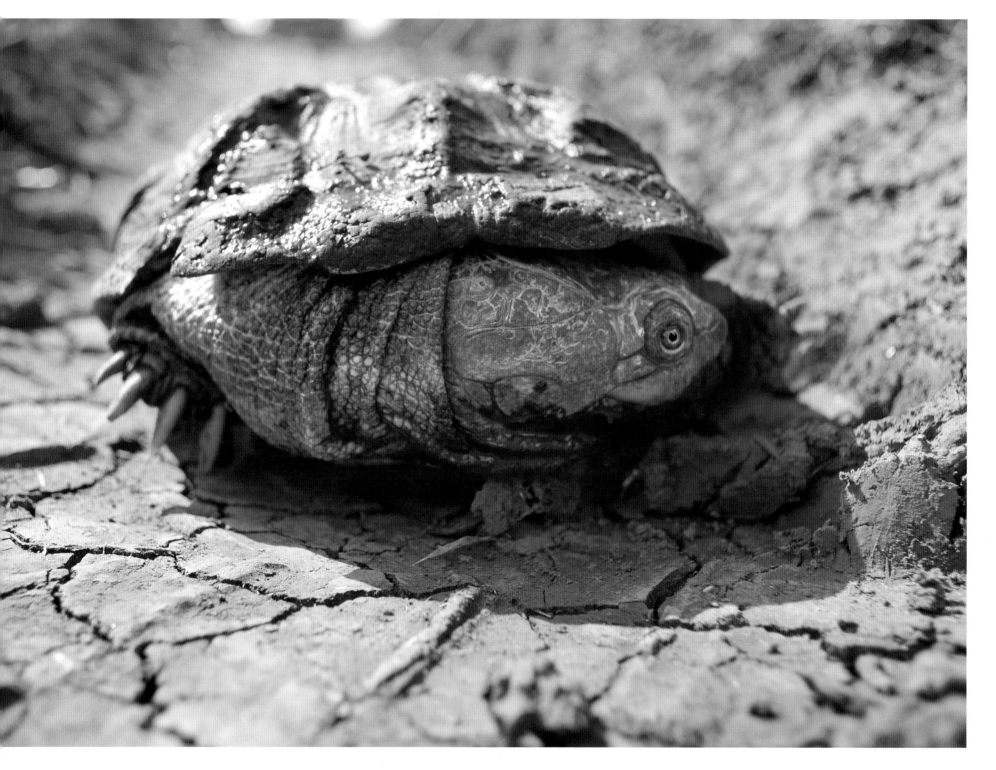

It is the end of February, and the wind blows warm over a shriveled landscape. At this time of
year, a lump of dried mud crumbles in the hand; dust devils form and scatter the soil haphazardly.
This terrapin is in search of a better source of water.

OPPOSITE: The mud in a drying pool can be dangerous. This inexperienced buffalo calf became
so stuck it was never able to extricate itself. Mercifully, a lioness came along and put it out of
its misery. She tried to drag it out, but even her strength failed to accomplish that task.

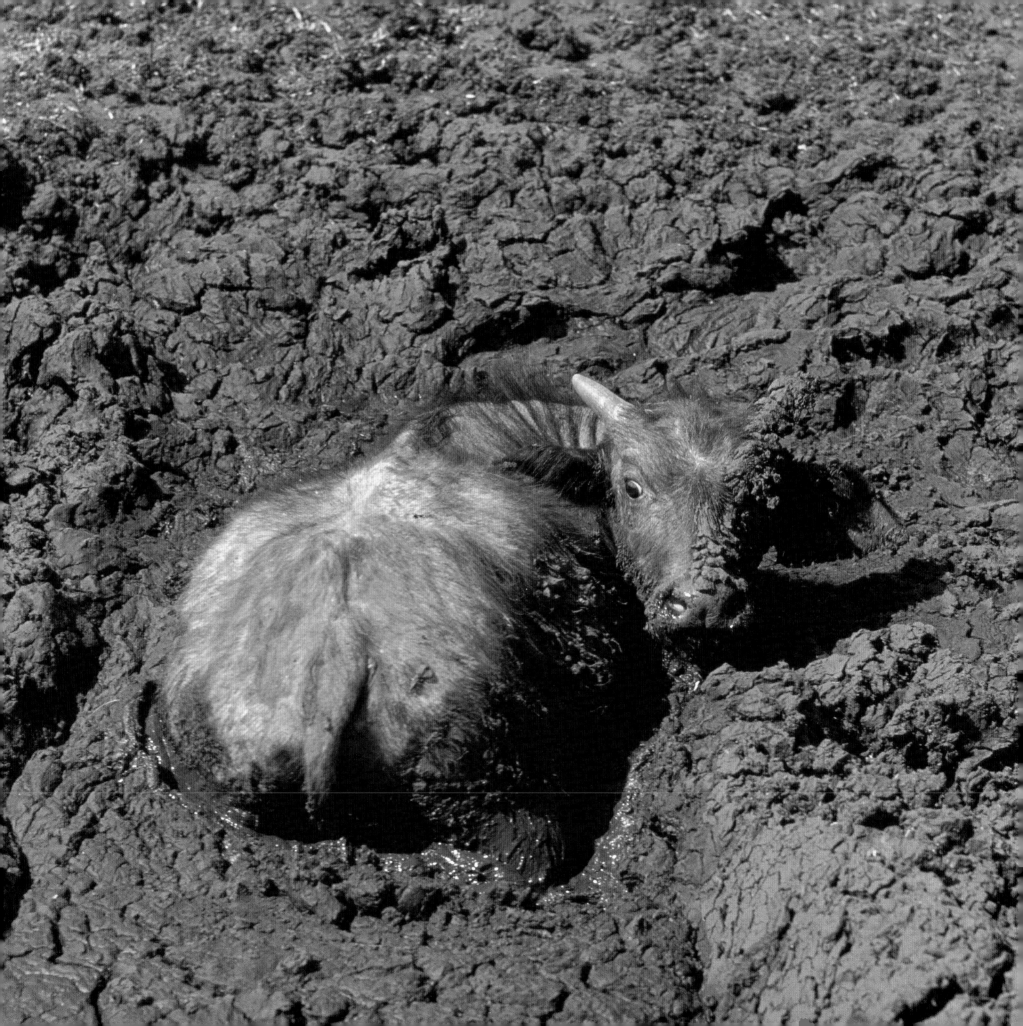

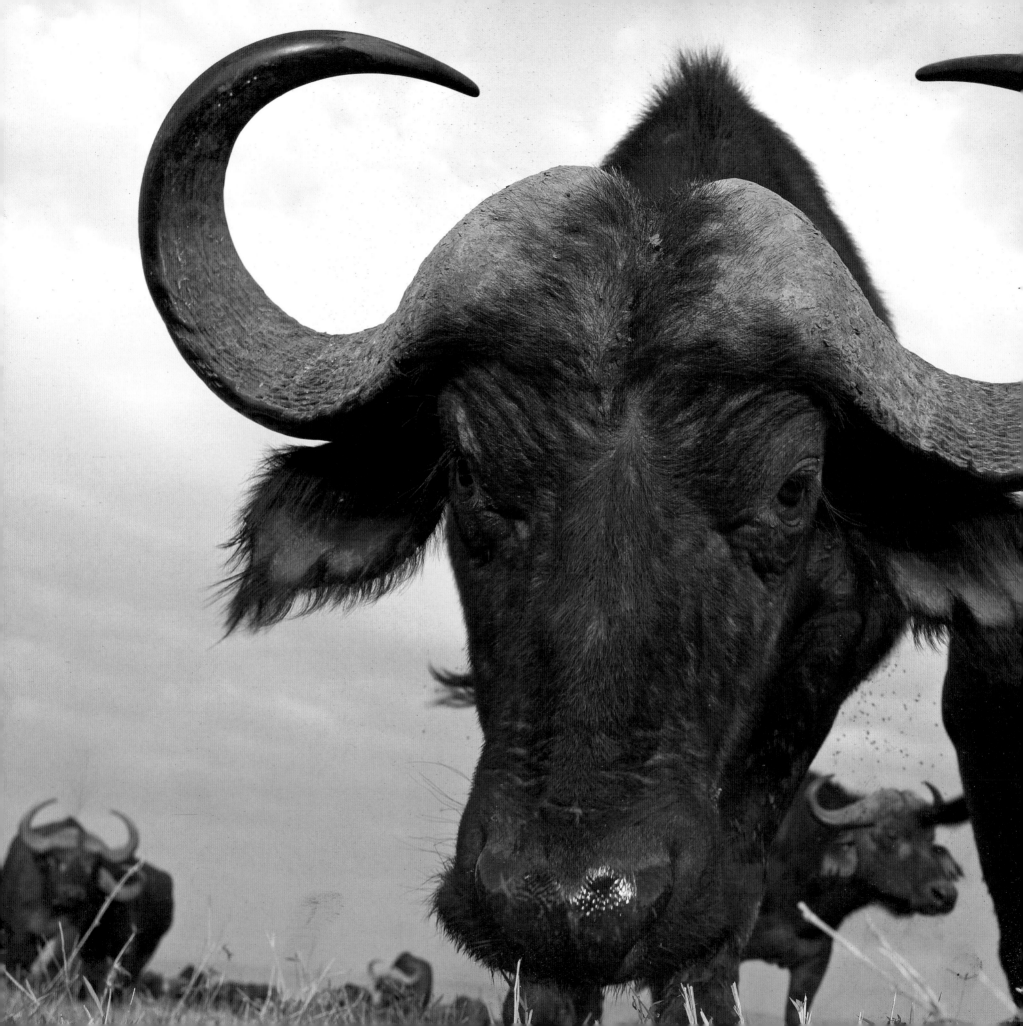

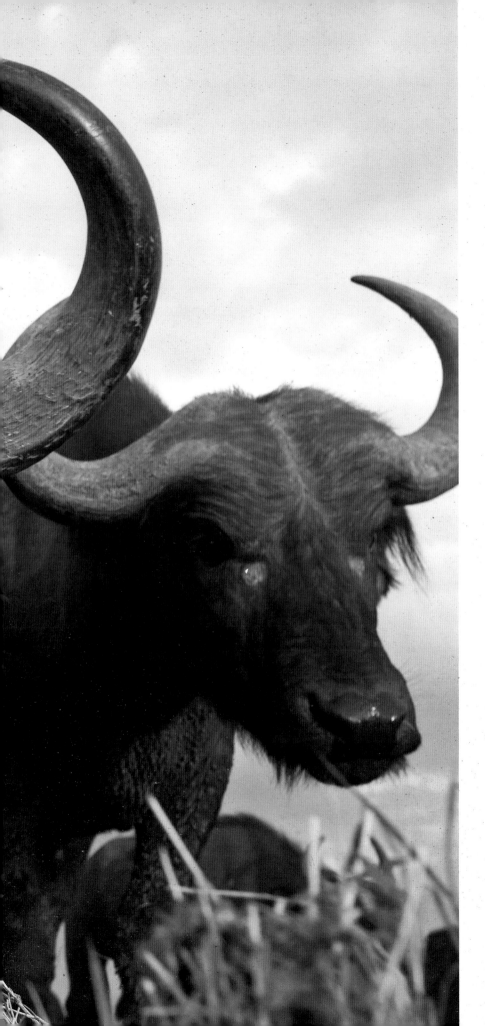

Up close, the Cape buffalo can look benign, but it has acquired quite a reputation for aggressive behavior.

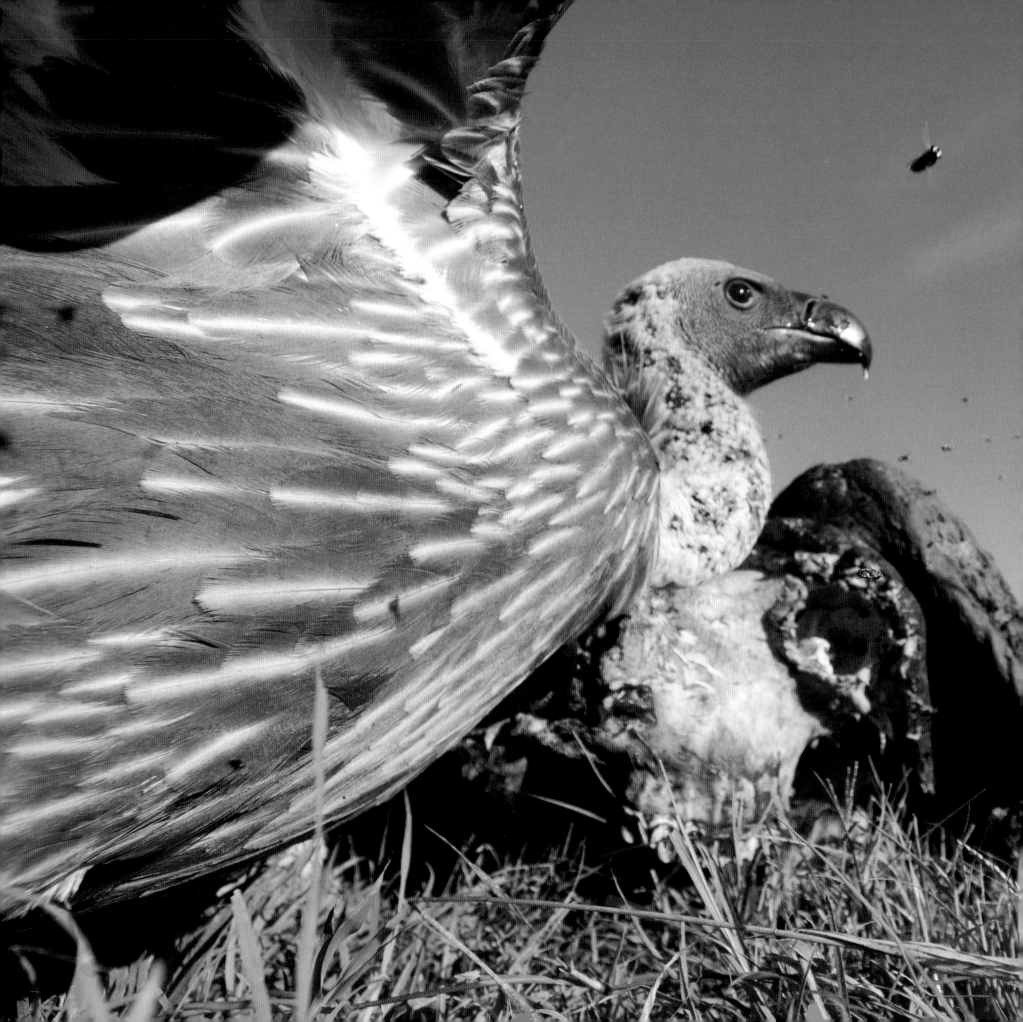

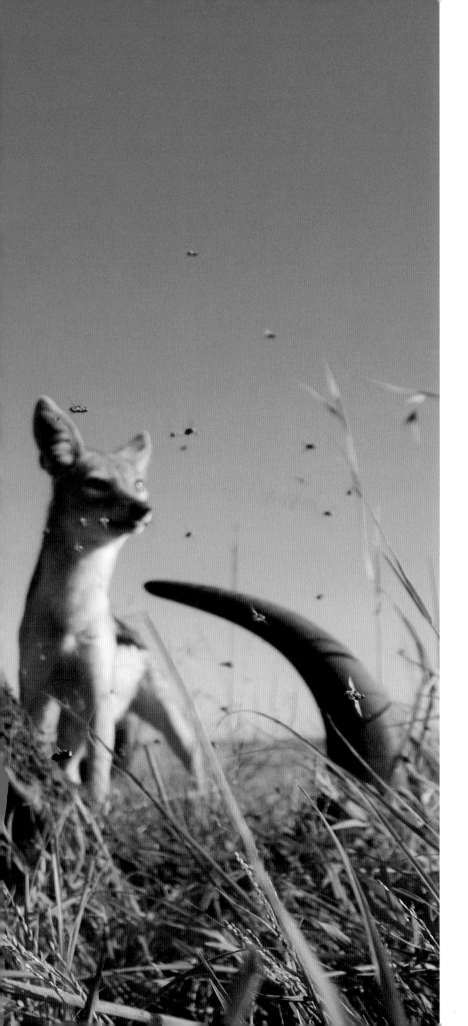

By this time of year, Cape buffalos, deprived of water, grass, and mud wallows, have weakened. Last night, the large Marsh lion pride brought down an adult buffalo, and by early morning, they had devoured a significant portion of it. After they've left the kill, the arrival of vultures scatters the flies. The vultures, in turn, are scattered by a determined black-backed jackal. Marabou storks forage, their sharp eyes picking out the few remaining scraps of flesh, but the lions have cleaned out the entire carcass, so very little is left.

53

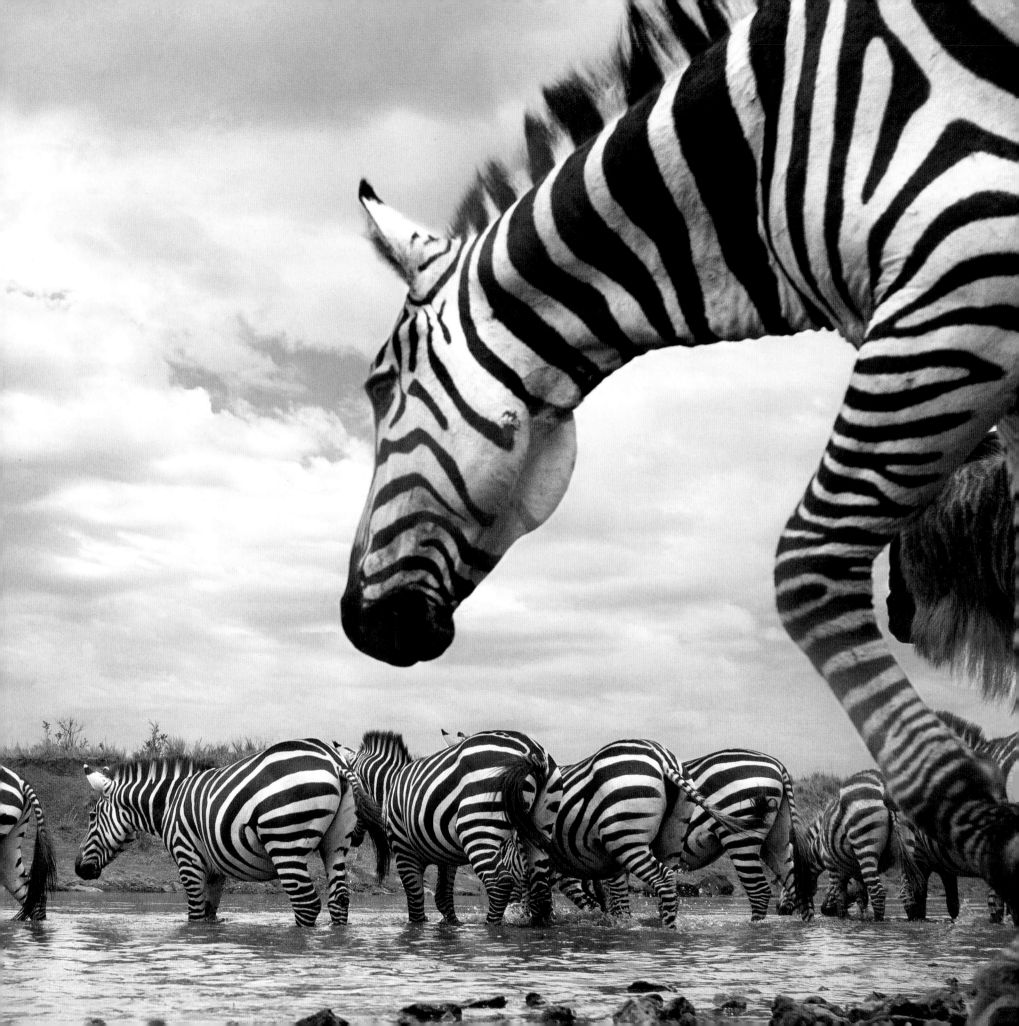

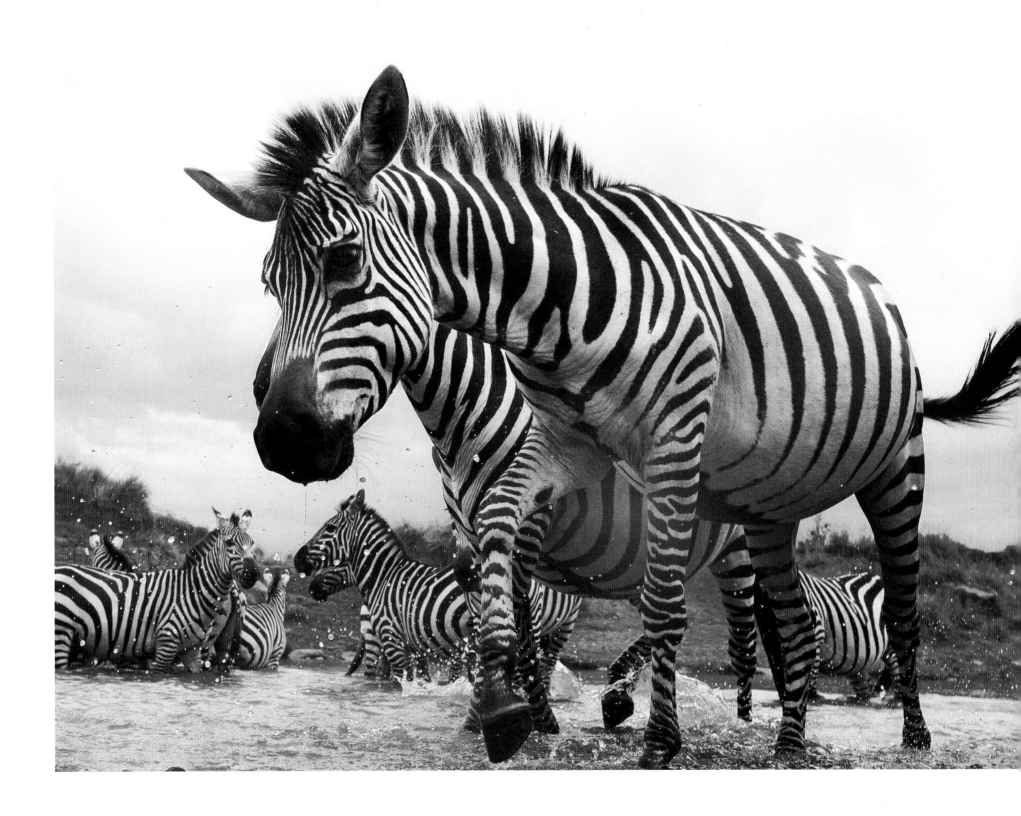

It is mid- to late March. Signs of rain, thicker clouds, and moist air start to appear just as water sources everywhere have practically vanished. Only the Mara River, seen here, remains, flowing from its source in the swamps of Mau Forest, located on the Great Rift Valley escarpment to Lake Victoria, and taking in the Maasai Mara National Reserve in Kenya and Serengeti National Park in Tanzania. Many animals owe their survival during the dry seasons to this river.

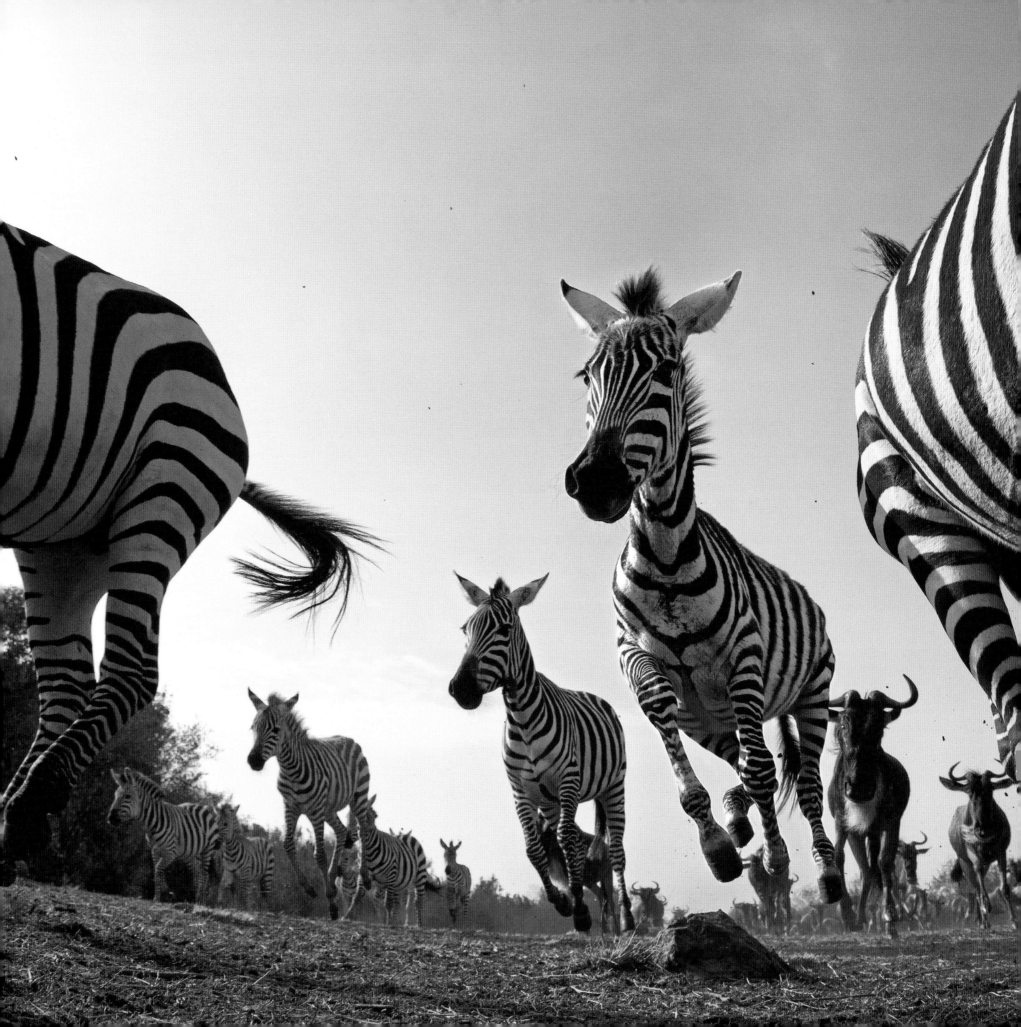

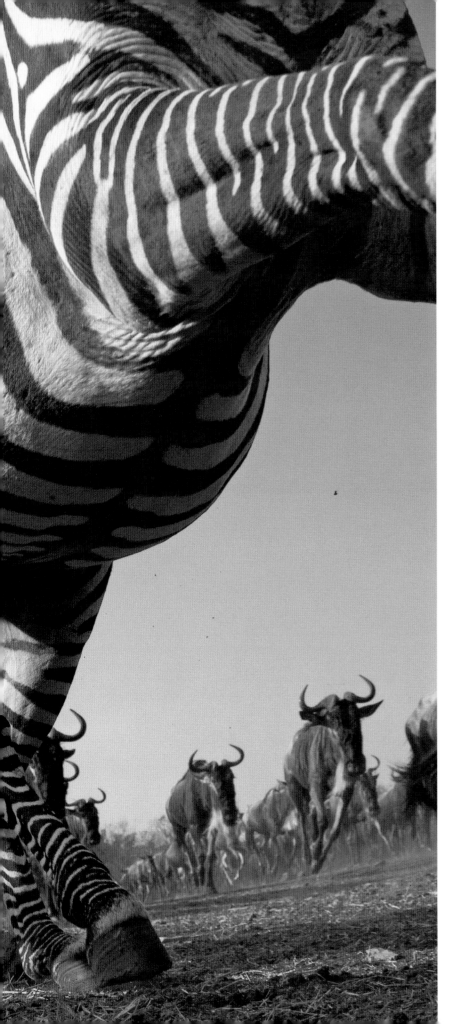

Drinking at the river is fraught with danger. Experienced lions wait in cover here, looking for an opportunity to strike. But whereas lions have skill, cunning, stealth, and patience, zebras have an acute sense of awareness and speed. They are also risk averse and run away at the slightest hint of danger.

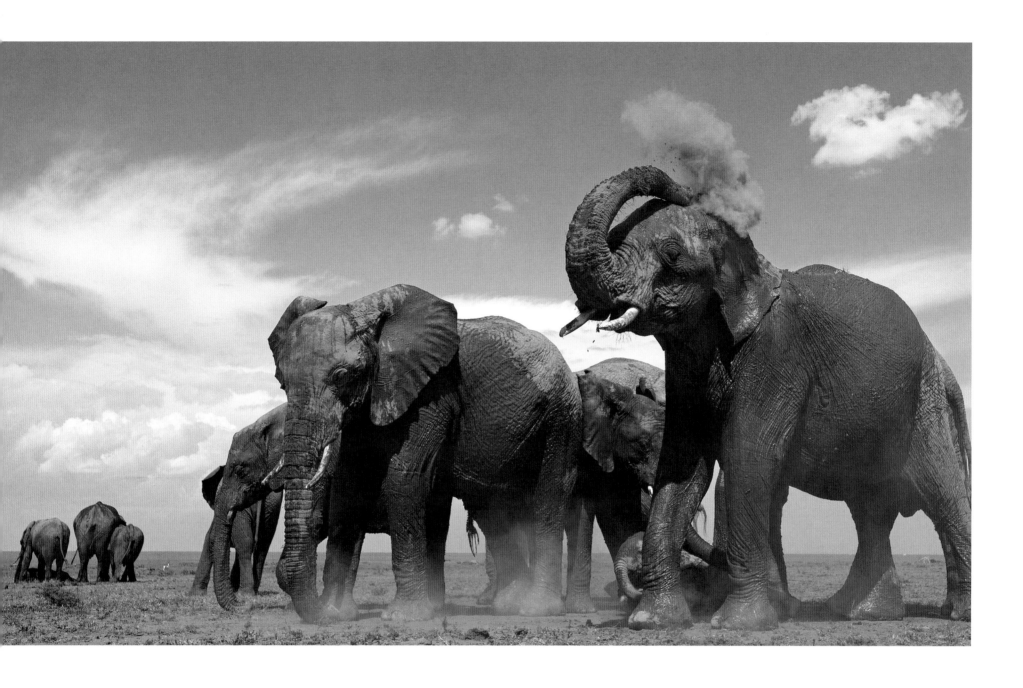

The scarcity of water this time of year compels elephants to congregate around a shrinking pool. For a couple of weeks straddling March and April, clouds build up through the sultry afternoons, promising rain—then dissipate without delivering. Although the cloud cover cools the air, it doesn't slake the thirst of the animals. Elephants, who have an uncanny sense for finding water sources, are the exception.

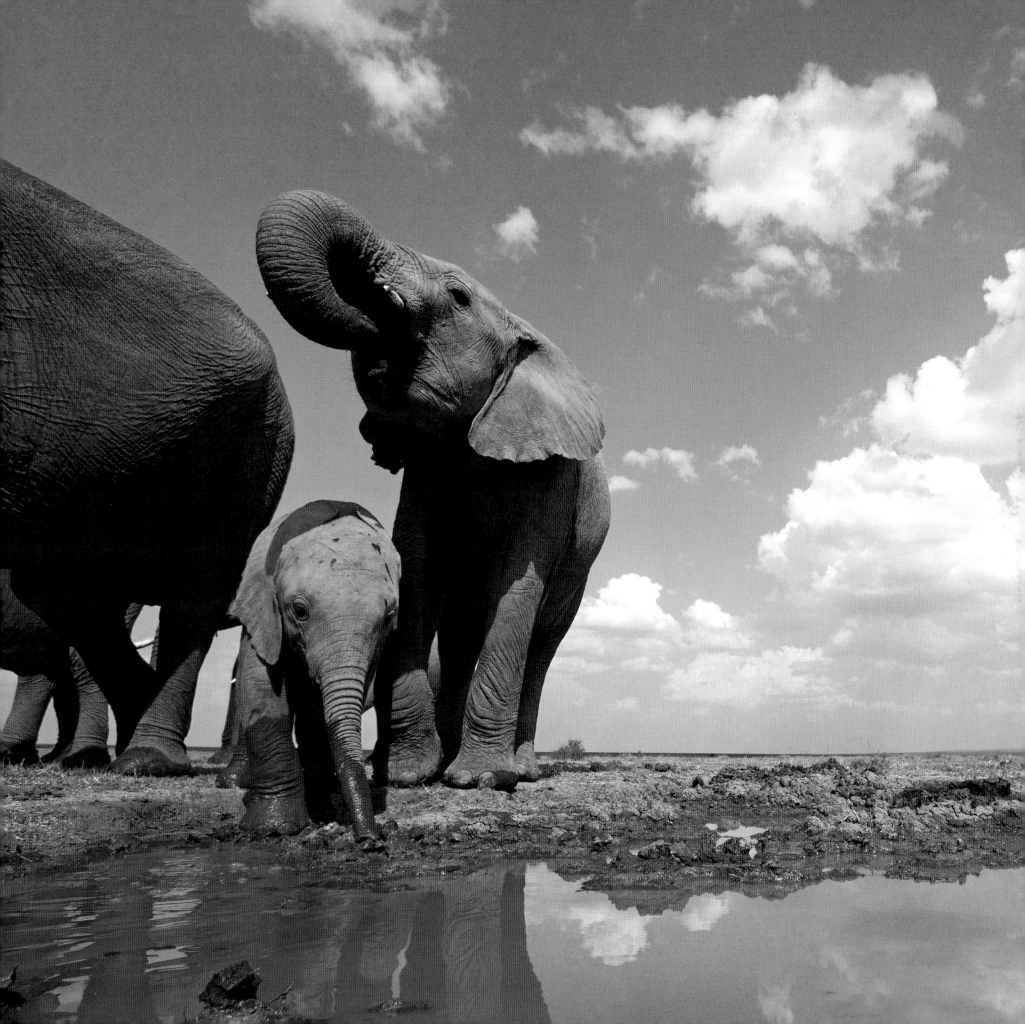

The elephant's trunk is an elongated fusion of its nose and upper lip with more than 100,000 muscles arranged in longitudinal bands. The trunk is so strong that it can lift a thousand pounds, and so precise that it can pick up objects one-tenth of an inch in diameter. Elephants put their trunks to a wide variety of uses: eating, drinking, dusting, fighting, throwing, spraying, catching, playing, scratching, smelling, trumpeting, caressing, and communicating, to name a few.

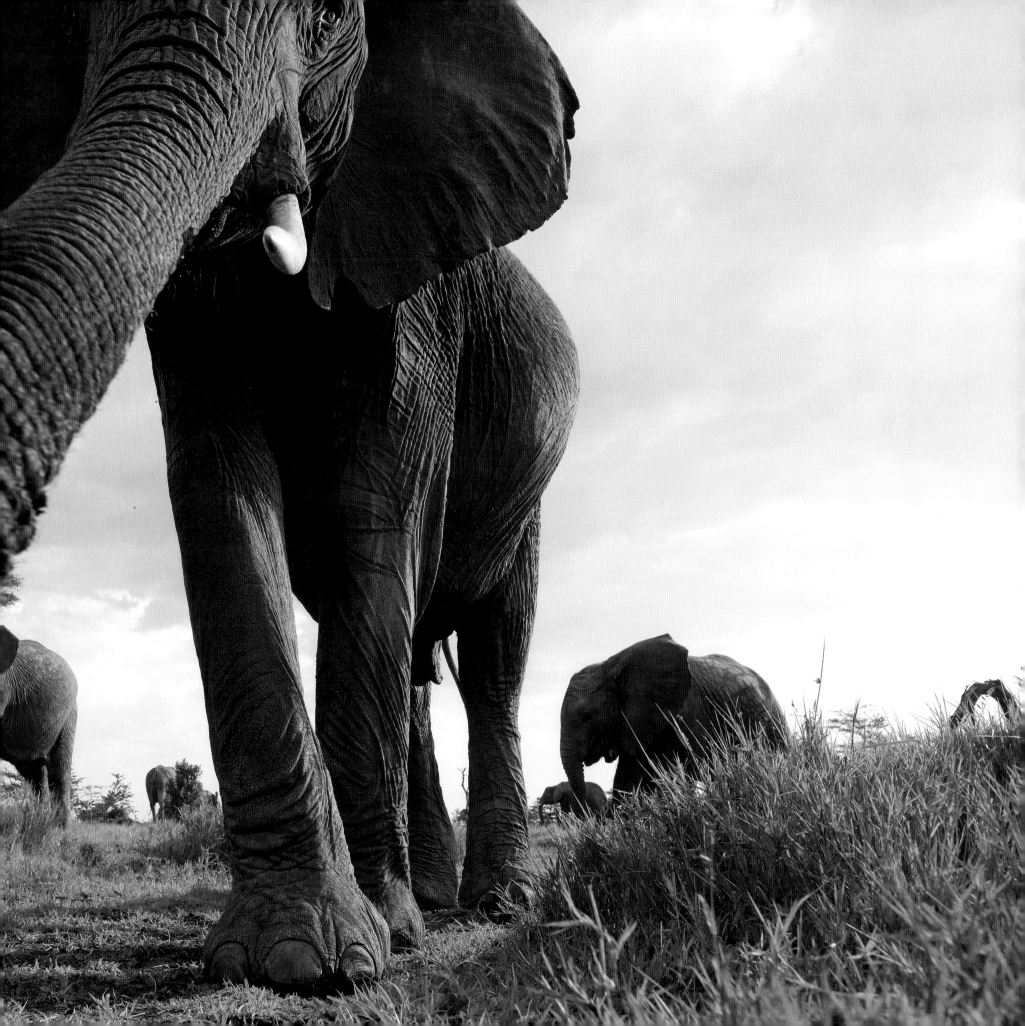

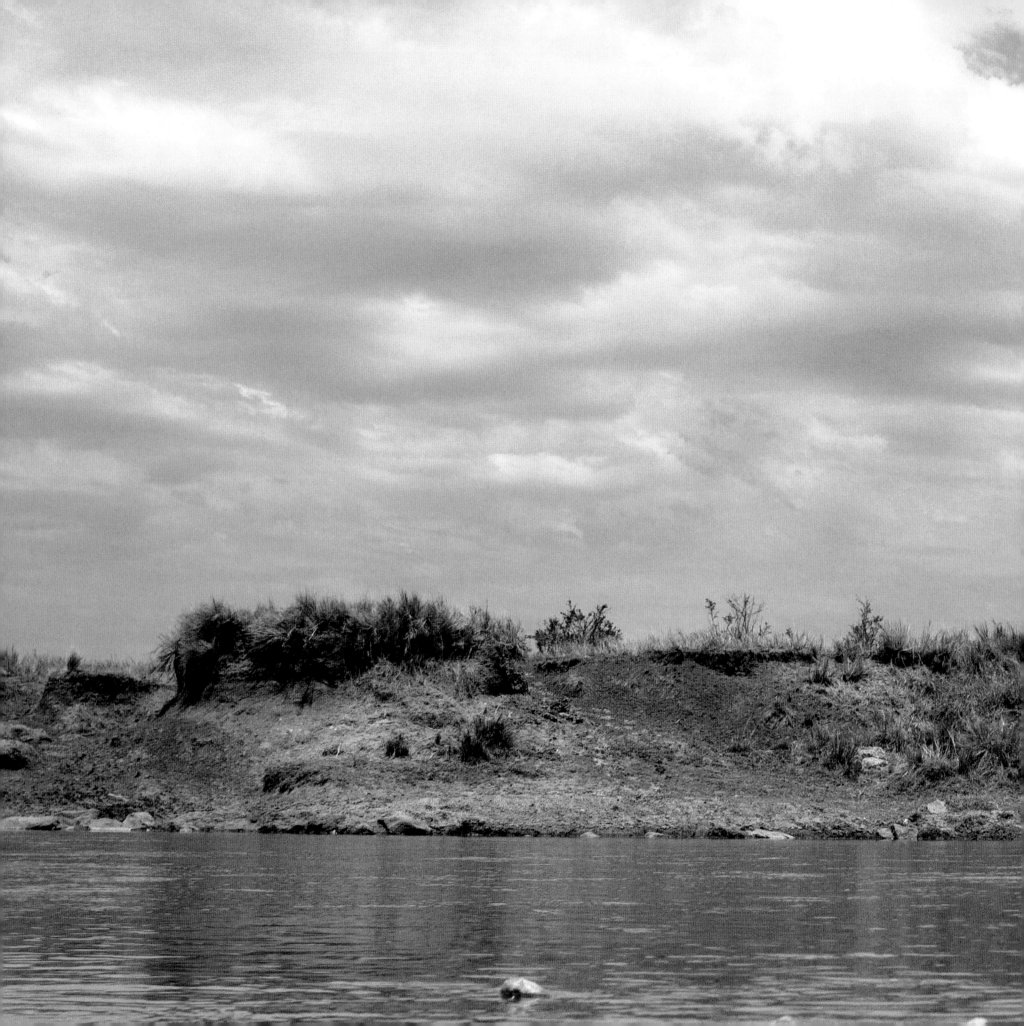

Signs that rain is imminent start to appear. Clouds take on a more somber hue; dust storms race against the darkening skies; the wind is cooler and feels damp. At first there is a very light shower, but it has little impact on the landscape. The herbivores start to disperse, anticipating that with the coming of the rains, there will once again be enough food and water for everyone.

These two male cheetahs, members of a three-cheetah coalition controlling a huge swath of the plains, are marking a prominent tree in their territory and will unhesitatingly attack any male who unwittingly wanders into their domain. They are a well-bonded team, patrolling, sleeping, and hunting together—and, unlike lions, they will share a kill amicably.

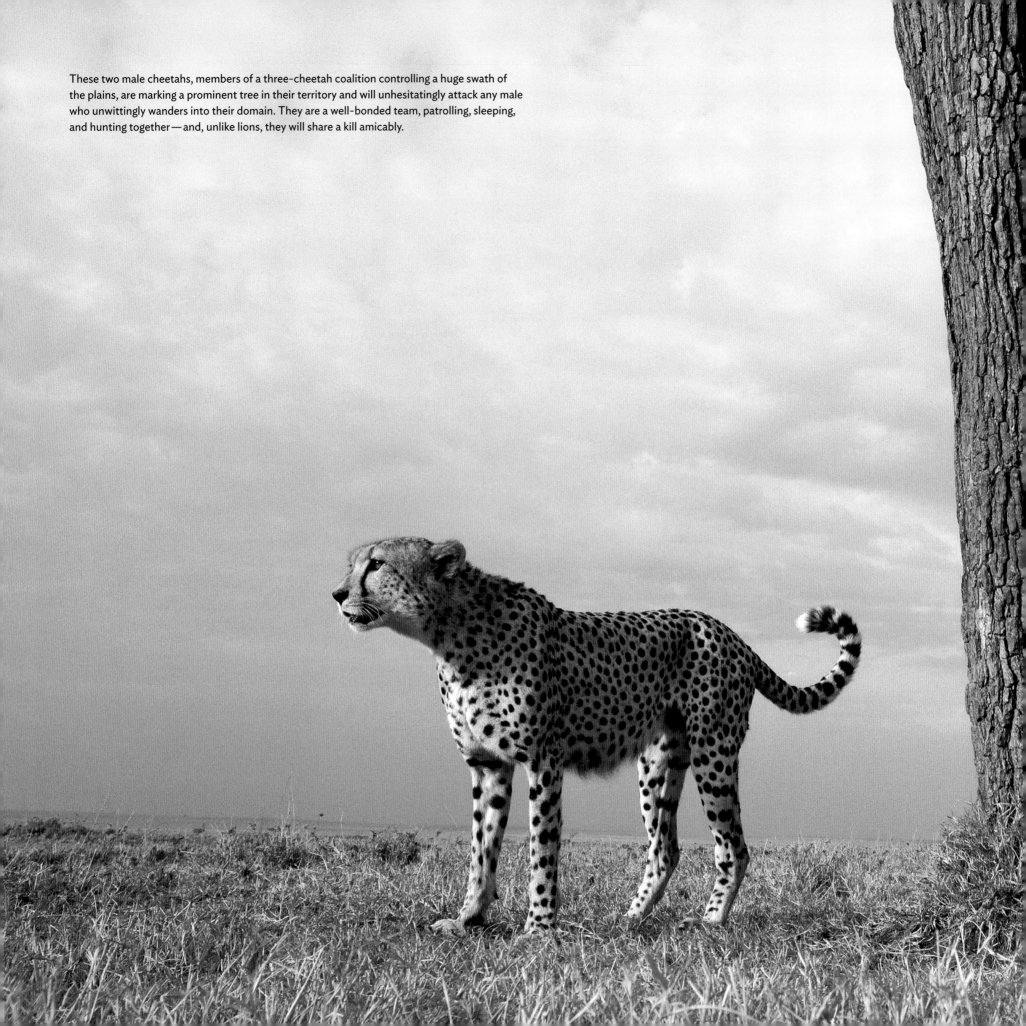

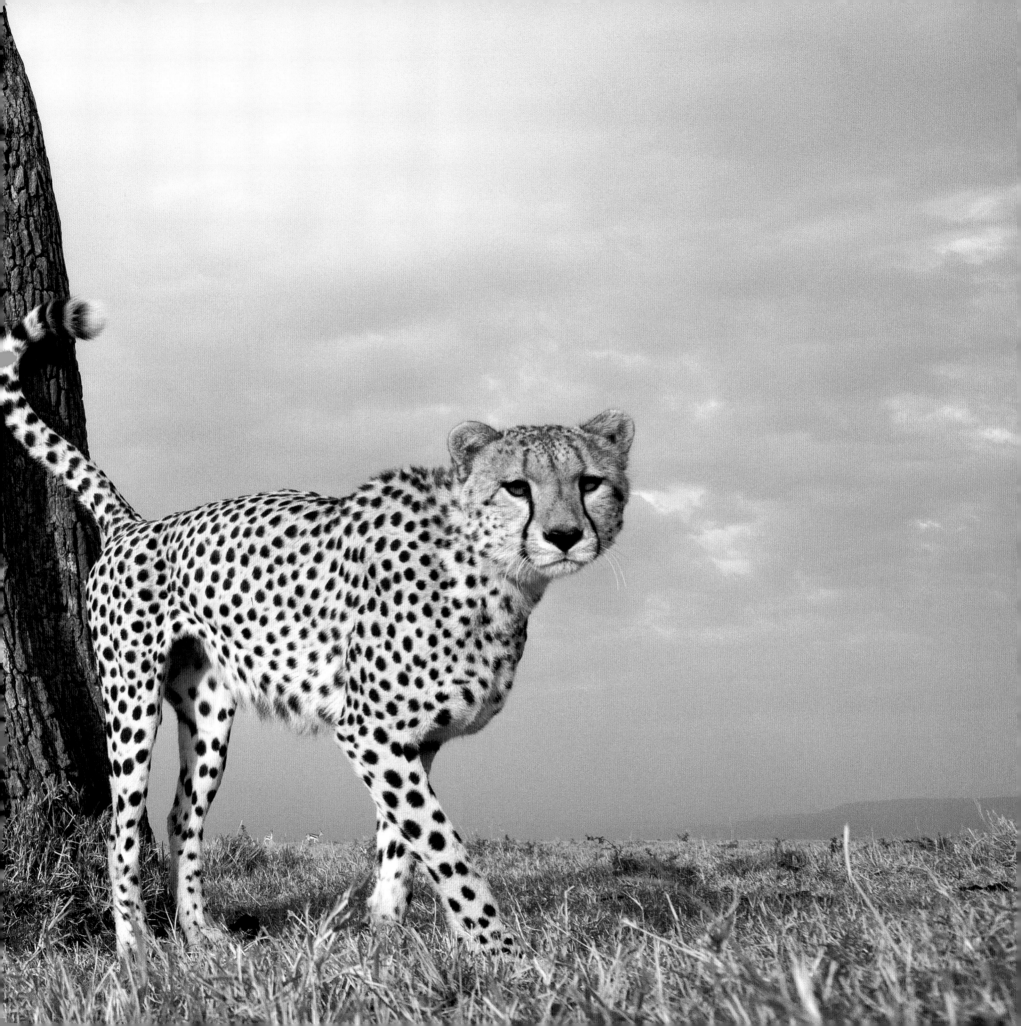

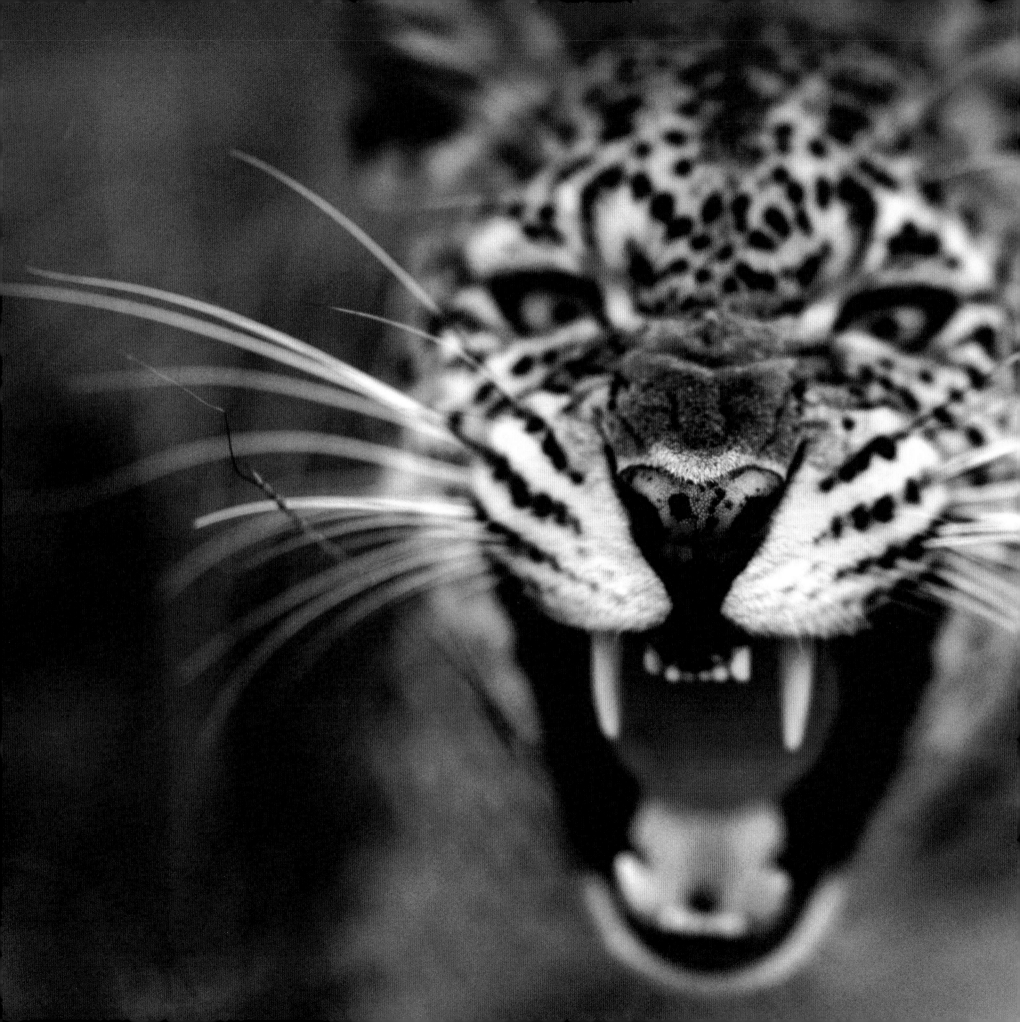

This leopard snarls a warning to nearby olive baboons. One-on-one, a baboon, even an adult male, would be no match for a solitary leopard. However, the tables are turned when an entire baboon troop encounters a solo leopard—the baboons might not hesitate to attack. After sunset it's a different story, since leopards have superior night vision and the baboons have an innate fear of the dark.

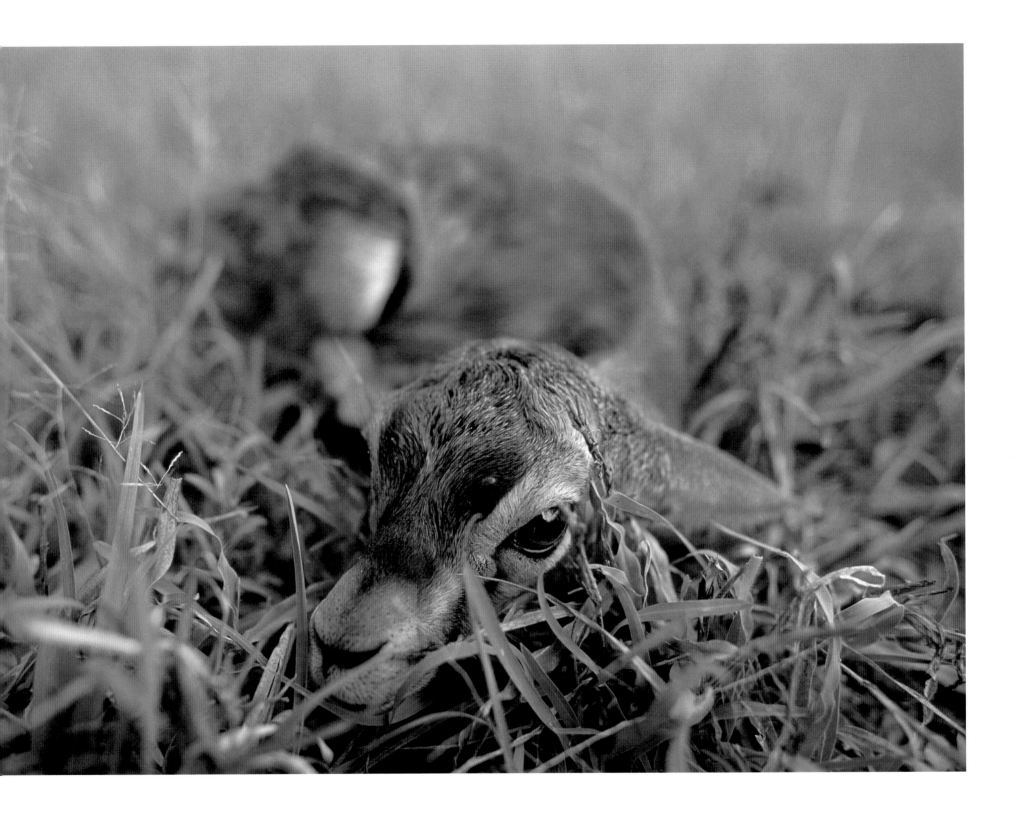

As the rains gather strength, new life springs up. A Thomson's gazelle fawn lies flat and motion-less while its mother grazes nearby. A fawn this young is extremely vulnerable, and when it gets up to nurse, it could be spotted by a predator.

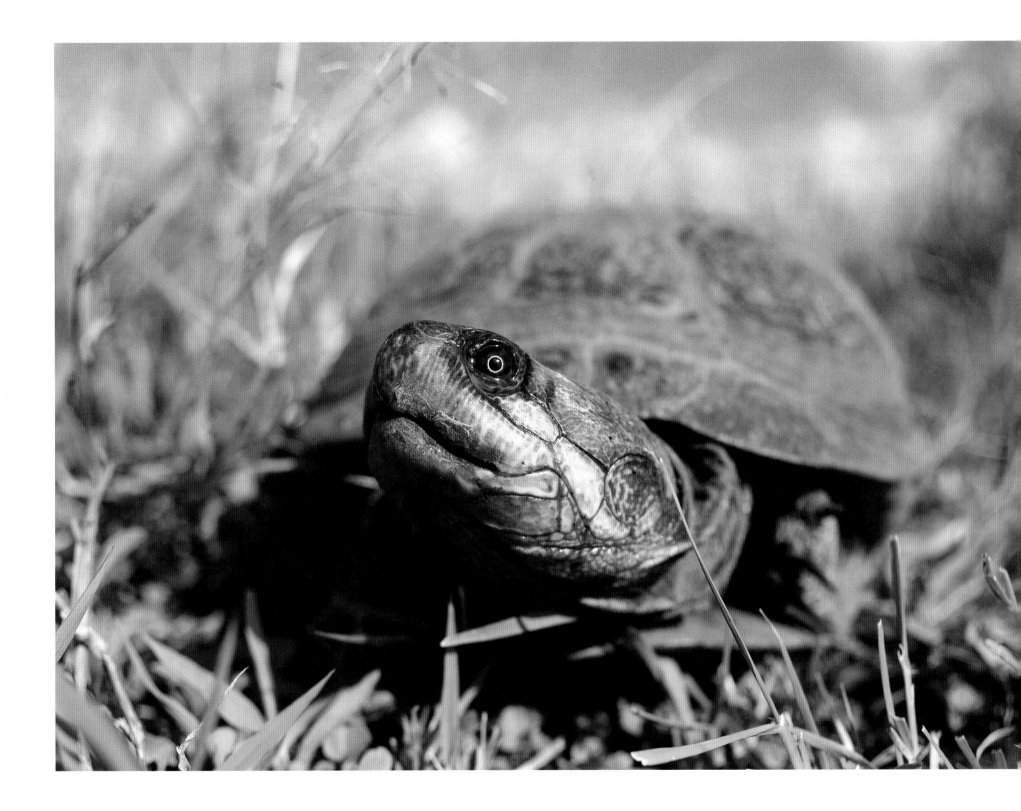

New shoots are springing from the ground, growing an inch or so daily. The fresh green of the landscape has overtaken the dusty brown of the last few months and is broken up by white sheets of temporary surface water. Many animals seek refuge on higher ground. A helmeted terrapin moves on to look for a larger pool.

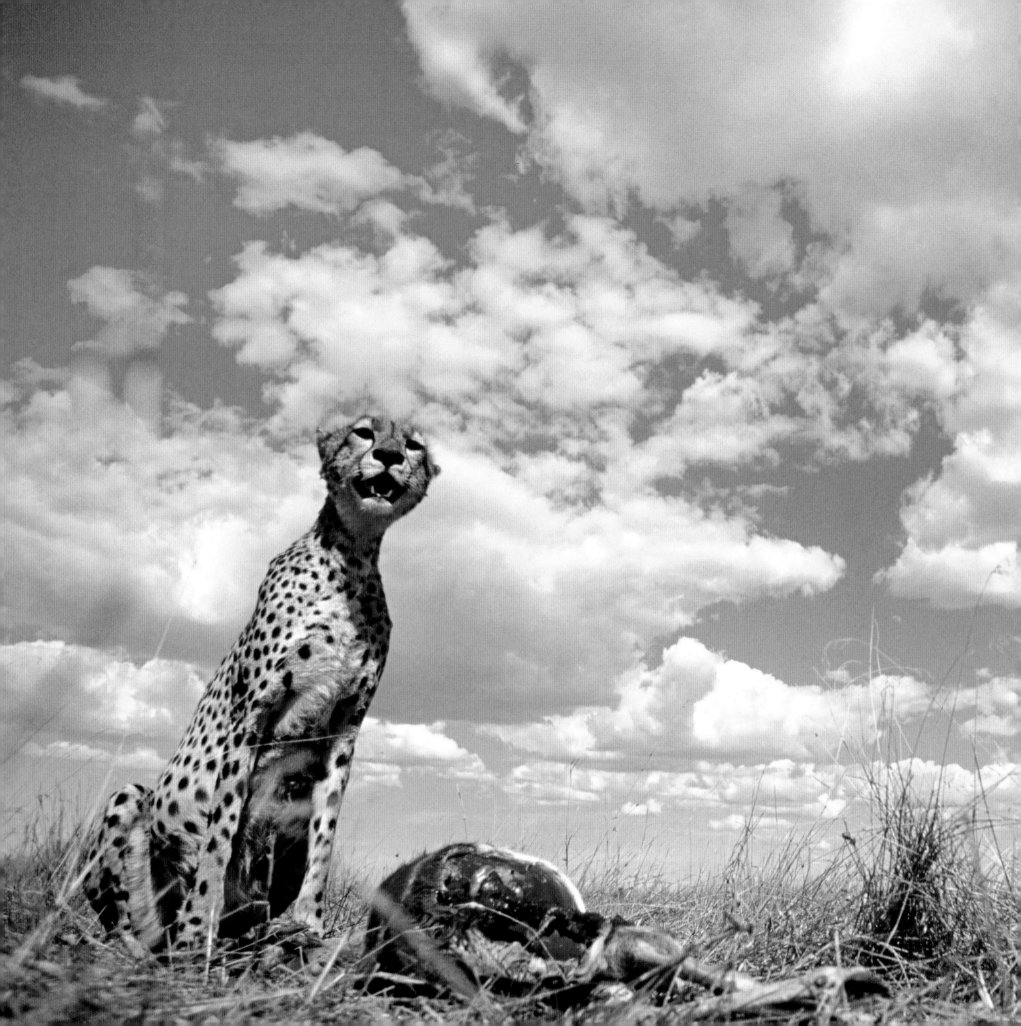

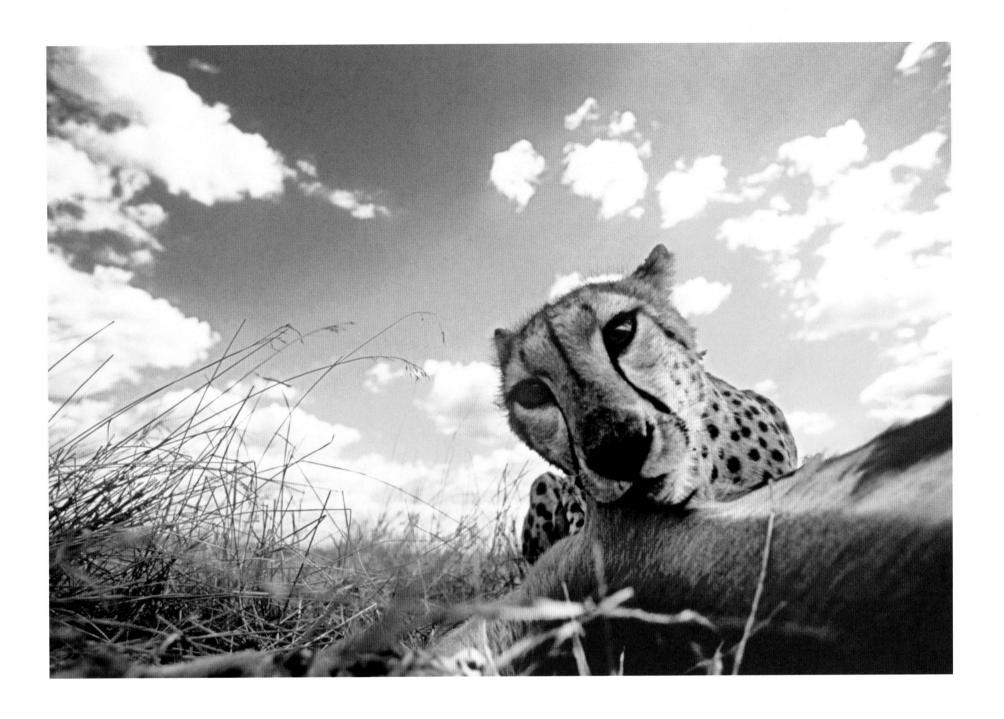

A female cheetah makes an easy catch, and after the struggle ceases, she opens the carcass by shearing the belly skin with her back teeth. First, she eats the muscles of legs, back, and neck. All the while, she keeps a lookout for scavengers. At one uninterrupted sitting, an adult cheetah this size can eat up to thirty pounds of flesh.

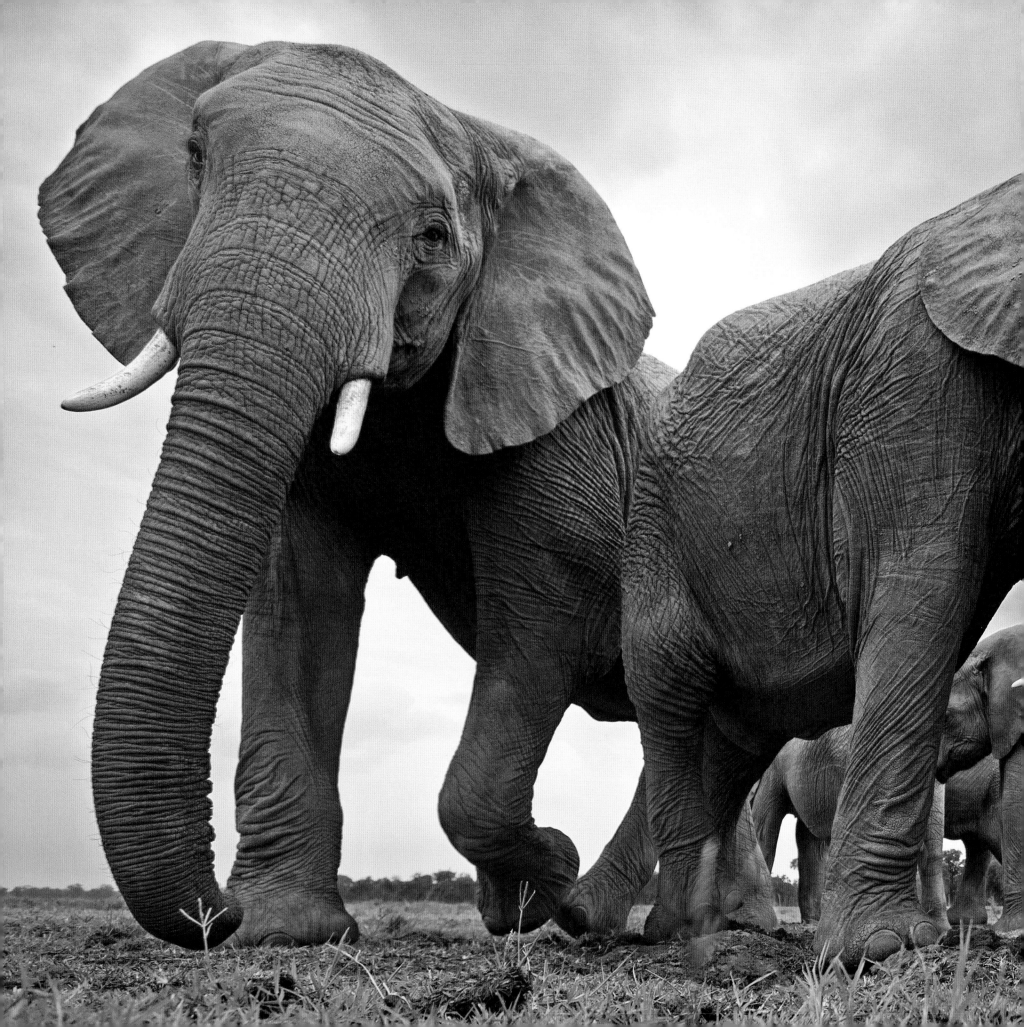

By early May, a pattern has set in. The mornings are bright, but by midday, clouds begin to form, and it usually rains at around four o'clock. By now the animals are no longer startled by the sound of thunder. Darkness gathers early. Elephants are far more nimble-footed than their bulk suggests. Although they walk on the flats of their feet, they also roll from their heels to their toes while running, just like humans.

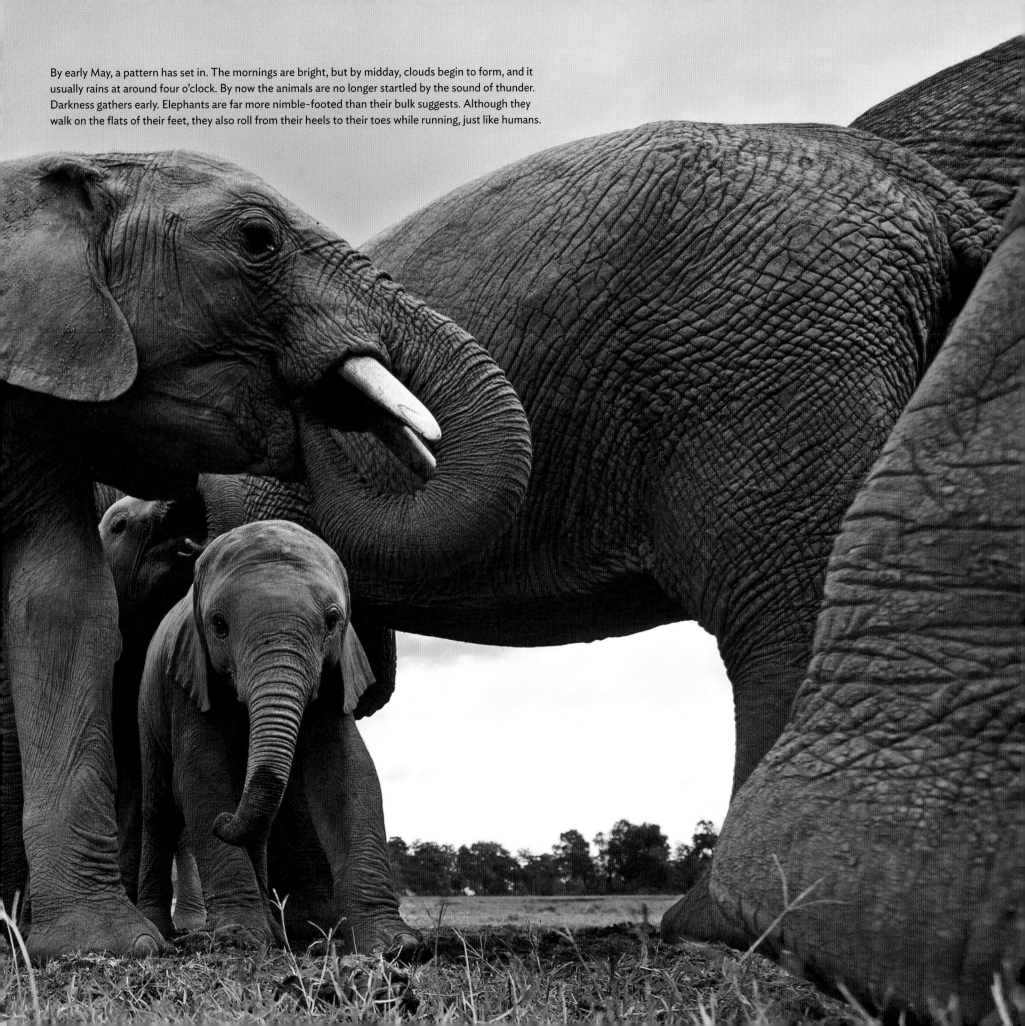

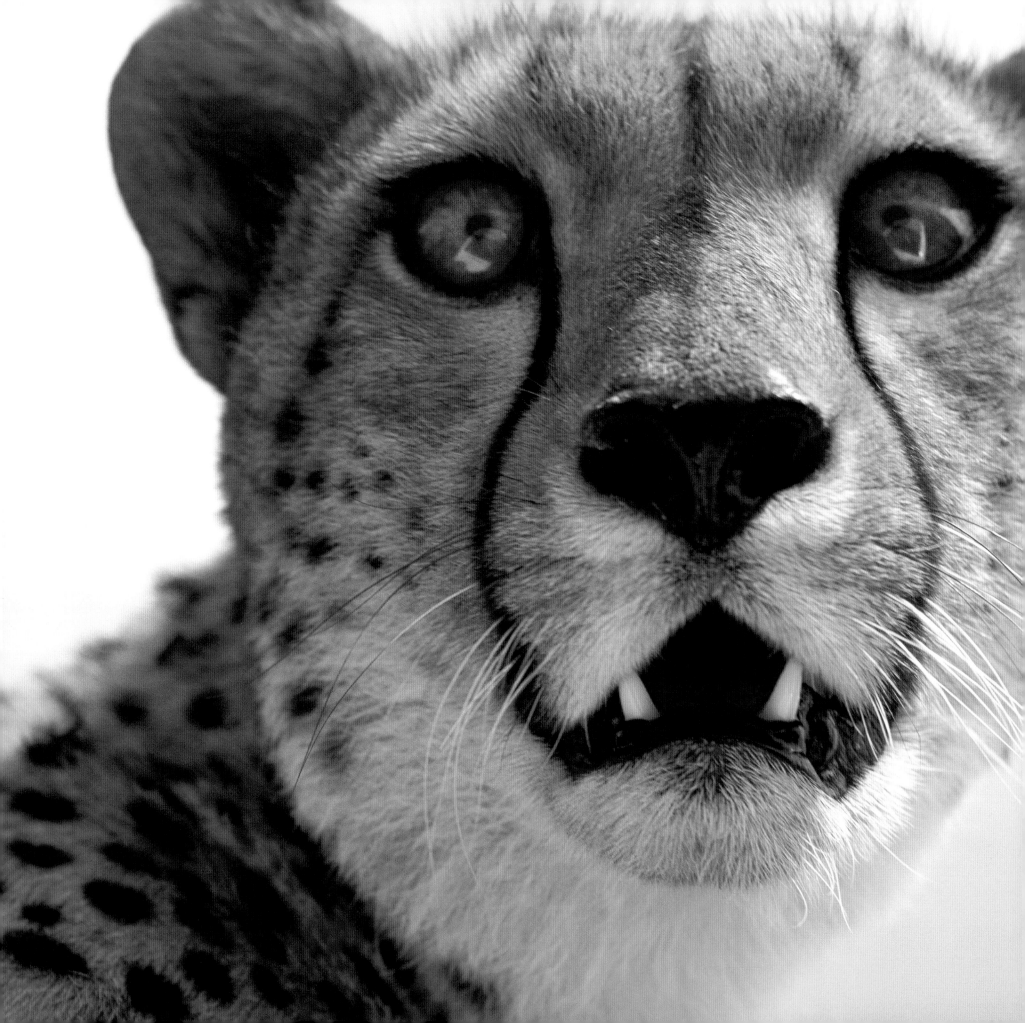

Due to facial markings, lions tend to look like they're grinning, leopards appear to sneer, and cheetahs seem to frown.

OVERLEAF: The first heavy downpour of the wet season washes the dust from the air so that by the following morning, the sun shines in a brilliant blue sky. The long rains, borne on the monsoon winds blowing over the Indian Ocean, have arrived. For the herbivores, the season of feasting starts as they disperse across the plains. For the carnivores, hunting is a more complex endeavor, but they tend to spread out as they follow the grazers. This cheetah is already on the prowl.

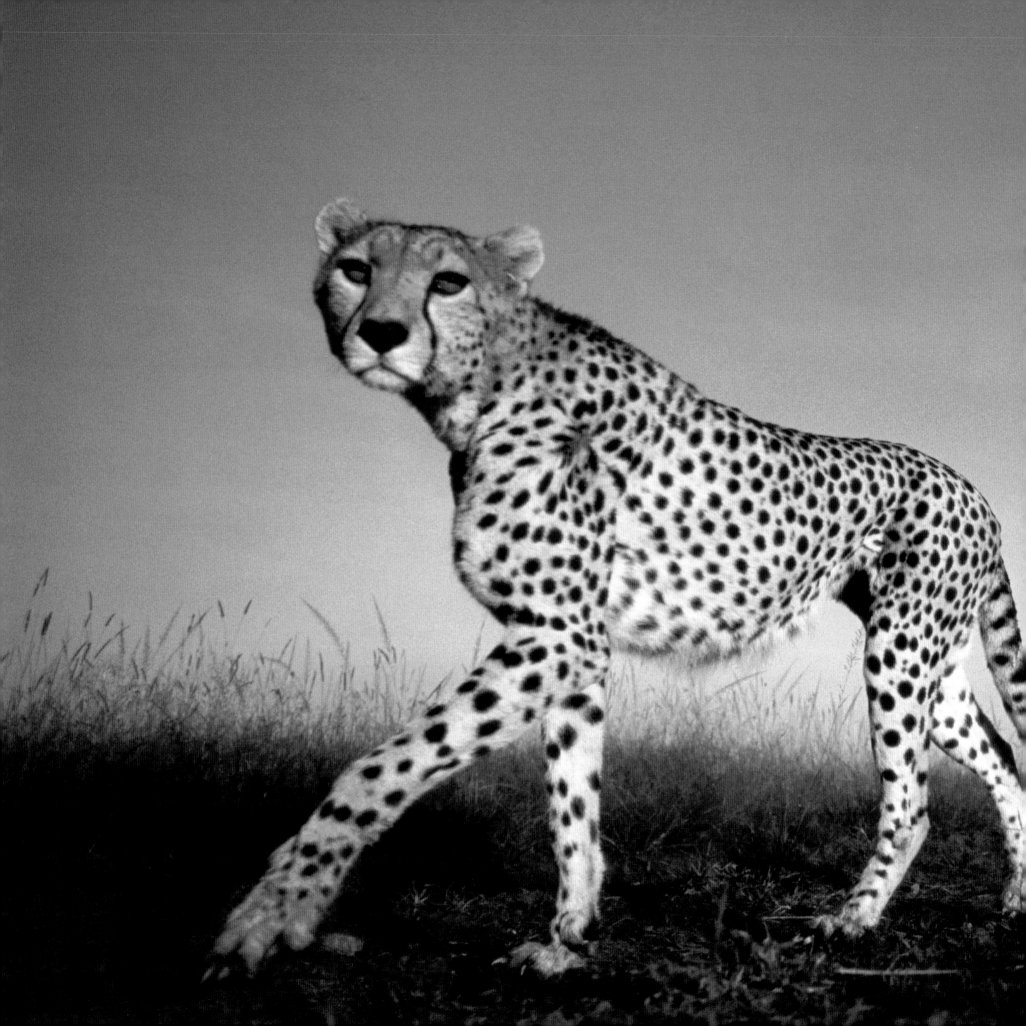

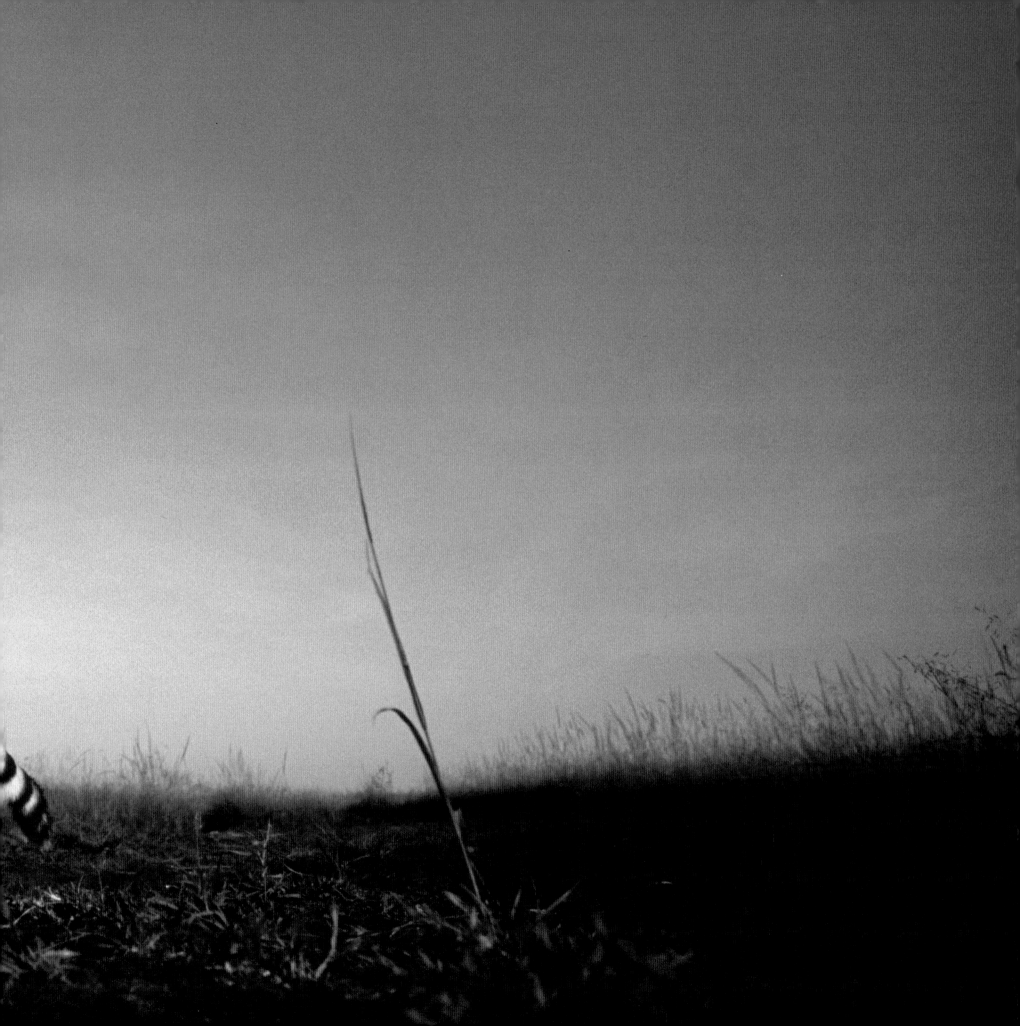

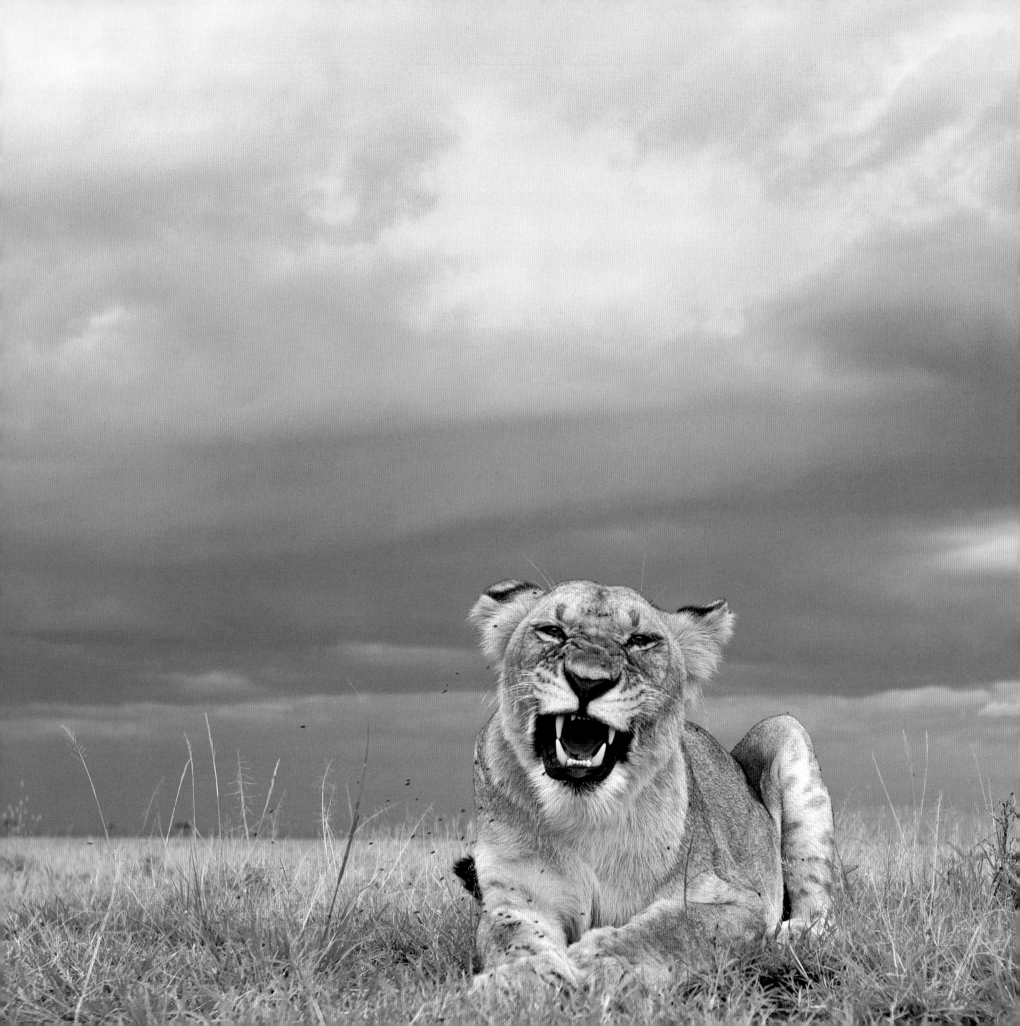

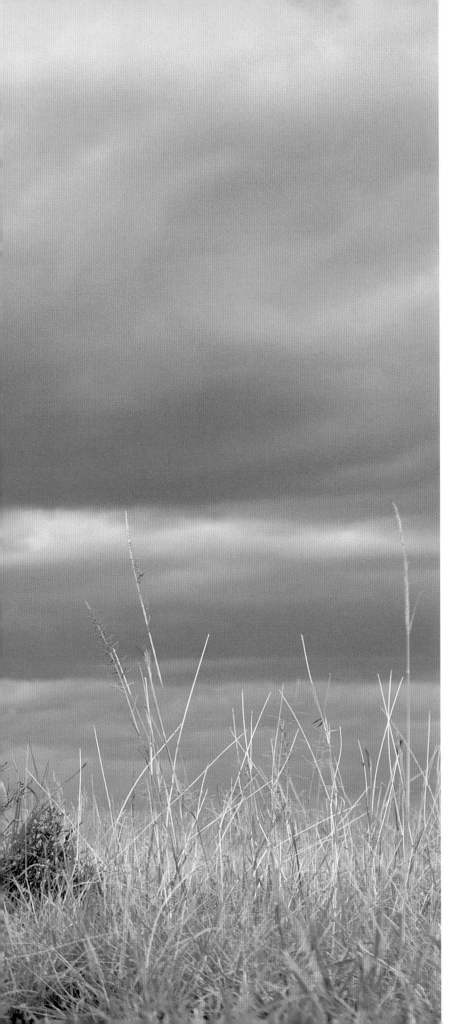

During storms, lions bow their bedraggled heads between their paws, squatting flat against the ground in their attempts to find shelter in clumps of long grass. When the storm stops, life on the plains resumes. Birds begin to call; gazelles break free from their huddle and return to grazing; and this lioness looked up, yawned, and shook herself, sending plumes of spray into the air.

OVERLEAF: A zebra family approaches water noiselessly. A mare steps forward, the stallion hanging back at the rear of the family. She hesitates at first but, sensing no danger, decides to move forward and drink. At once the herd joins her, with a few zebras venturing farther into water. The calm is shattered when a lioness, once hidden in the bordering grass, rushes at the zebras, scattering them far and wide. But it is only a halfhearted probe, and the zebras are safe for now.

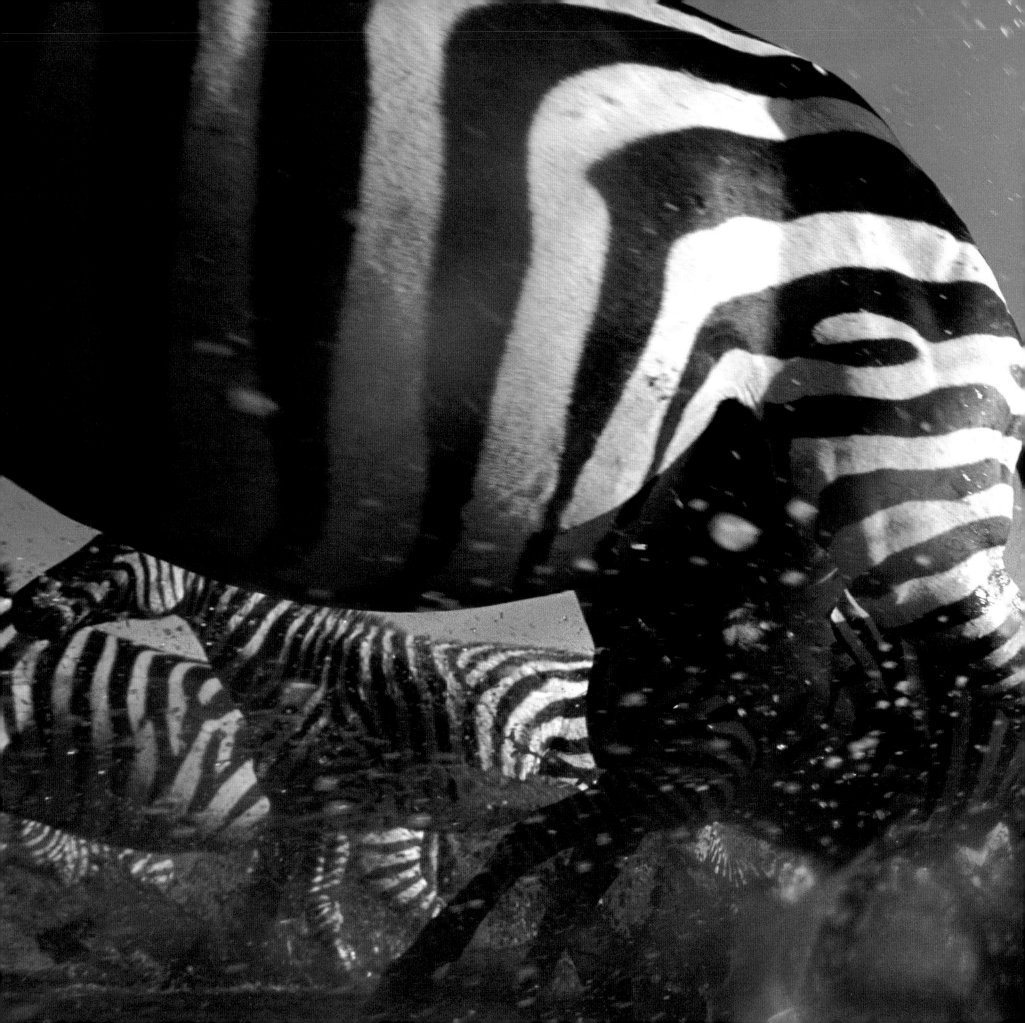

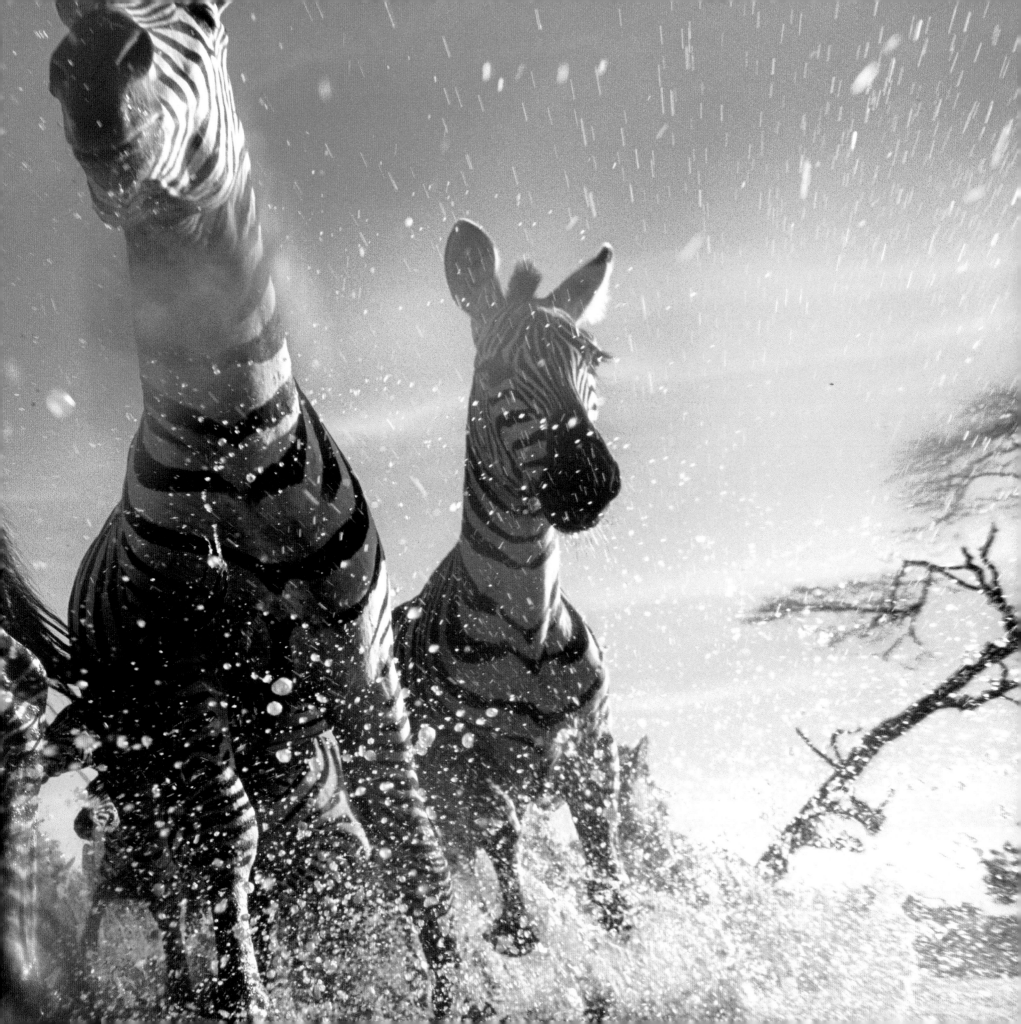

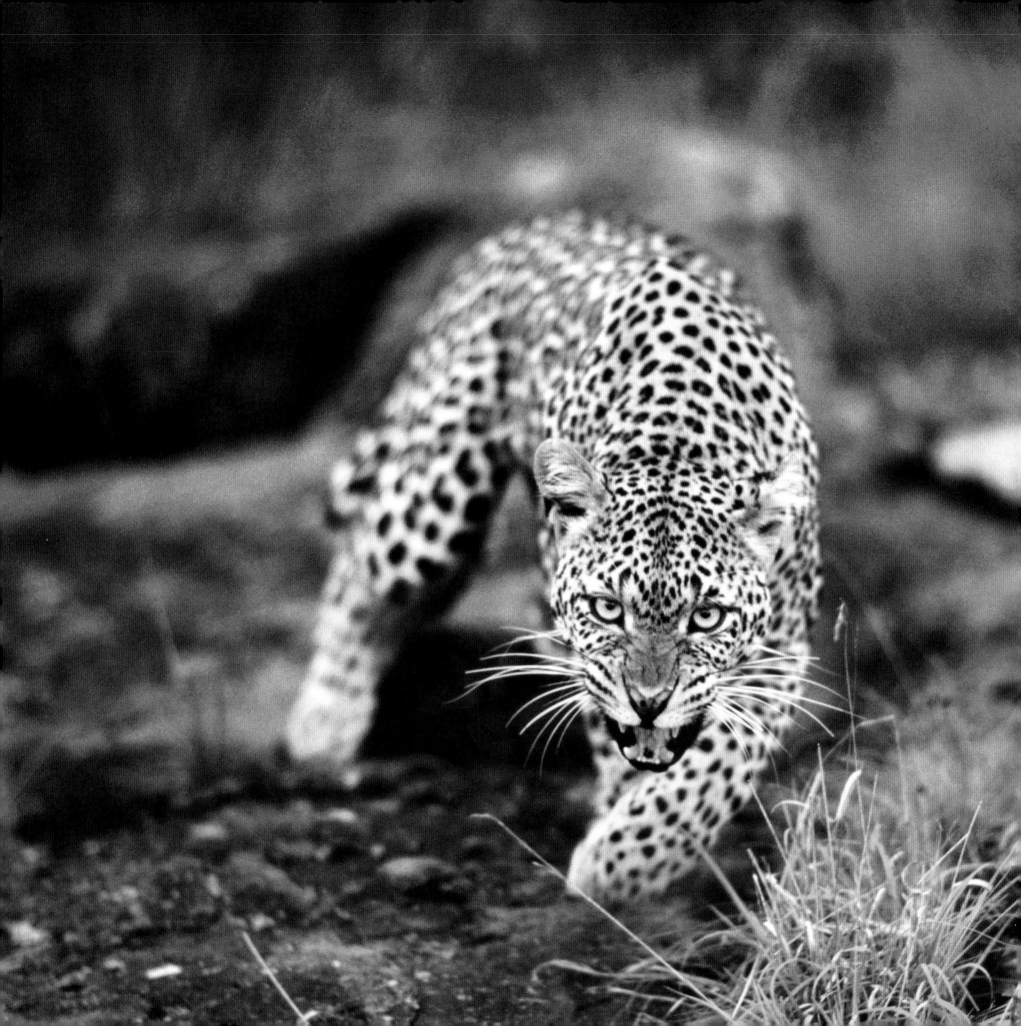

The territories of this female leopard and a troop of olive baboons overlap in an area called Leopard Gorge in Maasai Mara so encounters between the two are not uncommon. When she chanced upon the troop, this experienced female snarled in a show of bravado before seeking a place of safety.

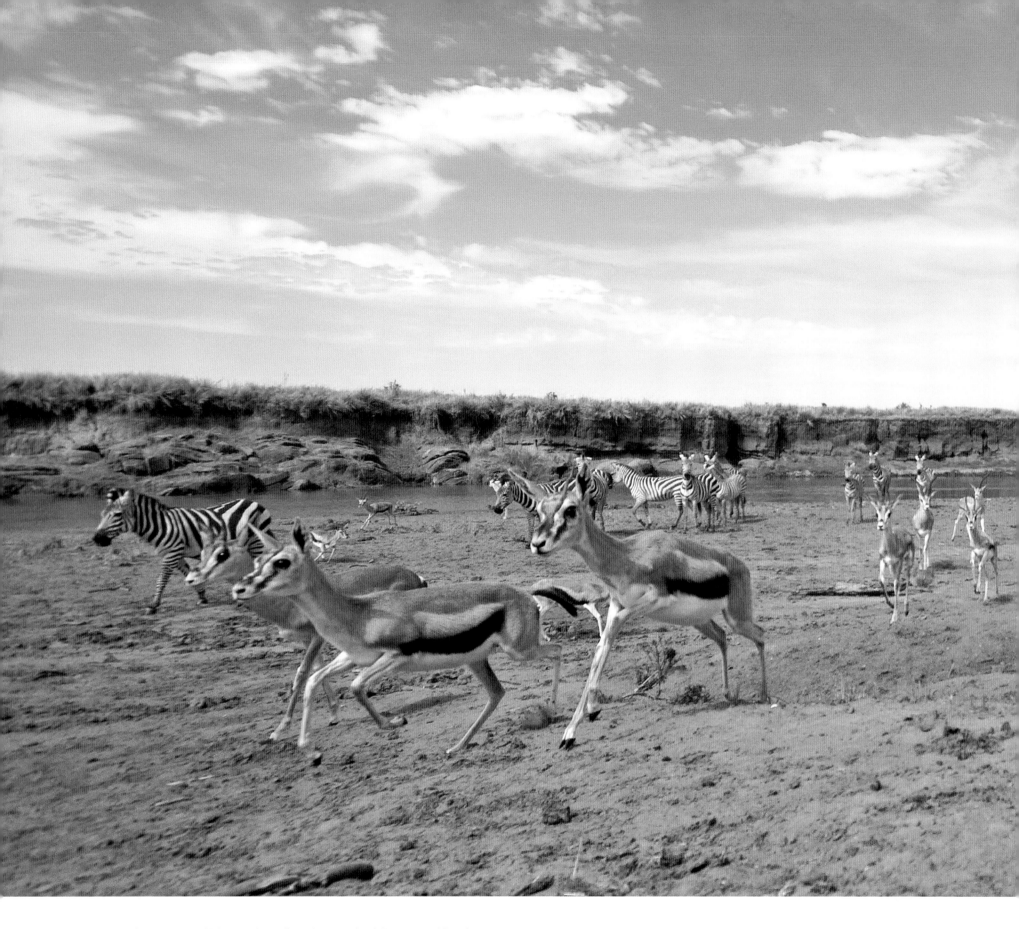

At this time of year, territorial Thomson's gazelle males try to herd disinterested females, and amorous males chase the ones who are reluctant to mate with them.

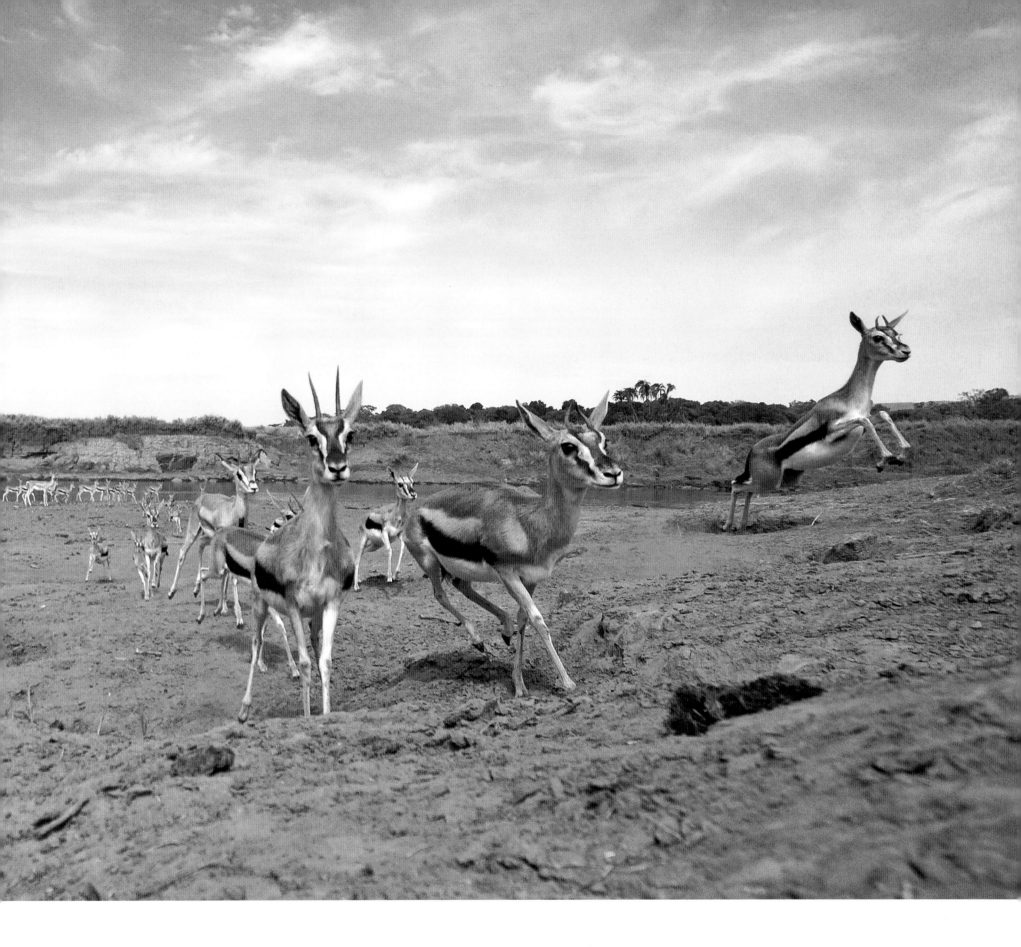

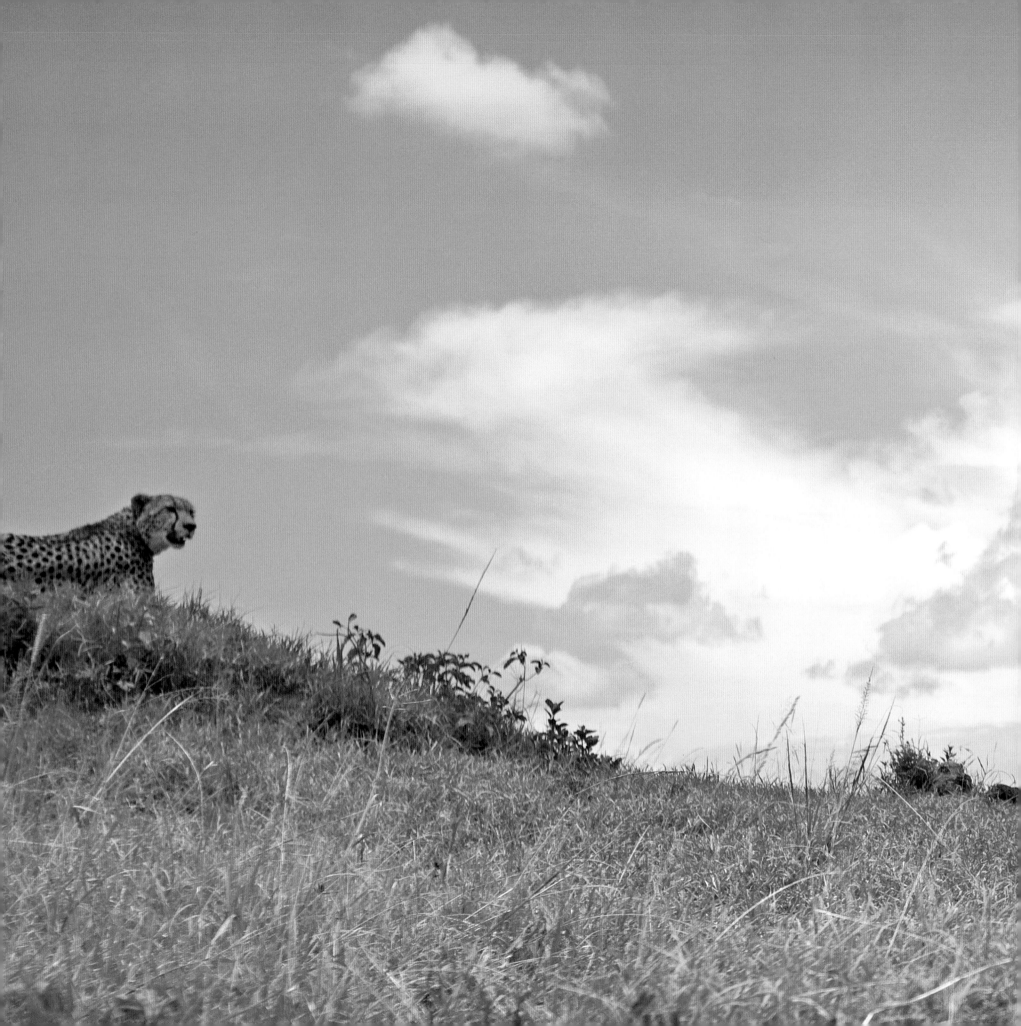

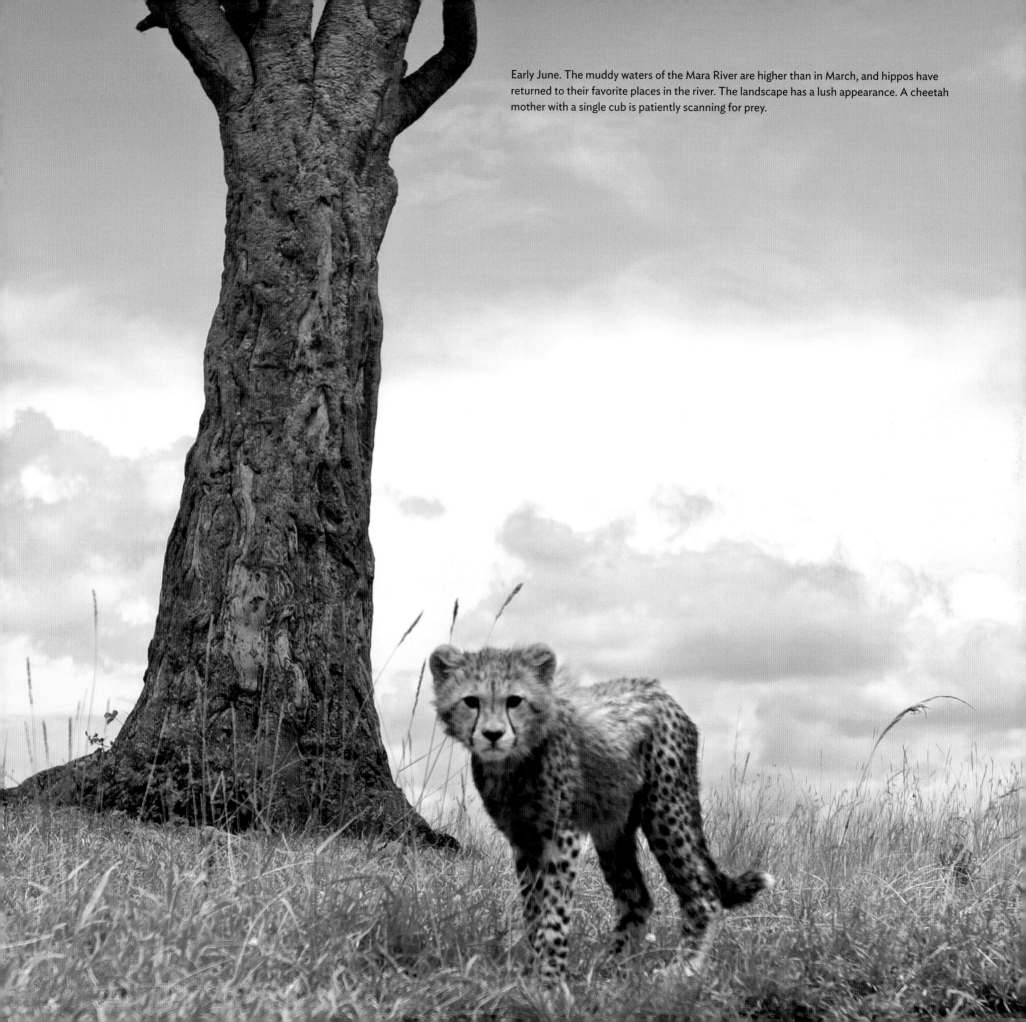

Early June. The muddy waters of the Mara River are higher than in March, and hippos have returned to their favorite places in the river. The landscape has a lush appearance. A cheetah mother with a single cub is patiently scanning for prey.

Hyena pups await the adults' return to the den. This juvenile will gnaw at any piece of flesh and bone that the adults bring back; pups of a younger age will only want to suckle.

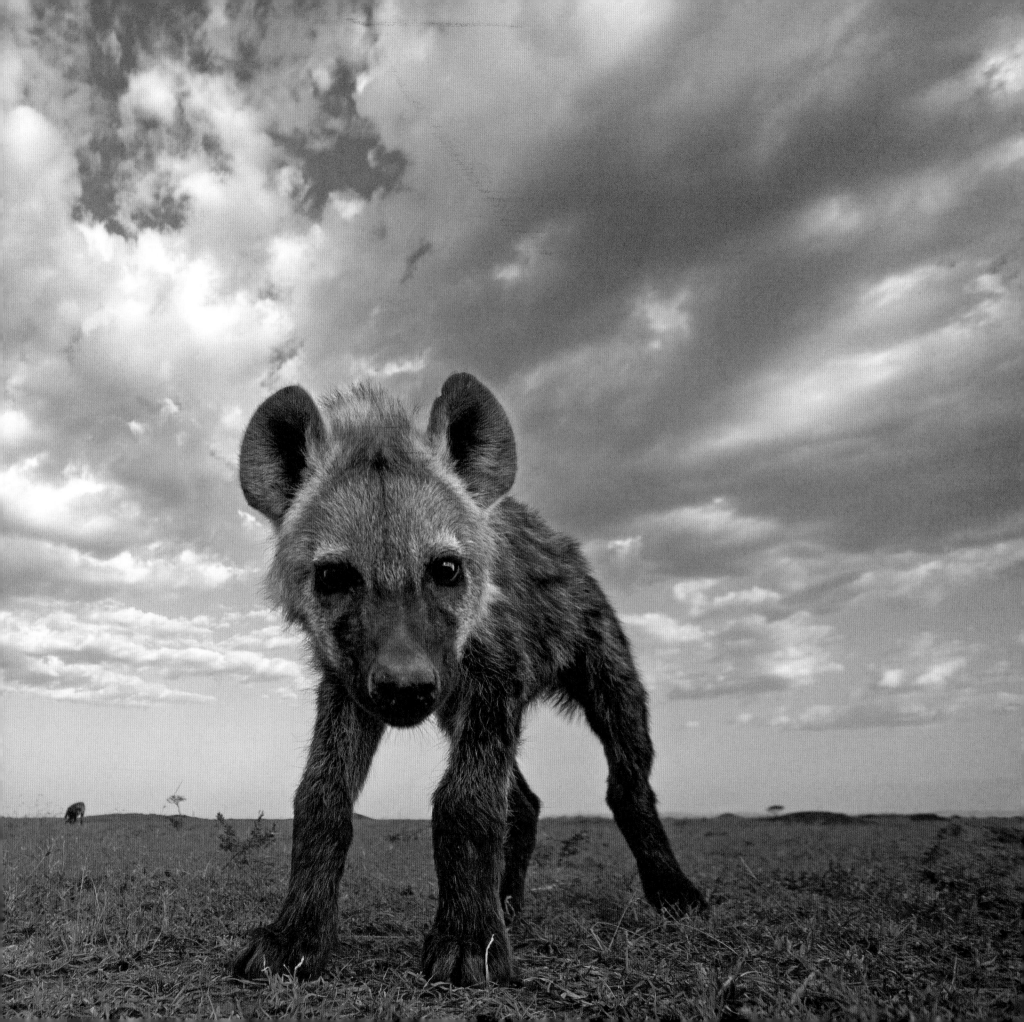

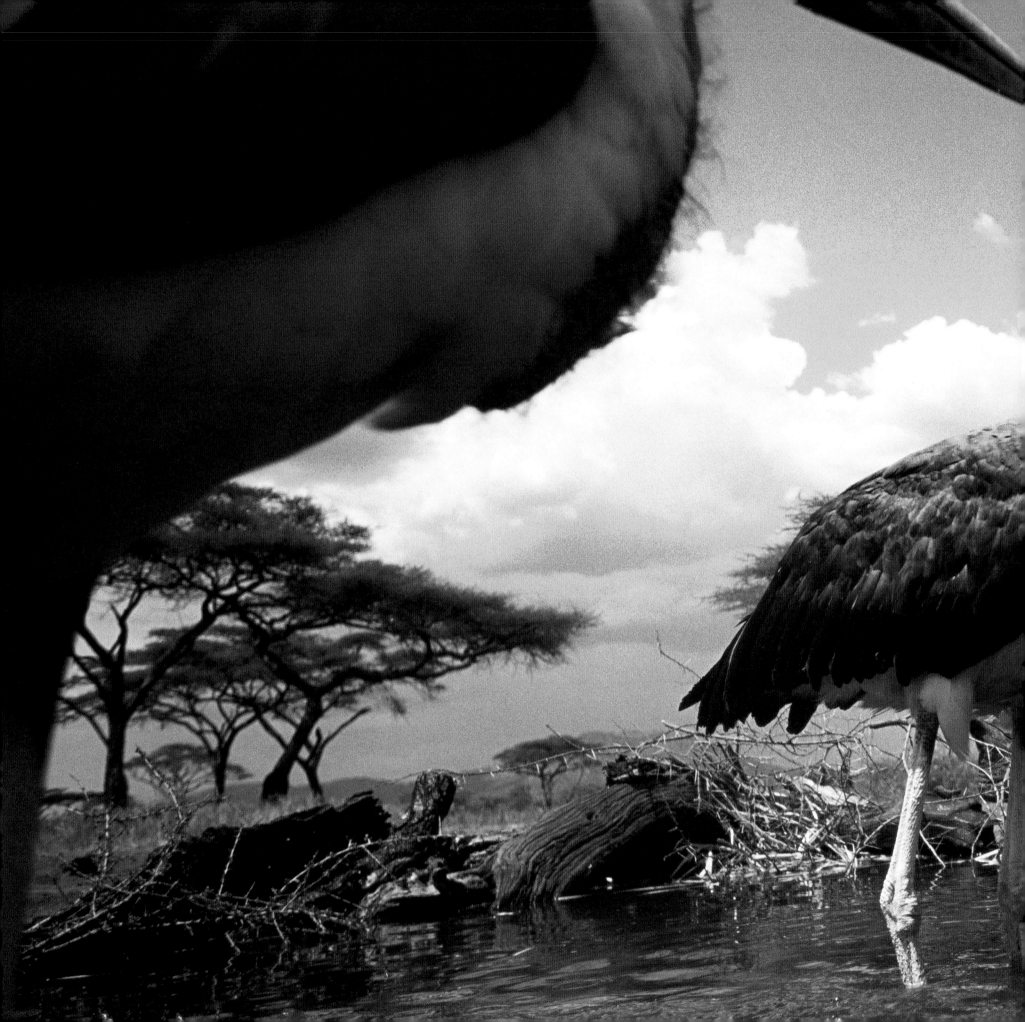

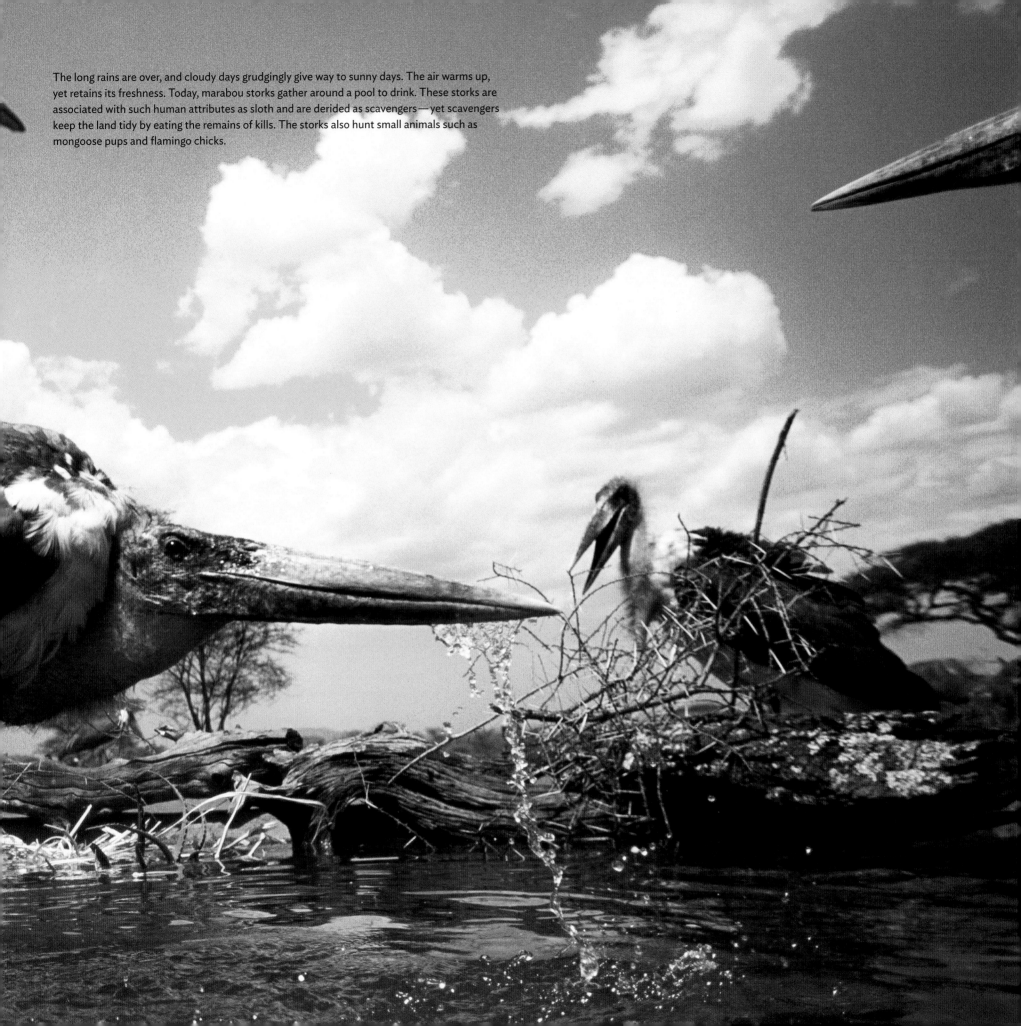

The long rains are over, and cloudy days grudgingly give way to sunny days. The air warms up, yet retains its freshness. Today, marabou storks gather around a pool to drink. These storks are associated with such human attributes as sloth and are derided as scavengers — yet scavengers keep the land tidy by eating the remains of kills. The storks also hunt small animals such as mongoose pups and flamingo chicks.

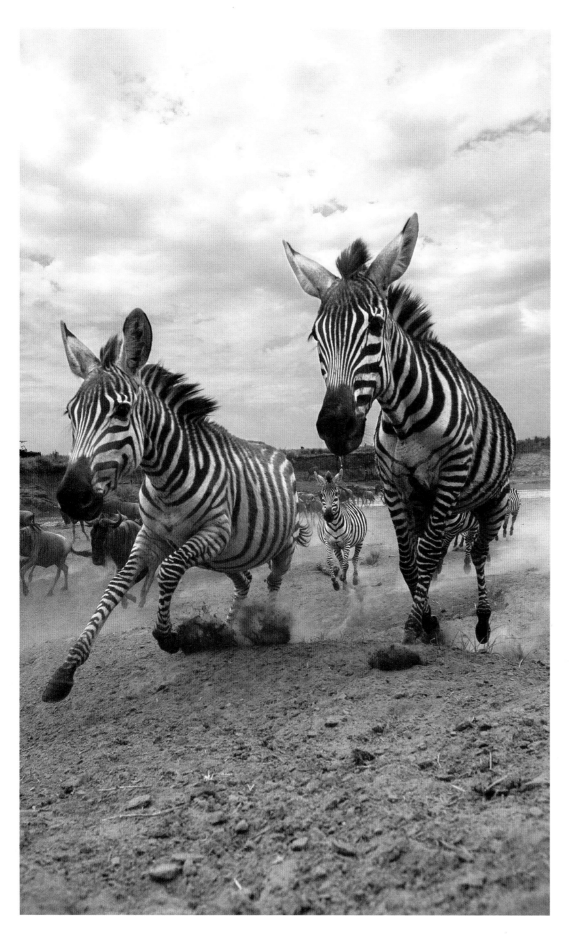

By late June and early July, the first zebras arrive in the Maasai Mara from the Serengeti in the south, marking the beginning of the great migration of zebras and wildebeests into the Mara. Their journey to find water and greener grass is an arduous one. It is a long trek through tsetse-fly-infested country under a hot sun; there is constant danger from predators, fording hazardous rivers, and climbing hills, but they seem well adapted to undertake it.

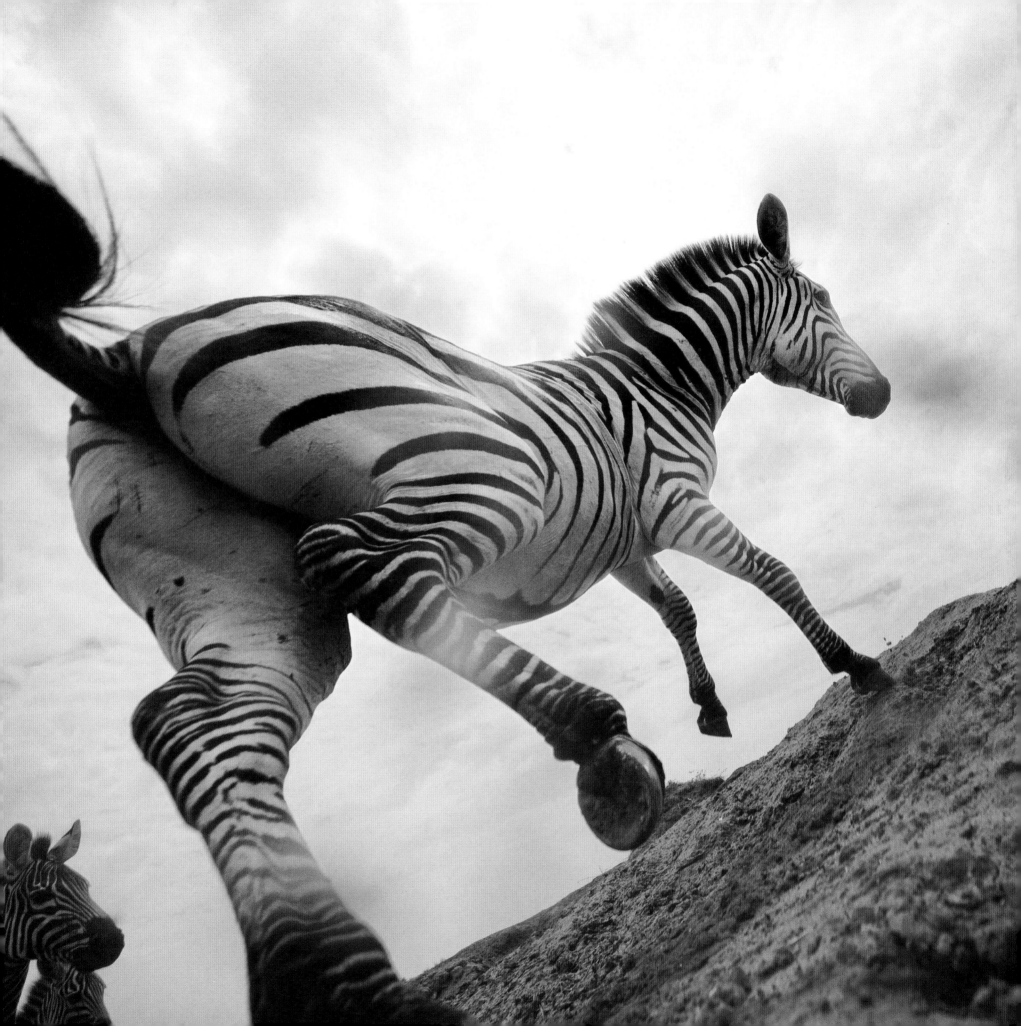

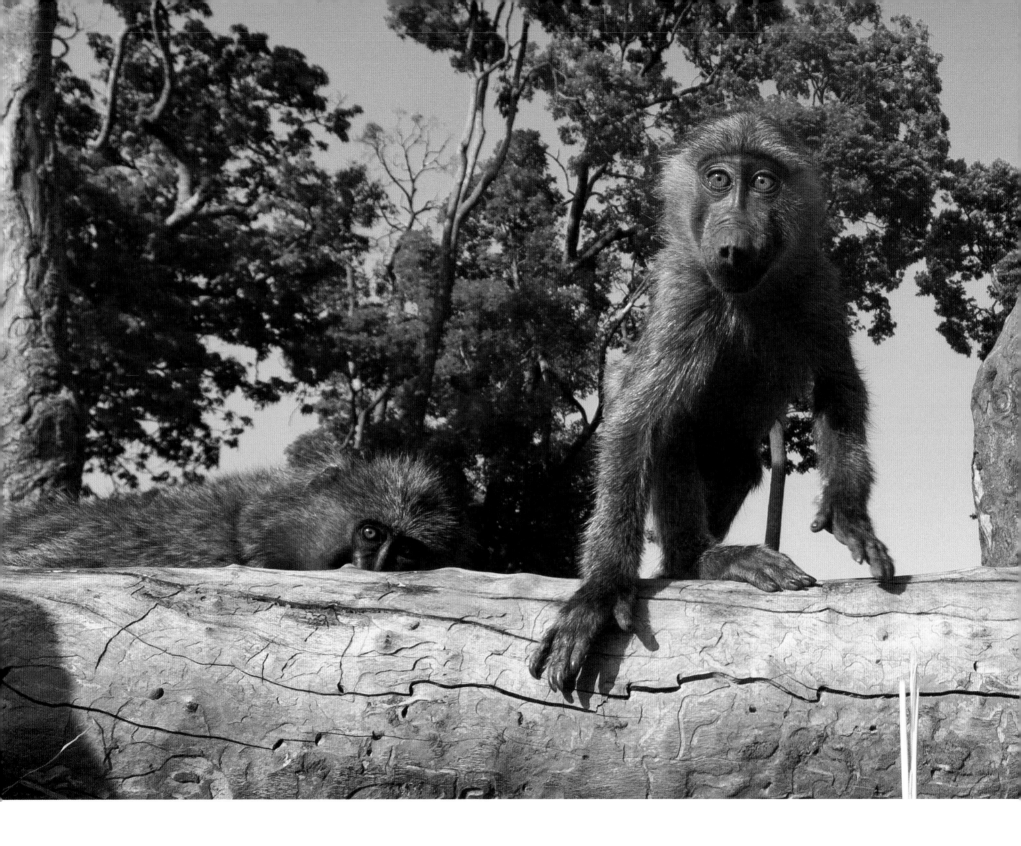

The olive baboon troop that roosts in the tiny forest has discovered the remote camera and quickly figured out that it is harmless. The adults decide that it is not edible, so they ignore it like haughty aristocrats, but the young still think it could be fun. A couple of juveniles are curious about their reflected image in the camera lens.

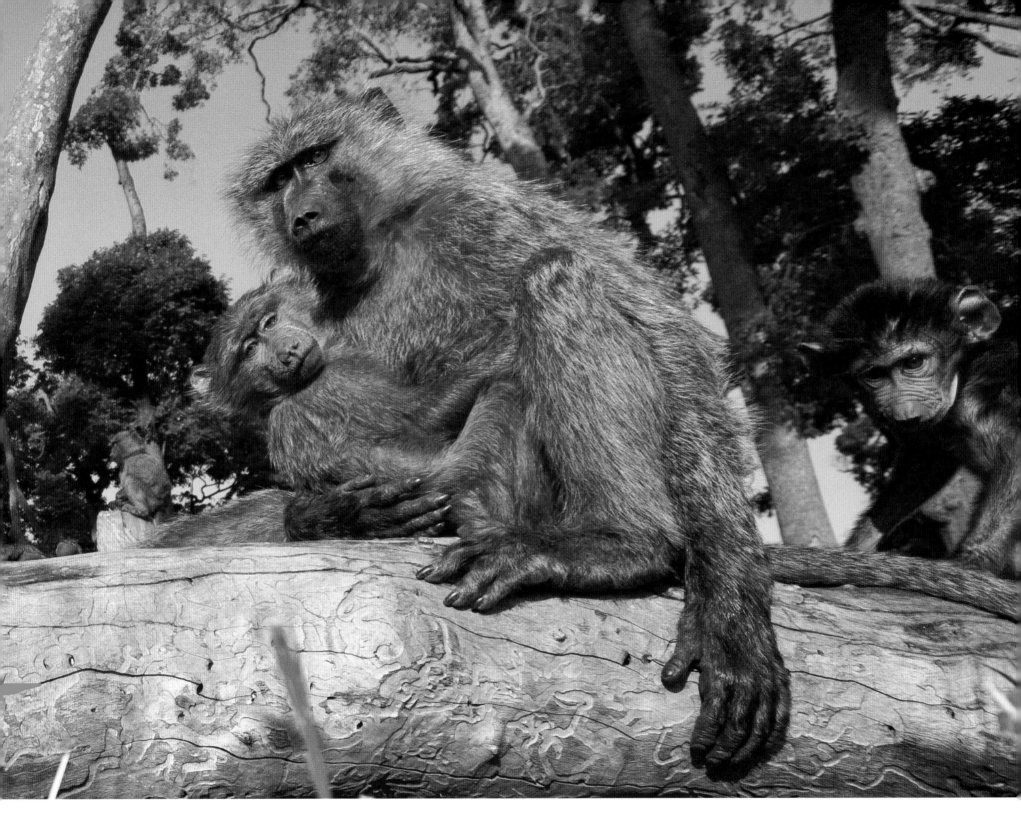

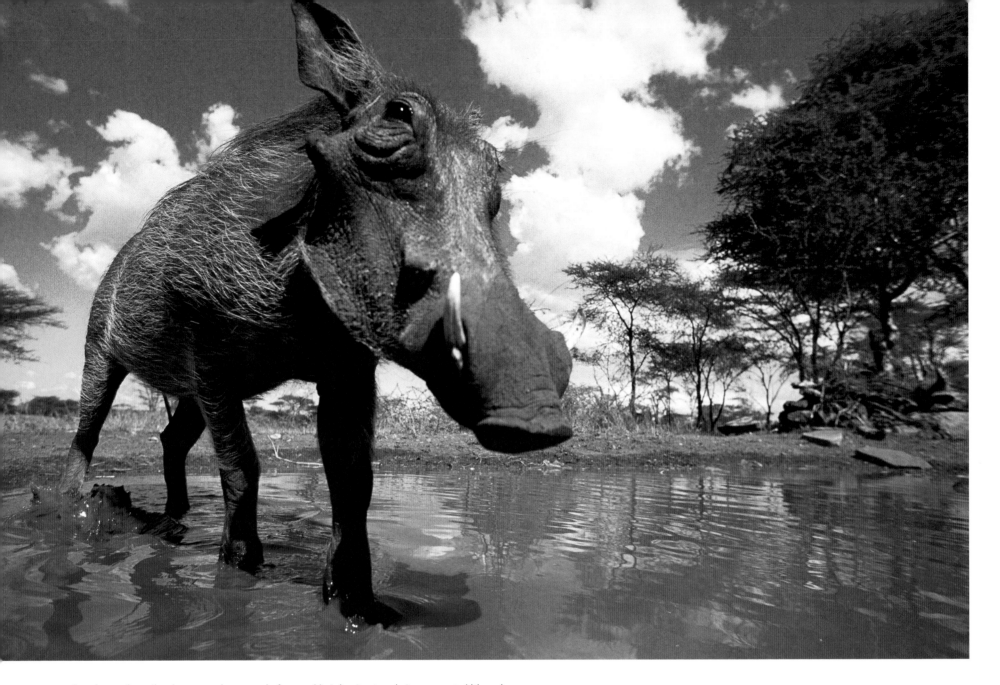

A male warthog silently approaches a pool of water. He is hesitant and circumspect. Although there is water to drink and some inviting mud to wallow in, there could also be predators lying in wait. Warthogs love to recline in soothing ooze, particularly as they are tormented by flies and parasites in their hides.

OPPOSITE: A pack of banded mongooses comes across a warthog. They go straight to the warthog, which settles down low. In this surprising symbiotic relationship, the mongooses set to work digging in the warthog's hide in search of ticks and other parasites. They get something to eat and, judging by its sublime expression, the warthog is rid of some irritating parasites.

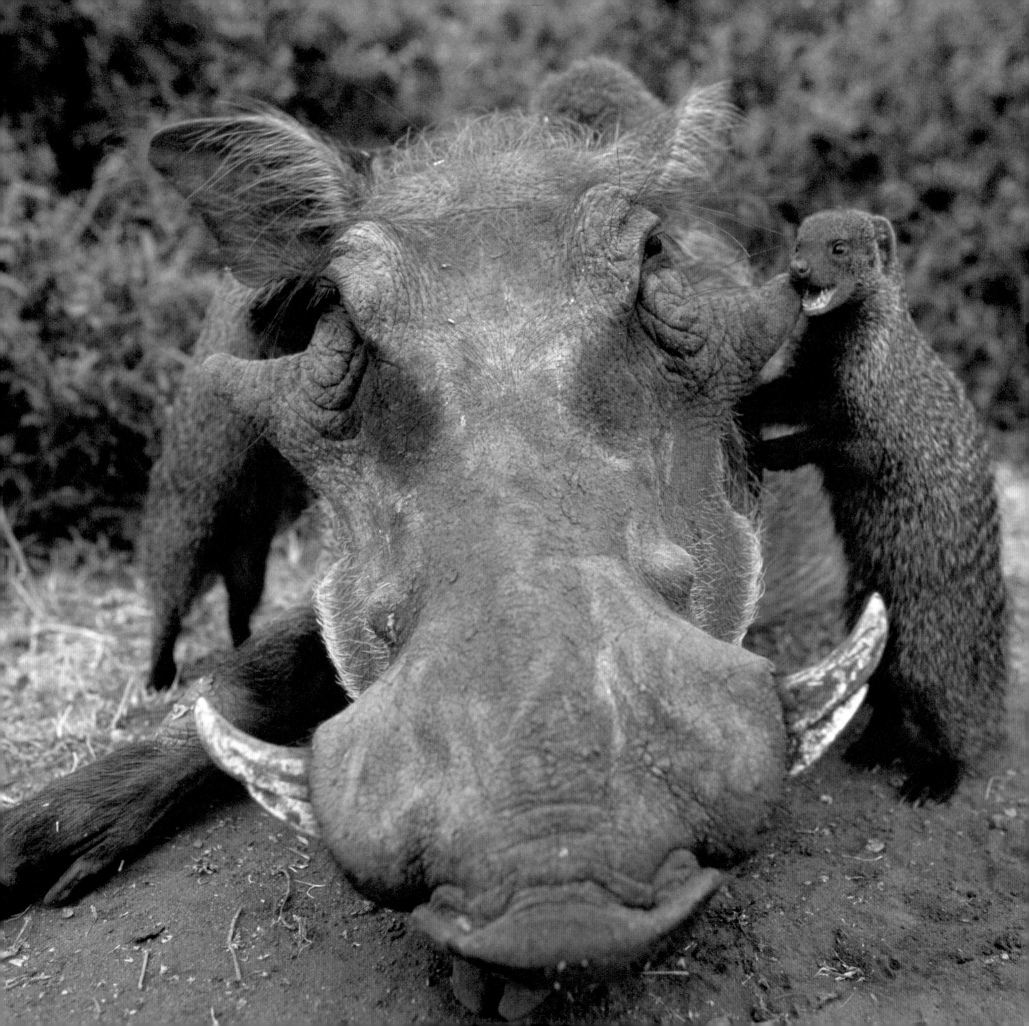

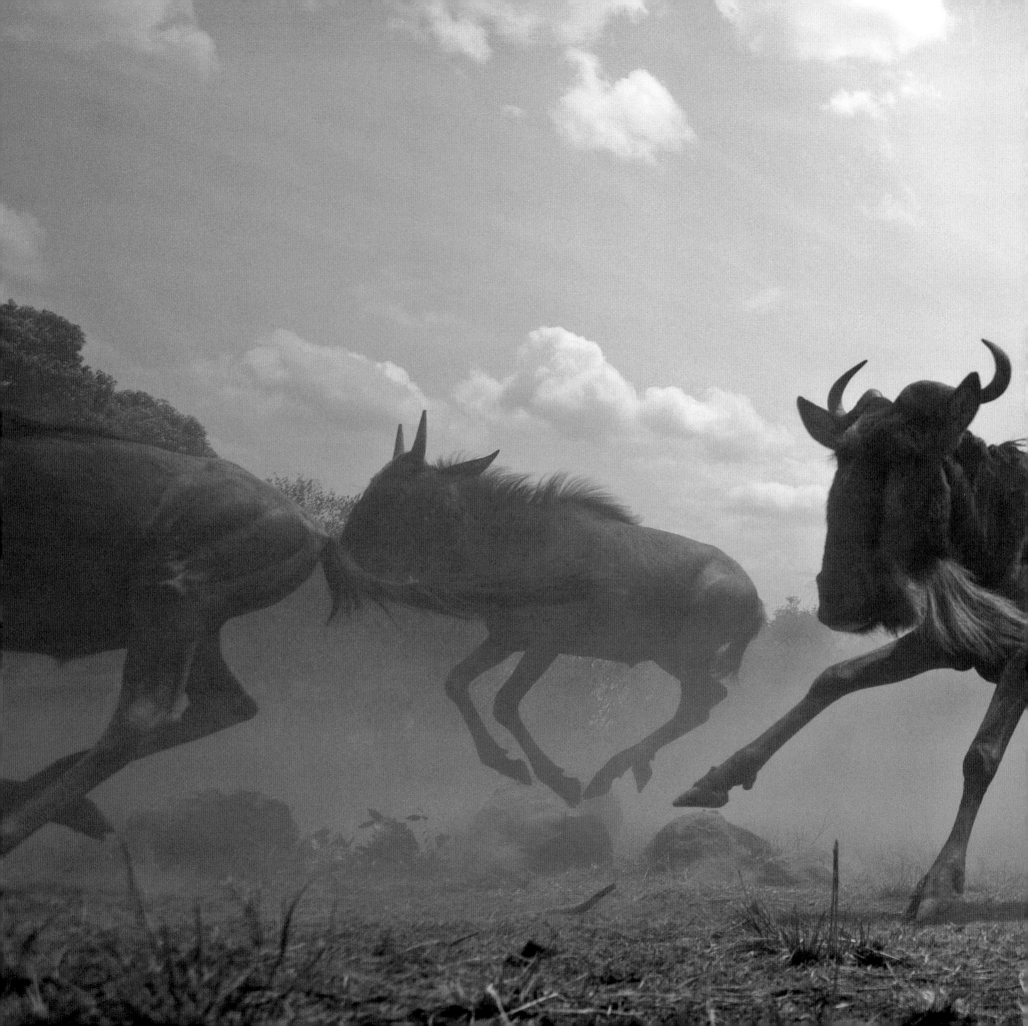

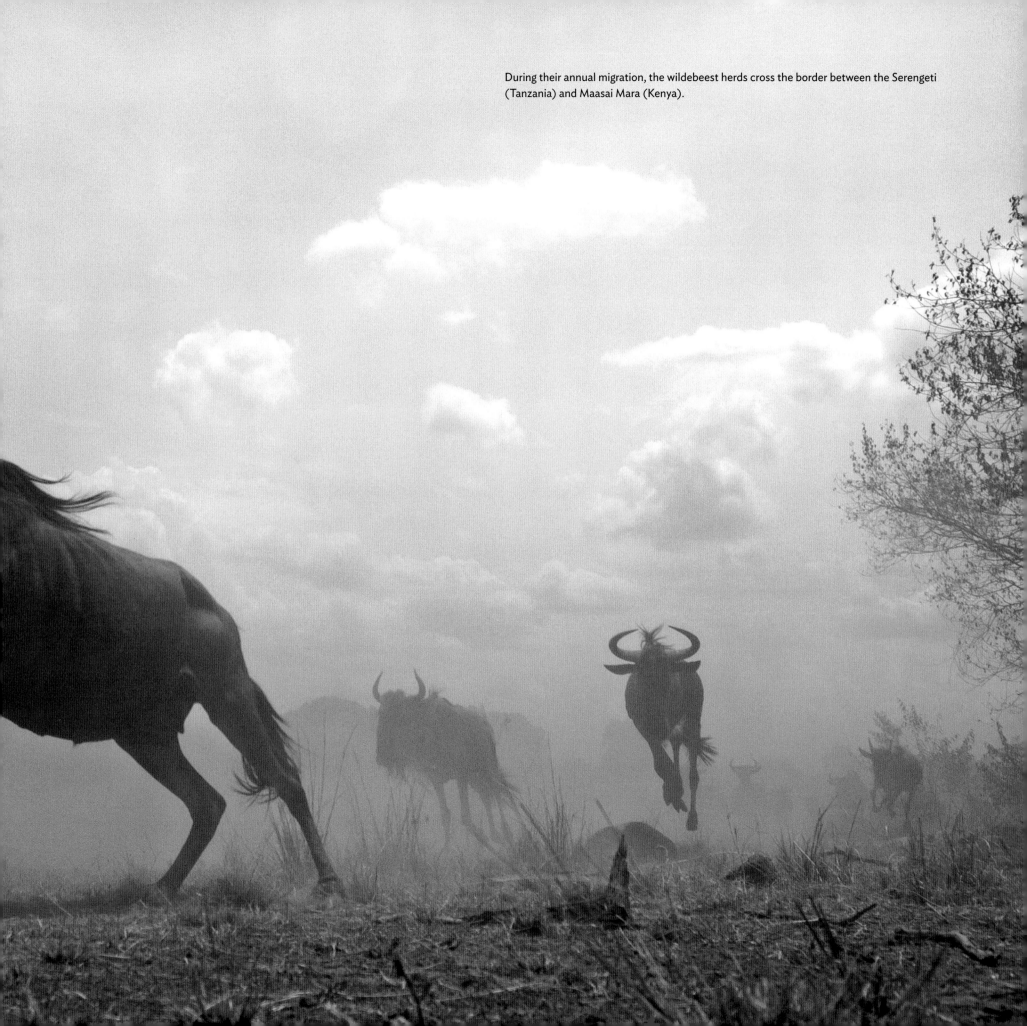

During their annual migration, the wildebeest herds cross the border between the Serengeti (Tanzania) and Maasai Mara (Kenya).

Hyenas have descended on an abandoned lion kill this gloomy morning. A cacophony of giggling ensues, and the scene seems chaotic, but in fact, a strict feeding hierarchy is instantly established. The pitch of the hyena's giggle reveals its age, while the frequency of notes encodes information about the giggler's social dominance.

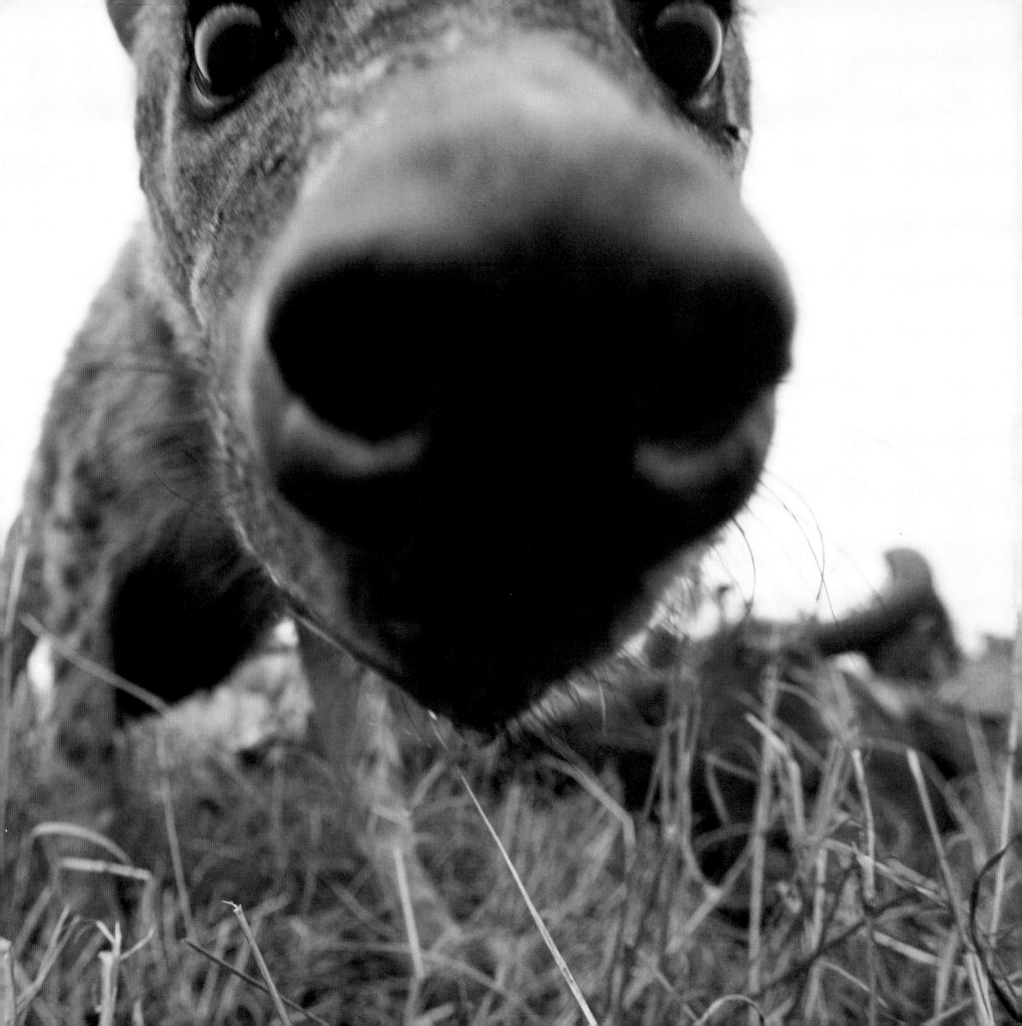

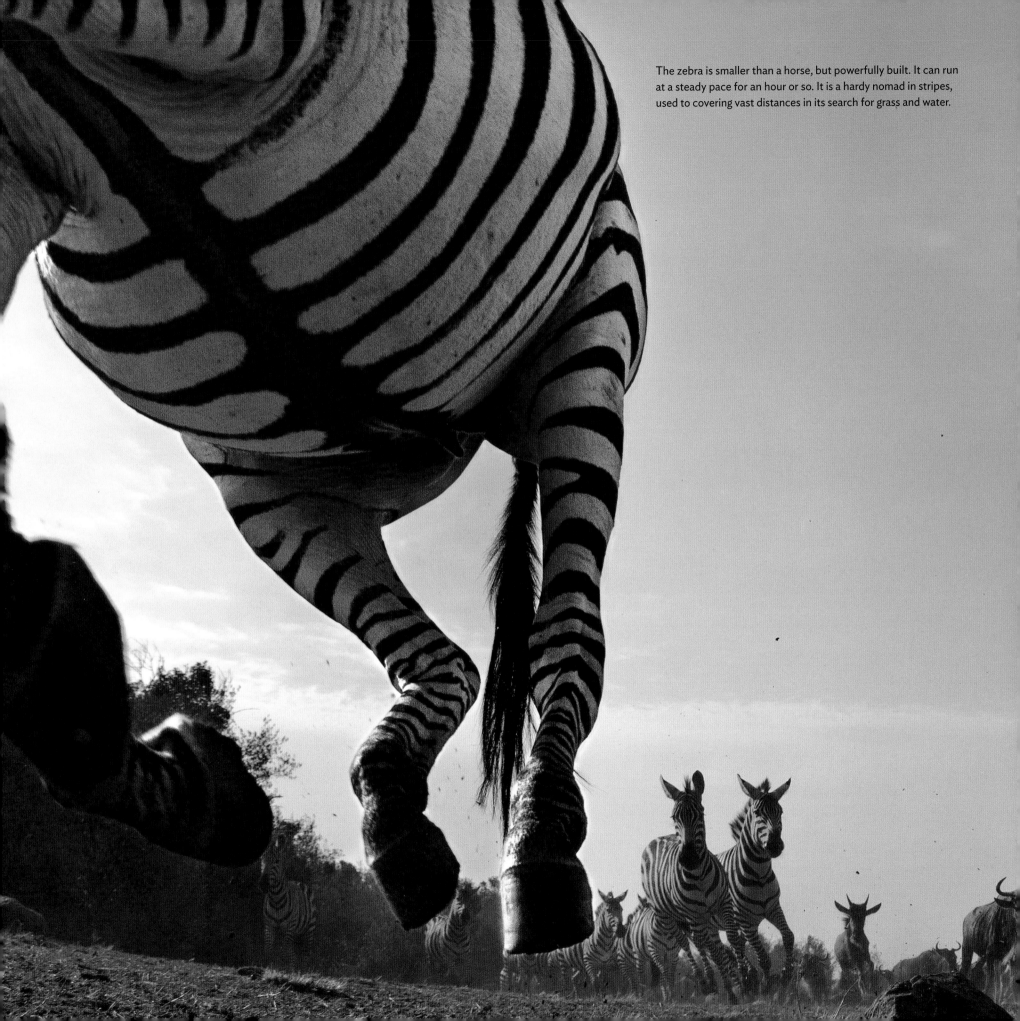

The zebra is smaller than a horse, but powerfully built. It can run at a steady pace for an hour or so. It is a hardy nomad in stripes, used to covering vast distances in its search for grass and water.

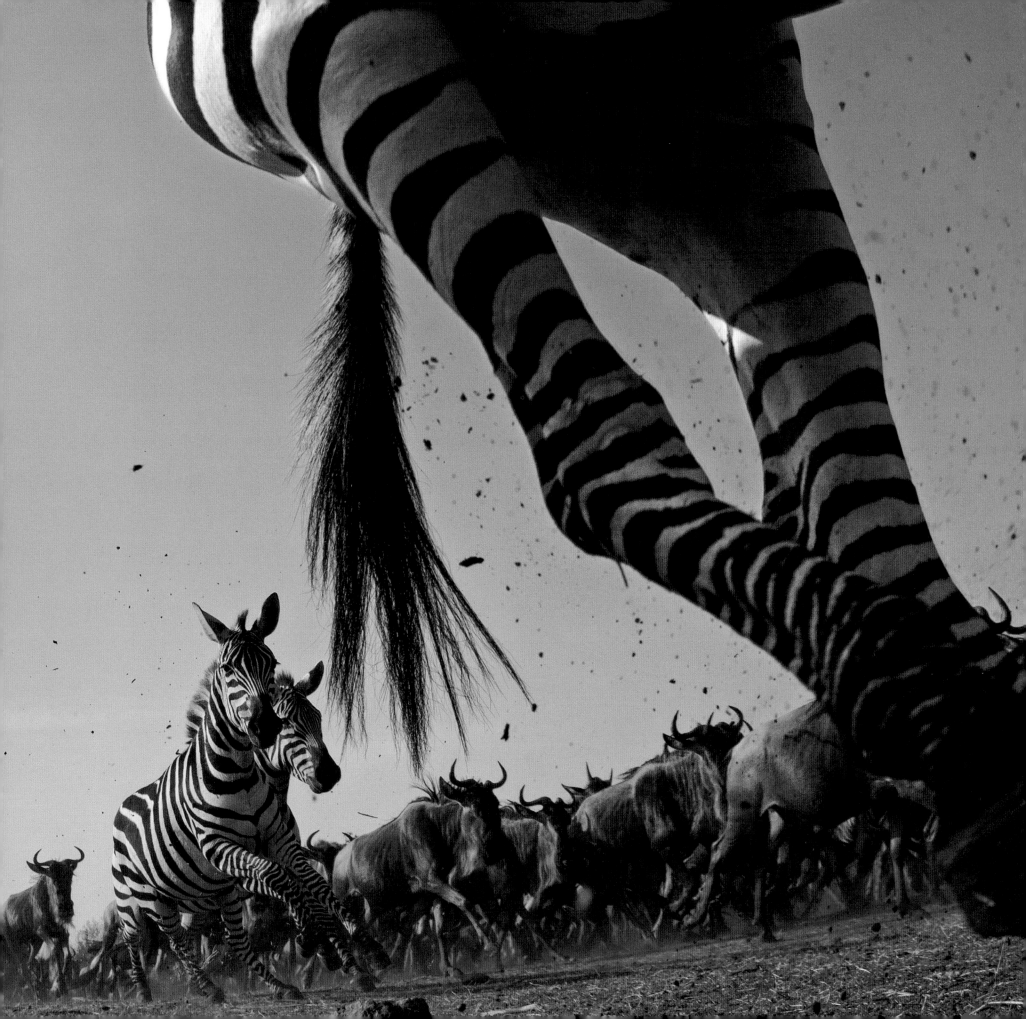

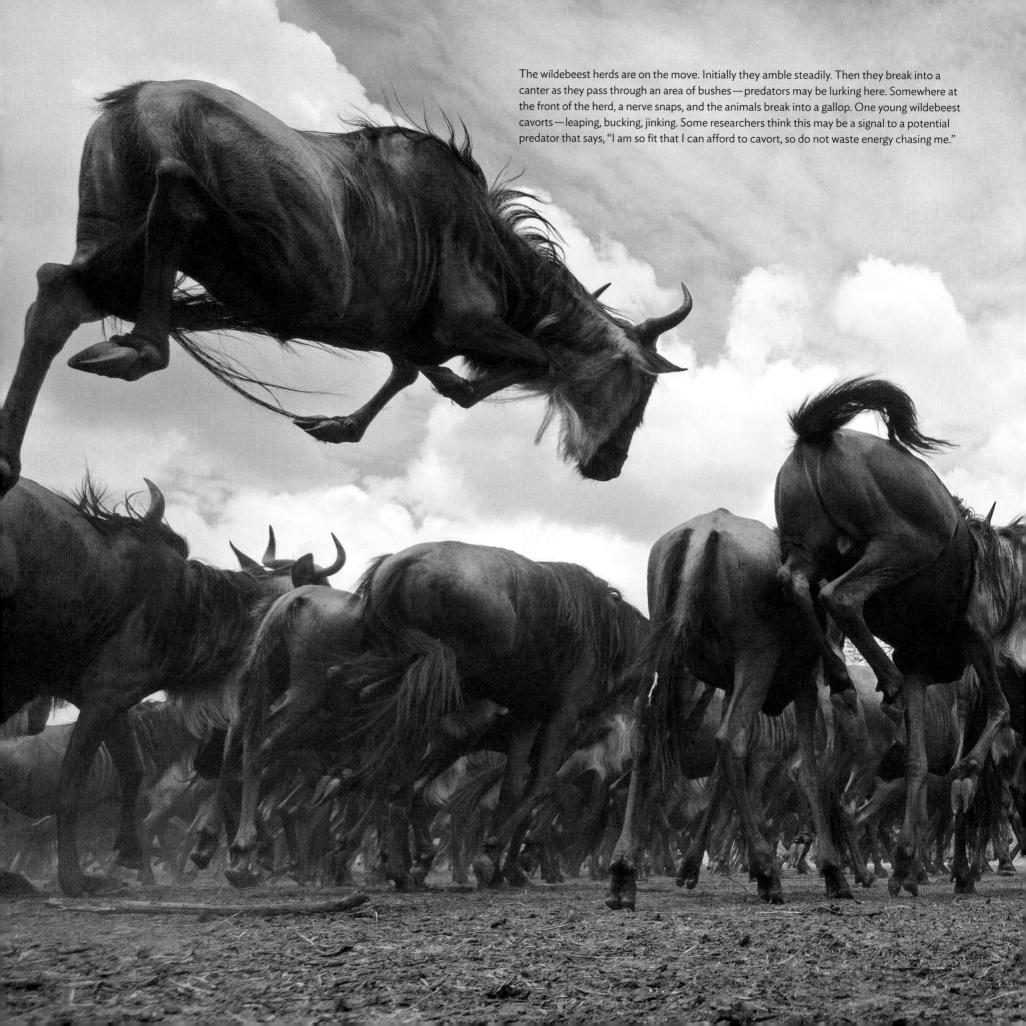

The wildebeest herds are on the move. Initially they amble steadily. Then they break into a canter as they pass through an area of bushes—predators may be lurking here. Somewhere at the front of the herd, a nerve snaps, and the animals break into a gallop. One young wildebeest cavorts—leaping, bucking, jinking. Some researchers think this may be a signal to a potential predator that says, "I am so fit that I can afford to cavort, so do not waste energy chasing me."

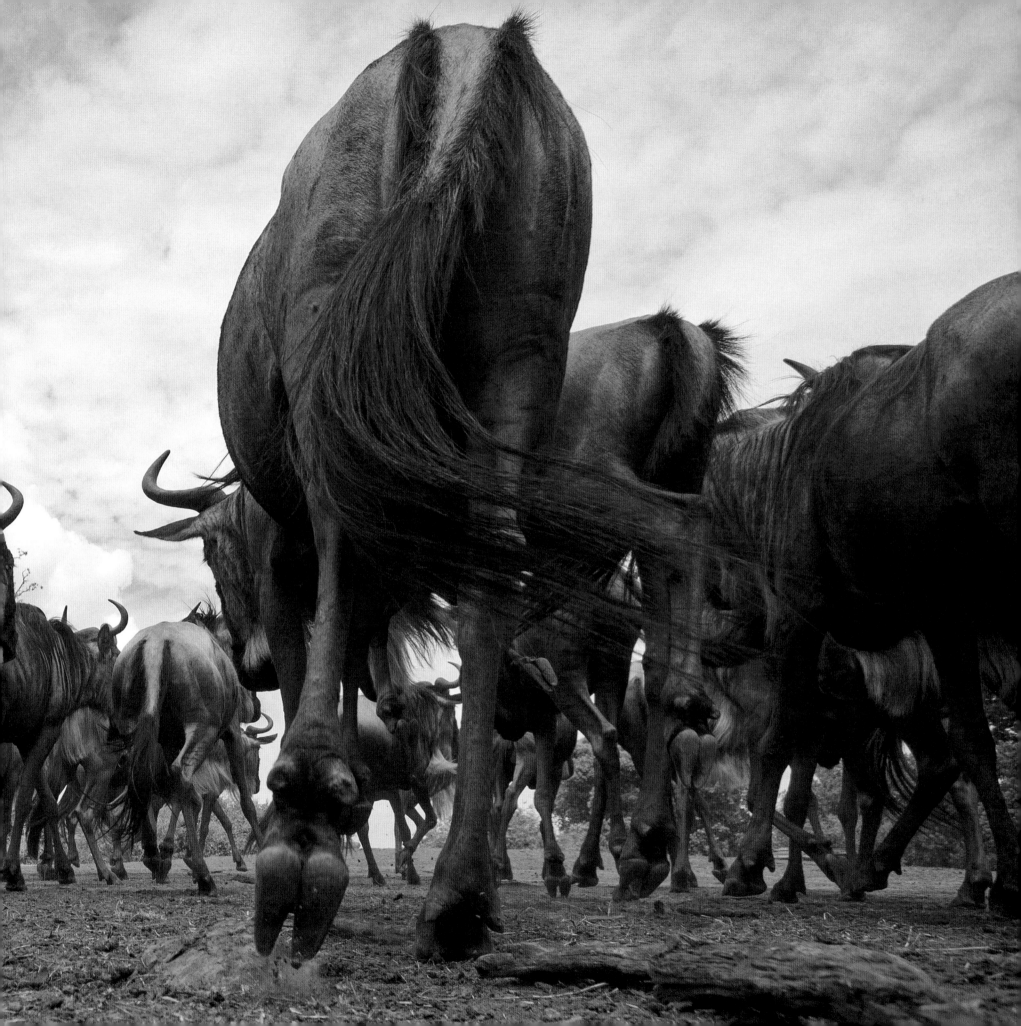

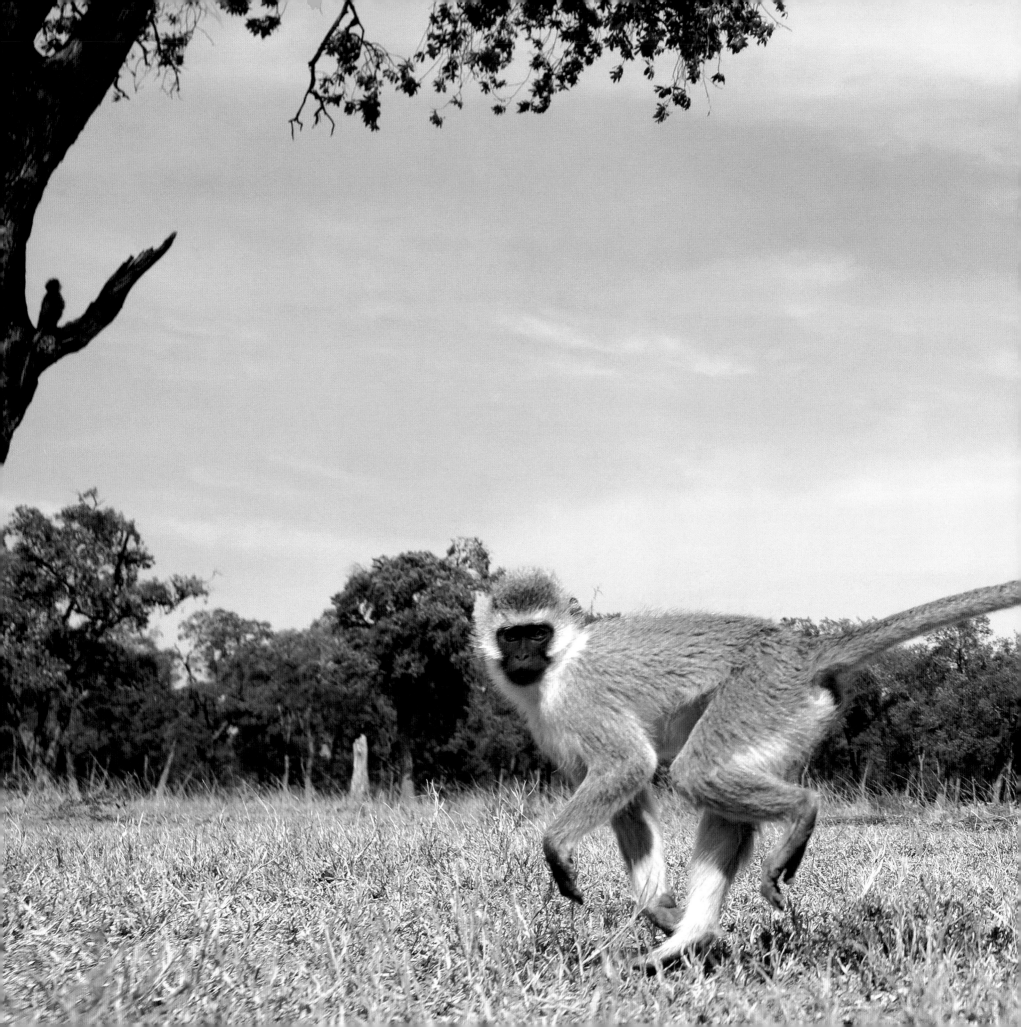

The vervet monkey is one of the few African primates to leave the rain forest and is often found at the edge of riverine woodland and scrubland or even open plain, though it rarely ventures far from the safety of trees.

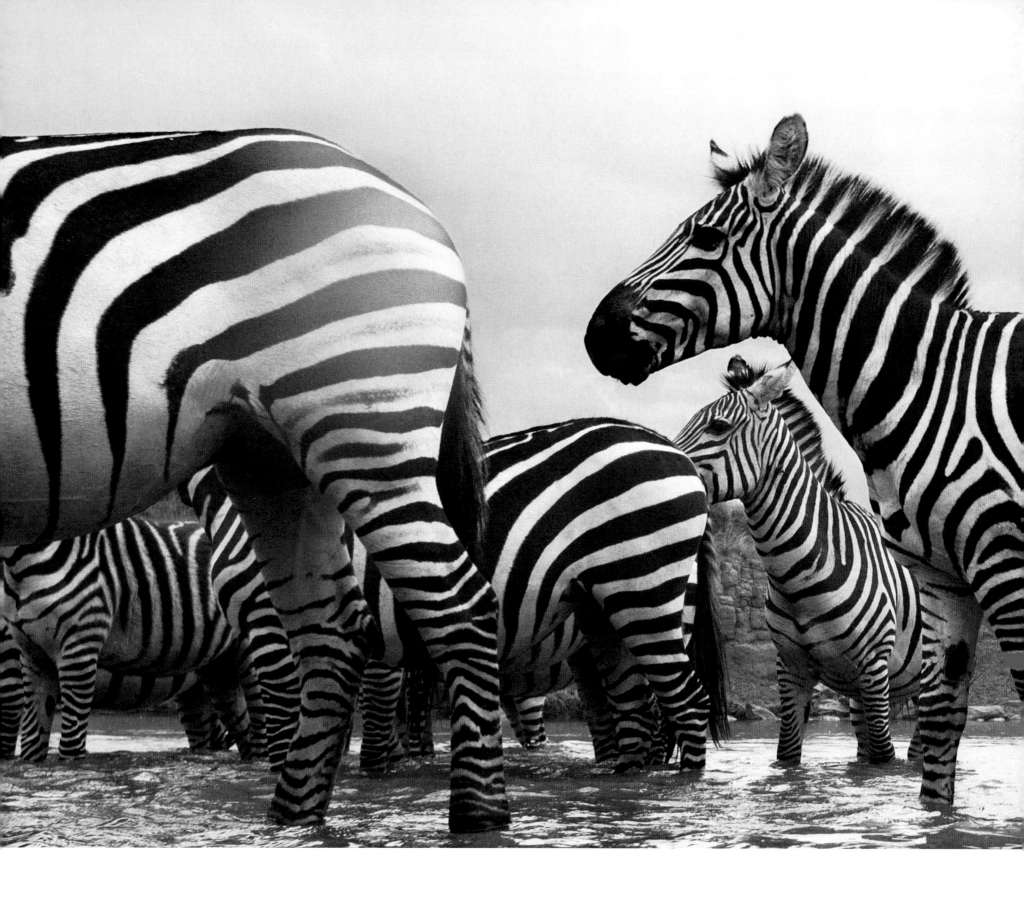

Zebras need to drink every other day. These zebras have quenched their thirst and are looking for a safe place to cross, where the river is not too deep, the current not too fast, the exit opposite not too steep, and the riverbed not too uneven and slippery.

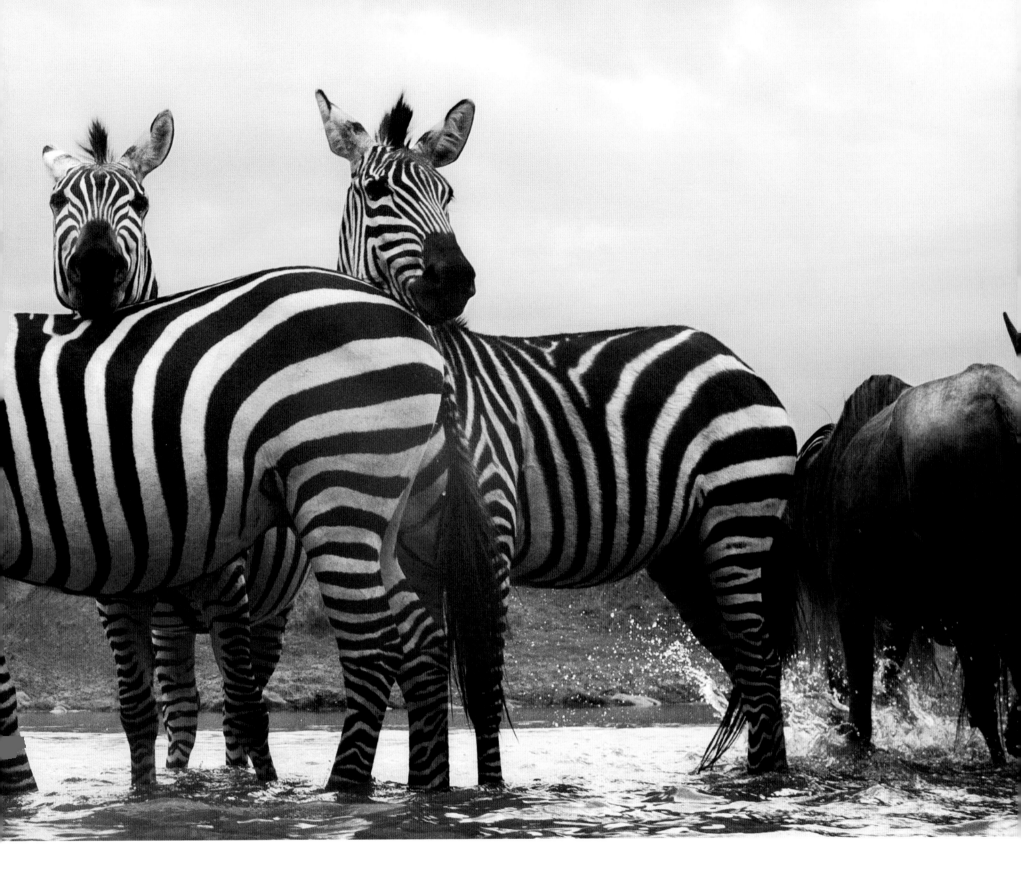

When attacked by a predator, adult zebras quickly surround the foals and adjust their speed to that of the young ones. The stallion usually brings up the rear and kicks out with his hind legs if a lion approaches him from behind. Should a hyena get too close, the stallion will charge at it with the intent to maim, in order to buy time for the rest to escape.

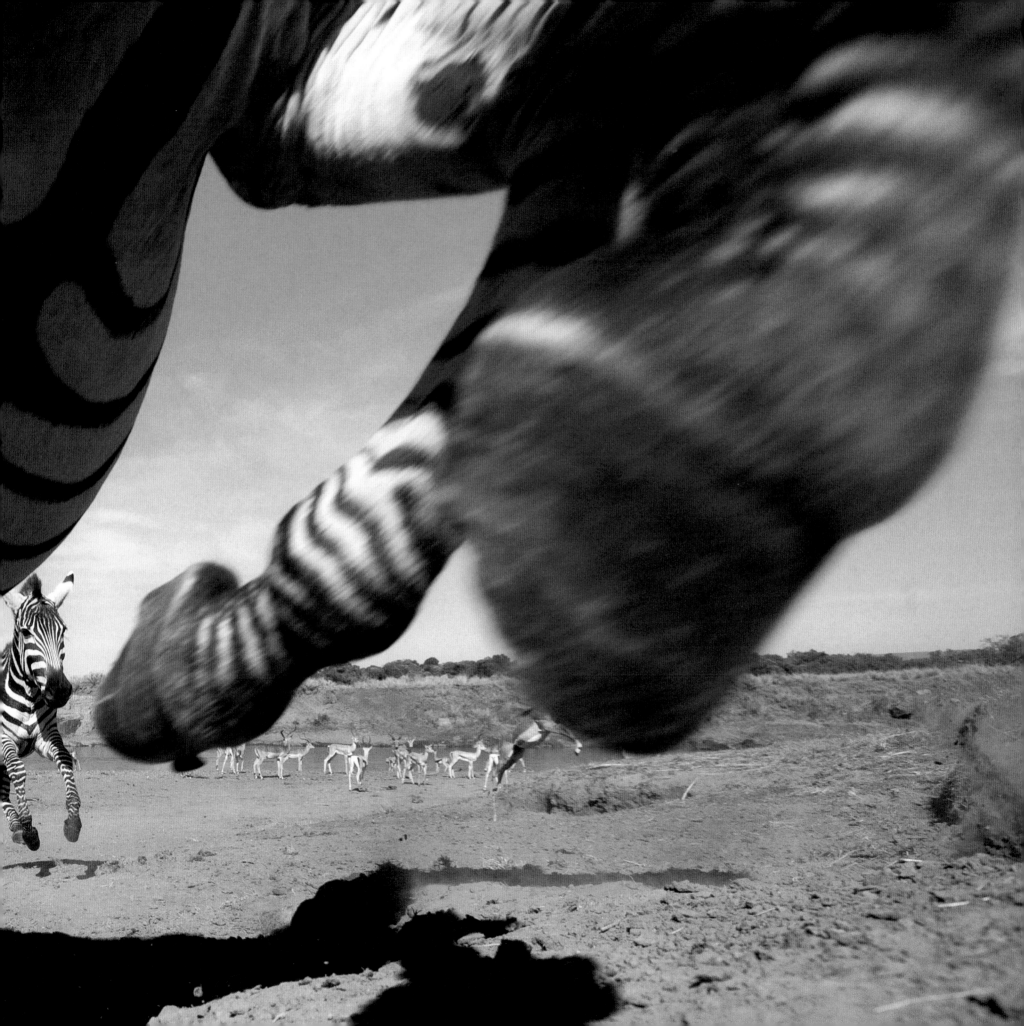

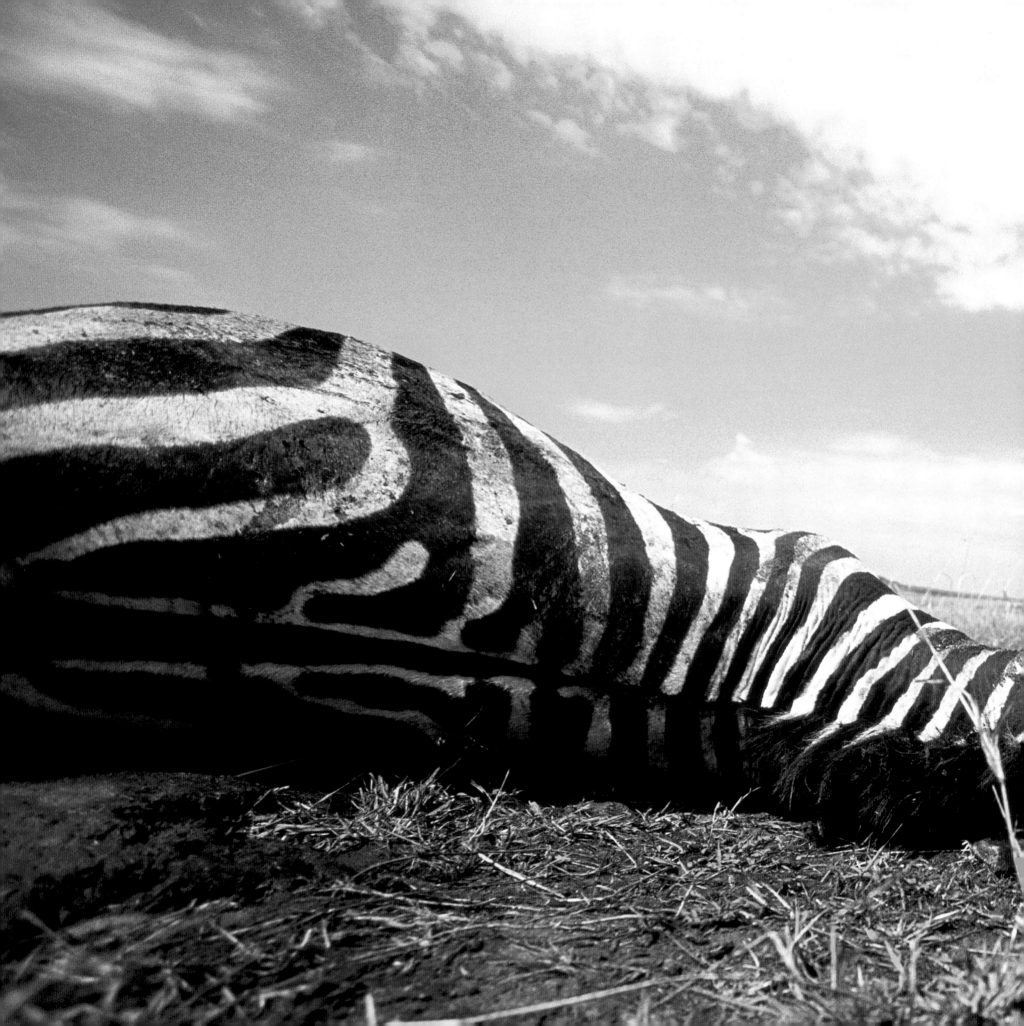

A lioness feeds on her kill. During her steady progress toward the targeted zebra, this lioness would wait motionless for long periods in whatever cover she could find, advancing only when the zebra's head was turned away from her. When she was fifteen to twenty yards from her quarry, still undetected, she sprinted. Moving at top speed, she leapt, latched on to the hindquarters of the fleeing zebra, and pulled it down. Then, avoiding the animal's kicking legs, she lunged for its throat and killed it by strangulation, which can take upward of ten minutes.

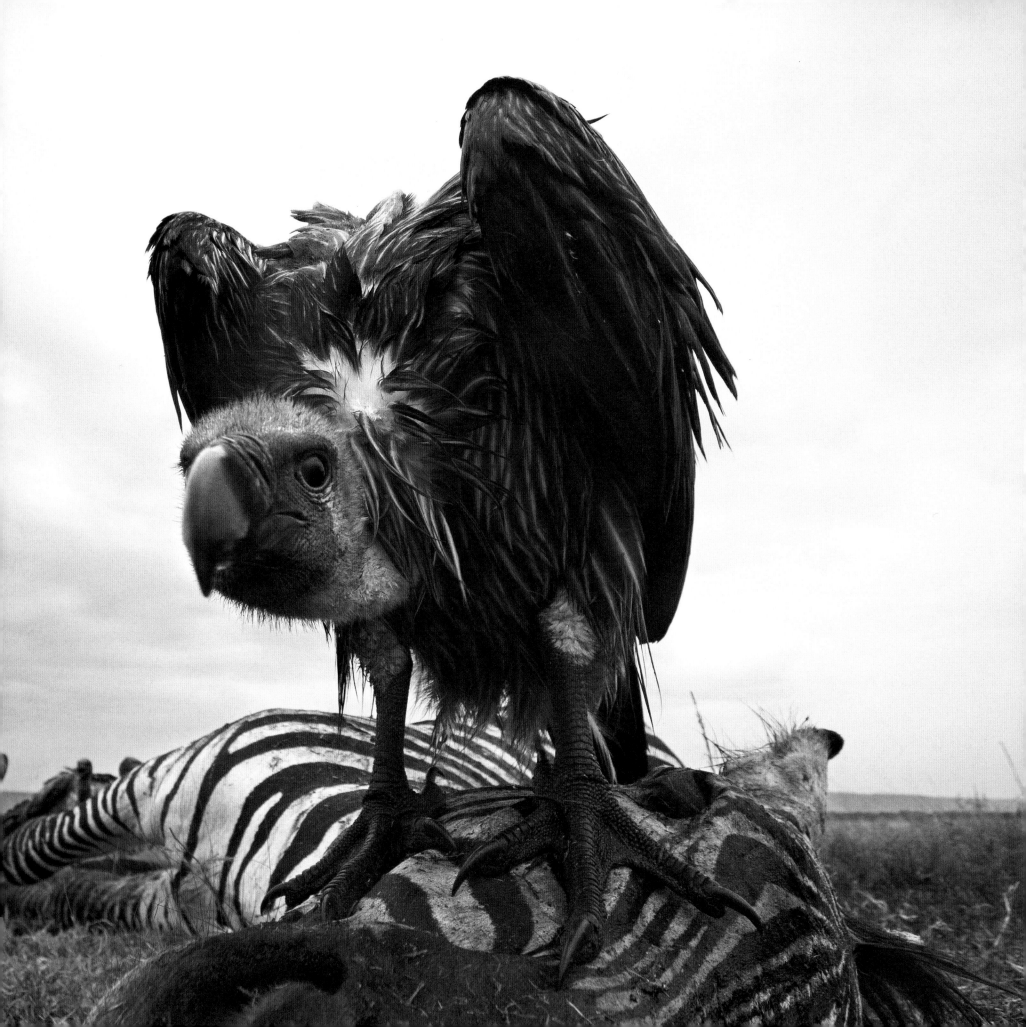

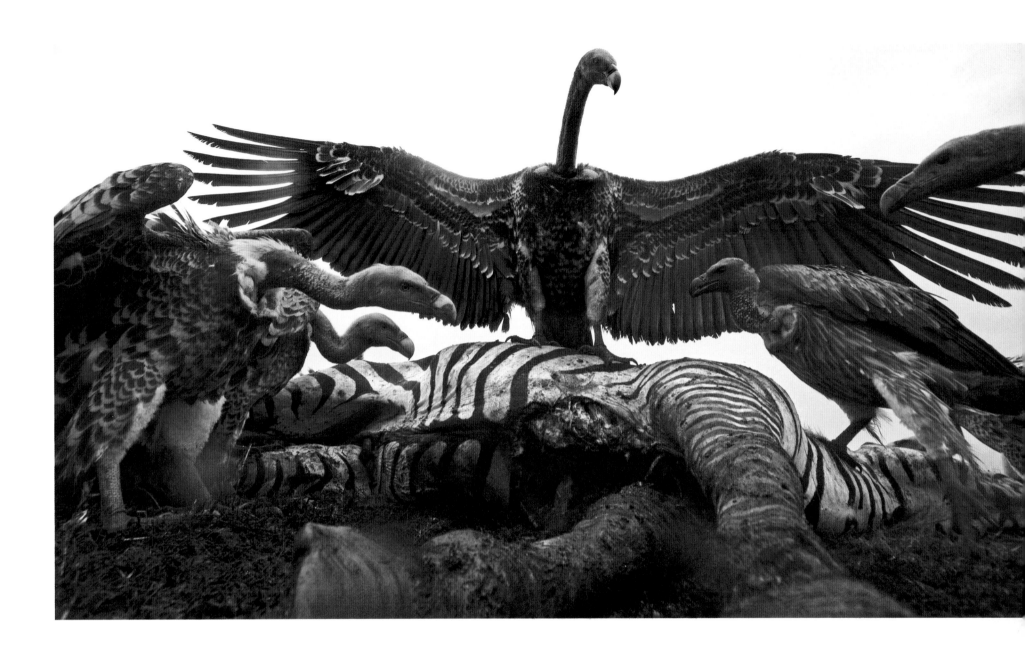

It is late afternoon in early August. There appear to be no bite marks on this zebra carcass, so it could have died from disease. The next morning, a spotted hyena lopes in, scatters the vultures, and starts feeding at the zebra's belly, scanning its surroundings every thirty seconds or so. After the hyena has left the scene, the noisy vultures scramble back to continue feeding.

This group of topi has trekked a long distance to drink from the river. Thirst quenched, they return to the plains to rest. The topi's favorite dozing position is odd: It lies down on the open plains, legs folded beneath it. As it nods off, its head lowers, still upright, until its mouth is pressed against the ground—it resembles nothing so much as a hammer balanced with its nose down, claw straight up.

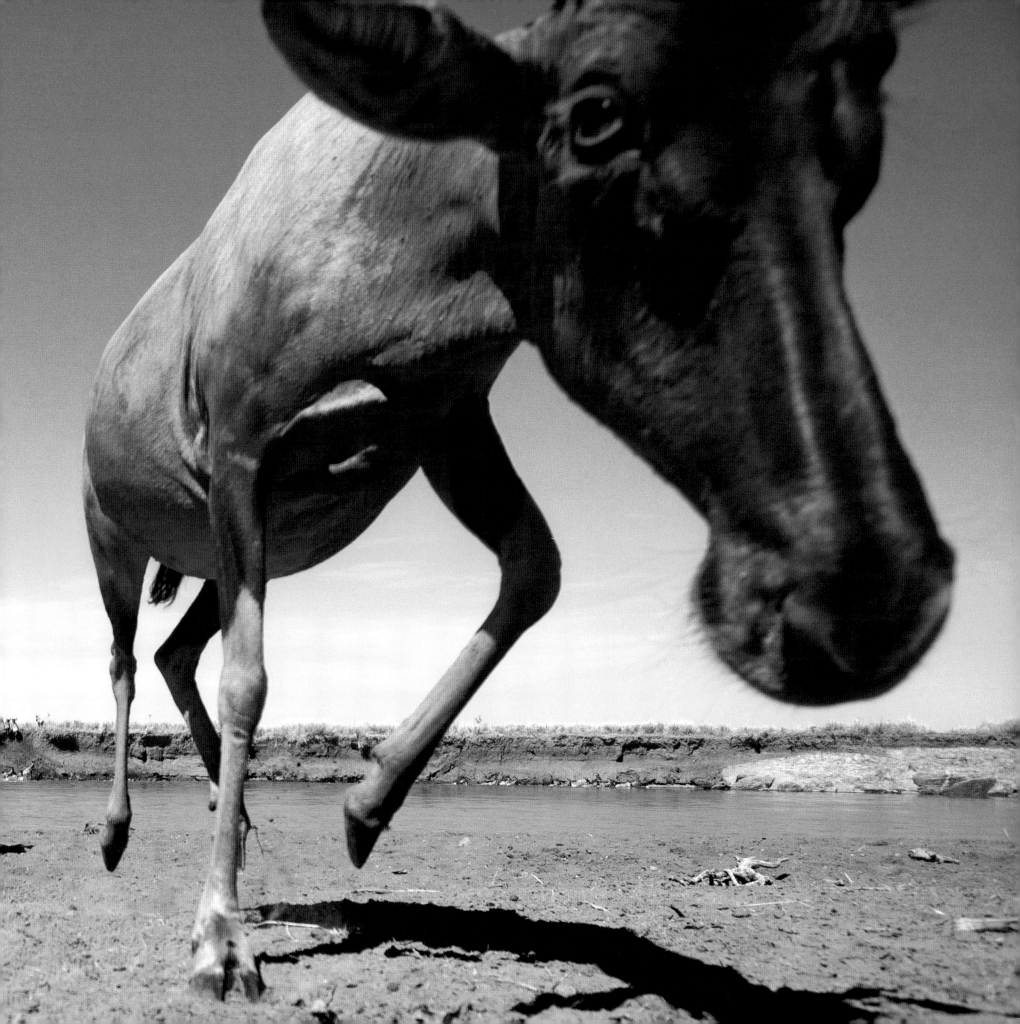

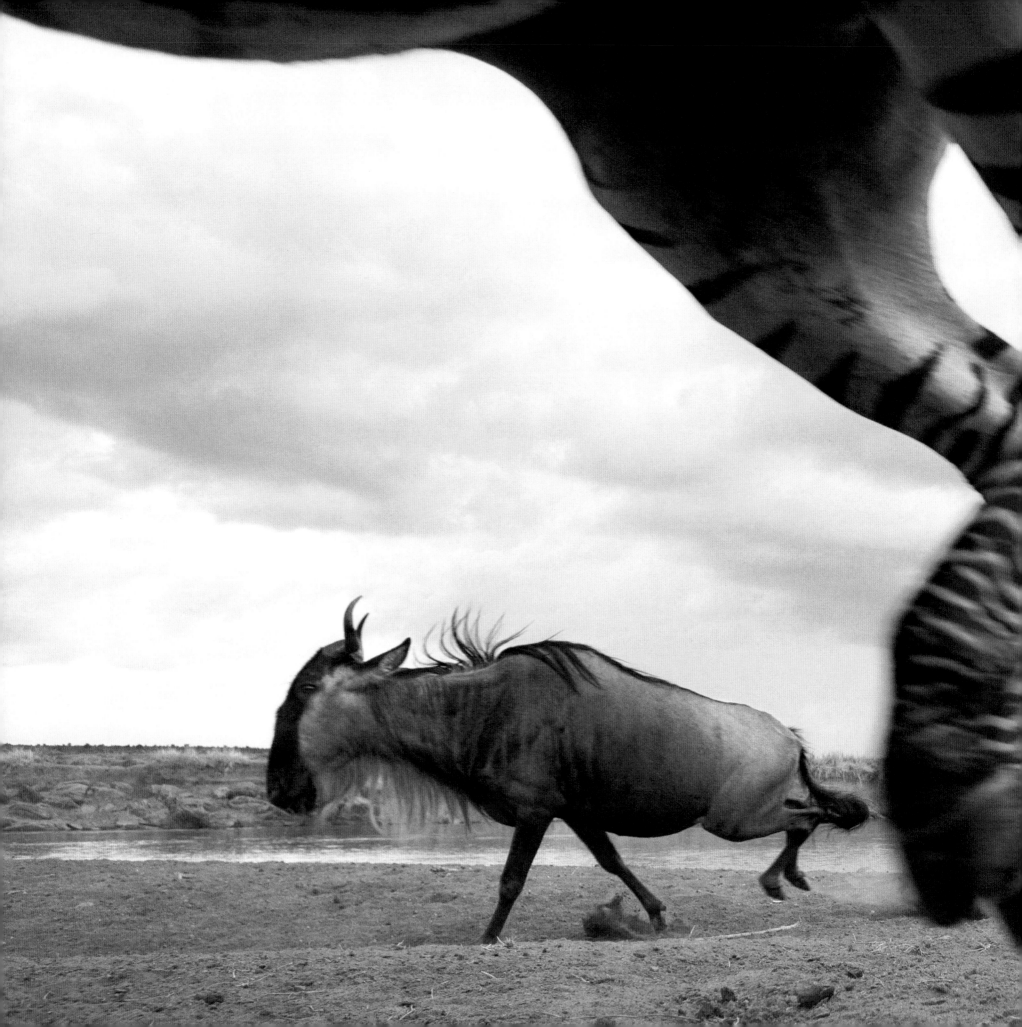

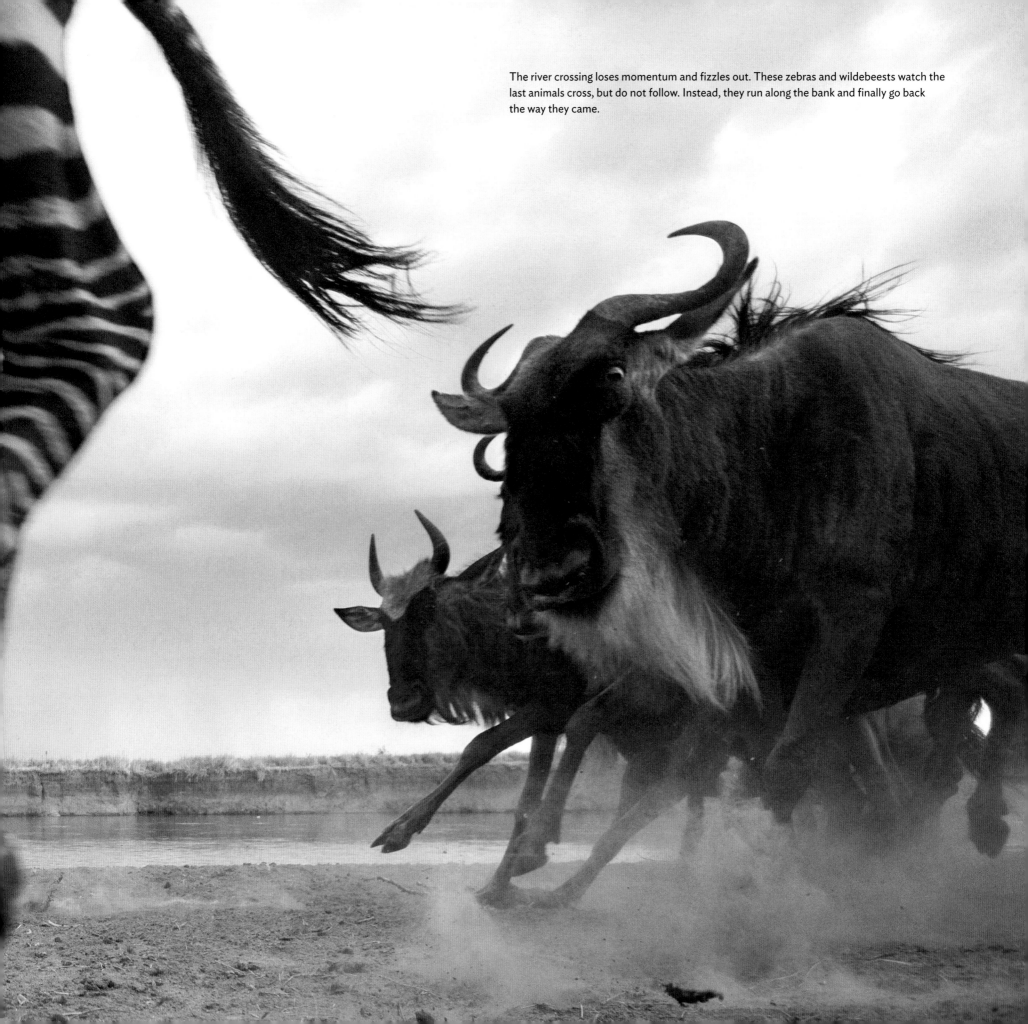

The river crossing loses momentum and fizzles out. These zebras and wildebeests watch the last animals cross, but do not follow. Instead, they run along the bank and finally go back the way they came.

Even during the long dry season in the Mara, dark clouds occasionally appear, especially in August. They are a product of local conditions heavily influenced by the winds blowing from Lake Victoria. This male lion is fascinated by the smell emanating from one of the lionesses in the Paradise Plain pride and follows her doggedly. She heads toward a wildebeest herd, but he is not interested in food, and his upright stance eventually alerts the wildebeests to the lions' presence.

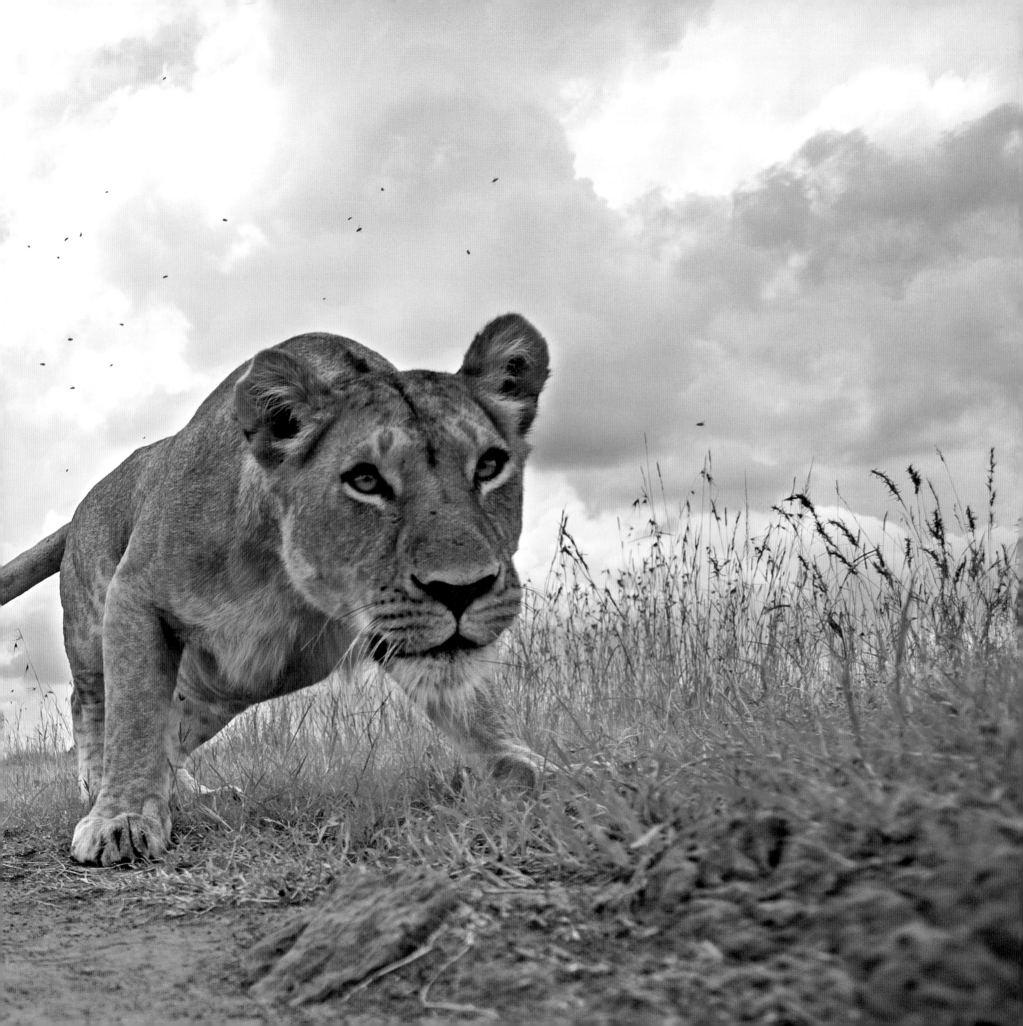

Despite appearances, especially of their sticklike legs, wildebeests are built for speed and stamina. They also have herd intelligence: By sticking together, they have the advantage of many eyes and ears. Given that there are 1.5 million wildebeests roaming over the Greater Serengeti ecosystem, they are the most intelligent antelopes of all.

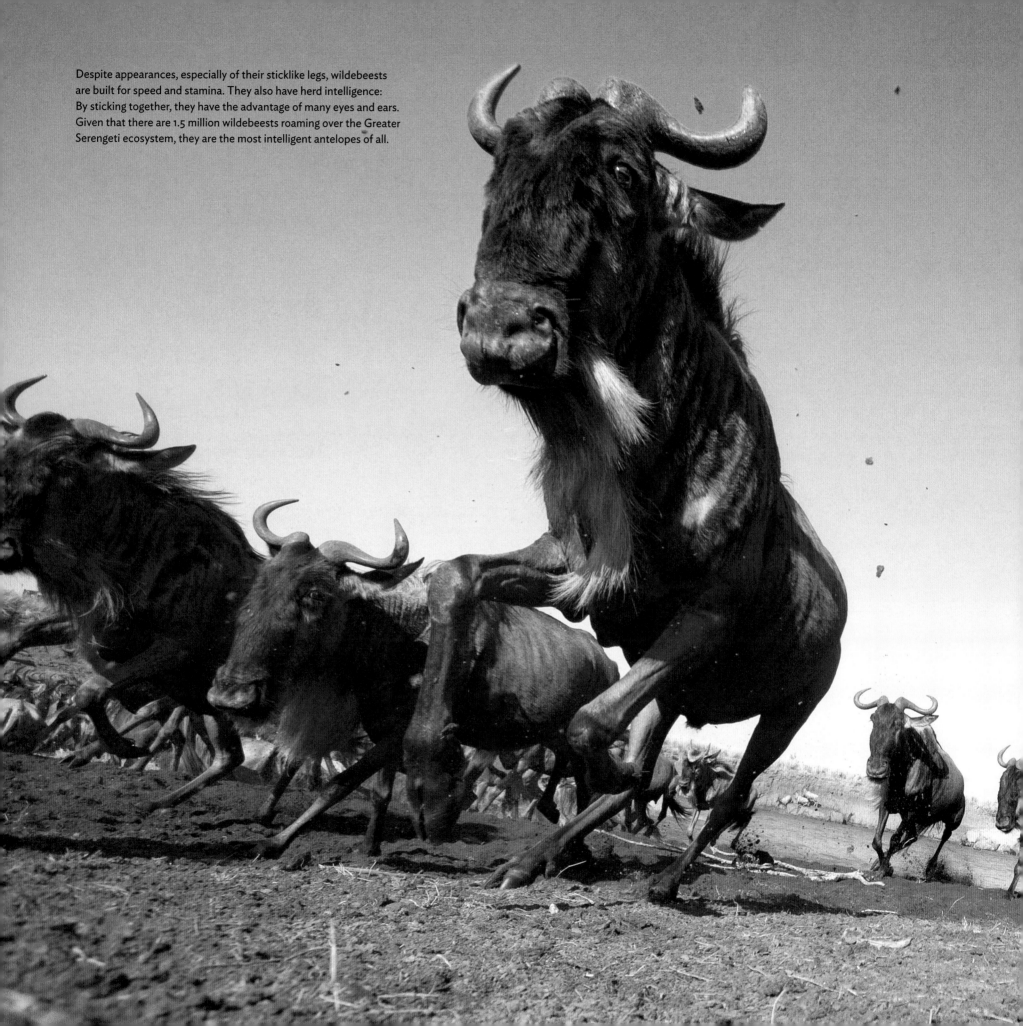

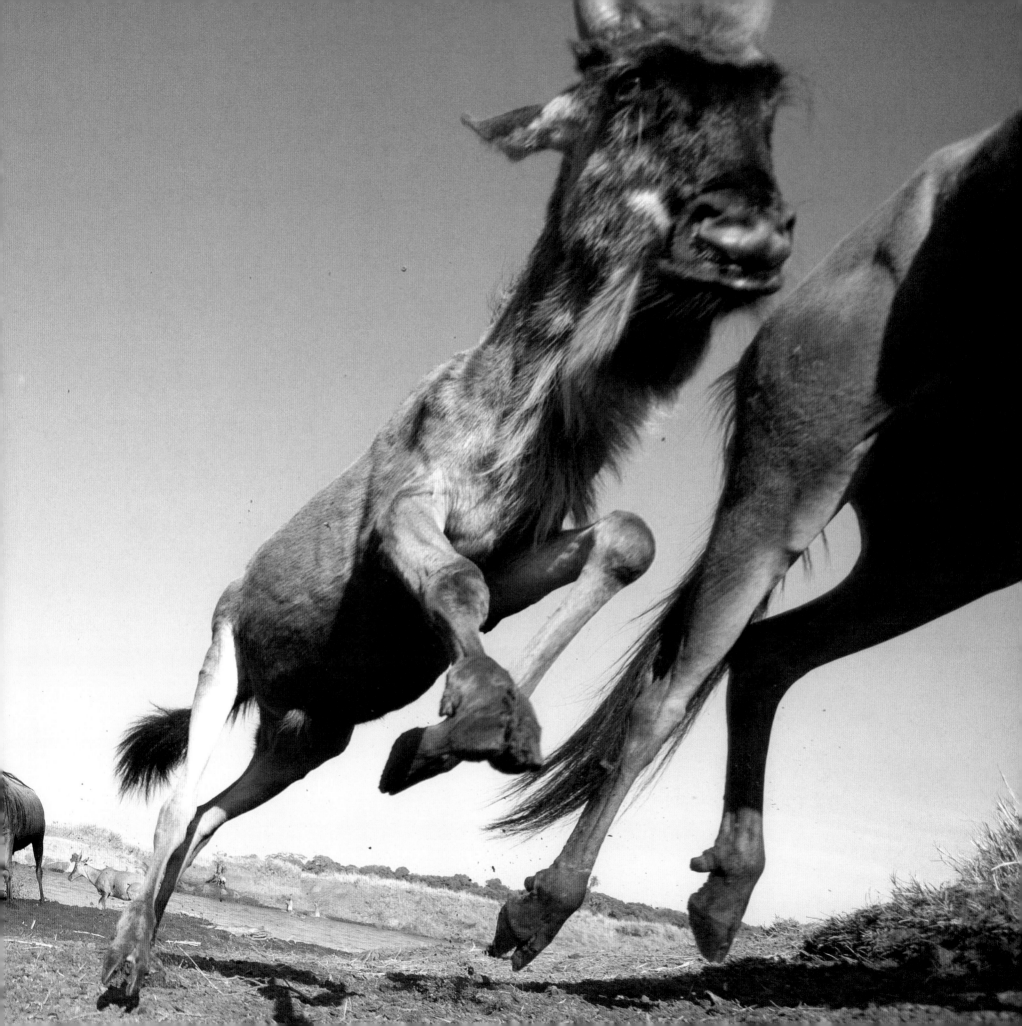

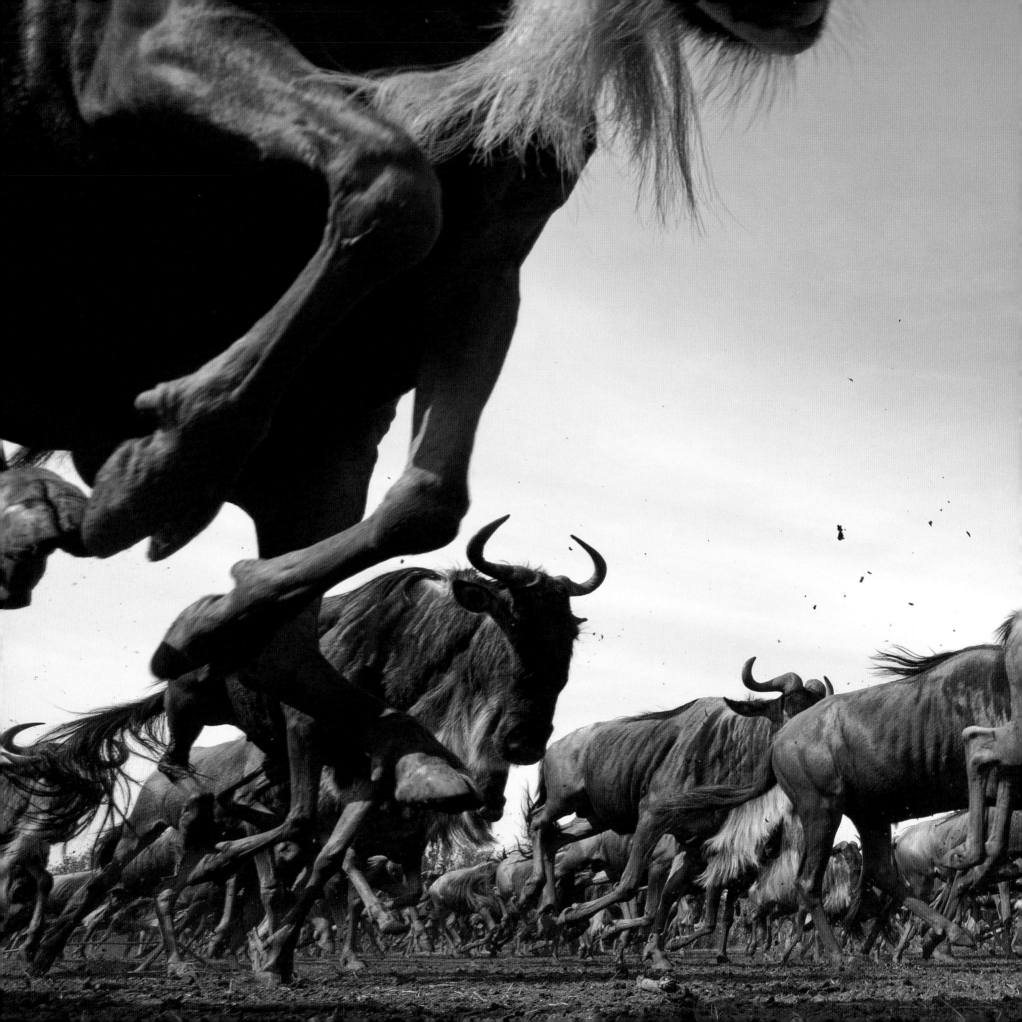

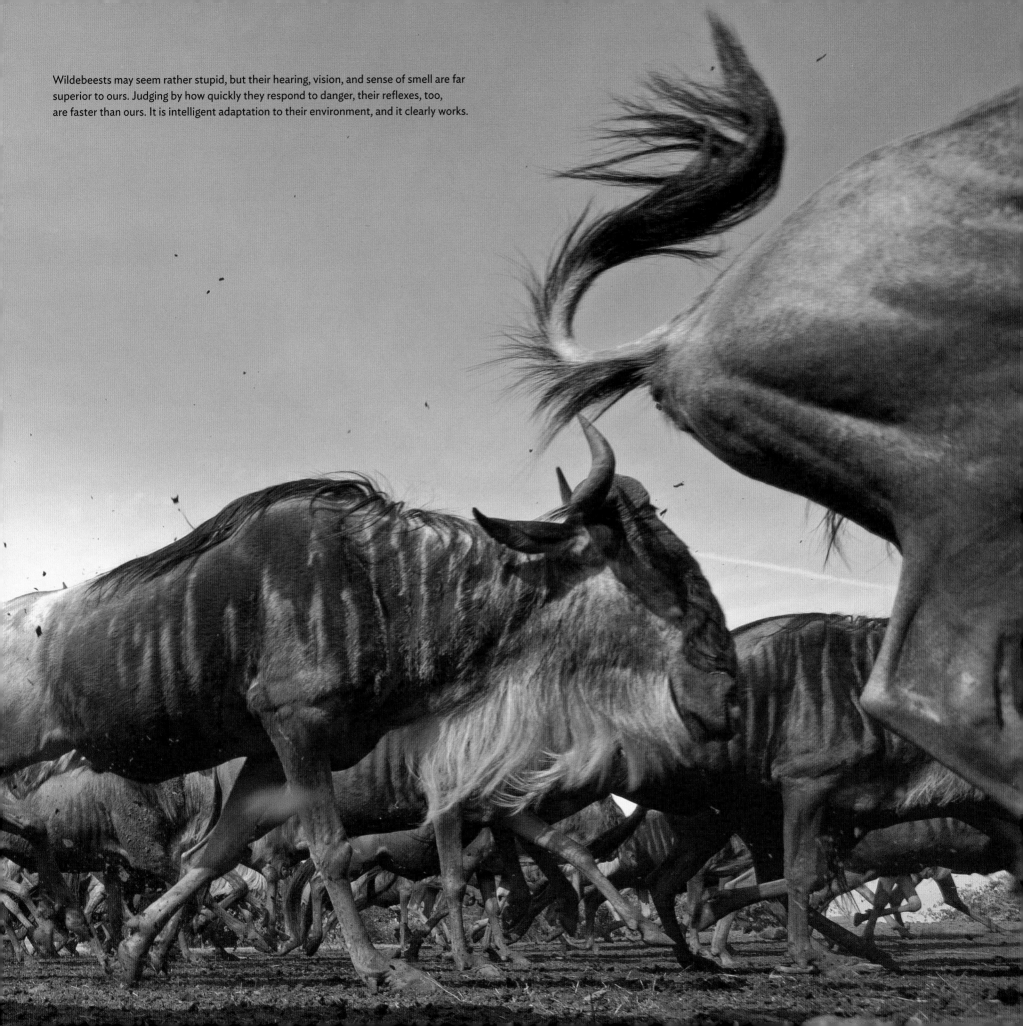

Wildebeests may seem rather stupid, but their hearing, vision, and sense of smell are far superior to ours. Judging by how quickly they respond to danger, their reflexes, too, are faster than ours. It is intelligent adaptation to their environment, and it clearly works.

RIGHT AND OVERLEAF: The grass has turned yellow, drained of nutrition, and a wildebeest has succumbed to death. A black-backed jackal pair is tearing off pieces of flesh from a carcass on the open plain. They feed in peace until this warthog sow with three adolescents in tow trots in for a closer look. The sow is tentative, not yet having established feeding etiquette with the jackals. But as the warthogs come closer, the jackals step back. The warthogs nibble, keeping an eye on the jackals, but they are jittery and take off when the first vulture flies in to perch on the carcass. This is the cue for the male jackal to wrest back control, and he easily chases the vulture off. However, a hyena then comes loping into the scene and takes over the carcass with impunity. More hyenas arrive, and the jackals, like the vultures, have to wait their turn at the kill.

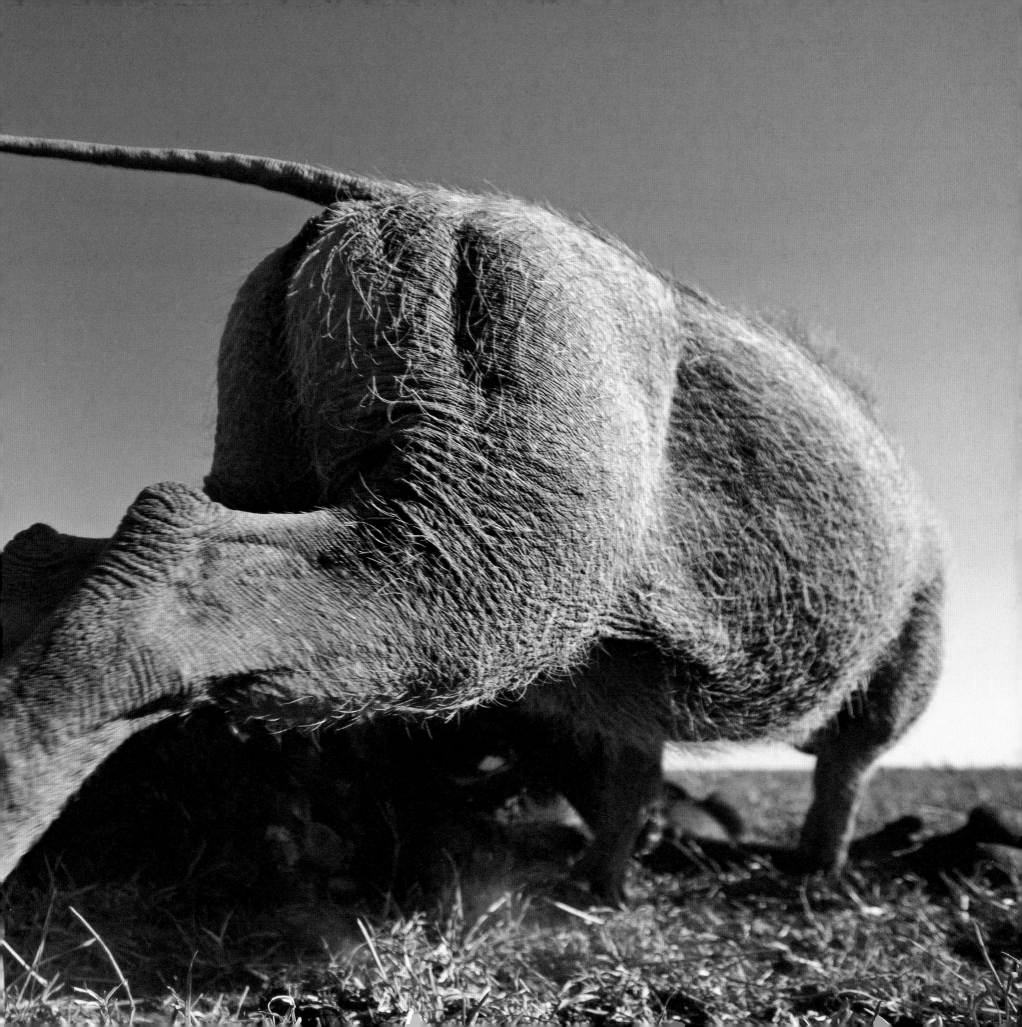

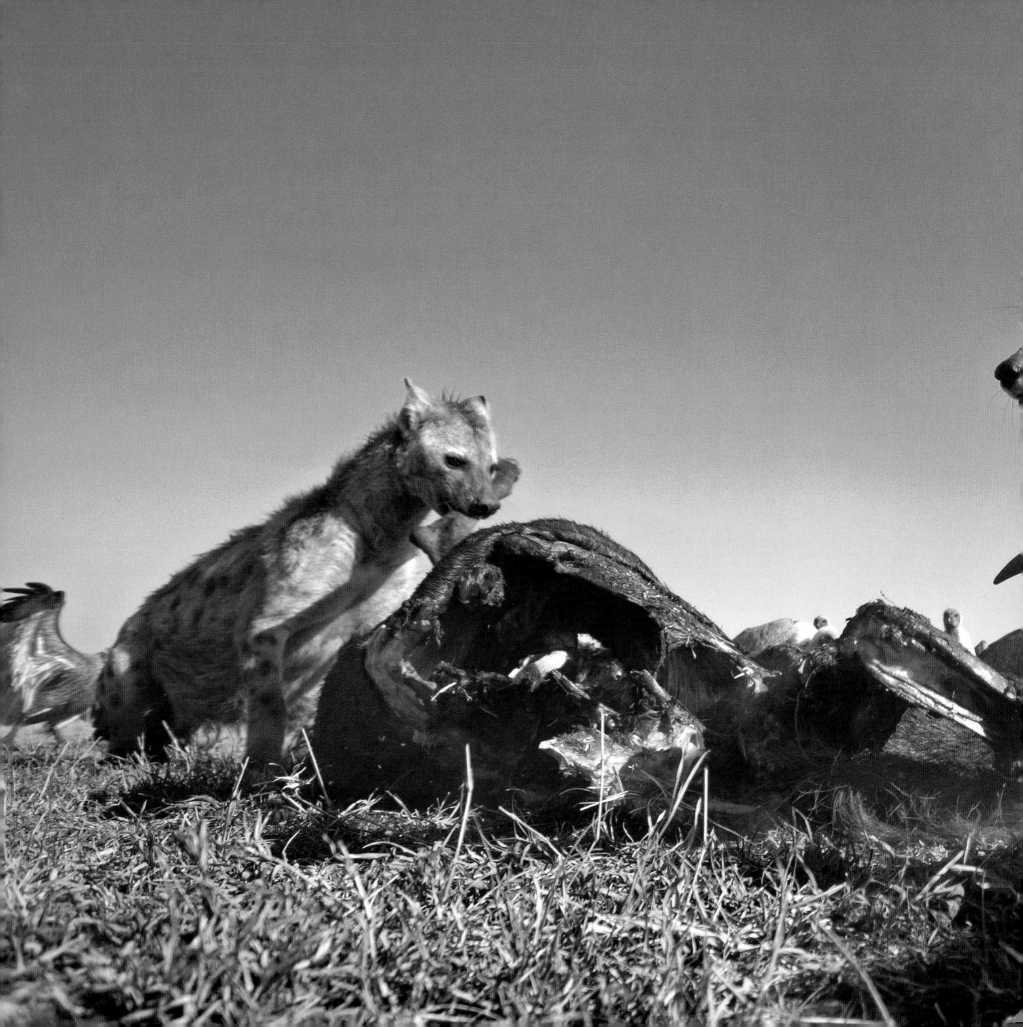

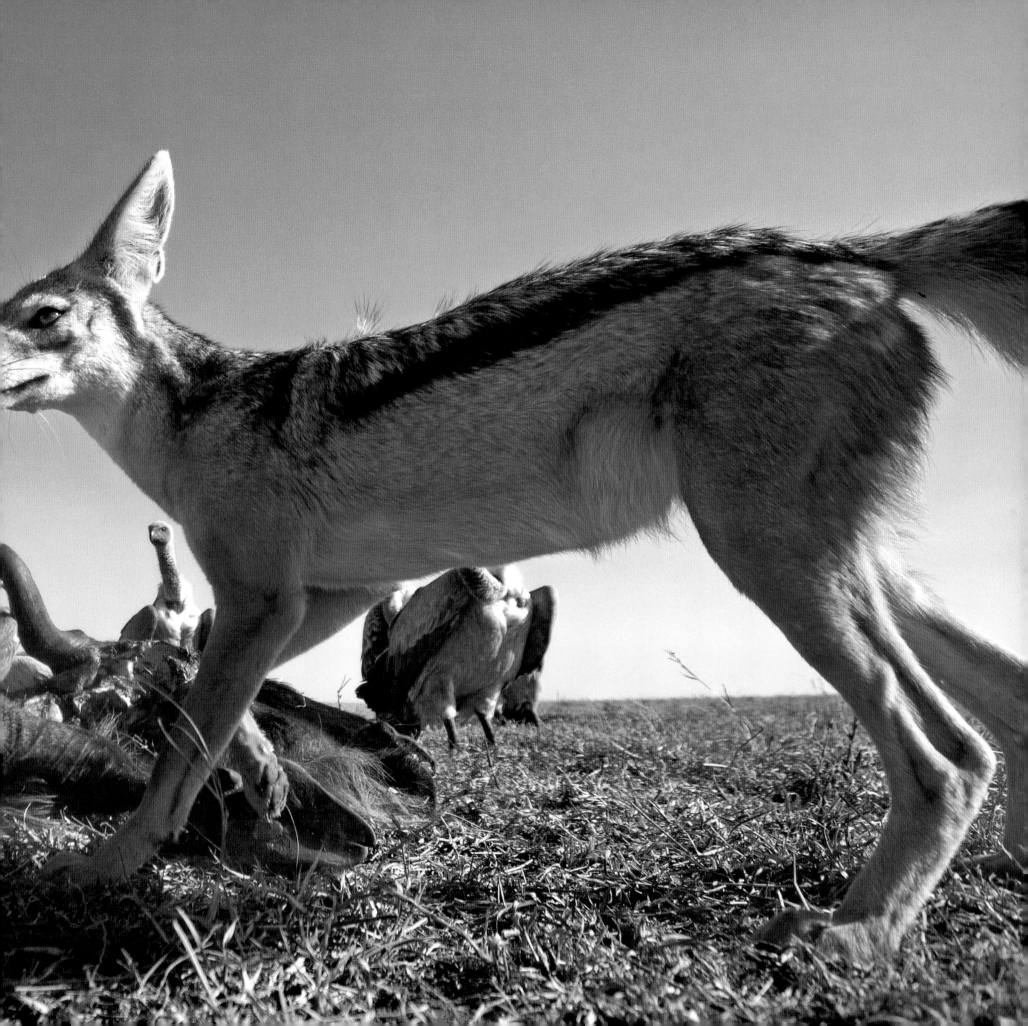

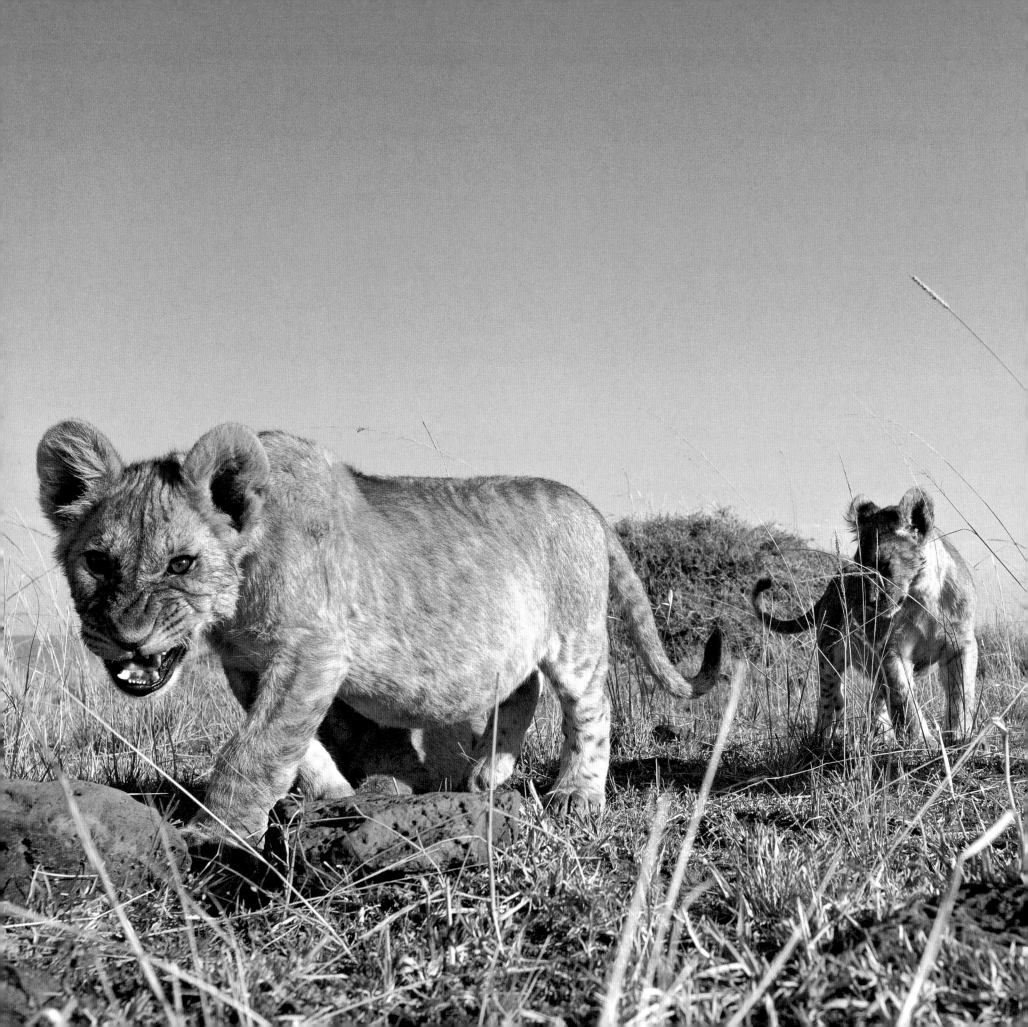

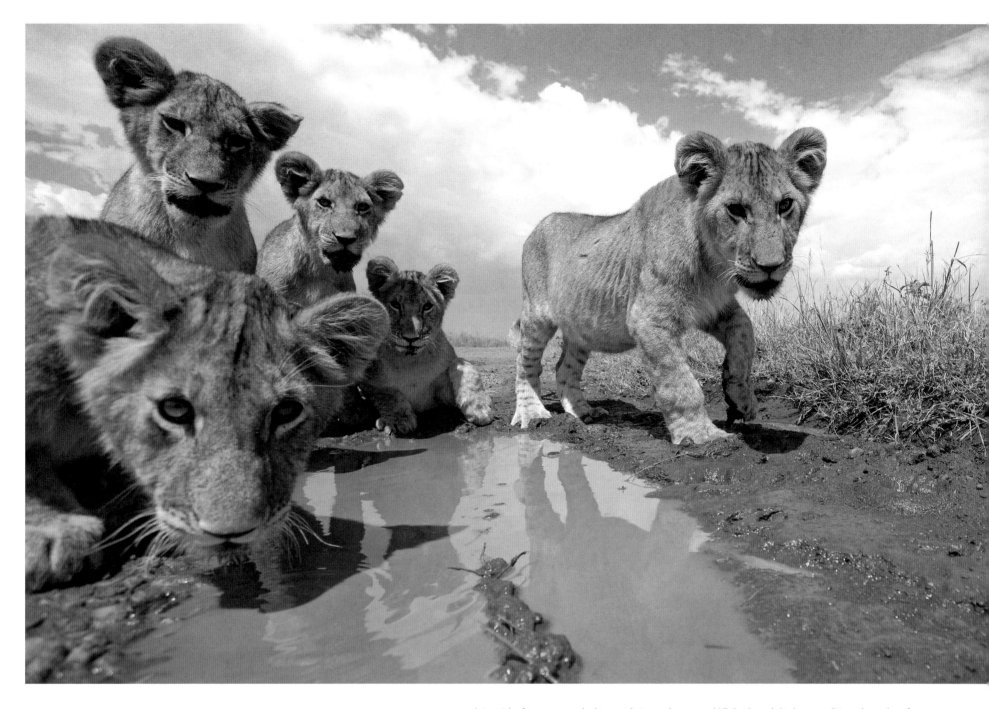

It is mid-afternoon, and a lion pride is on the move. While the adults keep walking, the cubs of nearly the same age and size stop at a puddle to drink and to check out the camera clicking away at them. Water, mother's milk, some meat, shade, company, and security are all that these cubs need. And long stretches of sleep, of course. It is a low-maintenance childhood.

OPPOSITE: Compelled by curiosity, but held back by fear of the unknown, three lion cubs have discovered the hidden remote camera. They approach it slowly at first, as if stalking it. Then a bold cub sticks out a paw to tap it. Once satisfied that it is harmless, the cubs circle it and sniff it. They even try to bite it. At that moment, the pride adults start moving on, and the cubs hurry off to join them.

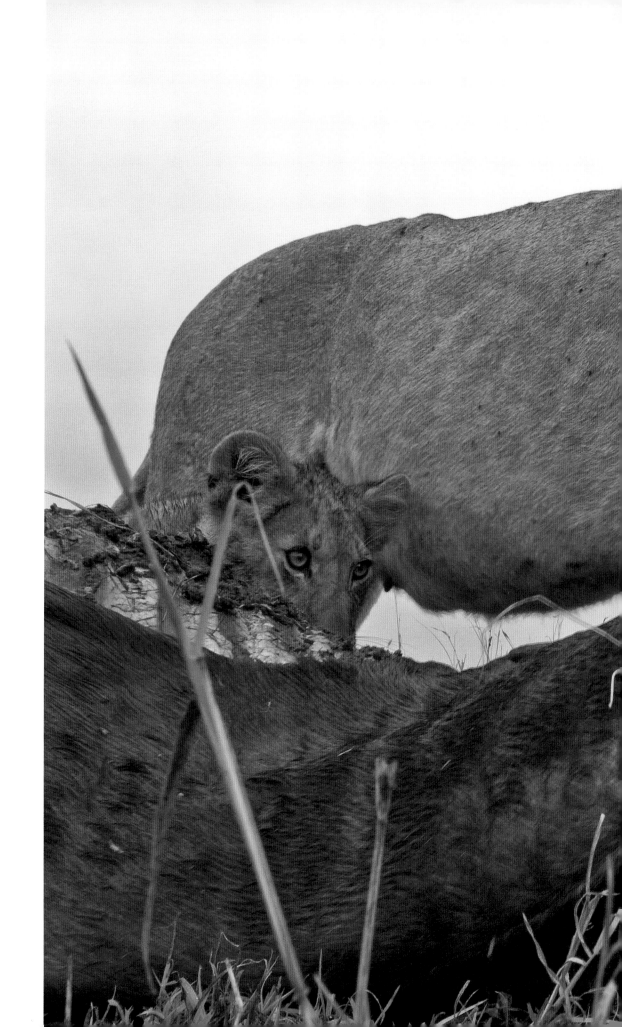

There was a shower last night. The clouds have lingered, and this morning is dull. A pride mother with two small cubs, having brought down a wildebeest on an open plain, is trying to drag it to cover to hide it from vultures. When vultures circle above a kill and swoop down to it, they attract the attention of the ever-alert hyenas and other scavengers that will quickly come to investigate and may steal the carcass away from the lioness.

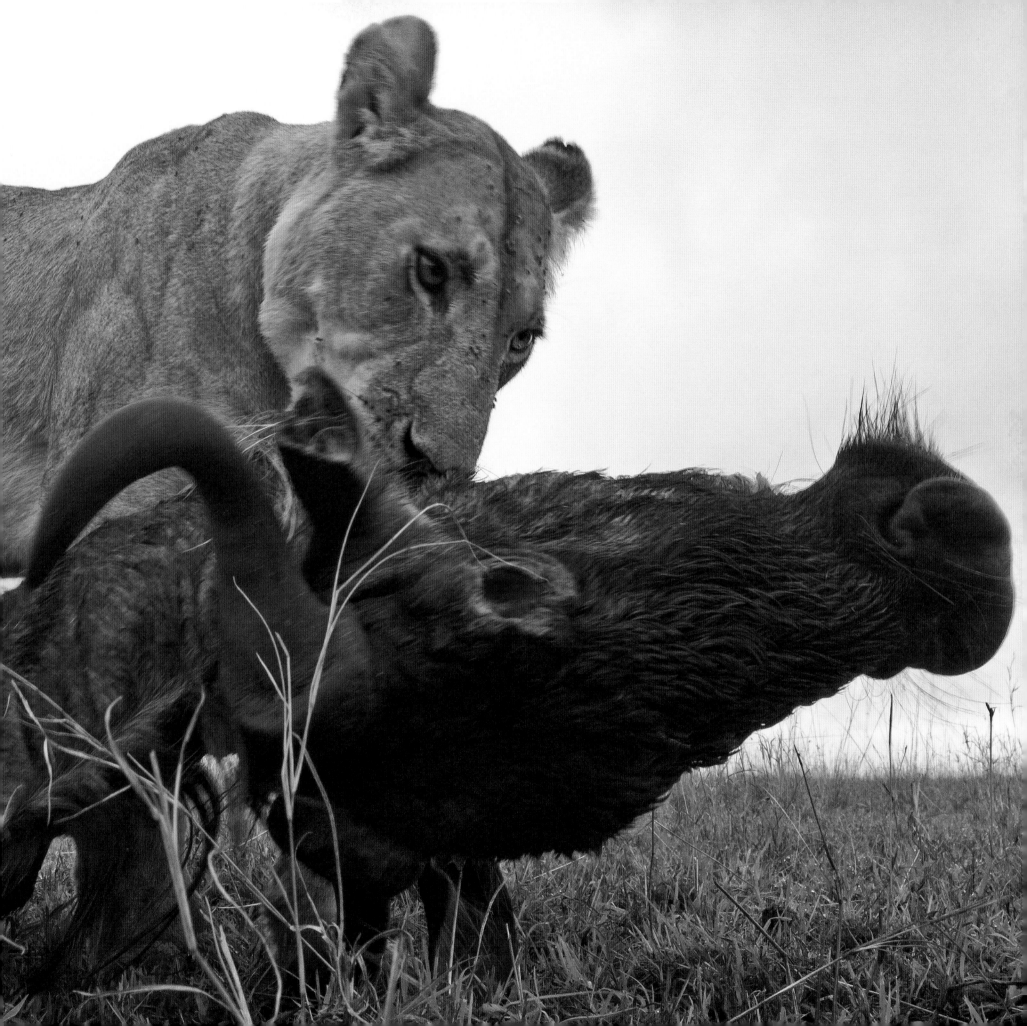

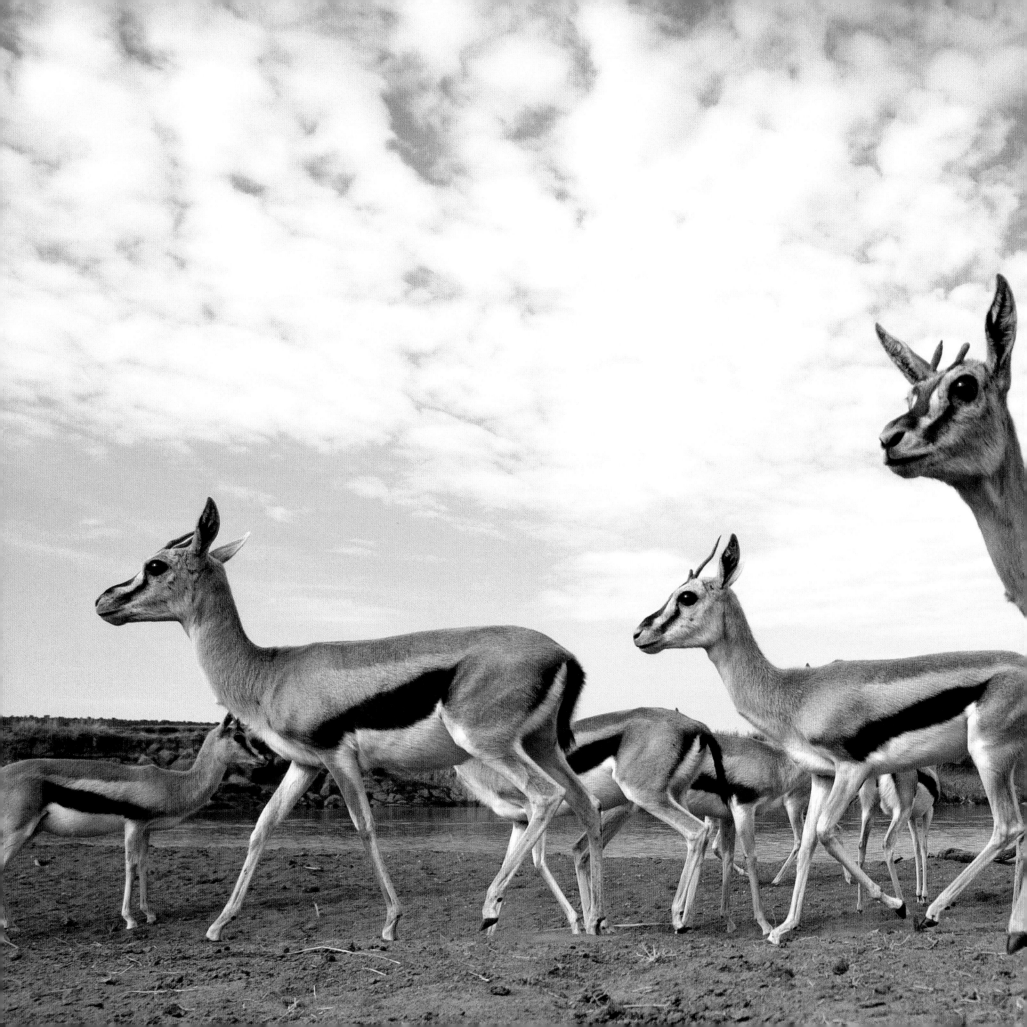

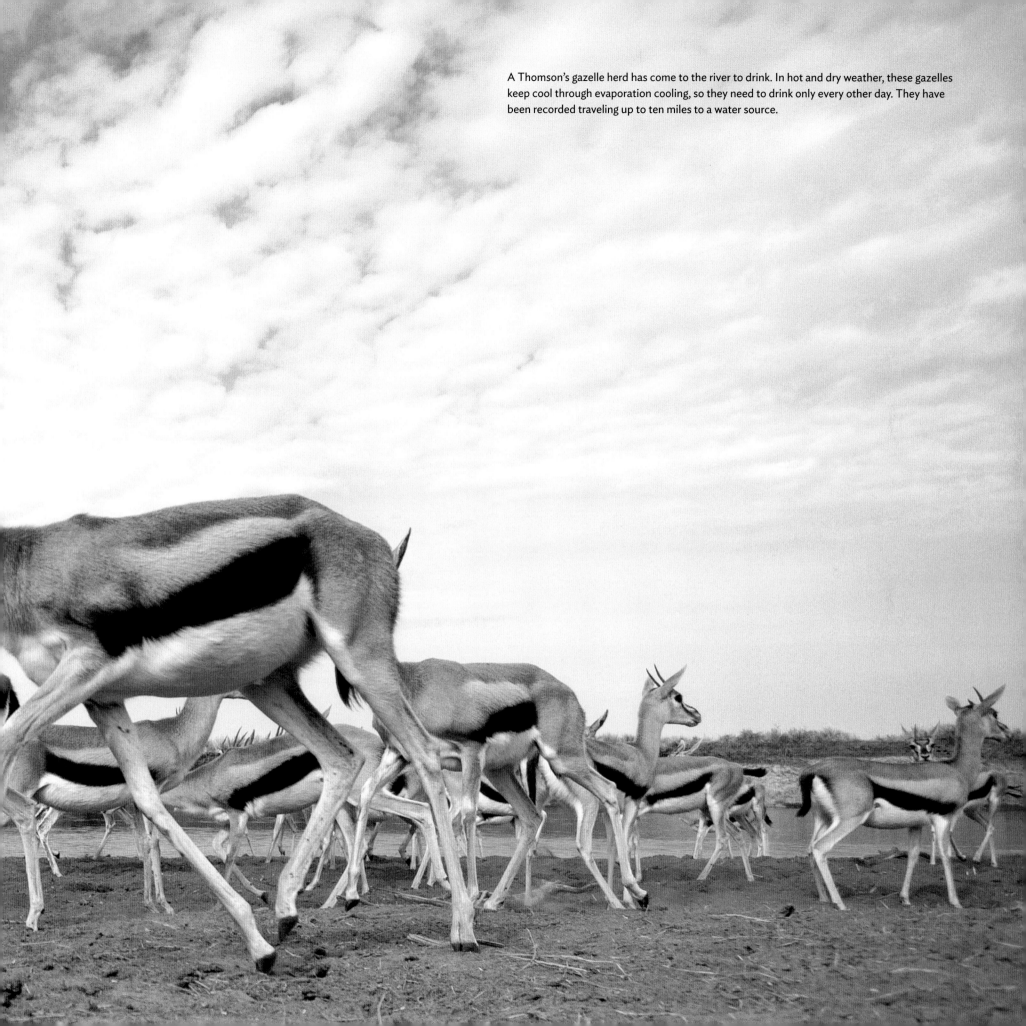

A Thomson's gazelle herd has come to the river to drink. In hot and dry weather, these gazelles keep cool through evaporation cooling, so they need to drink only every other day. They have been recorded traveling up to ten miles to a water source.

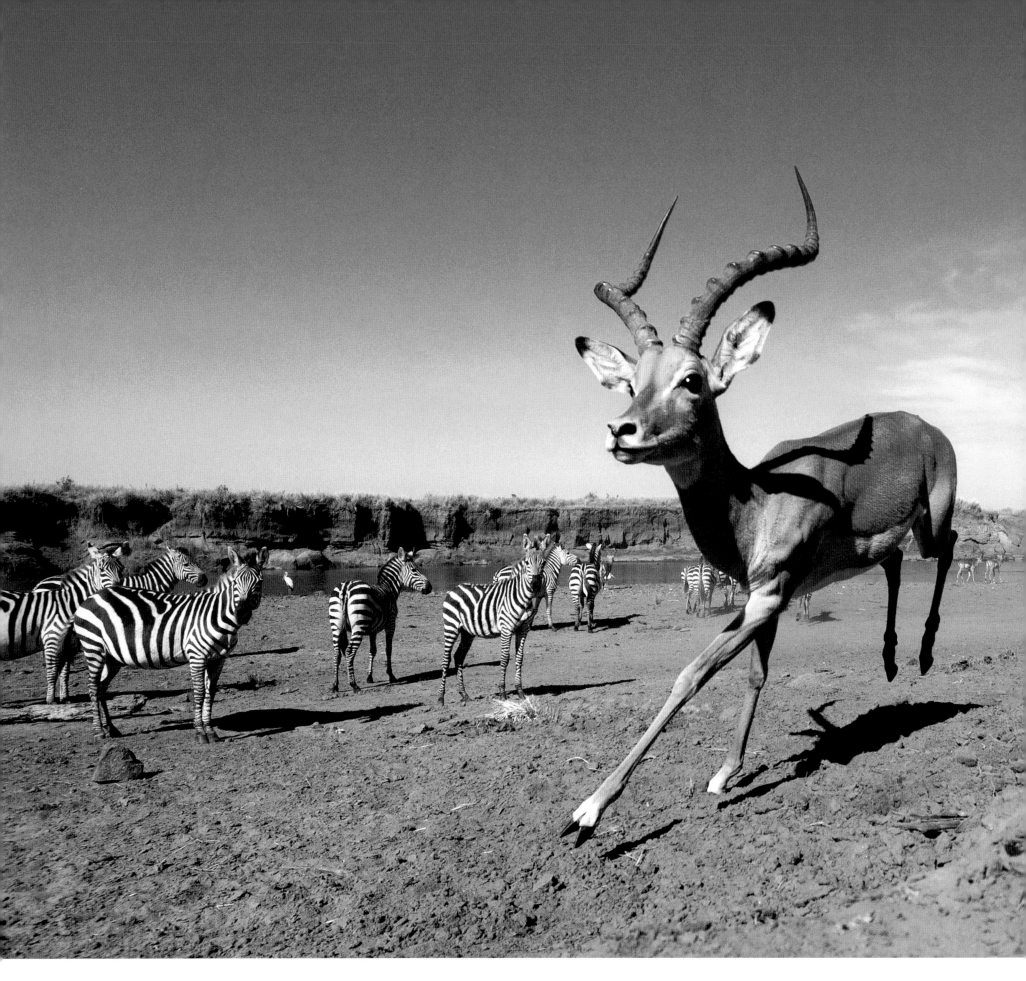

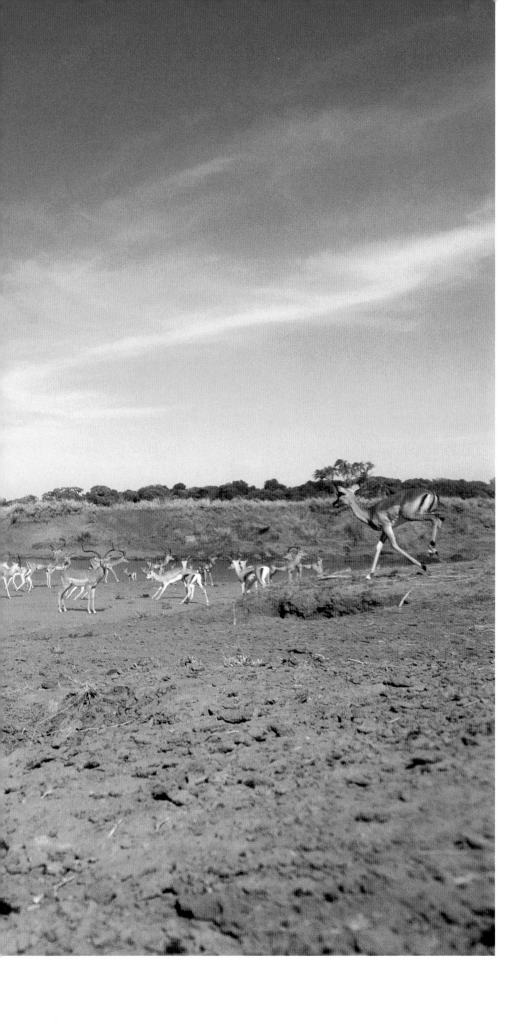

Having spotted sleeping lions, a male impala runs to within thirty yards of the prone cats to take a closer look. He stands fast, rigid with alarm, muscles tensed beneath his sleek, brown coat. He gives out an involuntary nasal snort, whereupon a lion stirs, and the impala takes off, stopping to look back only after he has put considerable distance between the lions and himself.

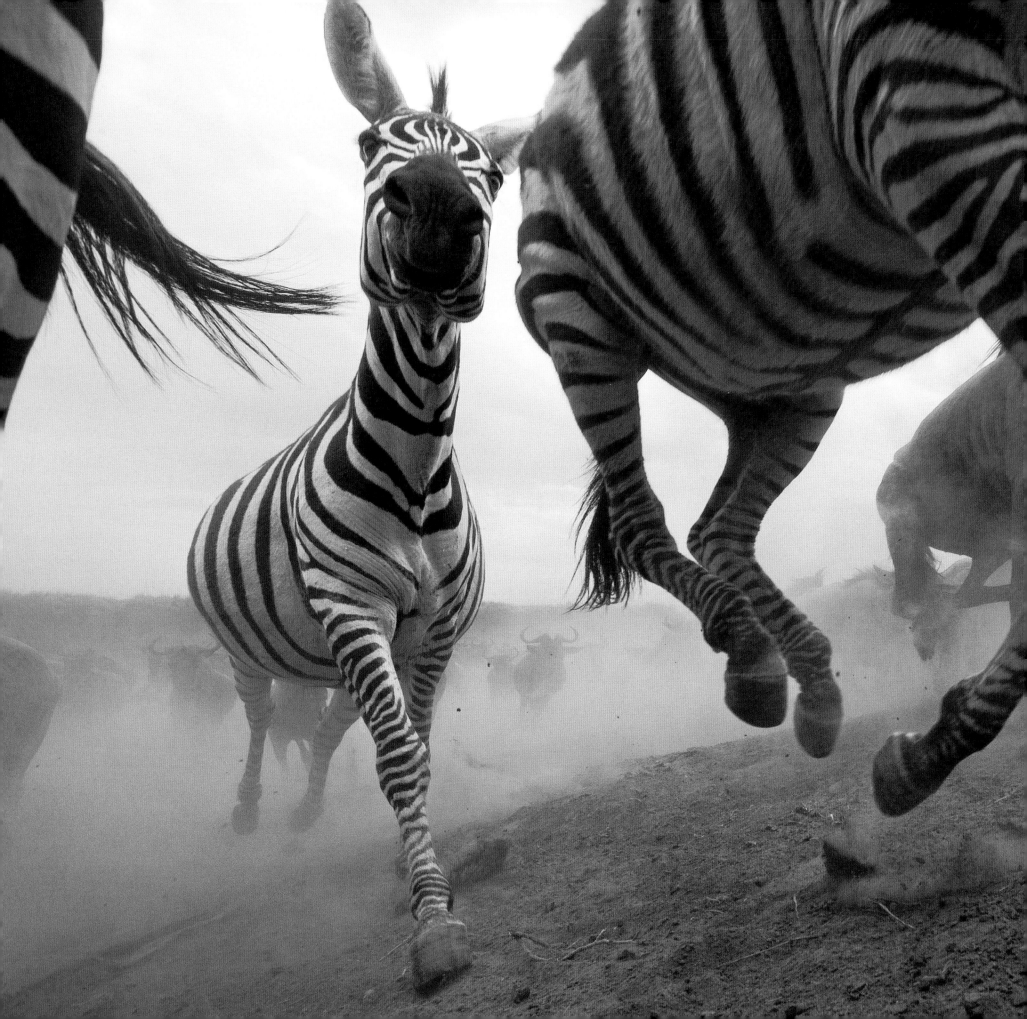

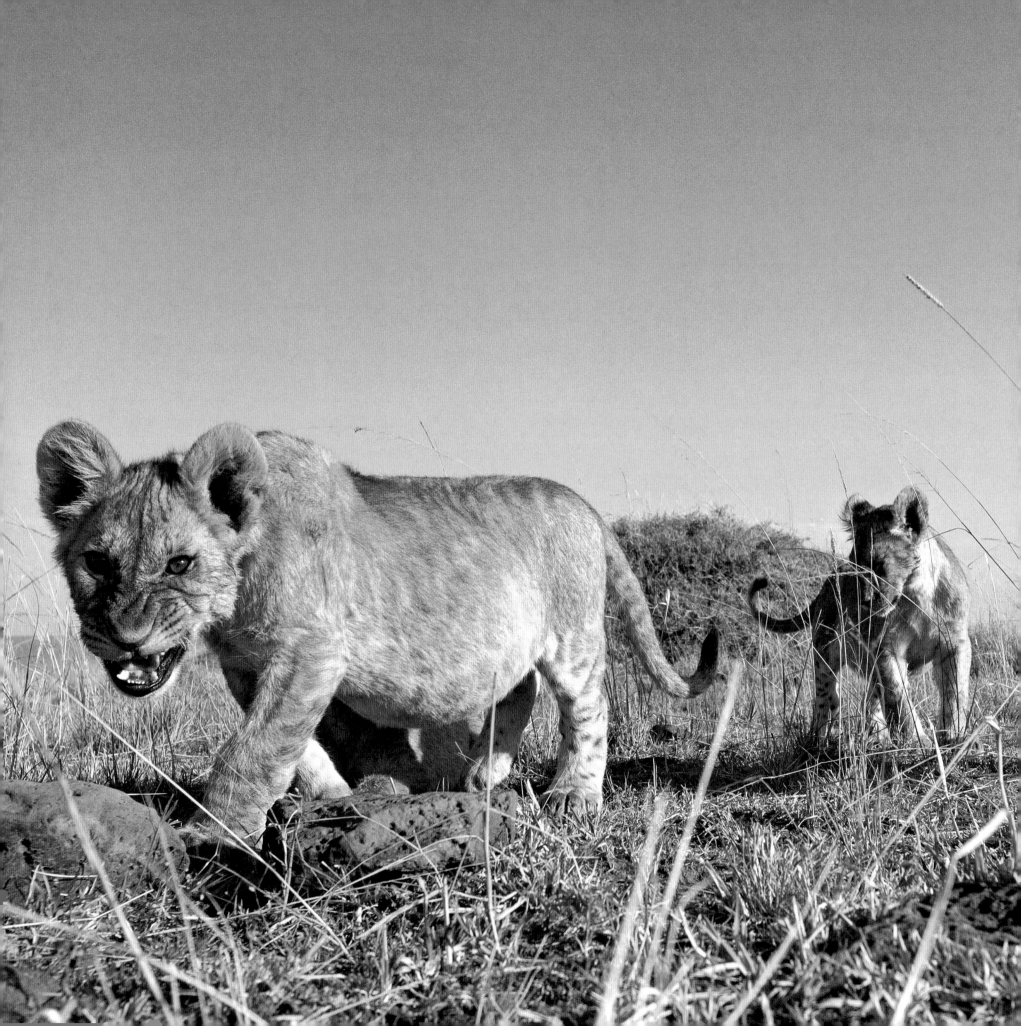

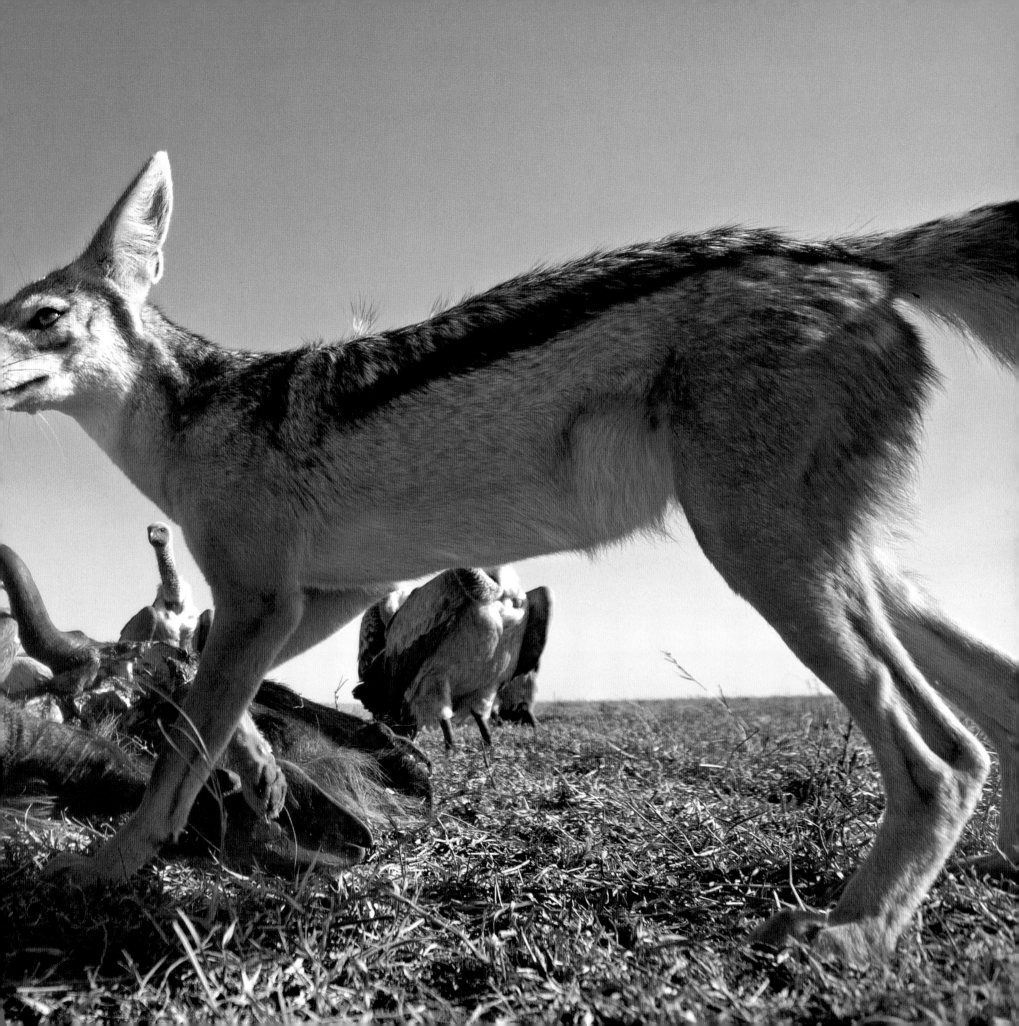

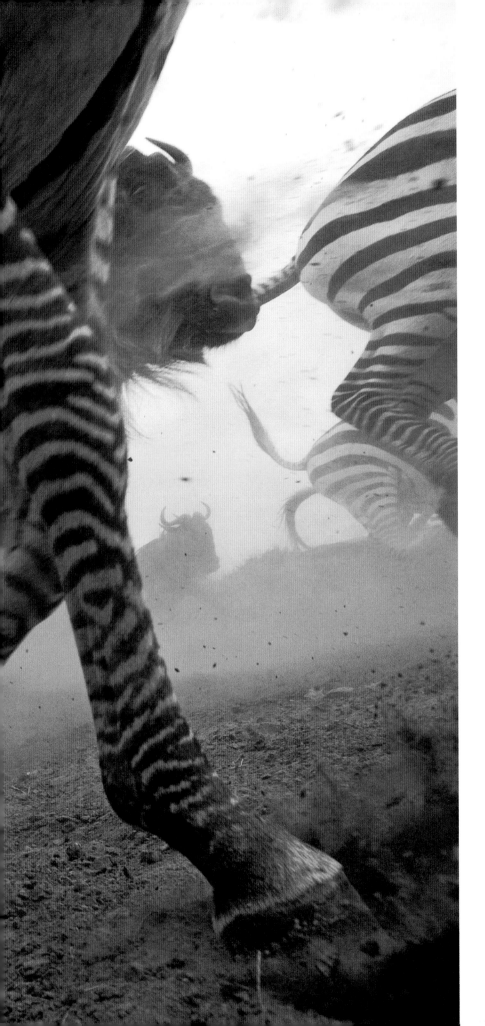

In response to an alarm call, zebras take off with hooves flying, nostrils flared. The zebra is a stubborn beast that has thwarted attempts at domestication. Some have managed to ride a zebra, but apart from such isolated cases, they have never been tamed.

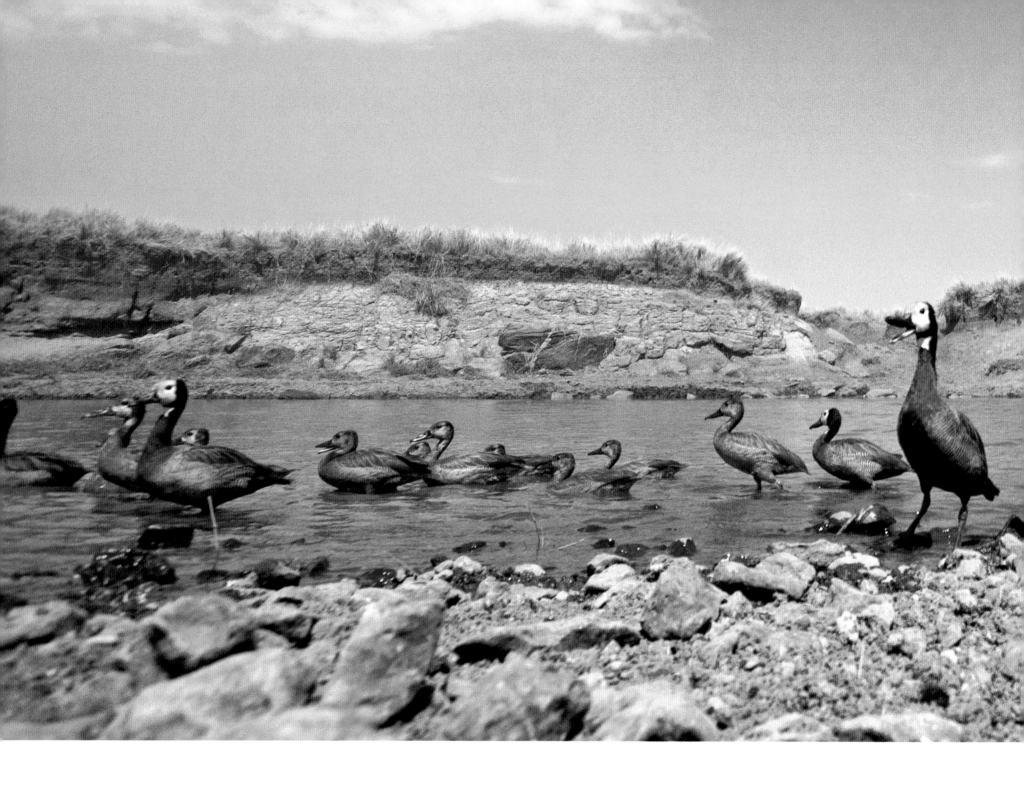

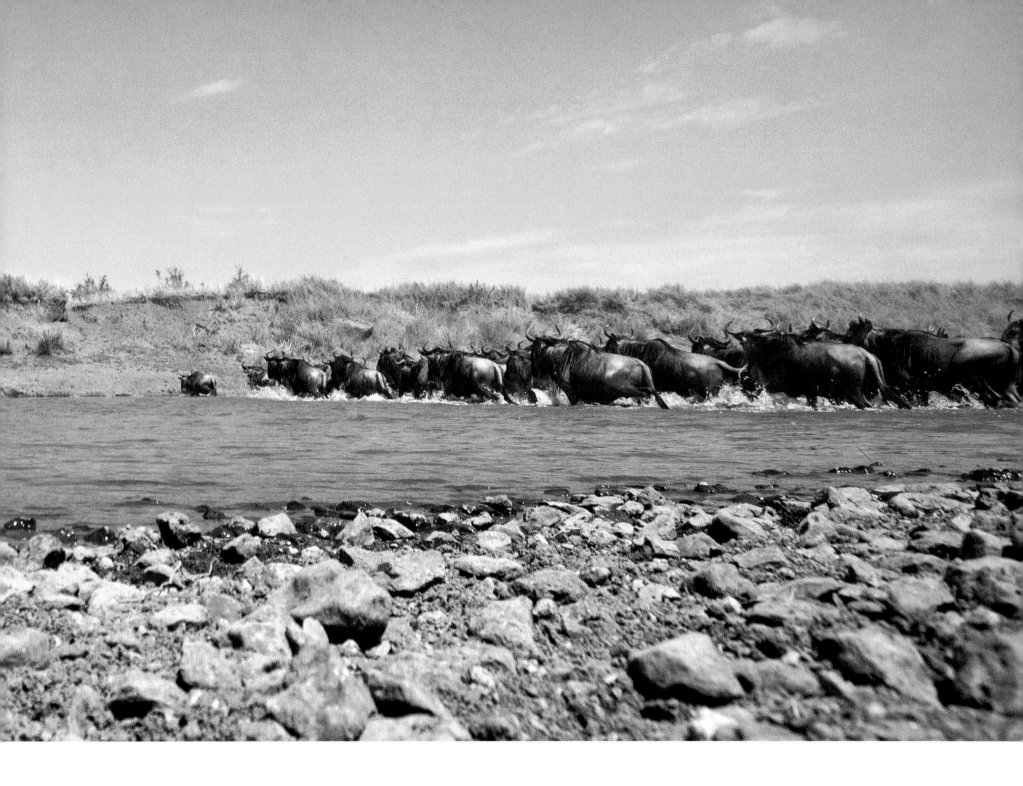

White-faced whistling ducks are most active in the early morning. Come mid-morning, these gregarious ducks stand near a water source, occasionally either preening themselves or each other. The name whistling duck arises from the bird's clear three-syllable whistle, often uttered when flying. The white-faced whistling ducks on the bank of the Mara River give way to a herd of wildebeests determined to cross at the very point where they were standing. Unfazed by the crossing, the ducks continue to rest only yards away.

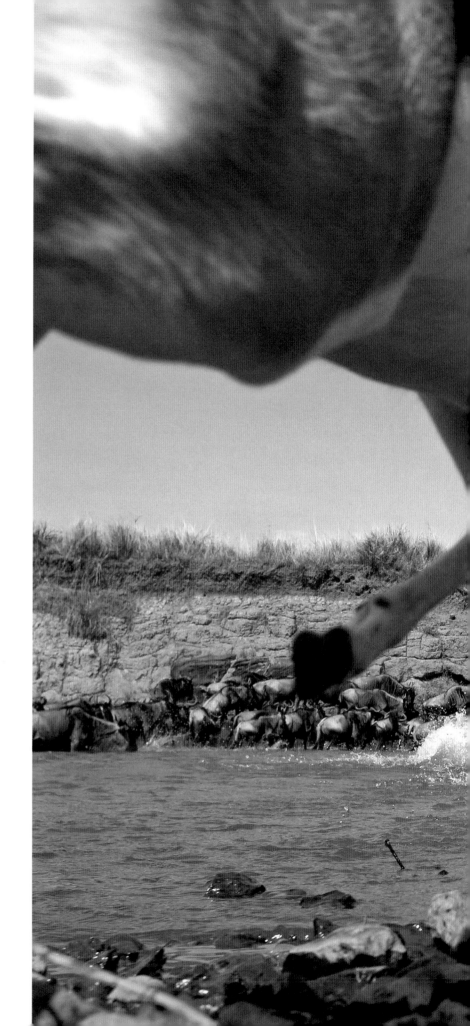

A herd of Thomson's gazelles has followed the big herds to the river. Some migratory urge compels them to stay with the crossing animals, but a deep-seated fear of the river holds them back. In their indecisive frame of mind, they mill around waiting for one of their own to take the first leap into the water.

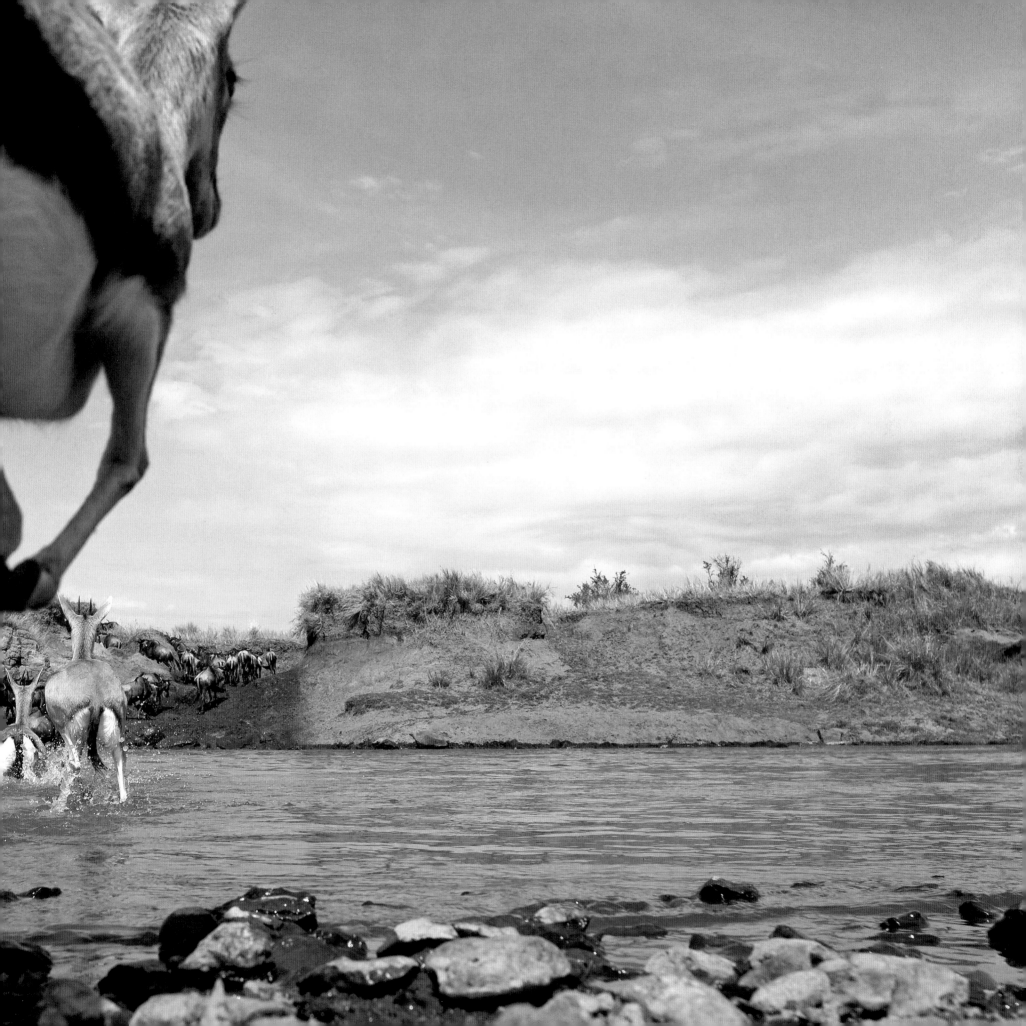

A male giraffe ambles across the Mara River. The giraffe has only two gaits, an ambling walk and a gallop. When walking, the entire weight is supported first on the left legs, then on the right legs, the same way camels walk. The neck moves in synchrony with the legs and helps the giraffe maintain balance.

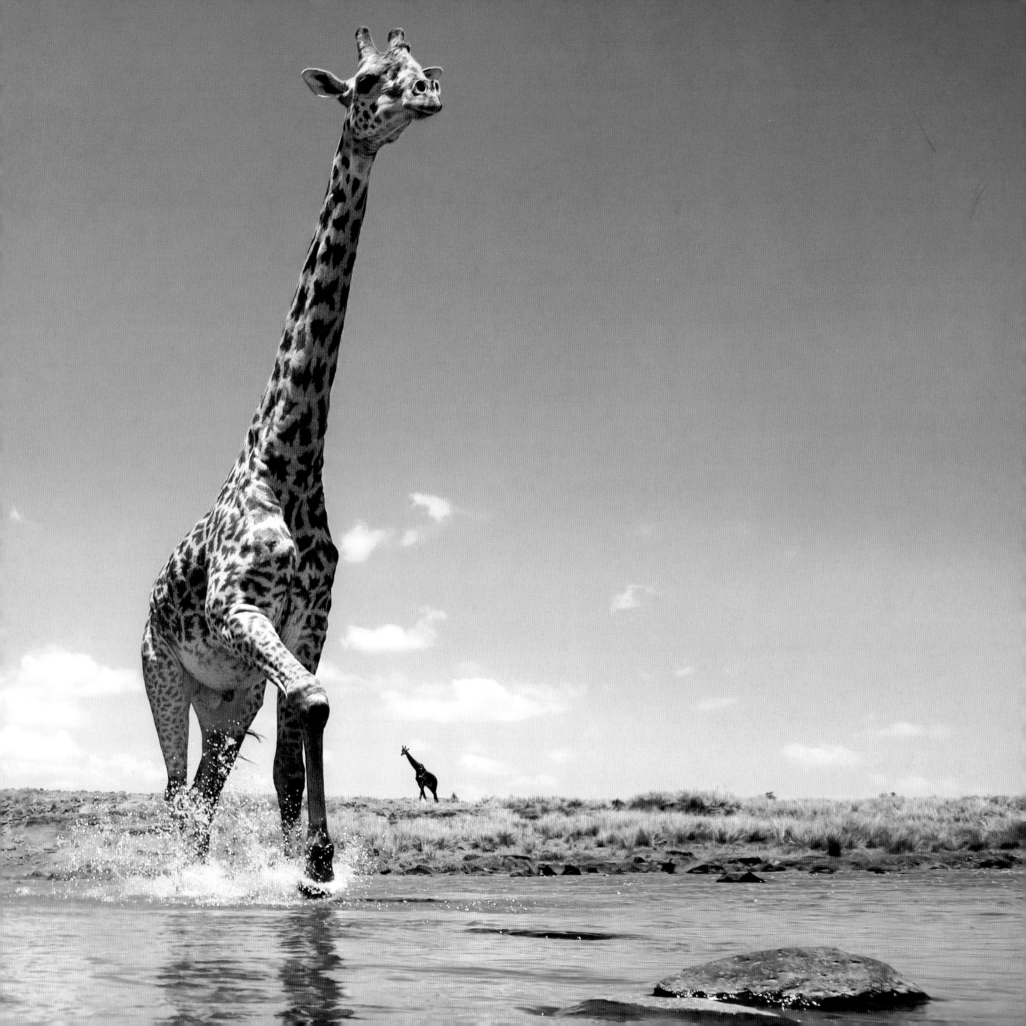

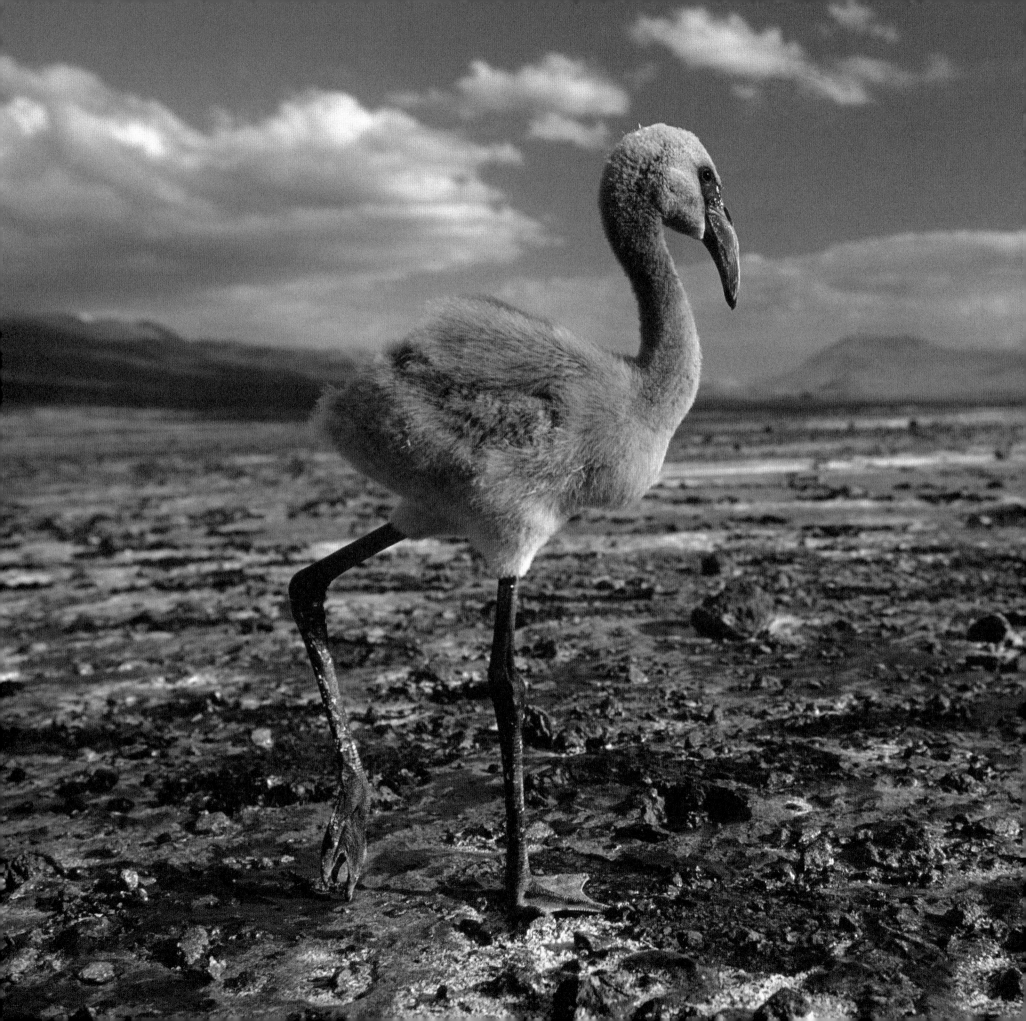

At Lake Natron, on the border between Kenya and Tanzania, a flamingo chick passes in front of the camera. The long rains triggered the growth of spirulina algae in the lake, which the breeding flamingos feast on as they nurse their young. Interestingly, 75 percent of the world's population of lesser flamingos come to this lake to breed.

OVERLEAF: Like humans, each baboon has a unique personality and facial features that set it apart from all others.

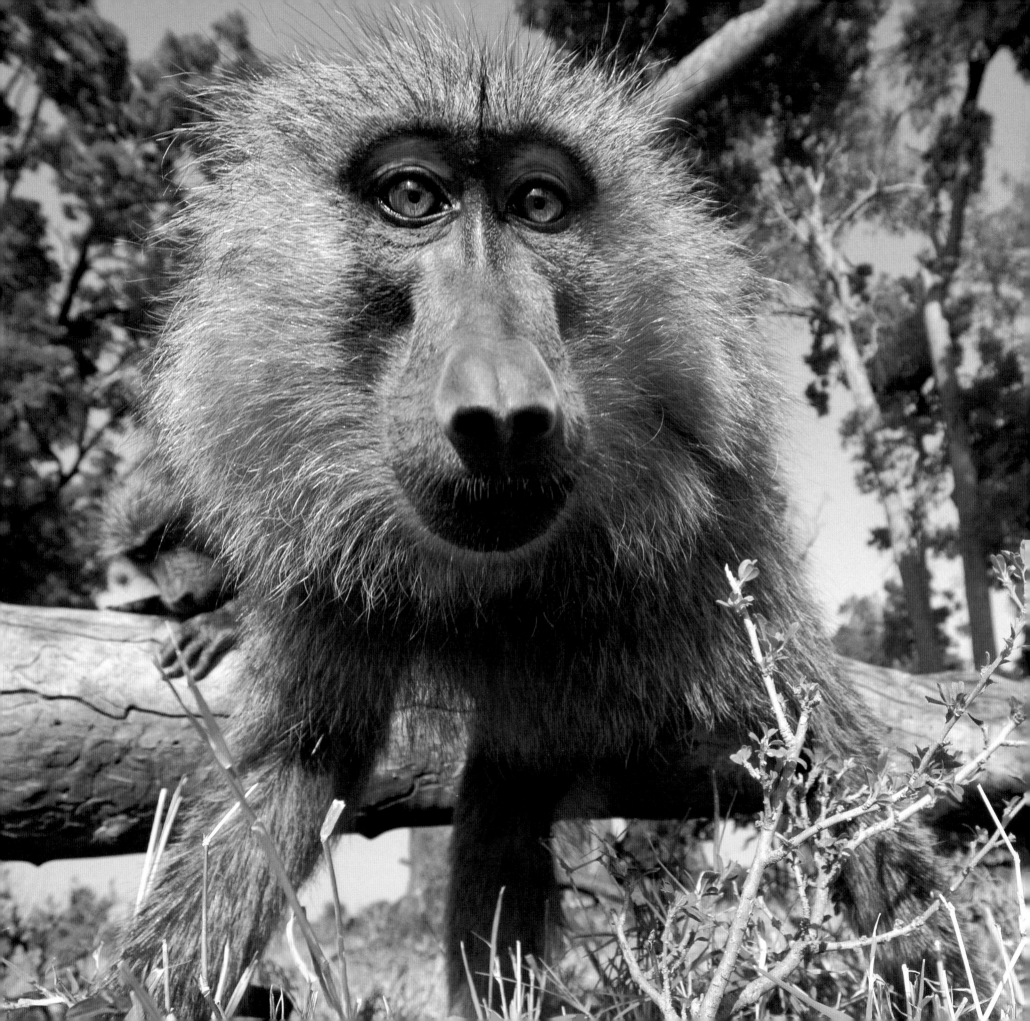

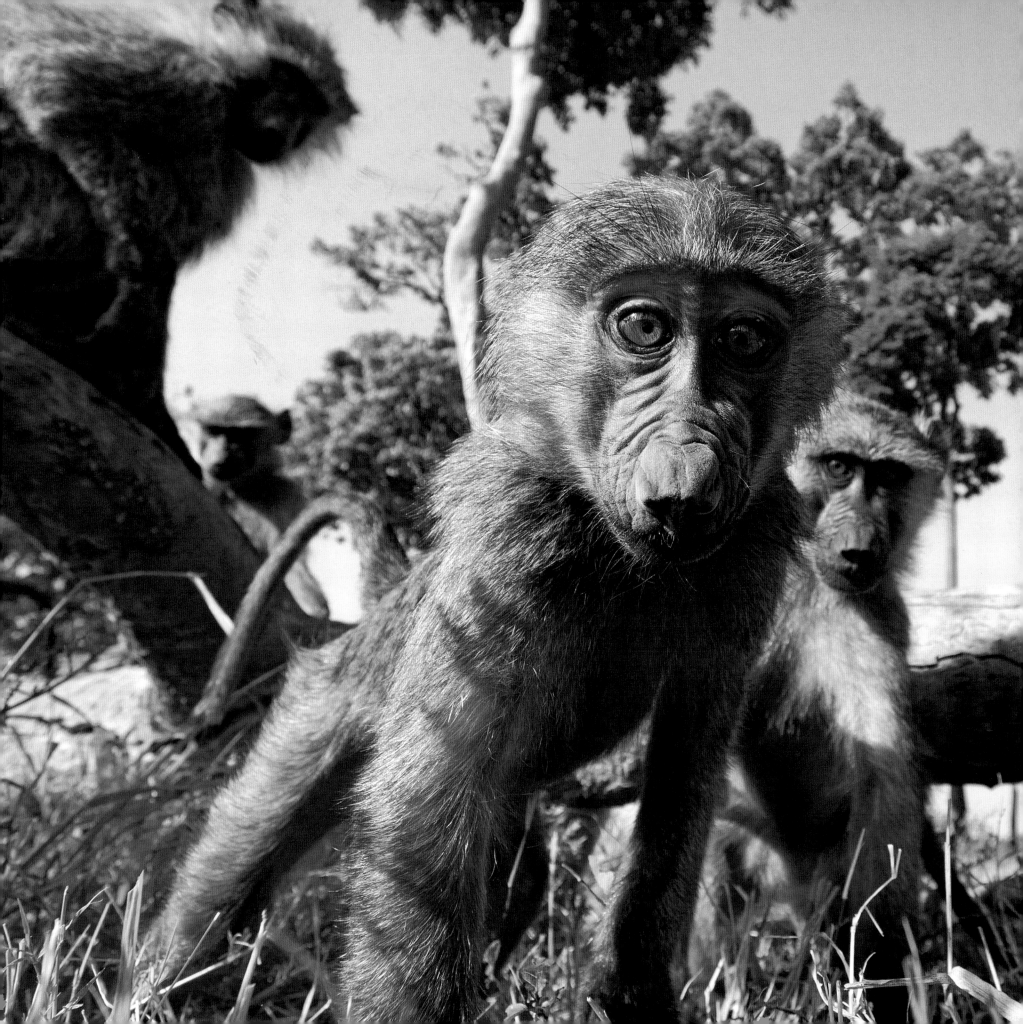

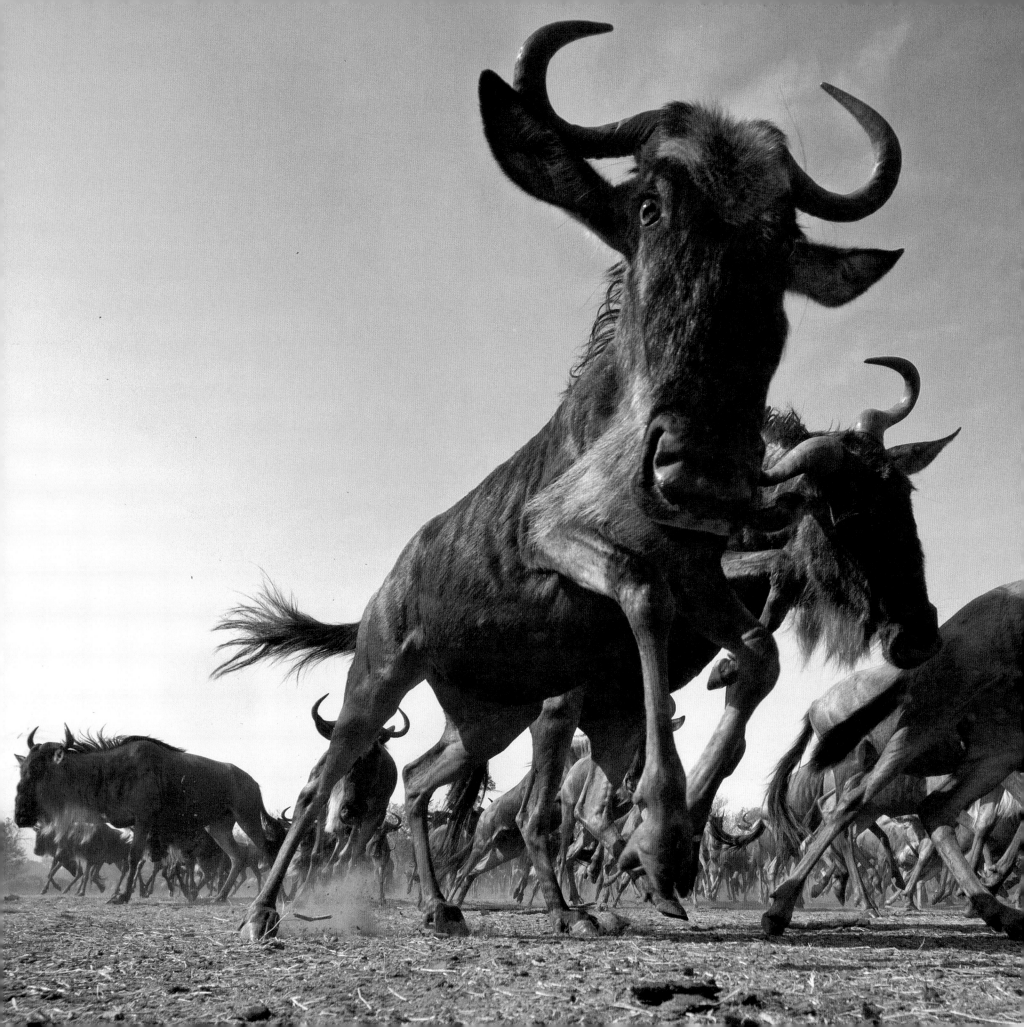

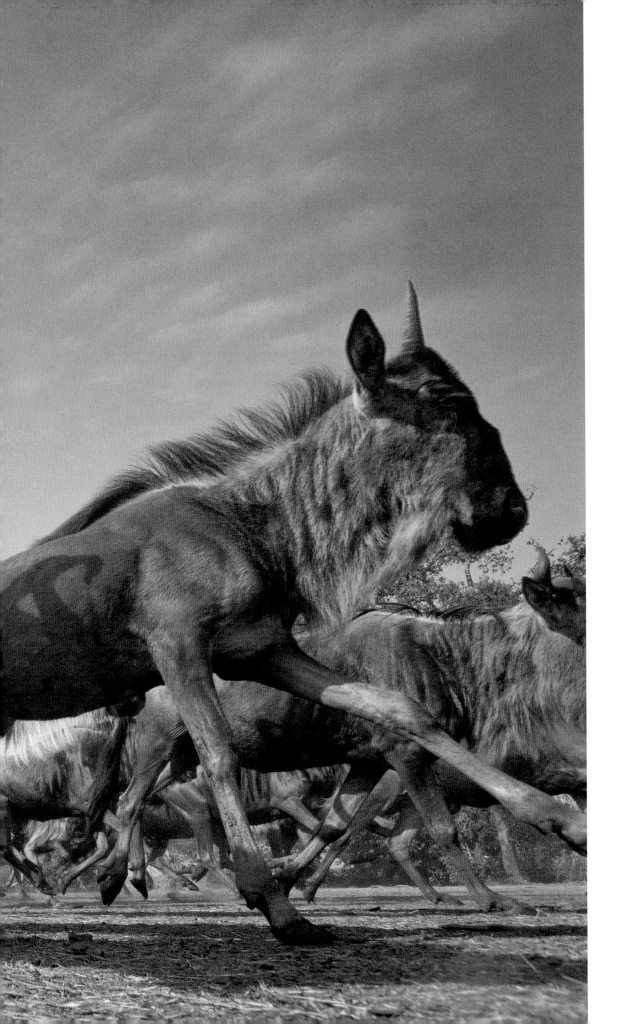

The wildebeest herds are heading toward the Mara River, one animal obediently following the other. Under normal circumstances, a given wildebeest's behavior and habits are usually quite similar to and reflective of the other wildebeests around it. The herd often acts like one cohesive unit, rather than a collection of individuals.

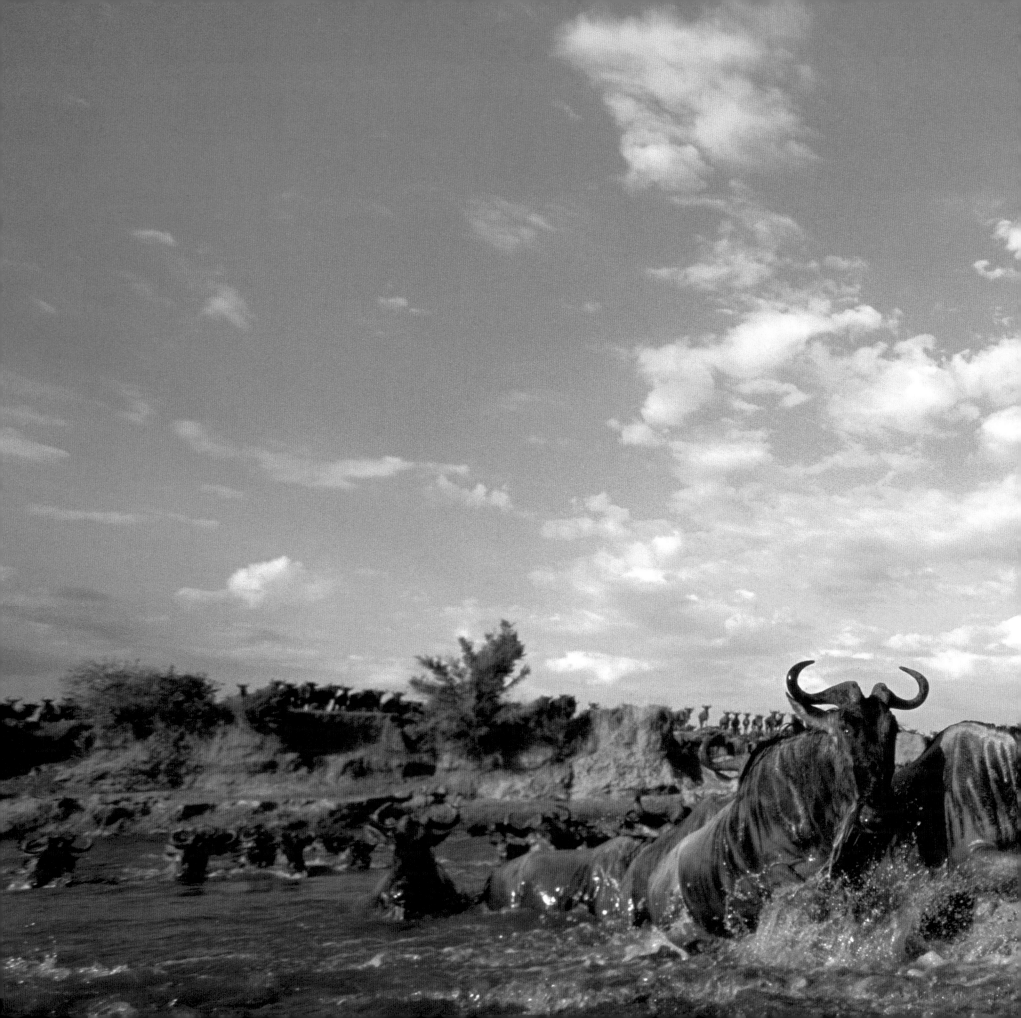

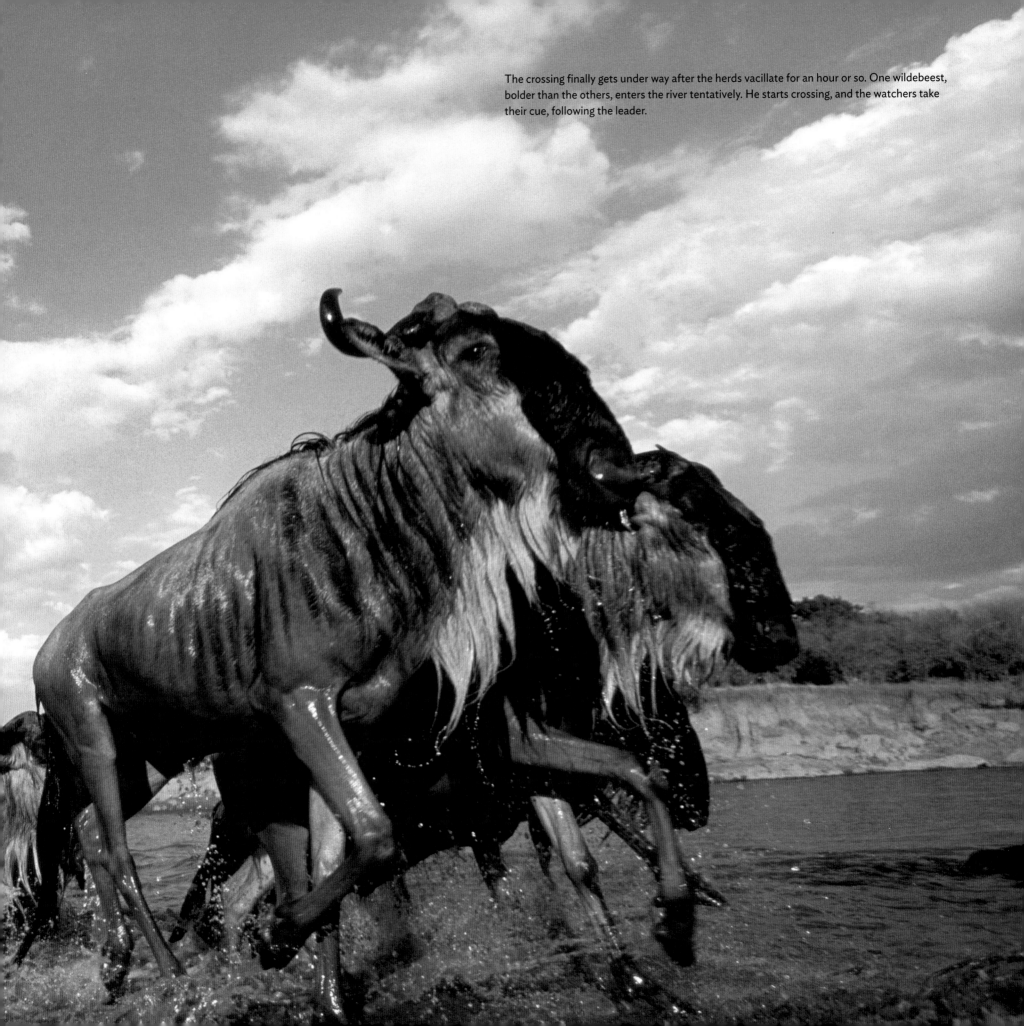

The crossing finally gets under way after the herds vacillate for an hour or so. One wildebeest, bolder than the others, enters the river tentatively. He starts crossing, and the watchers take their cue, following the leader.

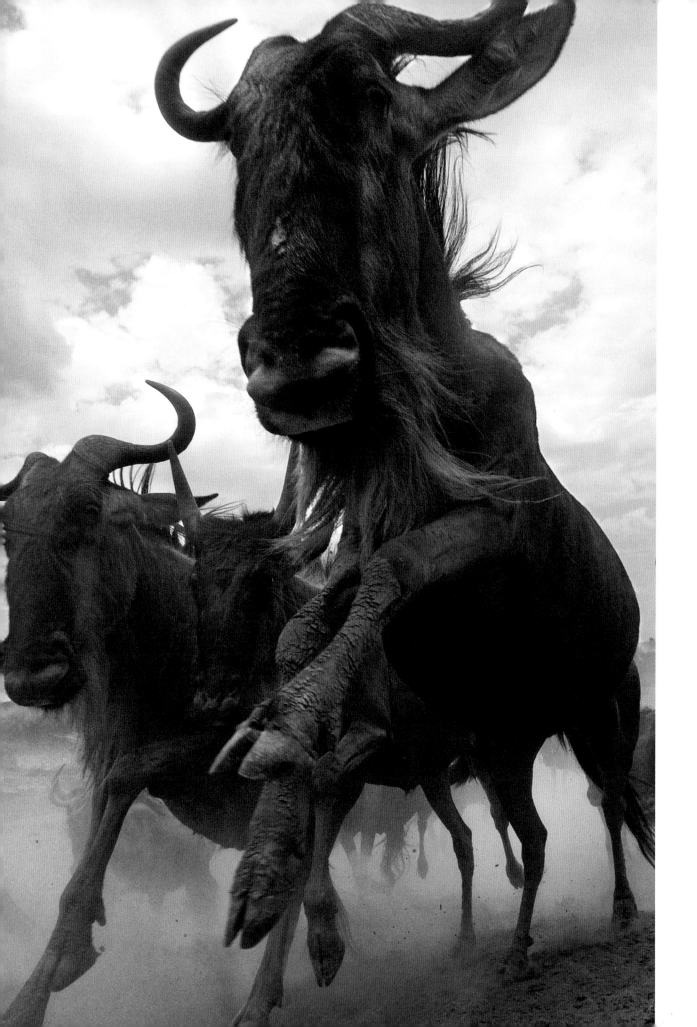

After the crossing, the wildebeests break into
a run, away from danger and toward new grazing
opportunities.

OPPOSITE: A male lion from the Paradise Plain pride,
one of a coalition of four, saunters toward shade.
Pride male lions of the Mara are somewhat enigmatic.
They rarely hunt, but readily take control of kills
made by the pride females. They do not hesitate to
kill cubs they have not sired, but they let their own
cubs feed while denying access to the lionesses.

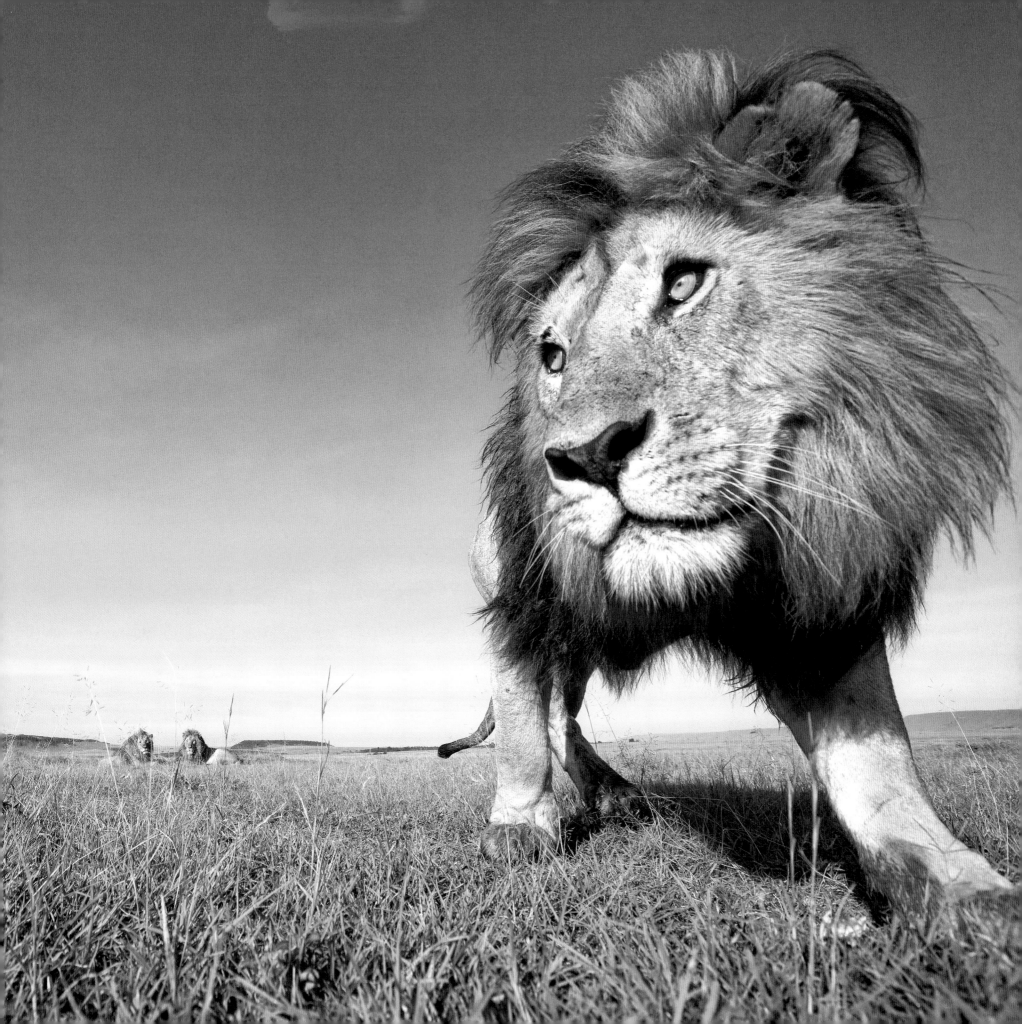

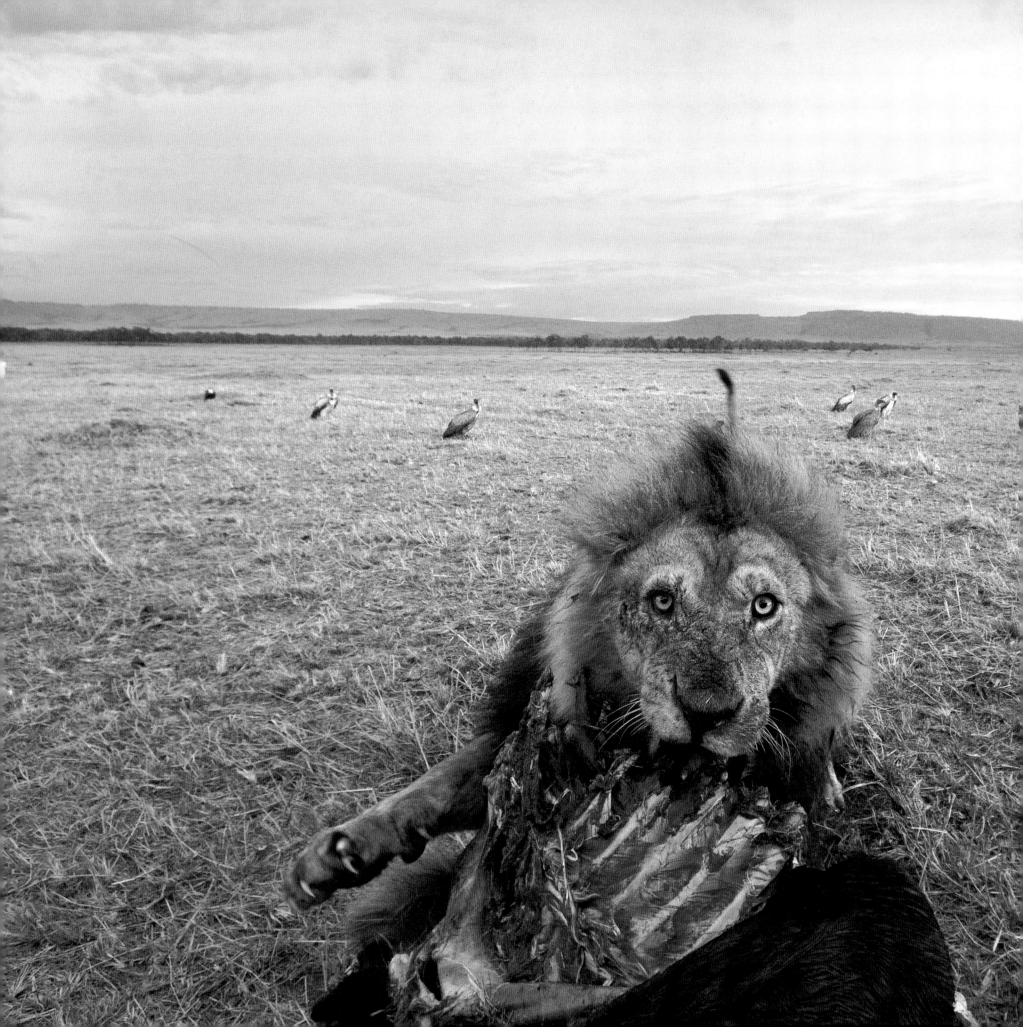

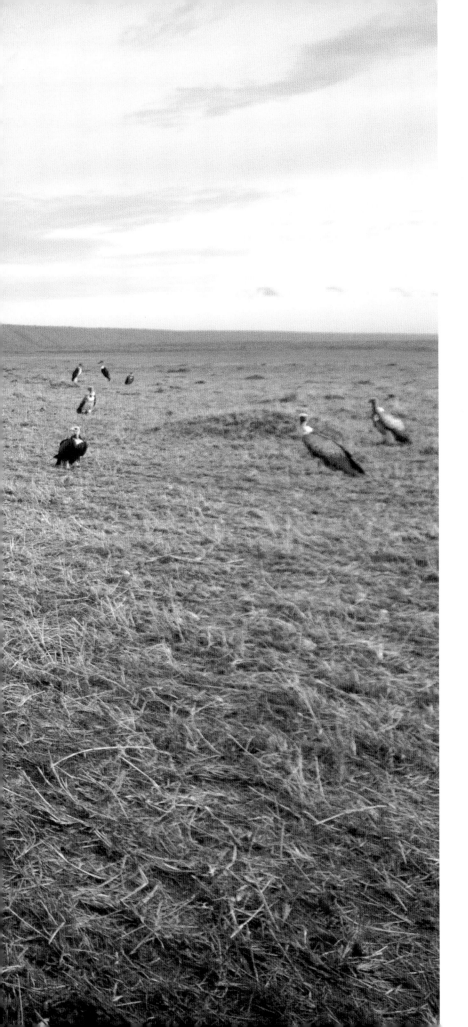

When the migratory herds are in the area, pride lionesses are occasionally able to kill more than the pride can eat. This male lion of the Marsh pride, with a pronounced limp, has moved in on a half-eaten wildebeest carcass abandoned by the pride. He appears to be very hungry and intolerant of any vulture that approaches. One advantage of being a male lion, injured or not, is that hyenas give him a wide berth.

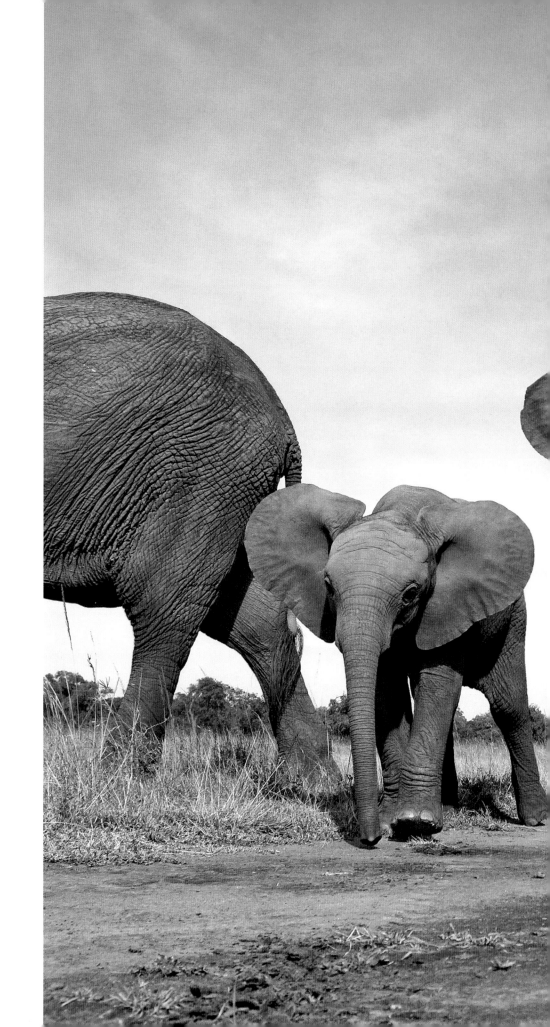

It is mid-September, and the intensity of the long dry season is at its peak. A line of elephants moves toward a water source, the location of which is stored in the matriarch's prodigious memory. The group moves slowly, quietly, and resolutely, each plate-sized foot raising hardly any dust as it treads the ground. It is only when the elephants detect the water, often before it is visible, that they quicken their pace. These elephants have picked up the sound of the clicking camera with their enormous ears, but they pass by undeterred.

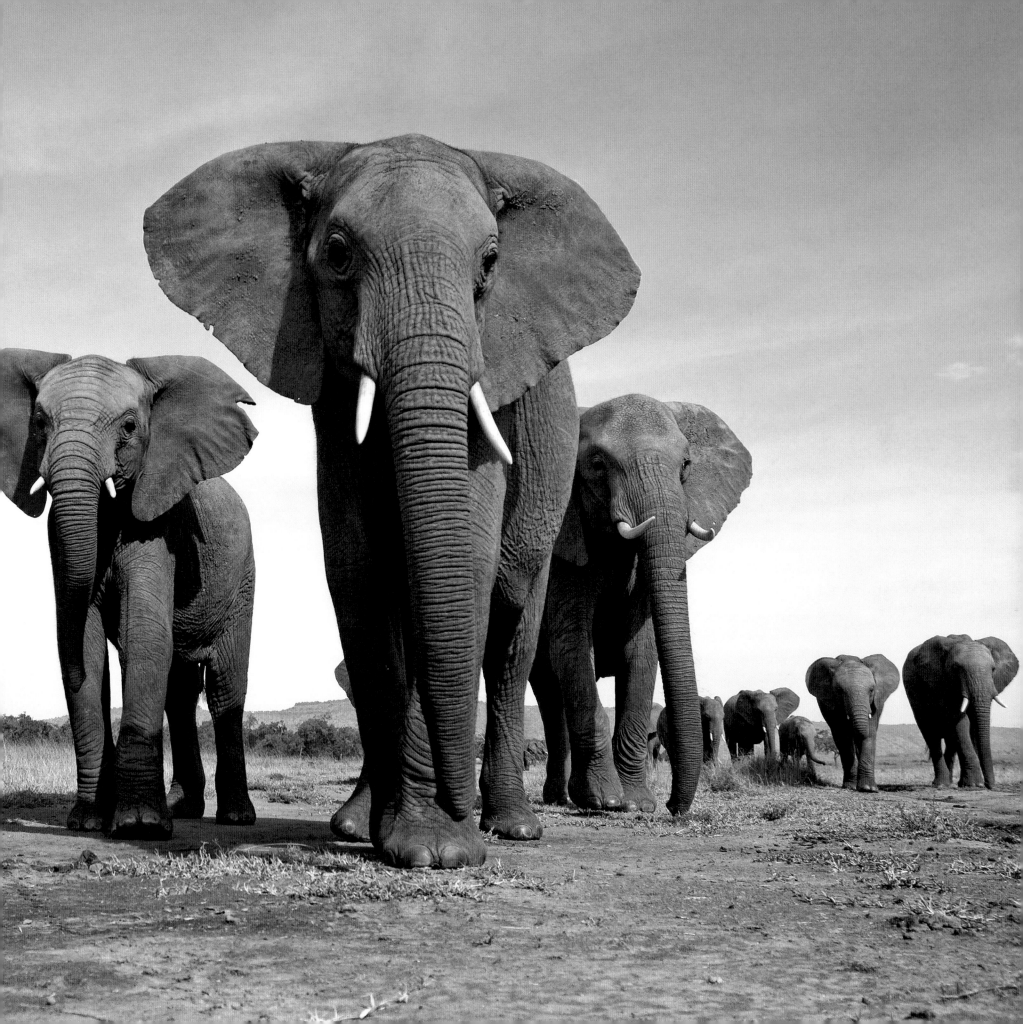

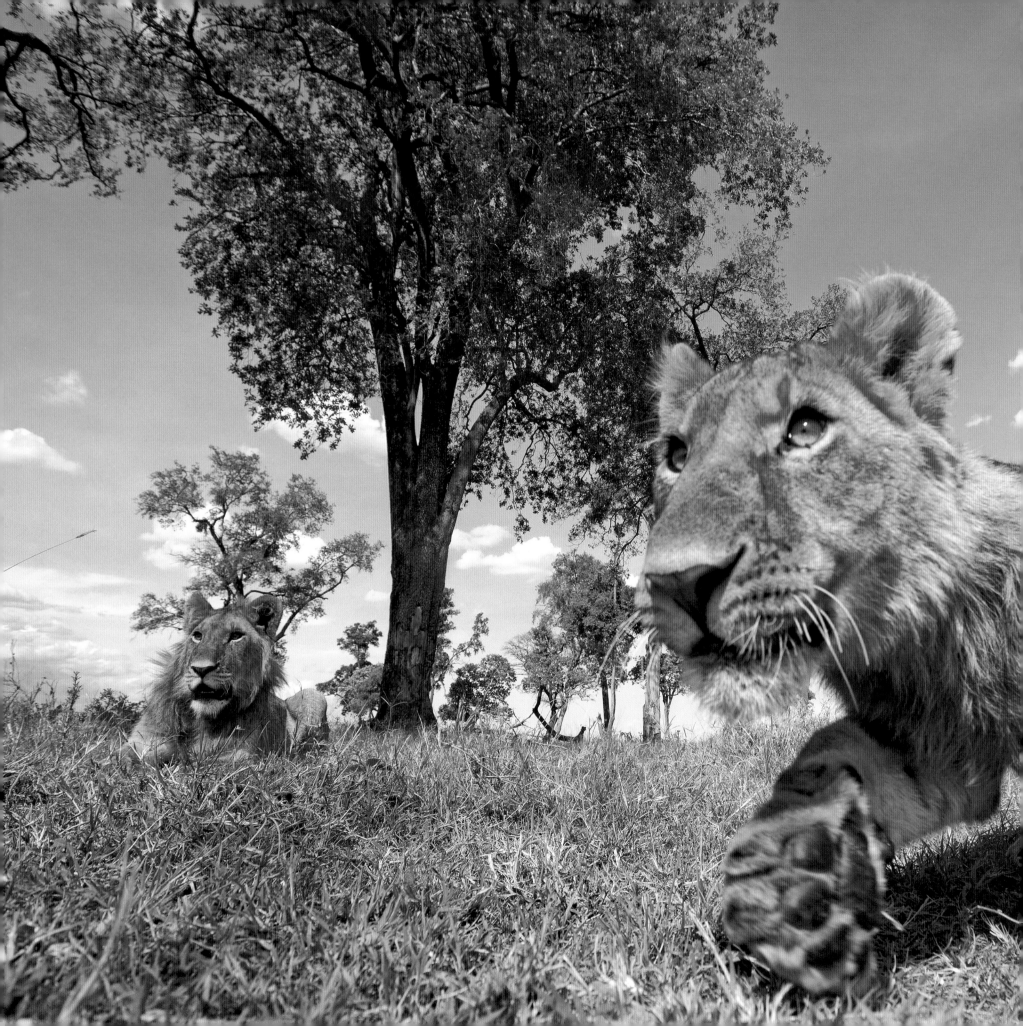

Young lions have boundless curiosity and energy. As a result, they're enticed into many fruitless endeavors, such as trying to catch a bird perched on a tree branch they could never reach, chasing vultures from a carcass . . . or charging the warthog their mother has been patiently stalking, thus alerting it to the danger.

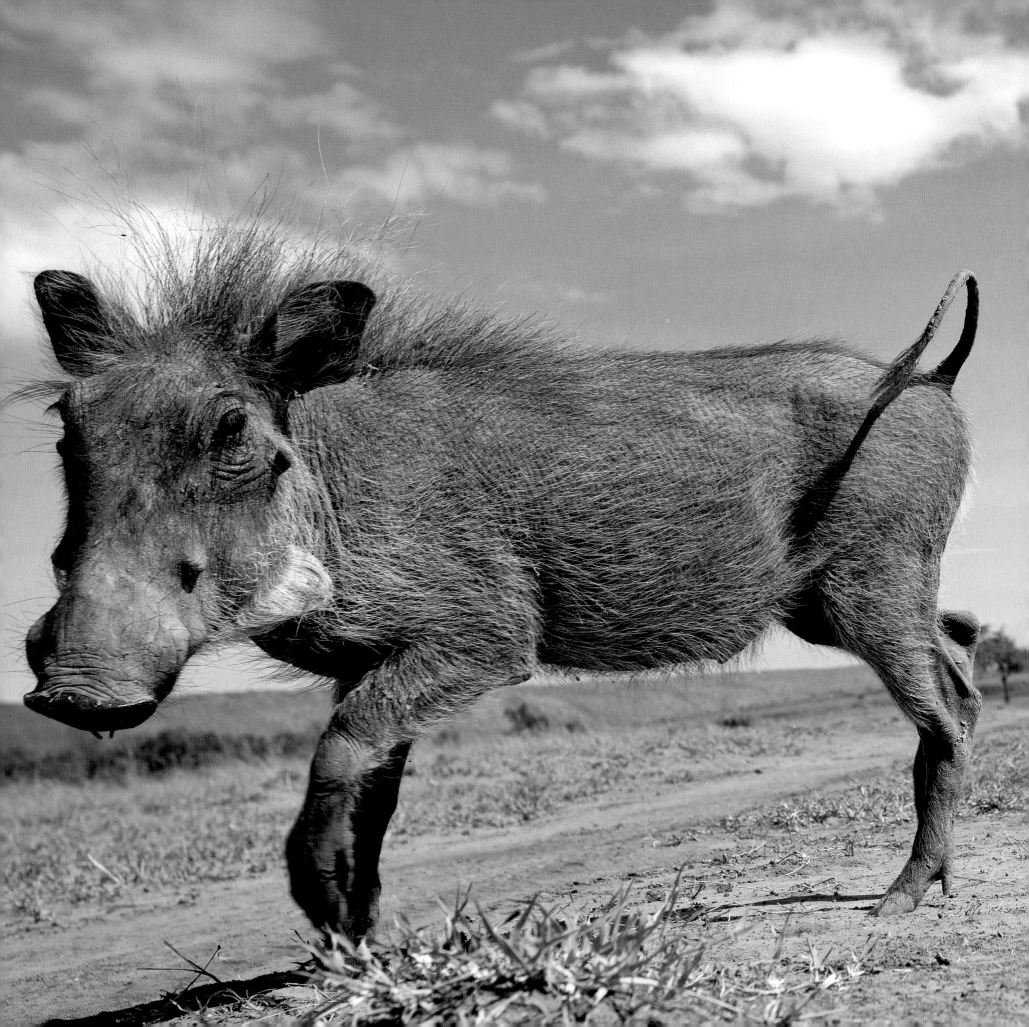

During the first week of October, there is a sense of expectancy for the coming of the short rains, but they are never predictable. In the meantime, now that the herds are leaving the Mara, it is the resident species, such as warthogs, buffalos, and topi, that are increasingly targeted by predators. Warthogs, despite the fact that their eyesight is relatively poor, are dangerous to hunt because they are aggressive and will retaliate and may injure the hunter in the process.

OVERLEAF: Baboon youngsters seem incapable of sitting still. However, their movements are partly governed by a dominance hierarchy. From a very early age, the daughter of a subordinate female must give precedence to the daughter of a dominant female, even if the latter is younger. For male baboons, the dominance hierarchy comes into effect when they reach puberty, the period when they encounter serious competition for rank. While they are still young, they establish who is stronger while they play. The act of a male mounting a male is both play and an assertion of dominance.

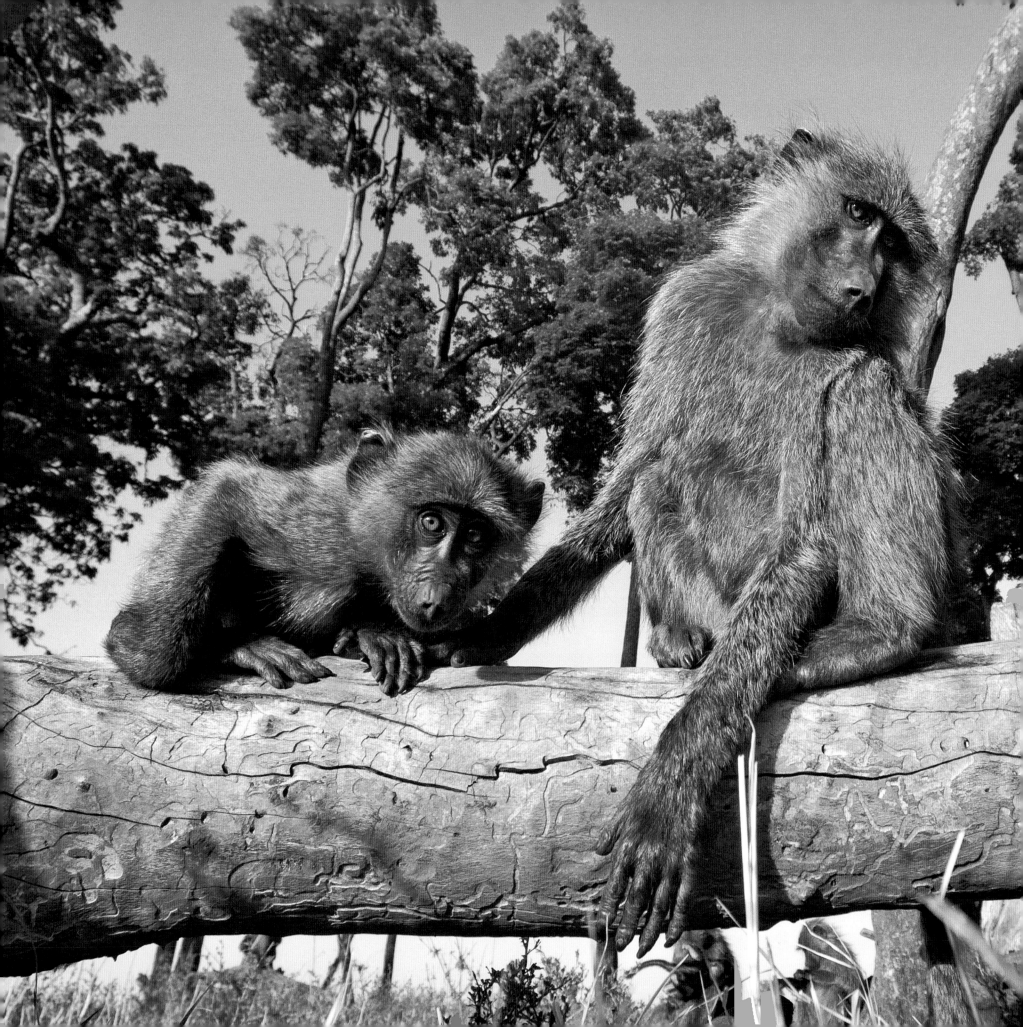

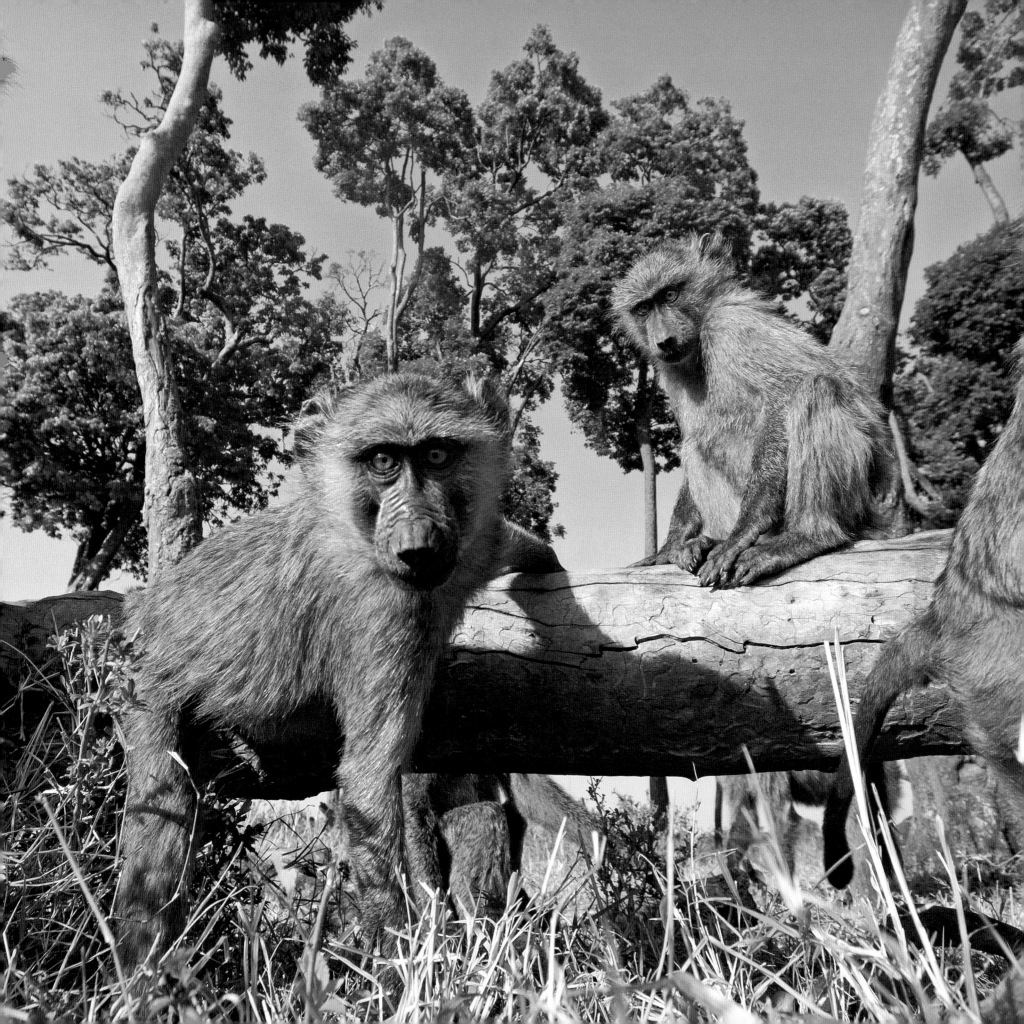

A zebra foal lies down to sleep in a small clearing, assured that the family members grazing nearby will keep a lookout for danger. Soon a lioness stealing through the grass gets close enough to charge — but at that very moment, the big cat is spotted by an adult zebra, who loudly snorts an alarm. The foal wastes no time scrambling to safety. The lioness yawns and goes to sleep.

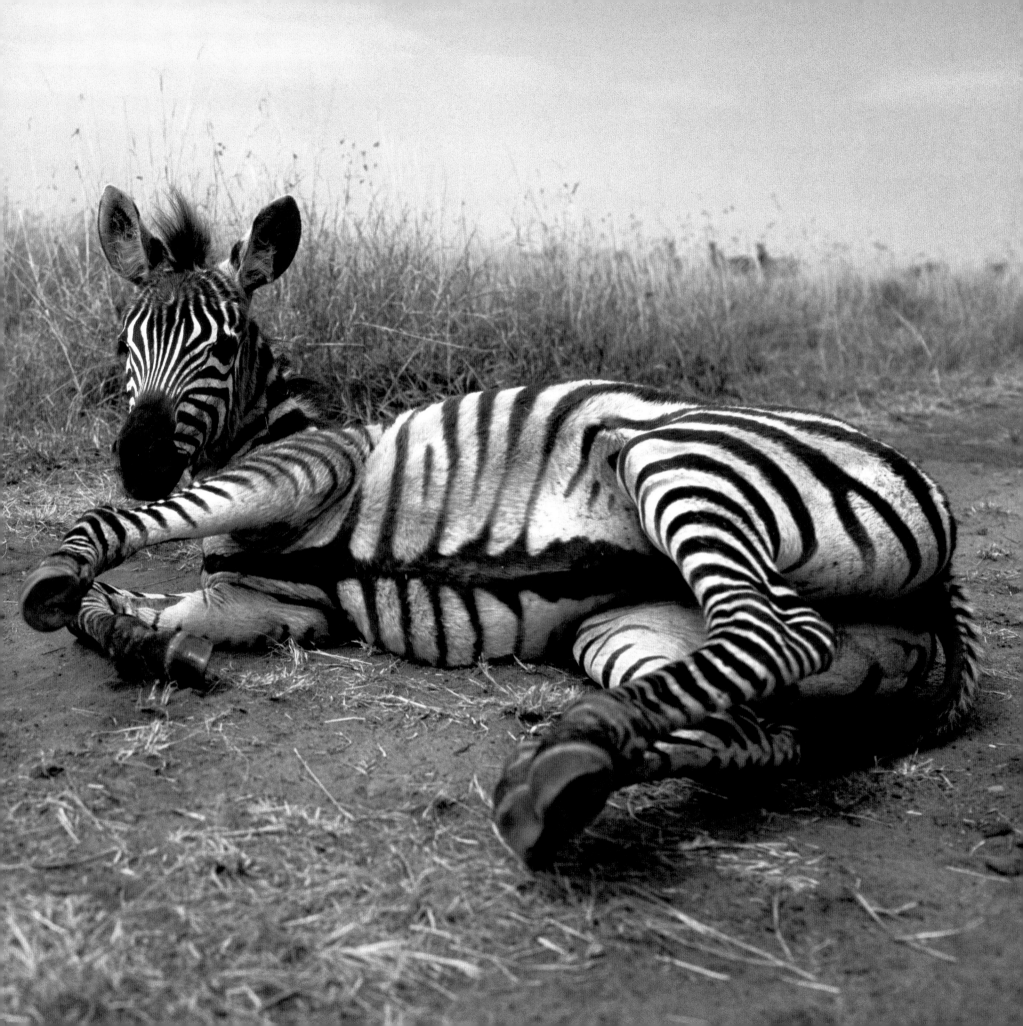

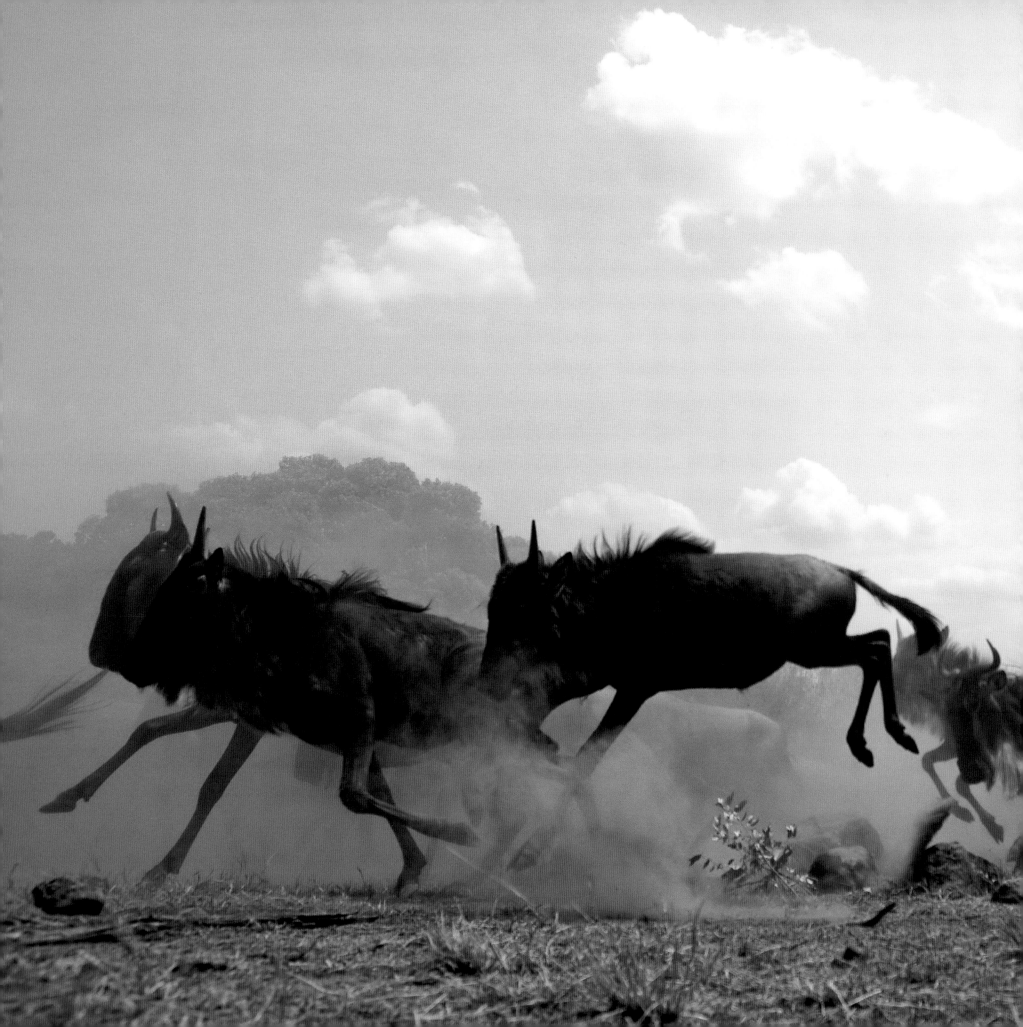

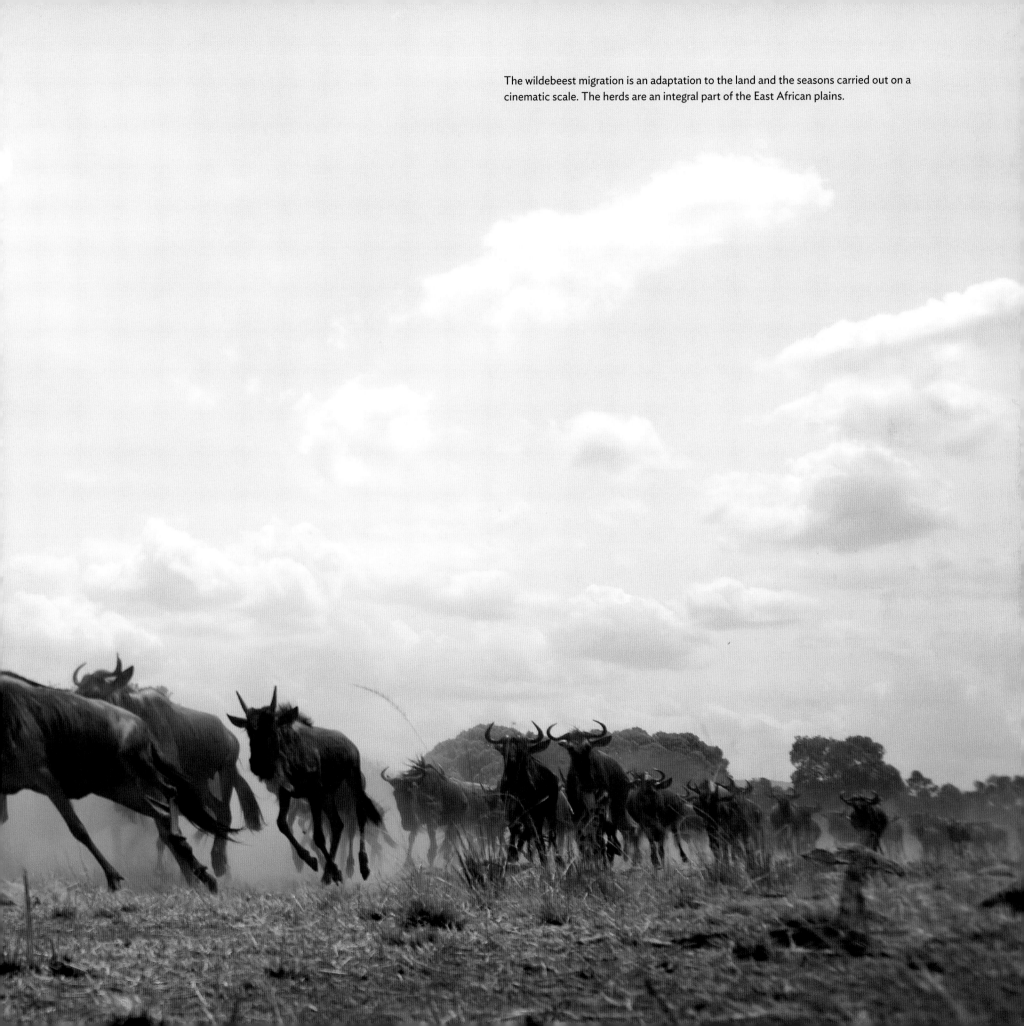

The wildebeest migration is an adaptation to the land and the seasons carried out on a cinematic scale. The herds are an integral part of the East African plains.

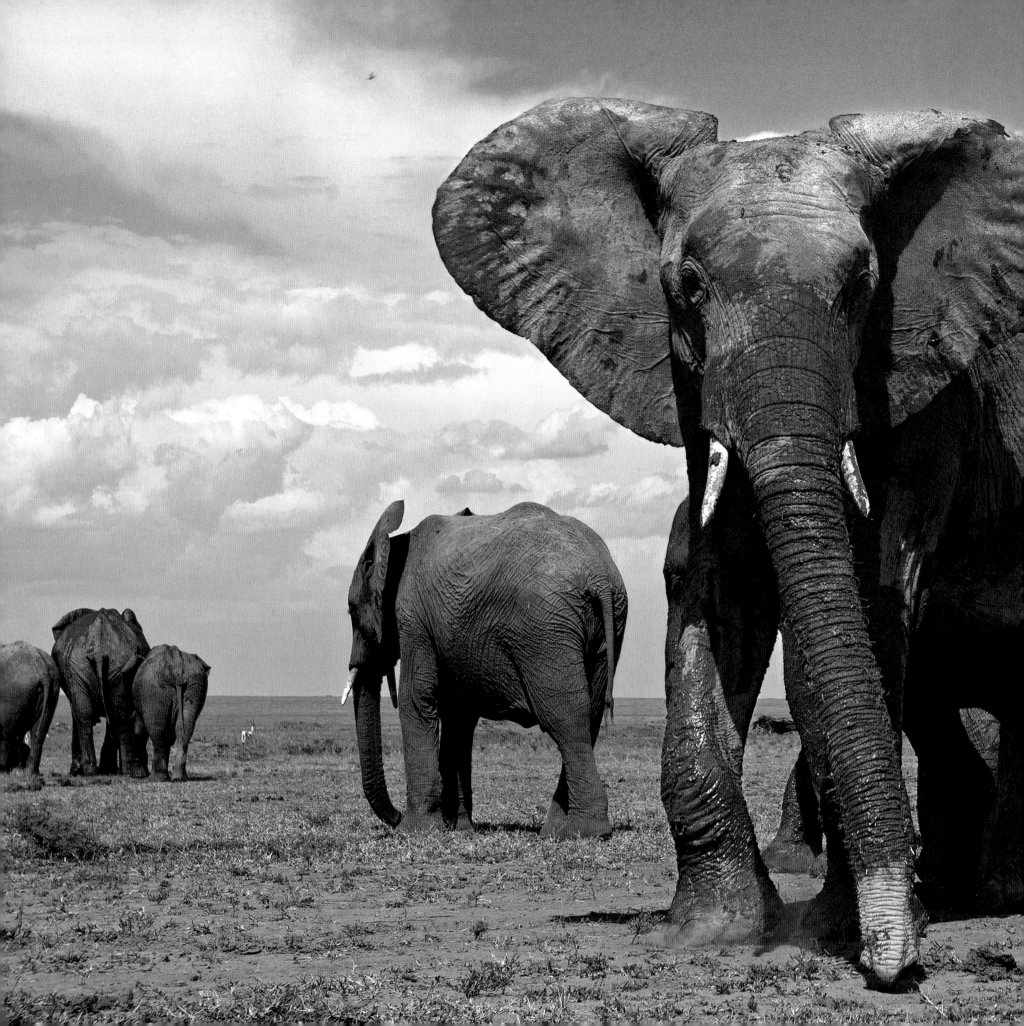

A family of elephants with a tiny calf have located a dry patch and congregate at it. While the adults dust themselves using their trunks, the baby relishes rolling in the dust. Although the baby is oblivious to its surroundings, it is closely watched and guarded by the adults.

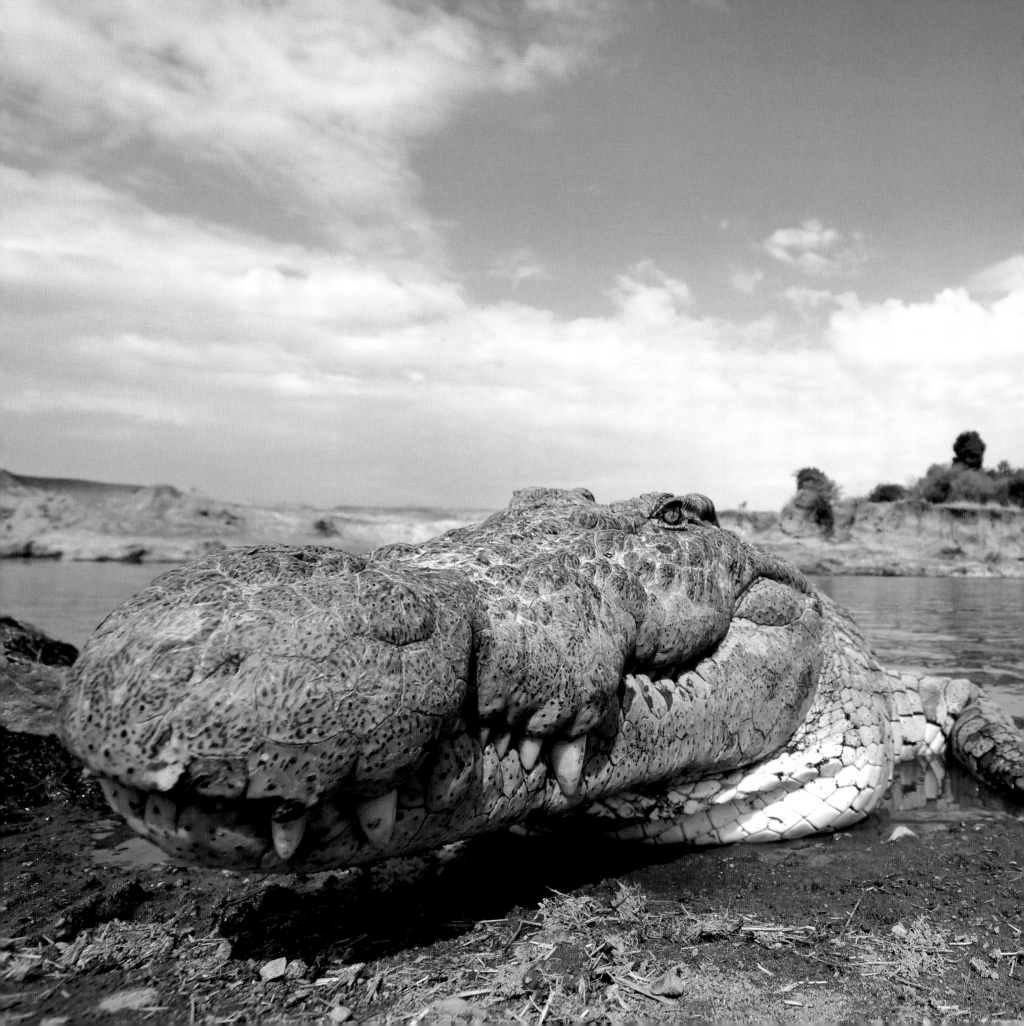

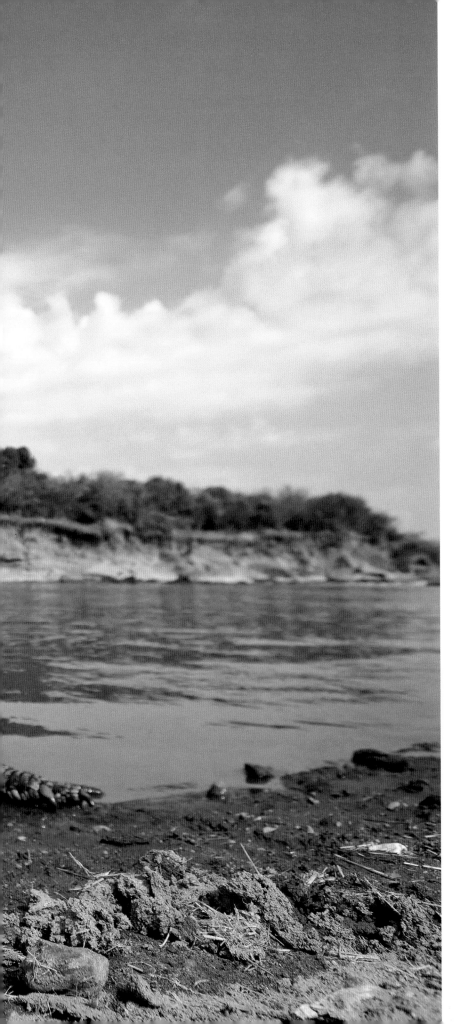

Crocodiles swim in the Mara River during the early hours of the morning. By mid-morning, they will have hauled themselves onto the bank, where they will rest, fully alert. A wildebeest coming to the river would be monitored by this crocodile, inert yet watching every move, waiting for this potential prey to enter the water.

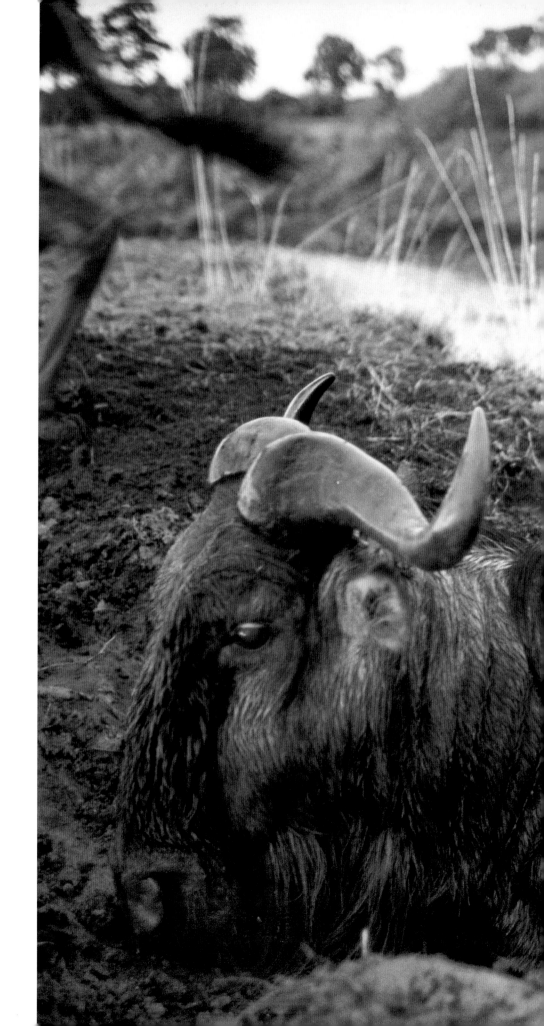

RIGHT AND OVERLEAF: Under the influence of the short rains, the grass springs up in fresh green flushes wherever the scuds of downpour wash the land. I am struck by the resilience of the land. The small remnant herds of wildebeests make their way south and, for them, a new hazard has arisen in crossing a river: scaling a steep, sticky, muddy, riverbank.

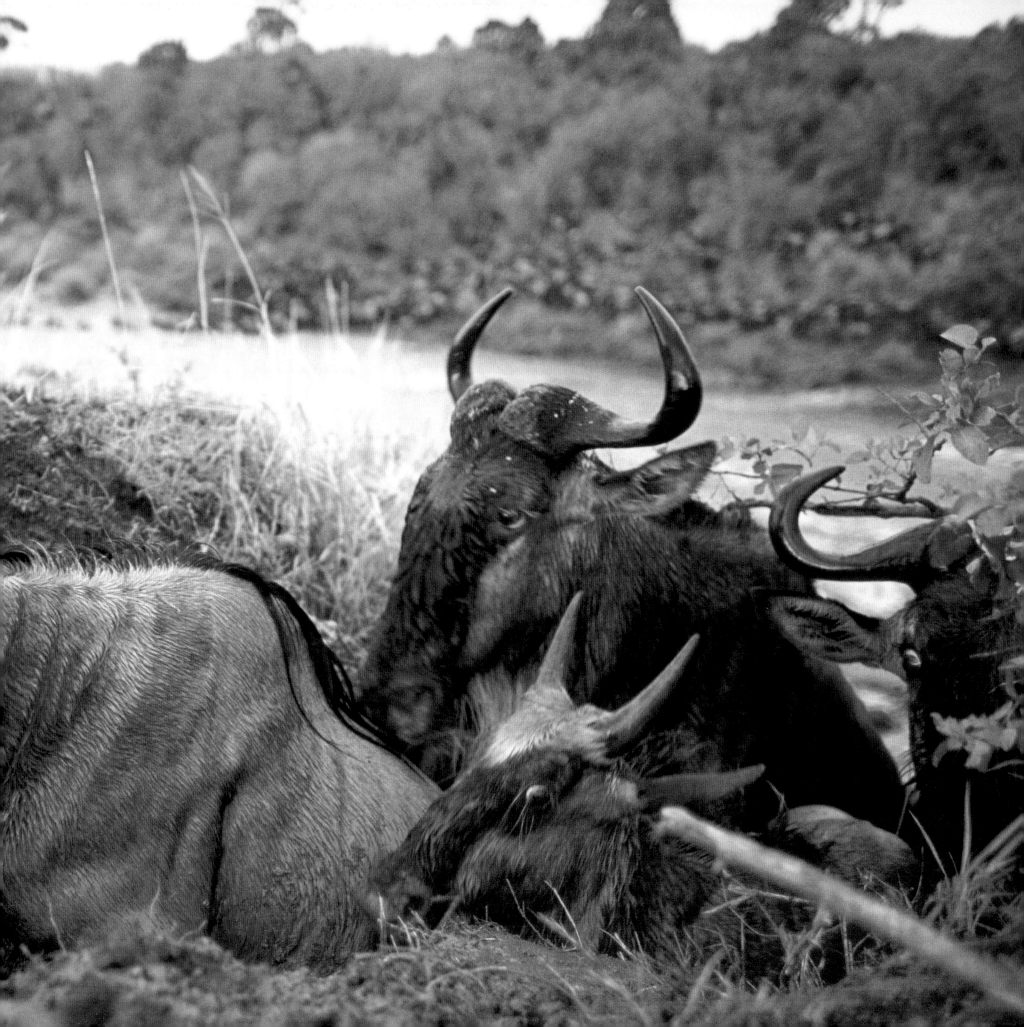

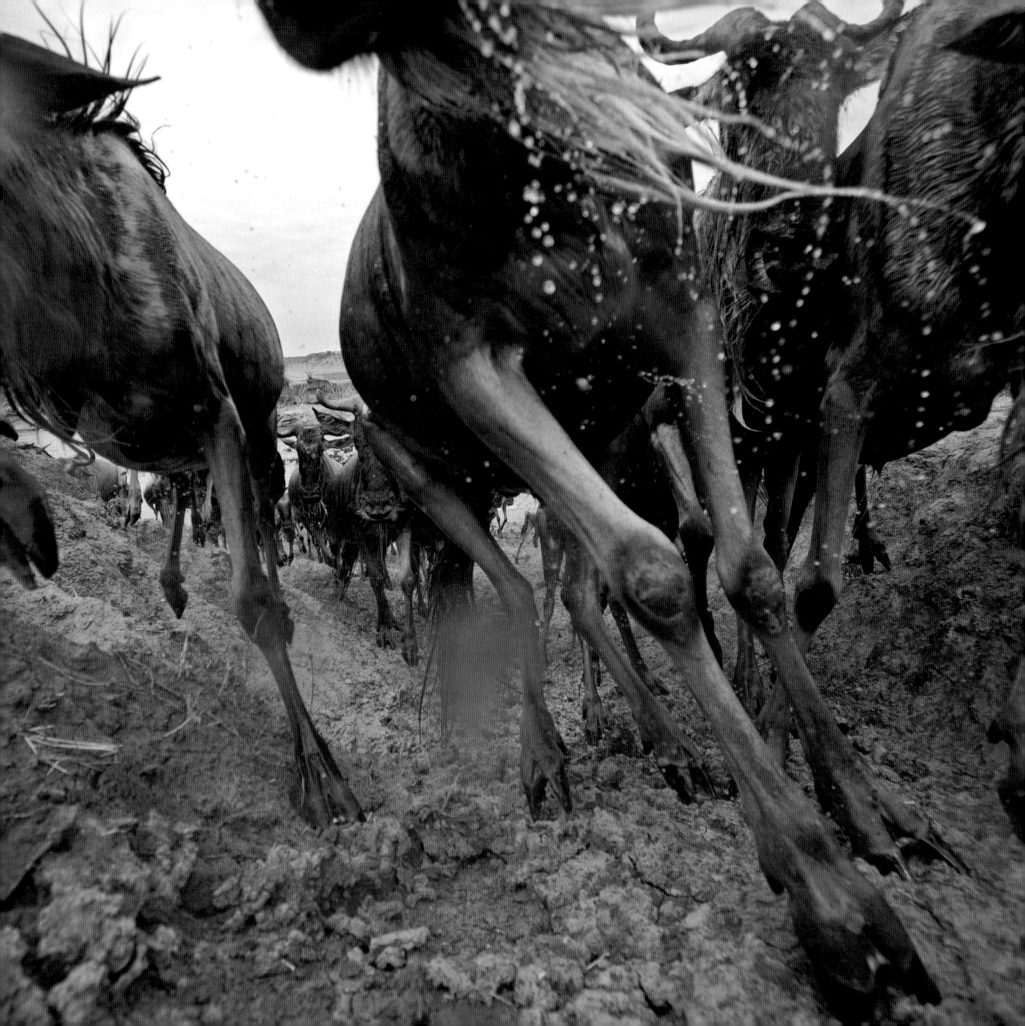

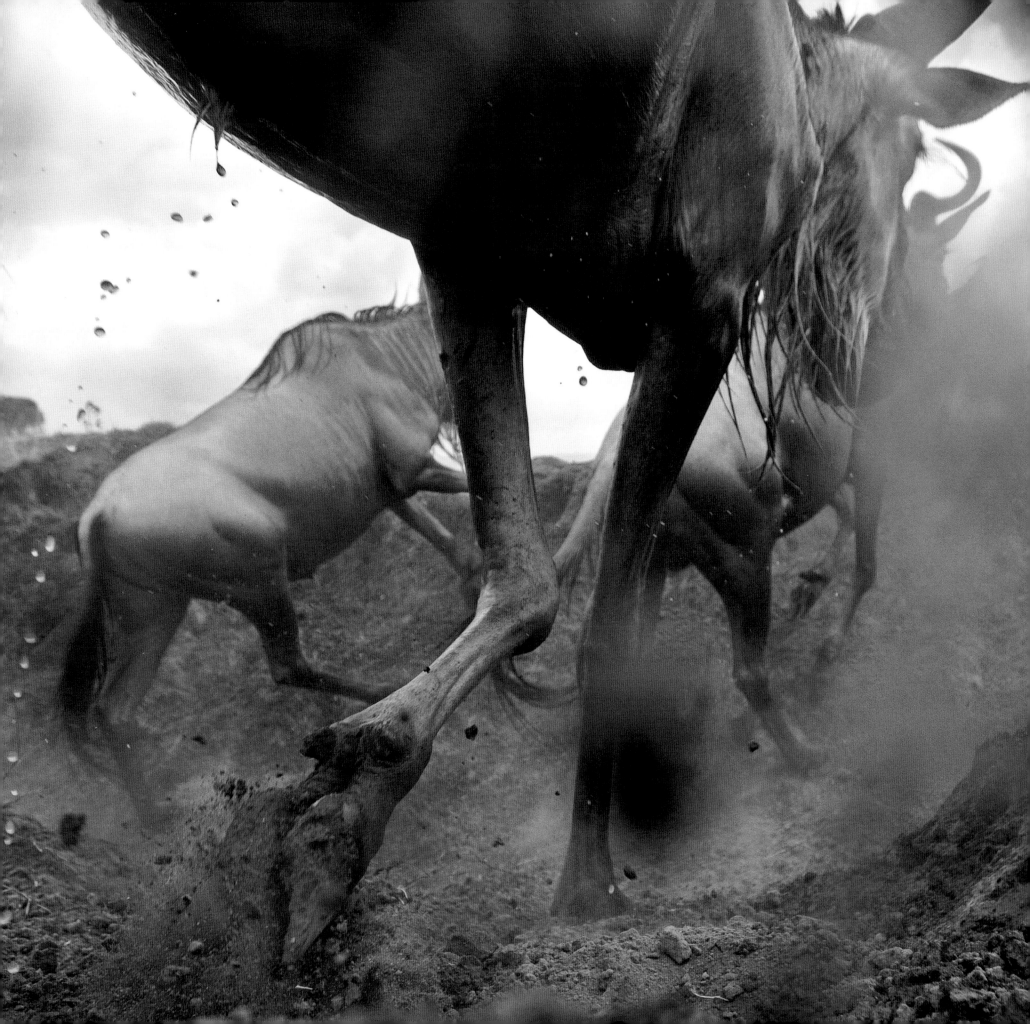

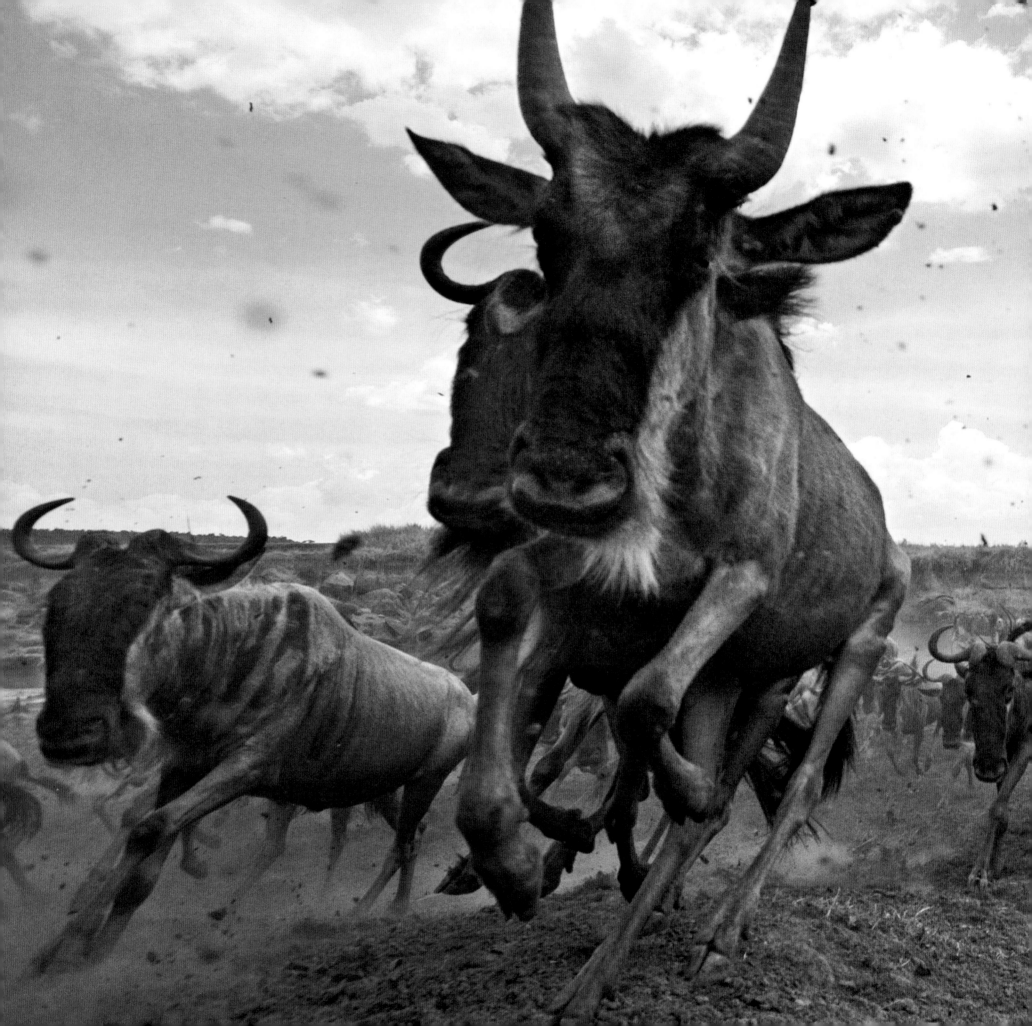

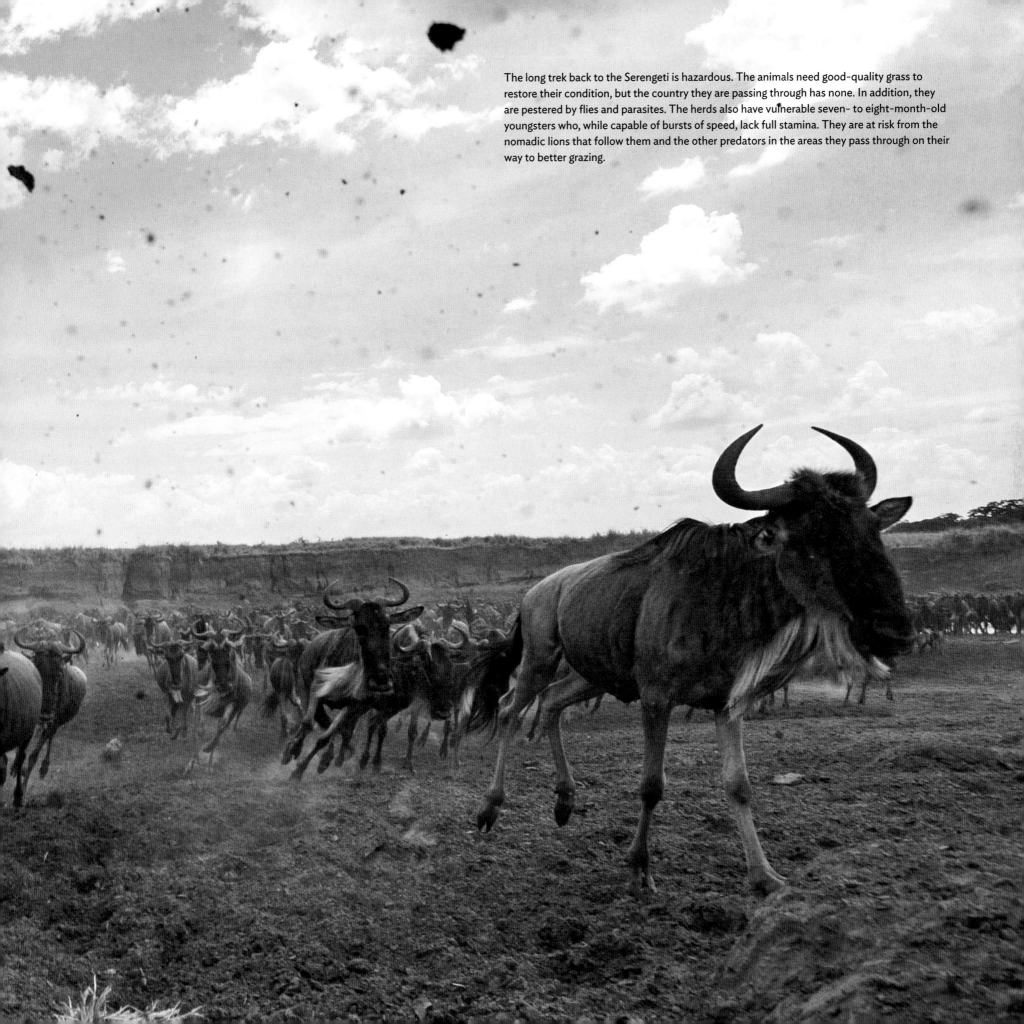

The long trek back to the Serengeti is hazardous. The animals need good-quality grass to restore their condition, but the country they are passing through has none. In addition, they are pestered by flies and parasites. The herds also have vulnerable seven- to eight-month-old youngsters who, while capable of bursts of speed, lack full stamina. They are at risk from the nomadic lions that follow them and the other predators in the areas they pass through on their way to better grazing.

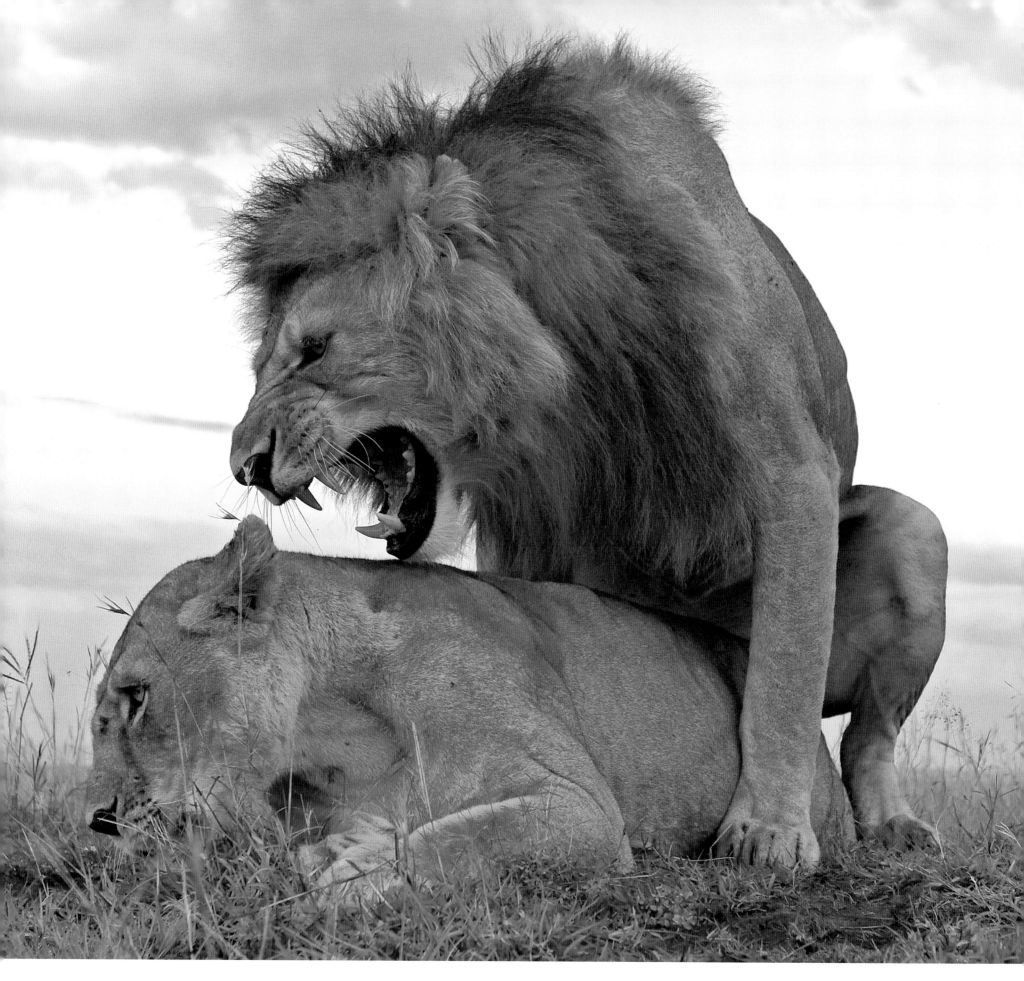

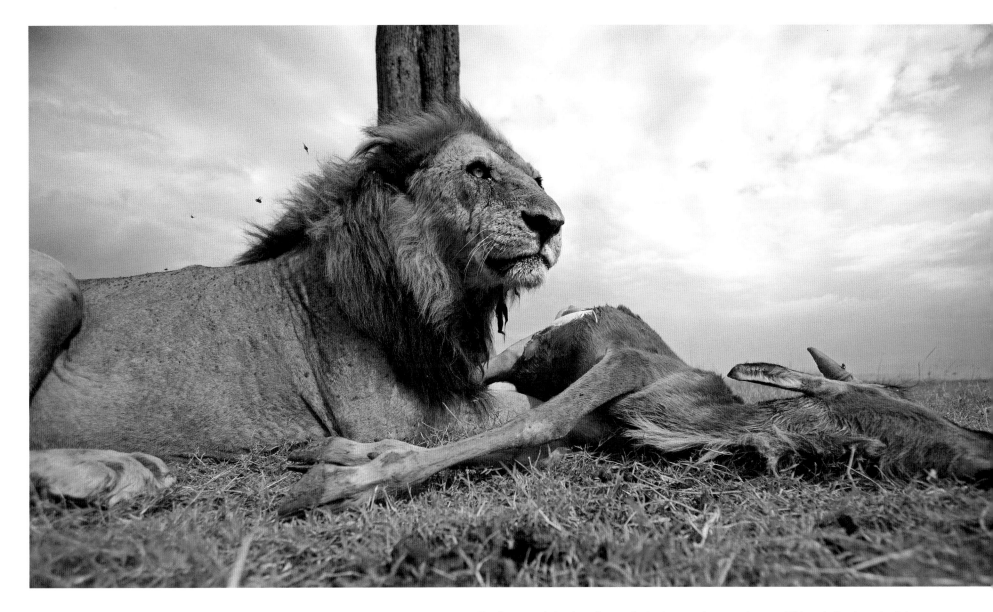

Flat-bottomed clouds gather on the horizon, and storms threaten. This male lion has a leg injury and can scarcely keep up with the wanderings of his pride. He is not able to hunt very effectively in his condition, so he takes every opportunity to scavenge. This wildebeest calf he is feeding on was probably brought down by a spotted hyena.

OPPOSITE: The female, as is usual in lion society, initiates the act of copulation, sinuously winding herself around her partner, raising her tail and wafting her scent under the male's sensitive nose. Towards the end of each coupling, she may rebuff him with a harsh grunt or growl accompanied by a swipe with her paw. The mating is tempestuous, with a lot of rumbling, grimacing, and that final swipe from her.

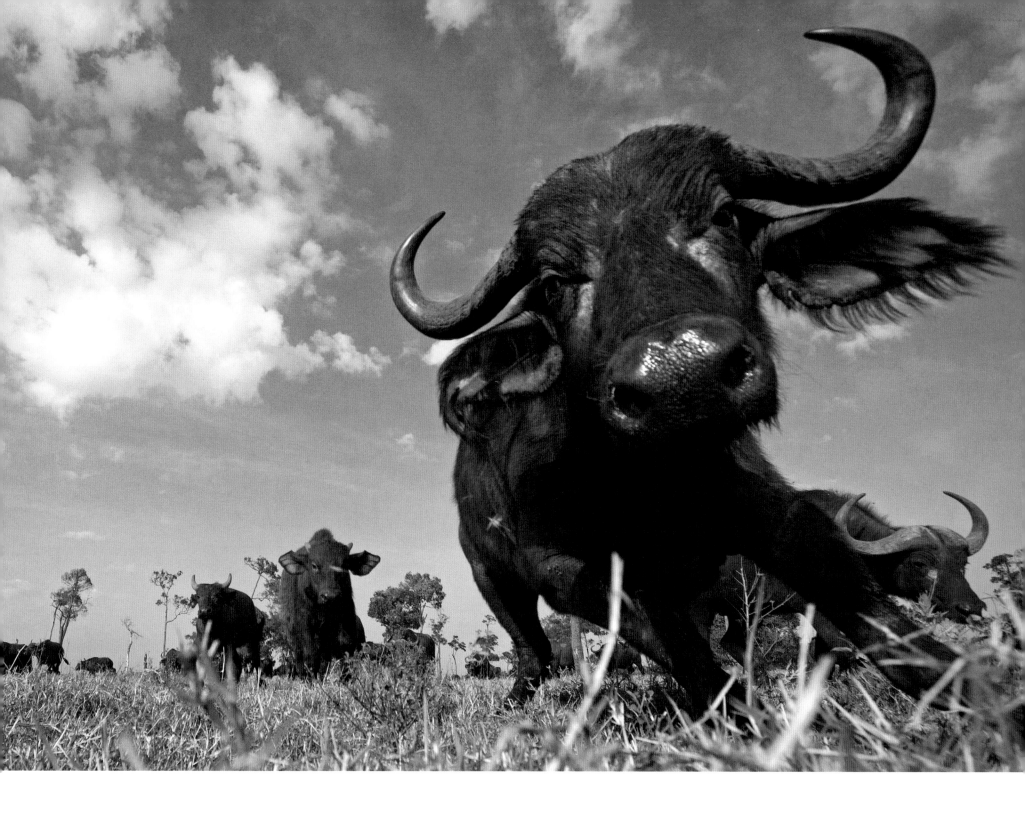

Even in protected park areas where most animals have become inured to tourist traffic, the Cape buffalo is one of the few animals that retains its uncompromising attitude. When vigilant, it holds its head high, its nostrils twitching, its ears straight forward, and its eyes on full alert. There is this moment of stillness, every muscle and nerve taut, as it strives to identify the object of its attention and assess its threat potential.

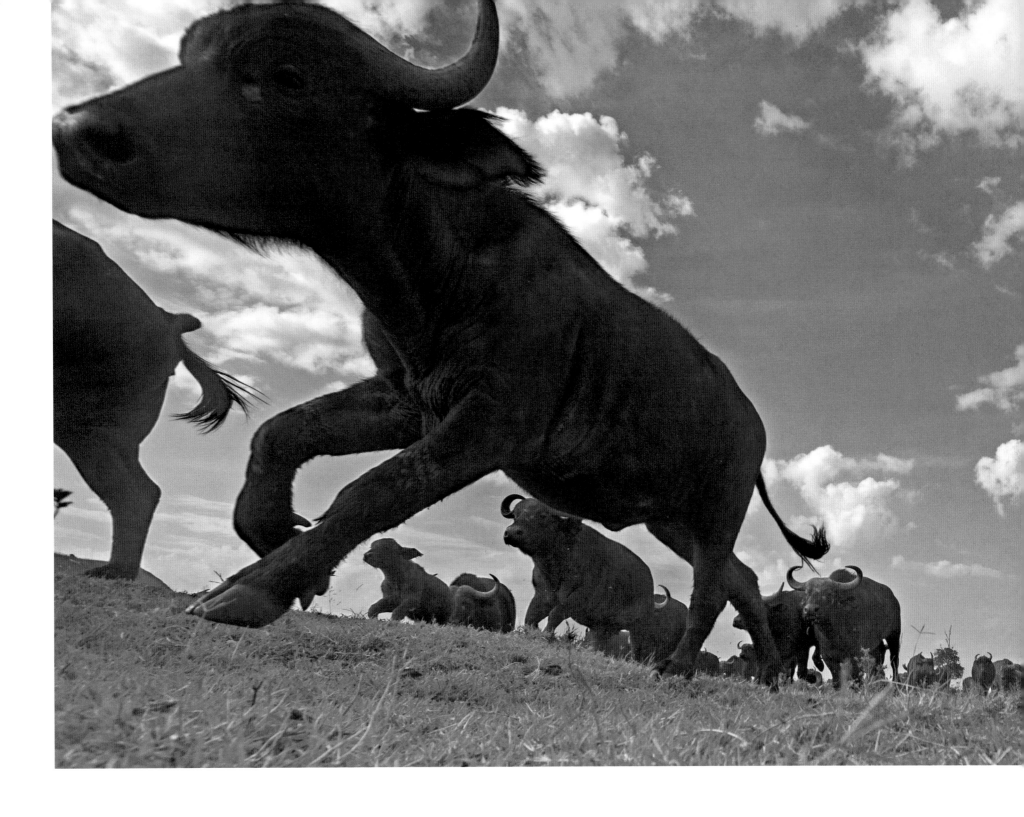

OVERLEAF: The lake water is alkaline, which is not good for the condition of flamingos' feathers, so, at about mid-morning and sometimes late evening, the birds make their way to the place where freshwater rivers flow into the lake to drink and to bathe. Ablutions completed, they preen.

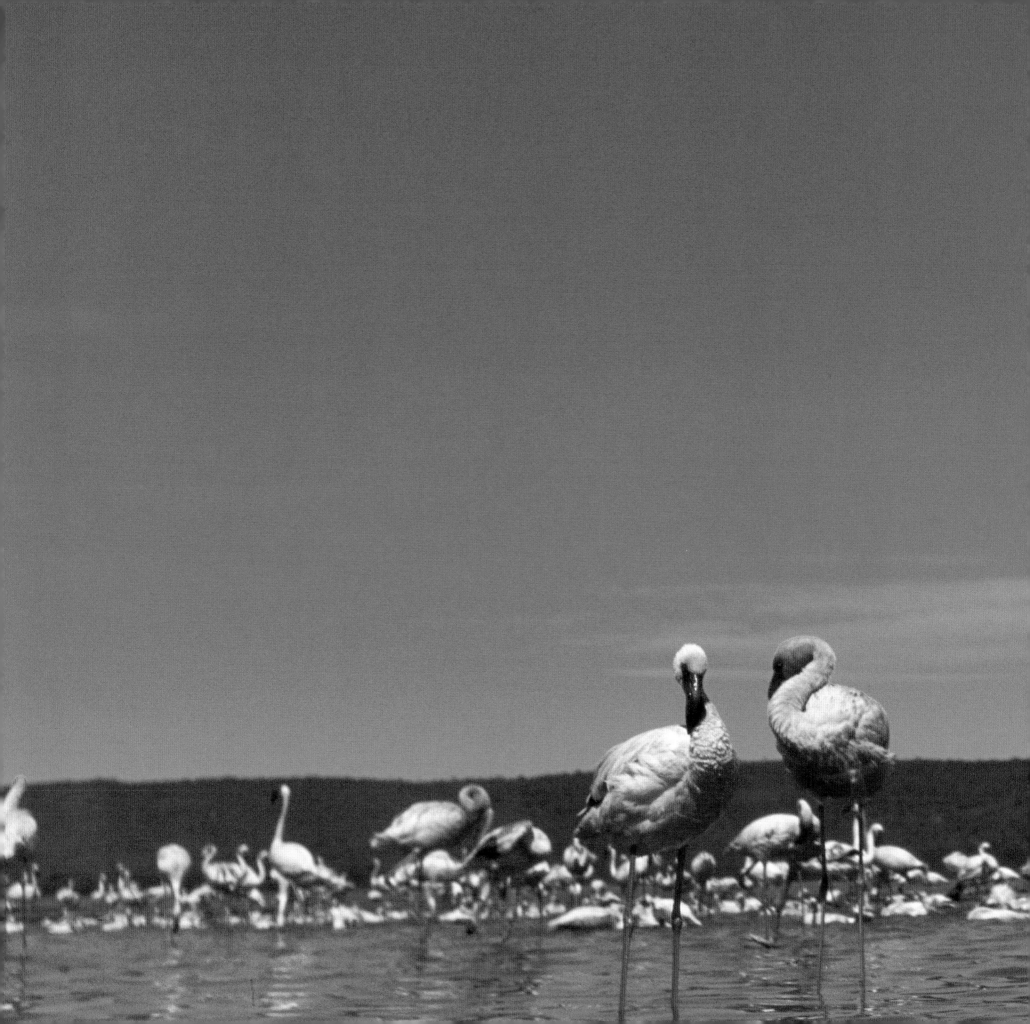

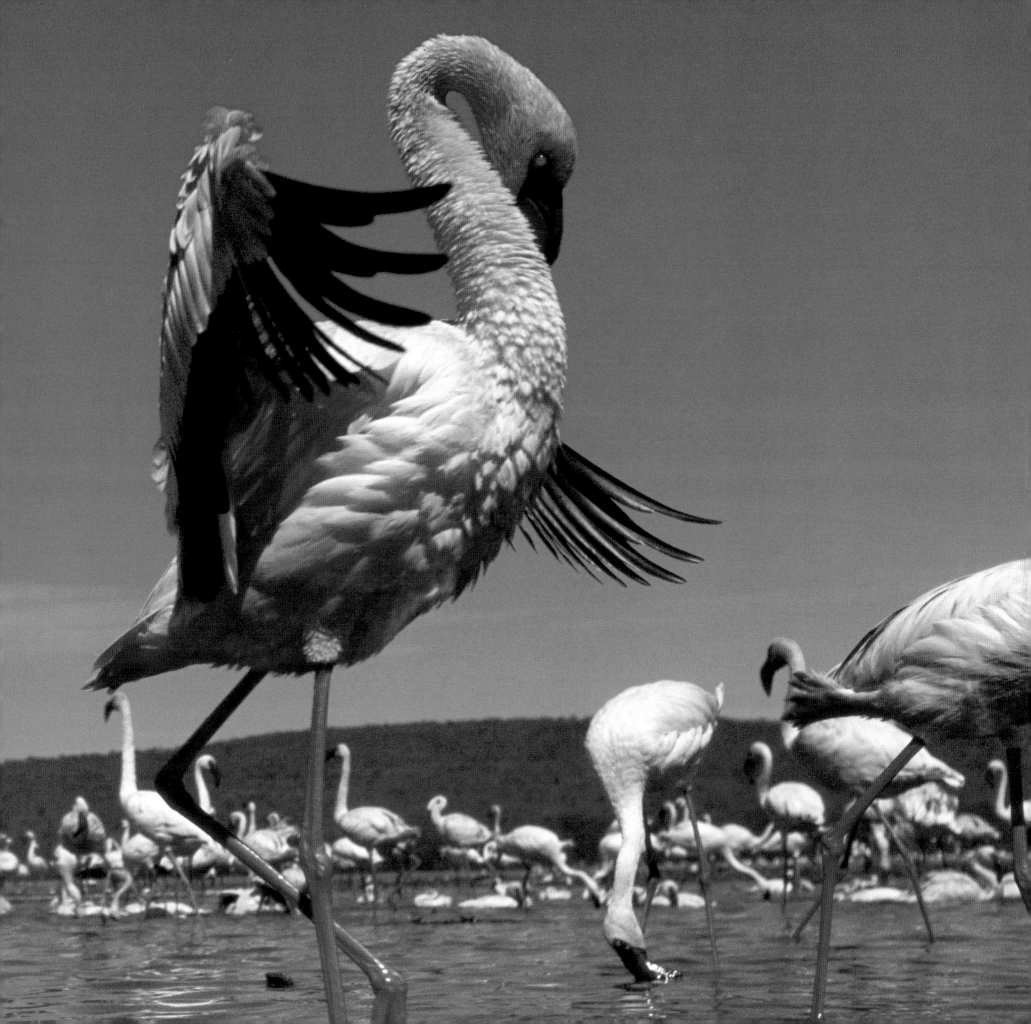

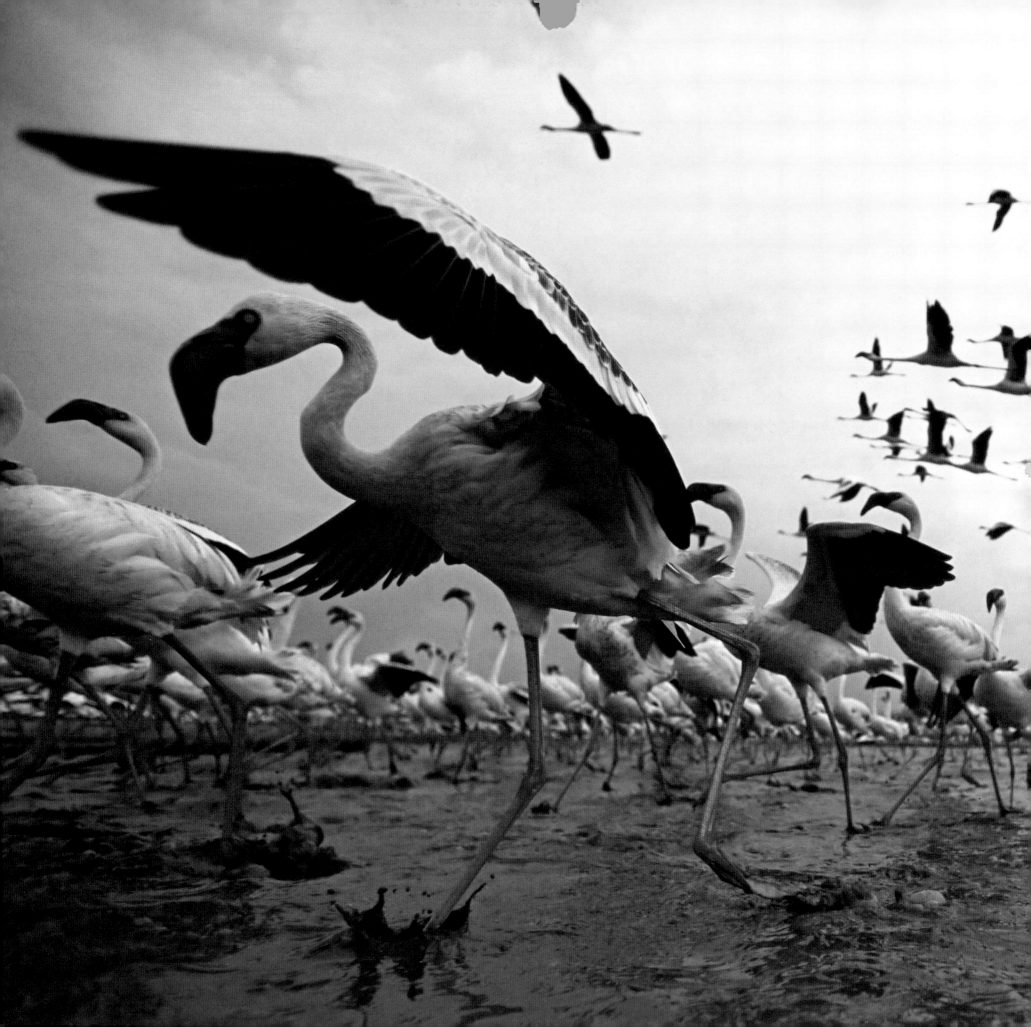

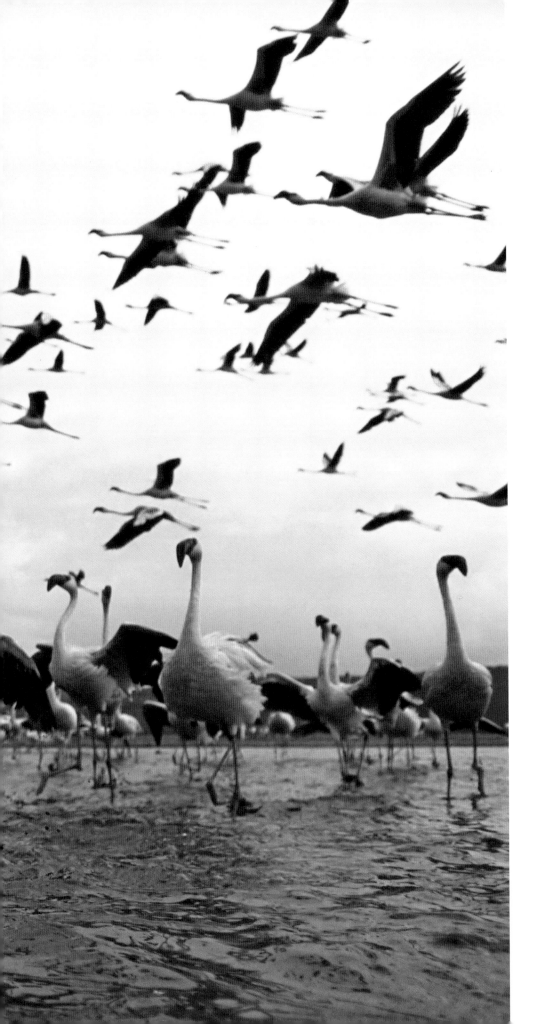

LEFT AND OVERLEAF: A hyena has disturbed the calm. Its hunting strategy is simple: It runs straight at the bathing flamingos, creating a panic. The tightly packed birds need space to run before they can take to the air, so while the birds nearest to the river mouth escape easily, those behind have to wait for their turn to take off—these are the ones in the hyena's sights.

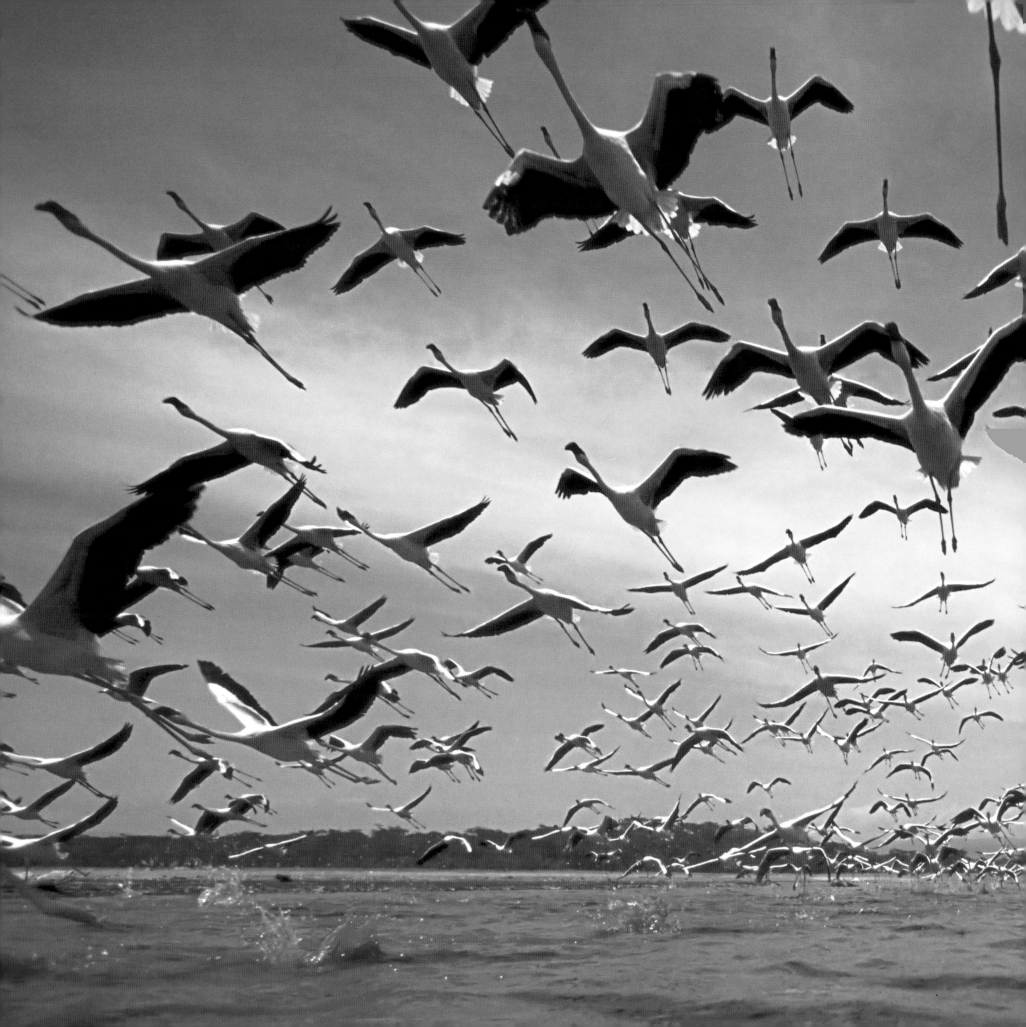

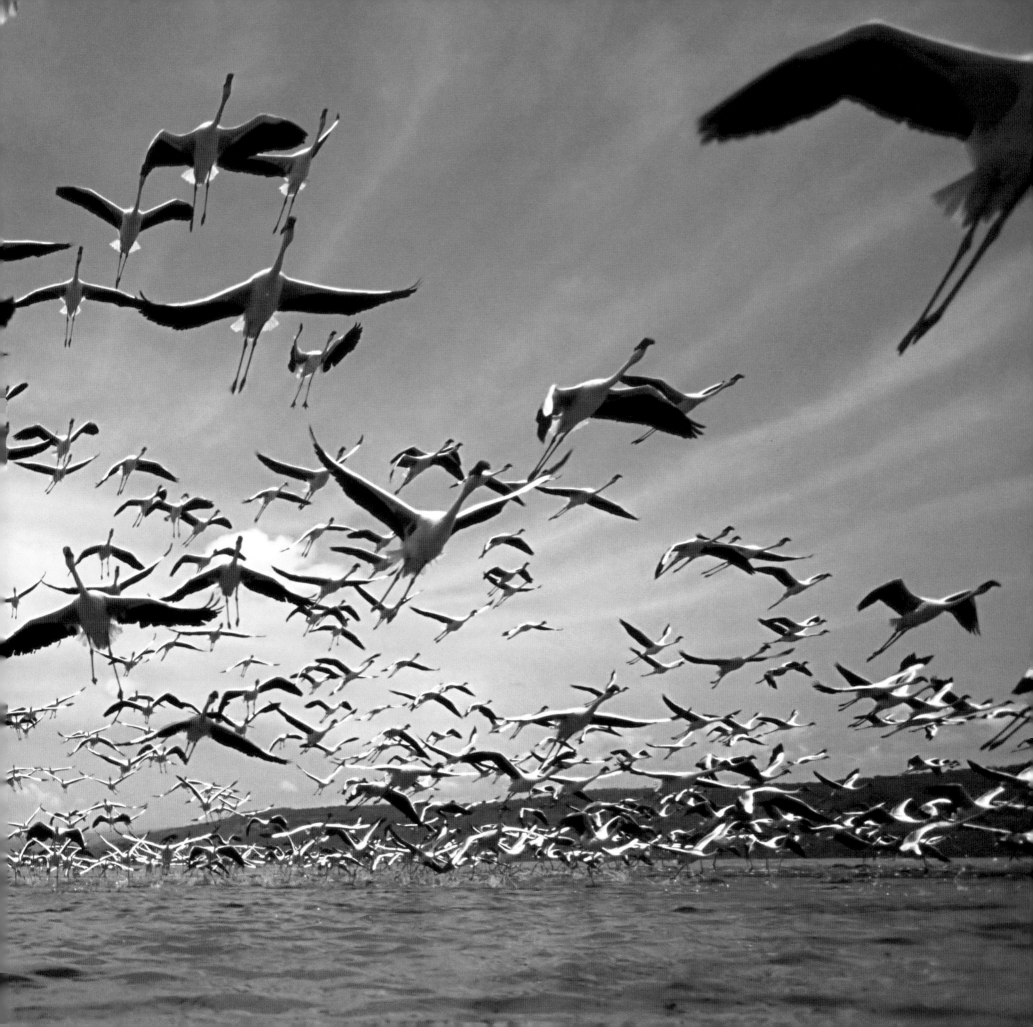

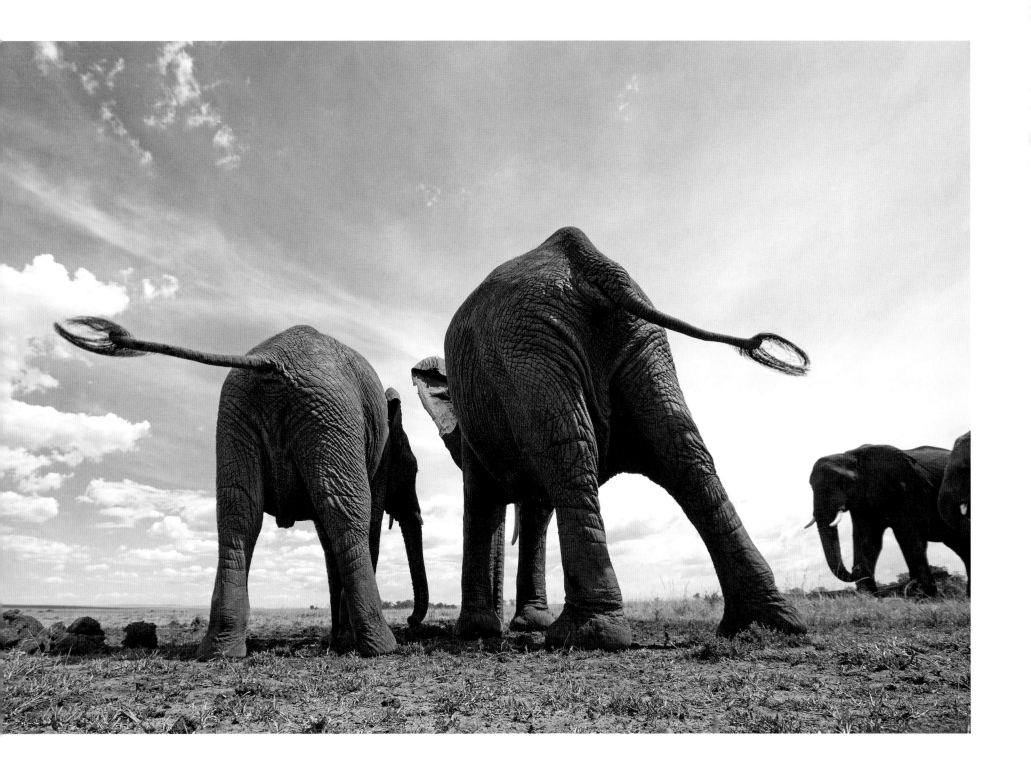

Elephants love soft, gooey mud, and thanks to the recent rains, there is plenty. New research suggests that not only do elephants use low-frequency vocalizations that we humans cannot hear to communicate over distances of several miles, but their rumblings also generate seismic waves in the ground that are picked up by their feet, which act as broad, flat receivers. Consider the following incident: The lead elephant of this herd stopped when she chanced upon some lions. There was no vocalization emanating from her, but the rest of the herd, scattered behind her and out of her field of vision, stopped feeding and immediately clumped in a tight group with the babies in the middle.

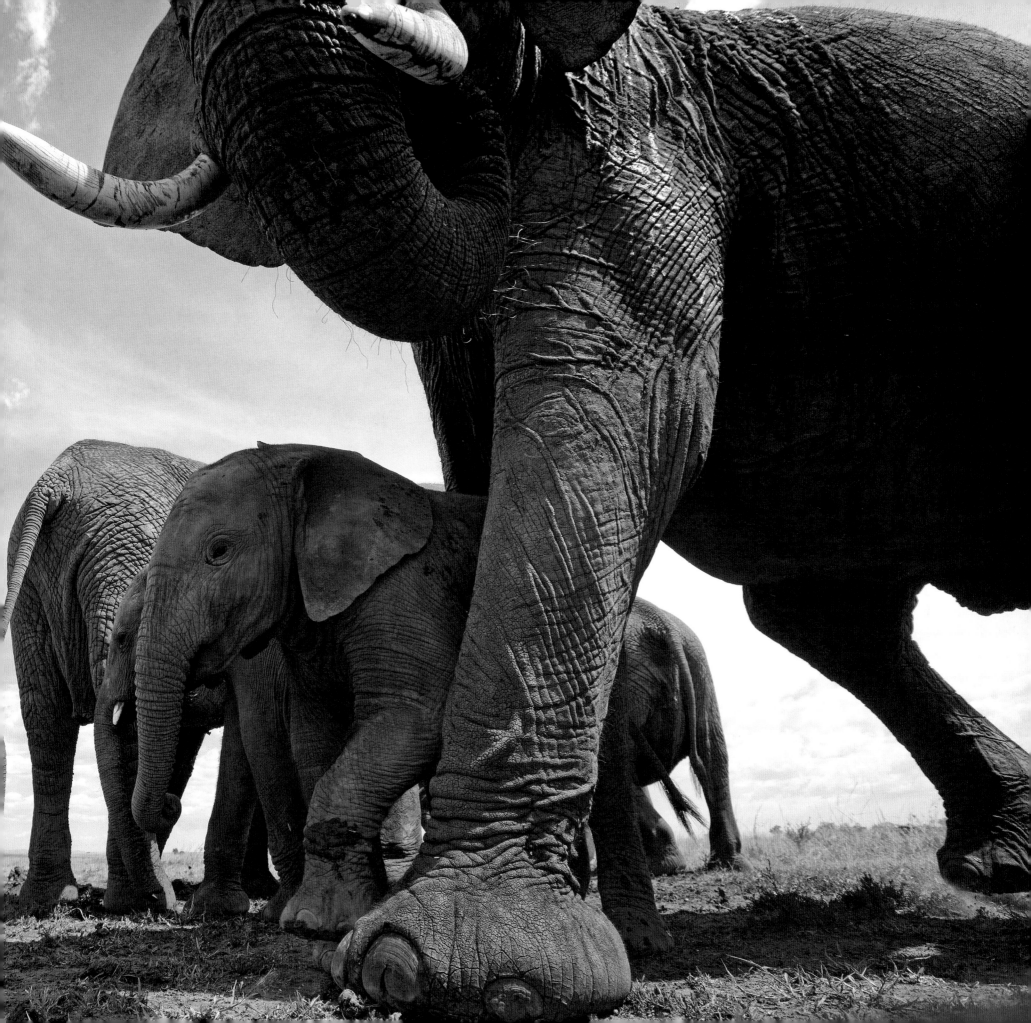

The short rains are drawing to a close. These lion cubs are of nearly the same age, but belong to different mothers. More often than not, pride females give birth at close to the same time and form a crèche.

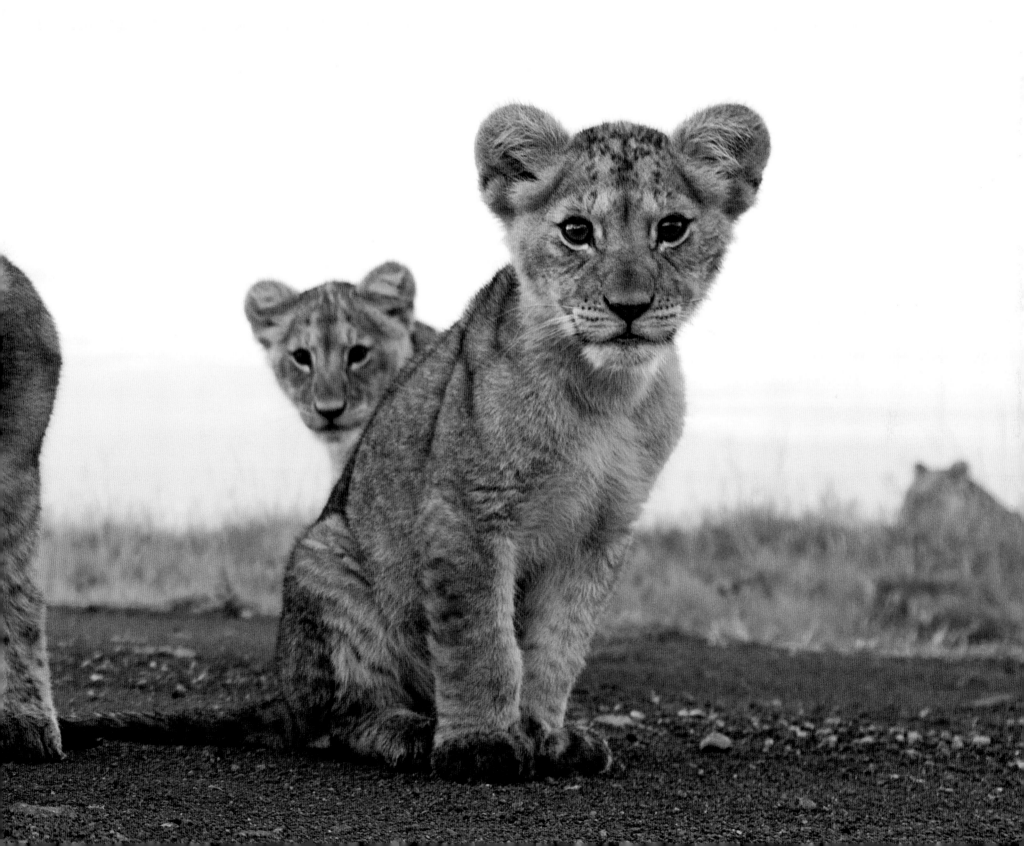

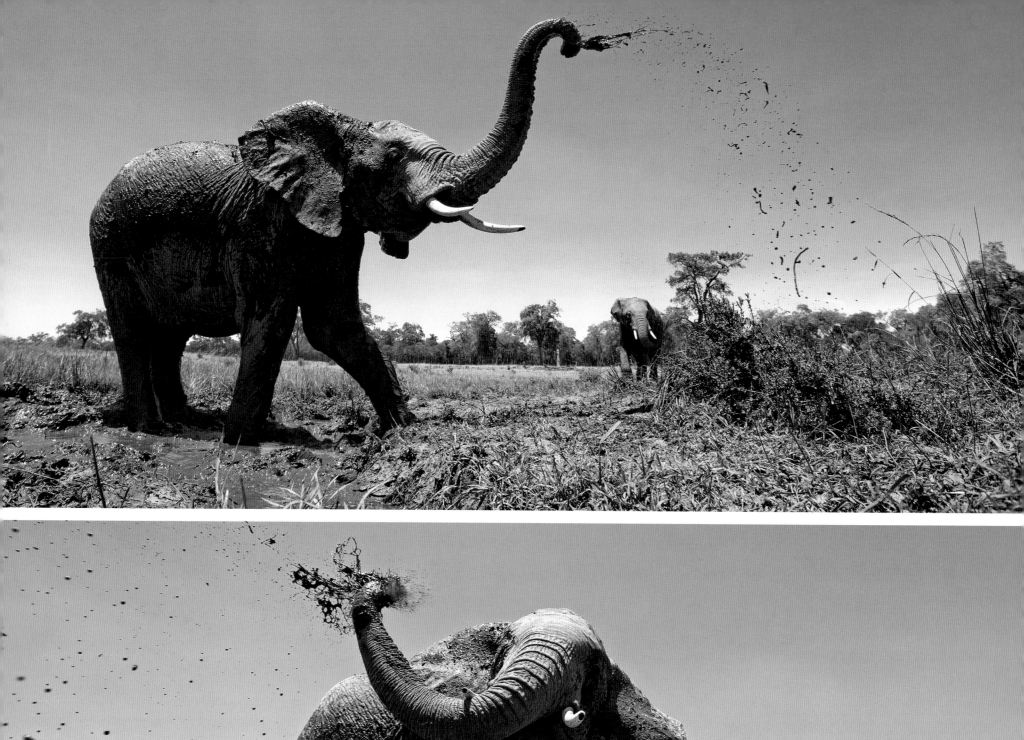
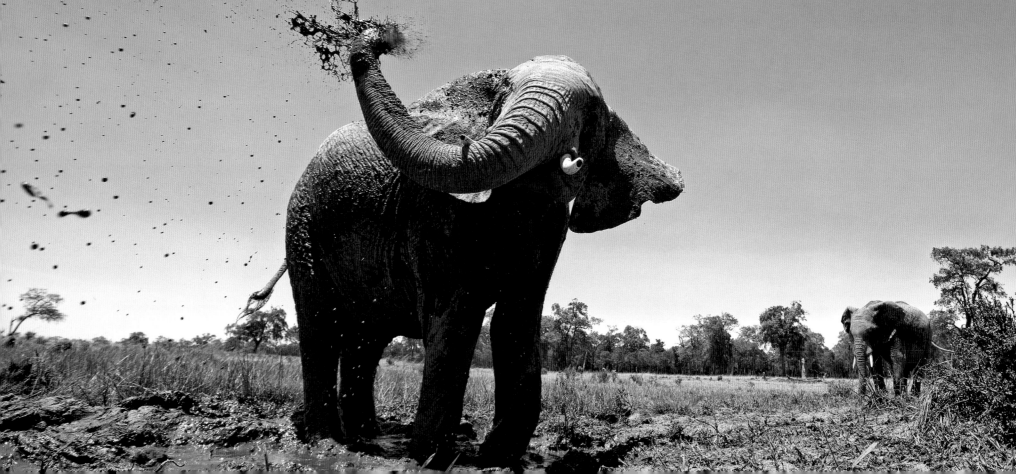

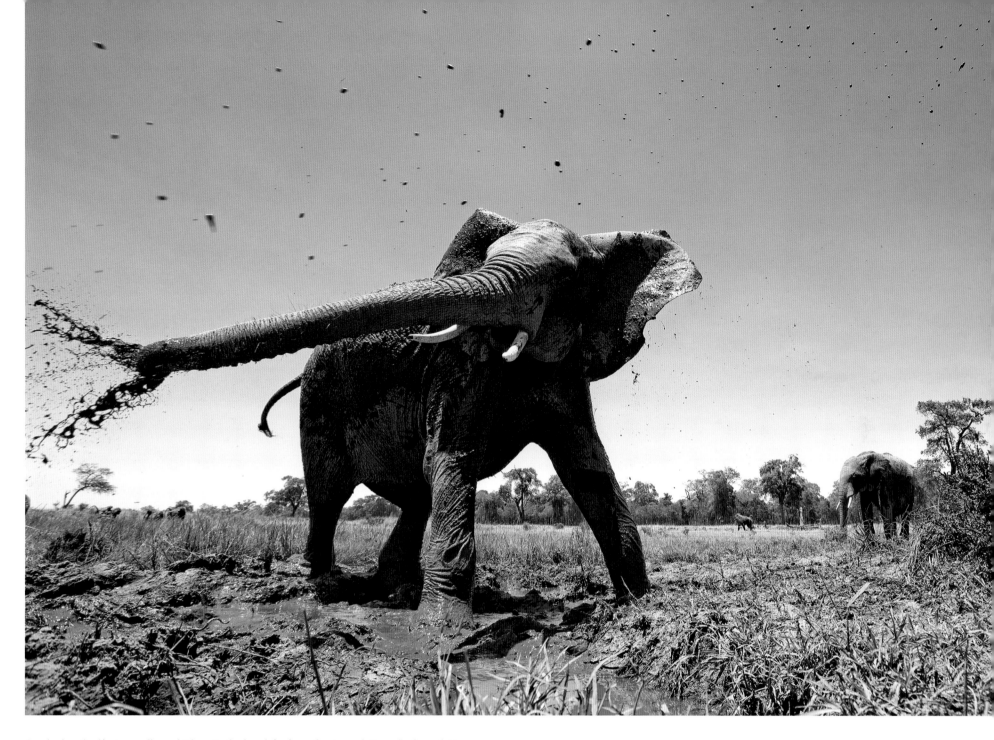

An elephant's olfactory cells are high up in the head, far from the ground. It smells through its trunk, which is hardly ever still; it is constantly probing, checking, and sampling everything within reach. The trunk is also like an extraordinarily versatile hand, capable of many actions.

OVERLEAF: A pack of banded mongooses may consist of anywhere from fifteen to forty members. Several adults, about an equal number of male and females, breed. Within a pack, just as in a lion pride, reproduction is synchronized. For the first few weeks, pups stay in the den, guarded by an adult babysitter. By five weeks of age, they accompany the pack when it leaves the den to forage.

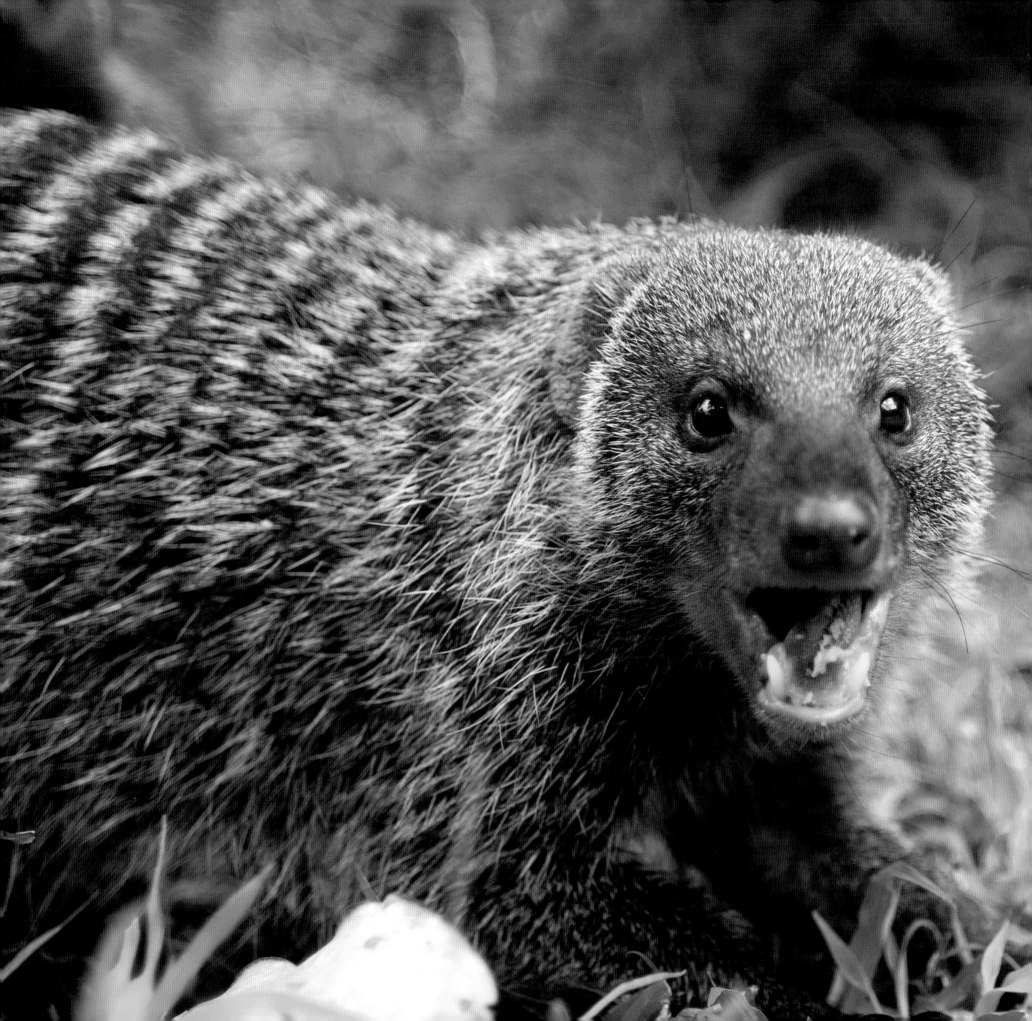

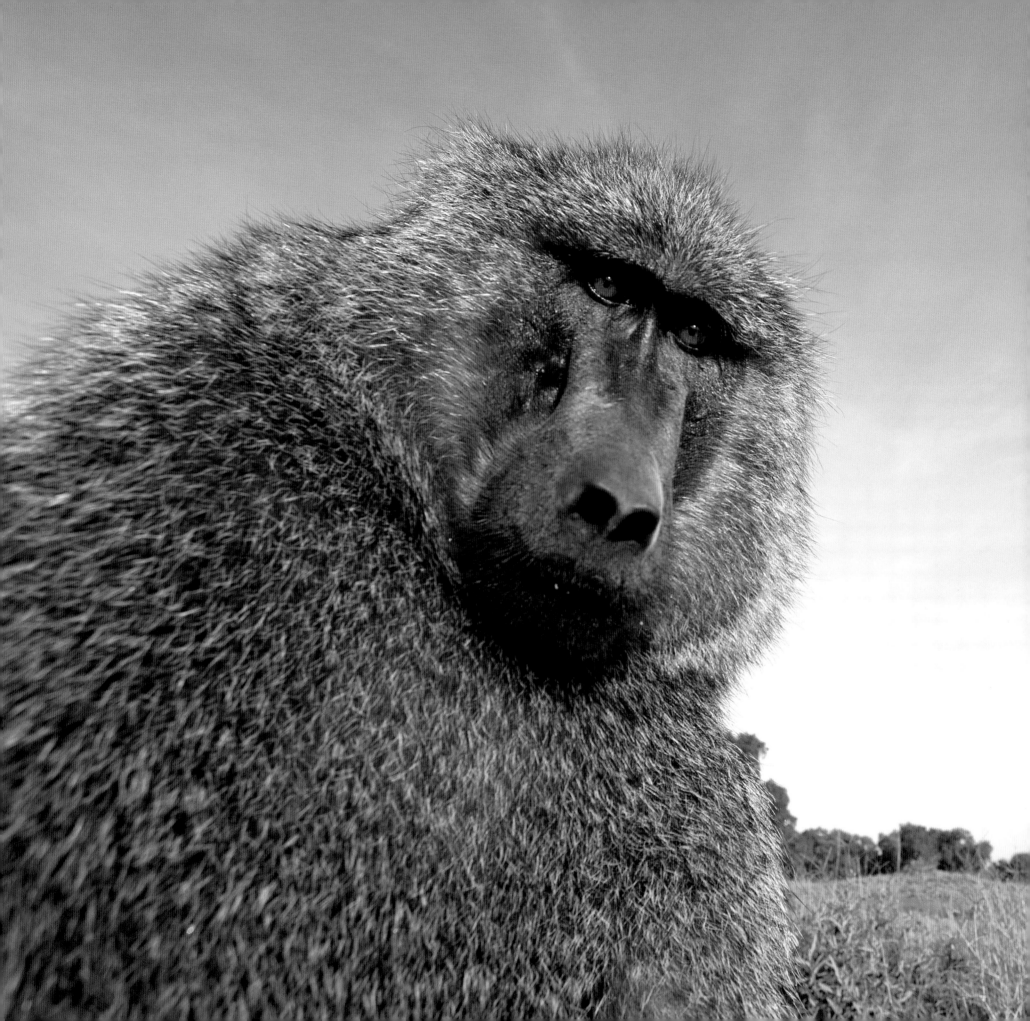

A male olive baboon. Like elephants and banded mongooses, olive baboons live in highly social, highly intelligent matriarchal societies. Female baboons spend their entire lives in their natal group, while males emigrate from theirs at maturity. It makes sense that the older females with a great deal of experience of the home range should lead the troop.

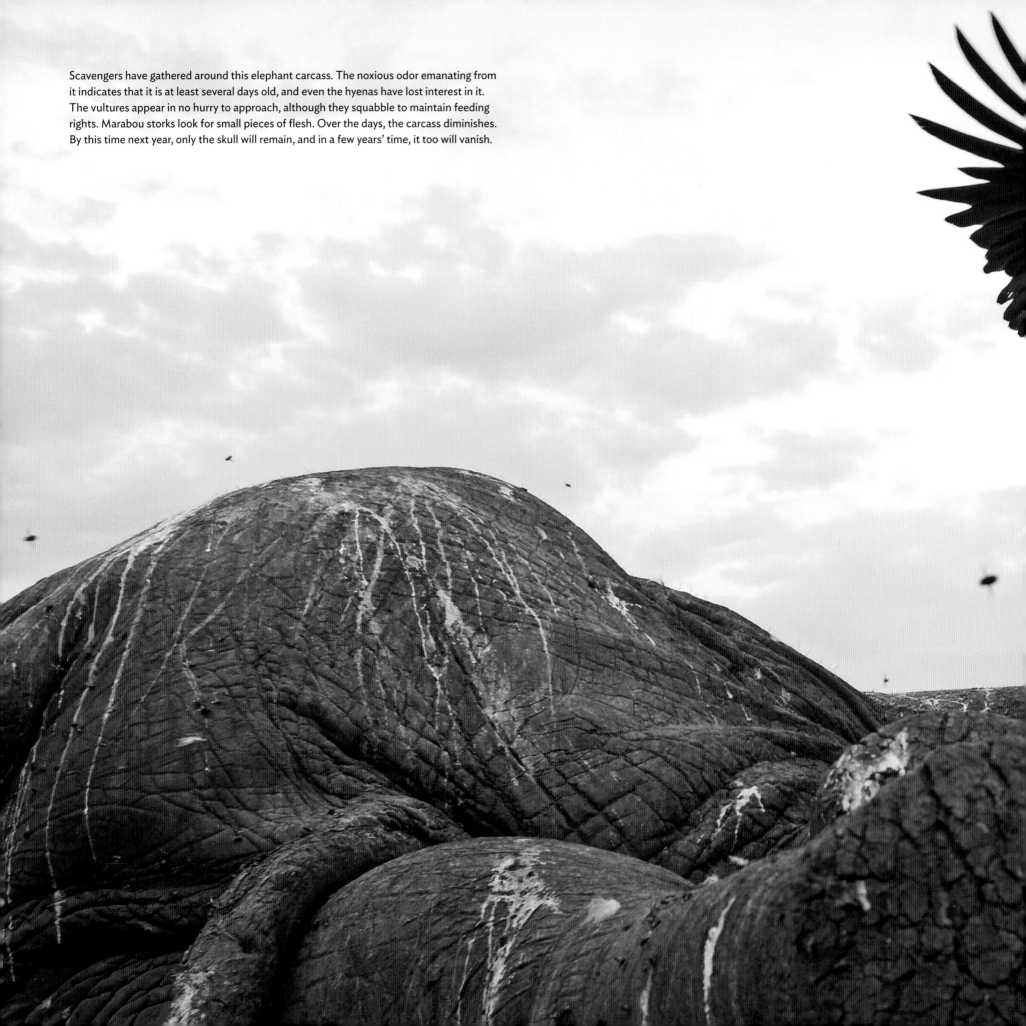

Scavengers have gathered around this elephant carcass. The noxious odor emanating from it indicates that it is at least several days old, and even the hyenas have lost interest in it. The vultures appear in no hurry to approach, although they squabble to maintain feeding rights. Marabou storks look for small pieces of flesh. Over the days, the carcass diminishes. By this time next year, only the skull will remain, and in a few years' time, it too will vanish.

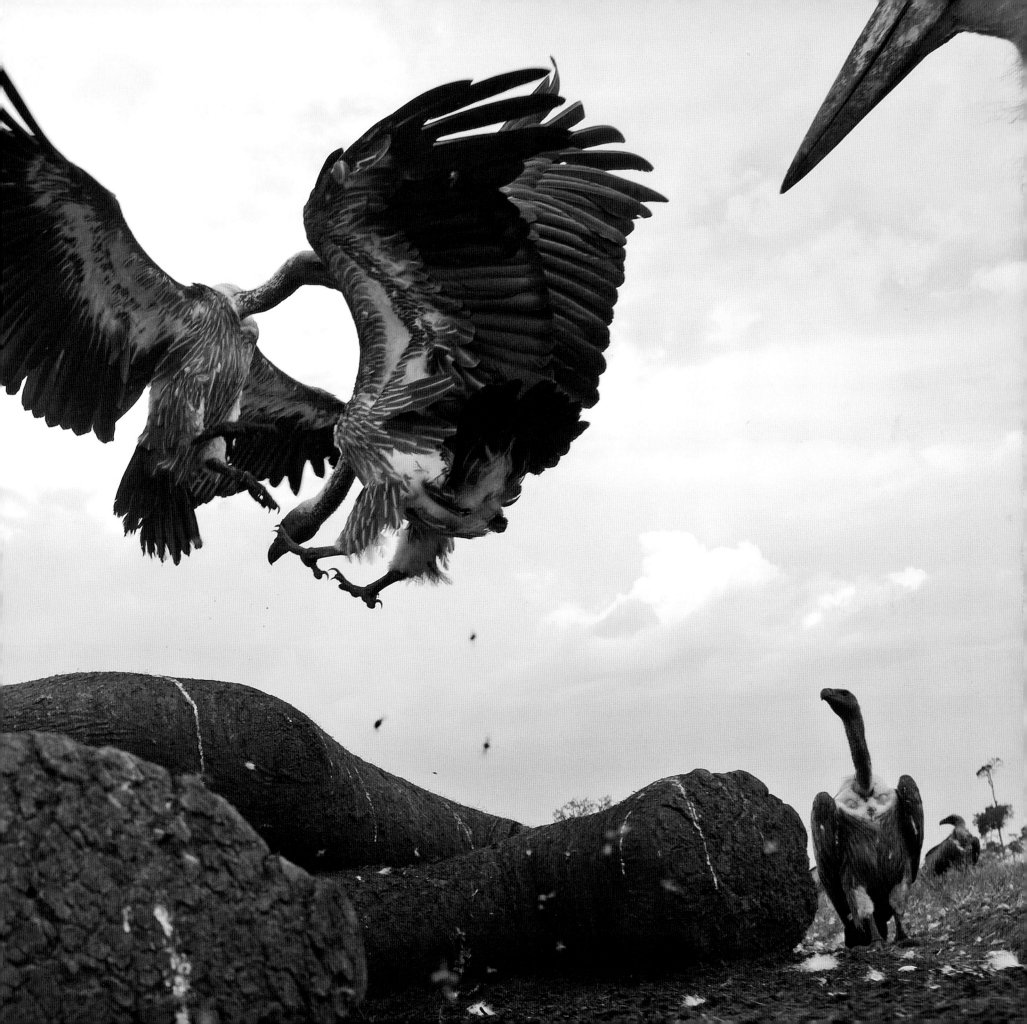

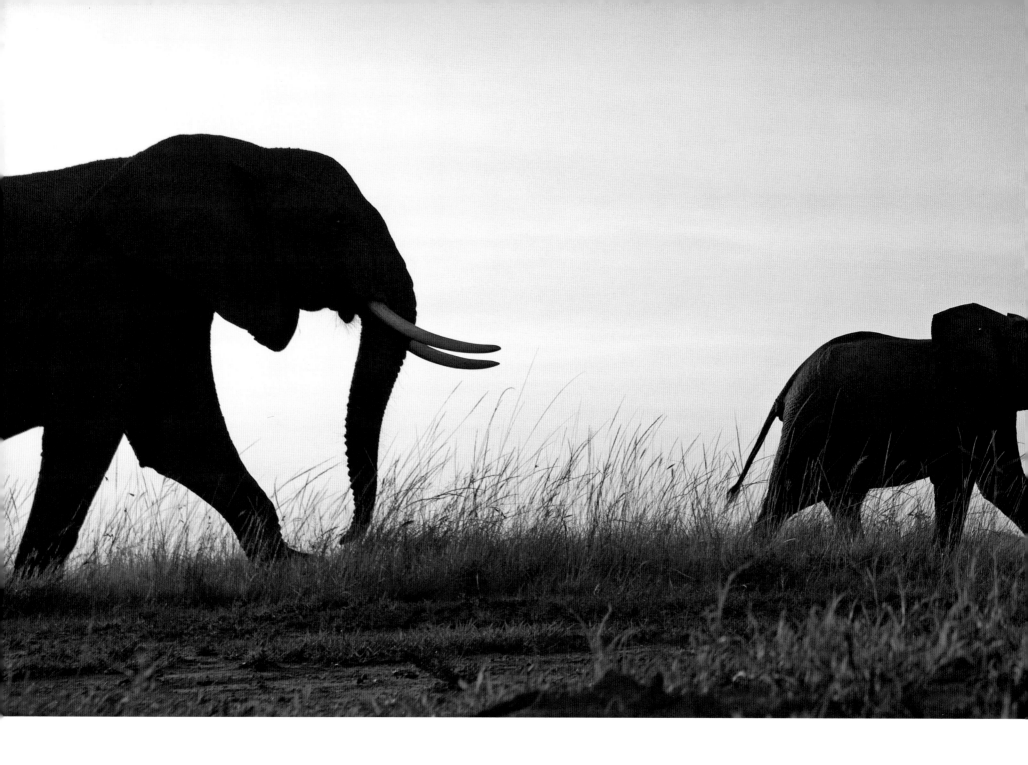

For the present, a family of elephants moves on, walking in single file, undisturbed. A year has passed, and with it, four seasons. The cycle will repeat itself, and the lives of elephants will be measured by the steady pulse of the seasons, by the rain and the sunshine, and by their success in adapting to the land.

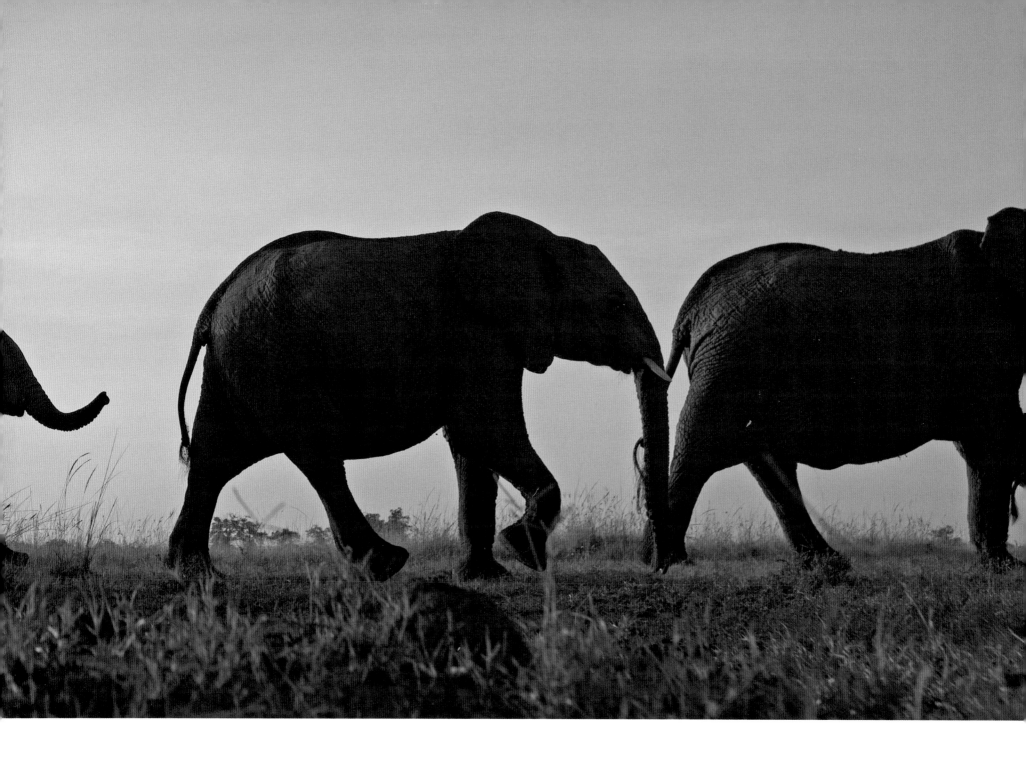

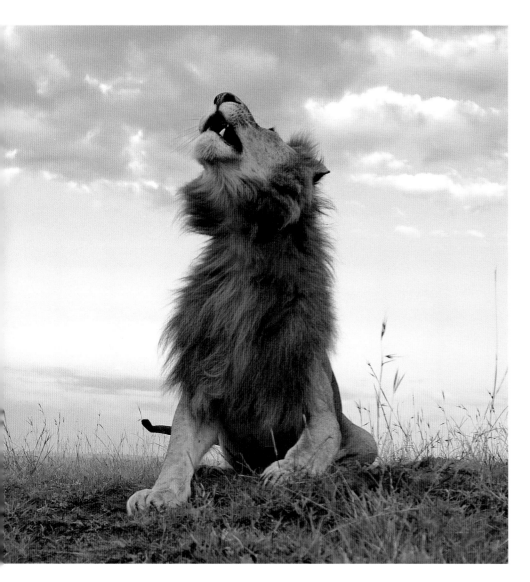

This male lion was lying down, resting, when he suddenly sat up on his hind legs to get a closer look at a low flying bird. If the bird had been any lower, the lion might have lunged at it.

ACKNOWLEDGMENTS

I would like to thank, in alphabetical order, Geoff and Martin Bell for their ingenuity; Patrick Beresford at Governor's Camp for his technical support; Andrea Danese for her faith in this project; Miko McGinty, Rita Jules, and Claire Bidwell for their design; Fiona Rogers for her incalculable input; Manoj Shah for his field support; and Sneh Shah for her managerial skills.

EDITOR: Andrea Danese
DESIGNER: Miko McGinty, Inc.
PRODUCTION MANAGER: Kathy Lovisolo

Library of Congress Cataloging-in-Publication Data:

Shah, Anup, 1949-
 Serengeti spy : views from a hidden camera on the plains of East Africa
/ Anup Shah.
 p. cm.
 ISBN 978-1-4197-0278-5 (alk. paper)
1. Wildlife photography—Africa, East. 2. Animals—Africa—Pictorial
works. I. Title.
 TR729.W54S53 2012
 779'.32—dc23
 2012008029

Copyright © 2012 Anup Shah

Published in 2012 by Abrams, an imprint of ABRAMS. All rights reserved. No portion of this book may be reproduced, stored in a retrieval system, or transmitted in any form or by any means, mechanical, electronic, photocopying, recording, or otherwise, without written permission from the publisher.

Printed and bound in China
10 9 8 7 6 5 4 3 2 1

Abrams books are available at special discounts when purchased in quantity for premiums and promotions as well as fundraising or educational use. Special editions can also be created to specification. For details, contact specialsales@abramsbooks.com or the address below.

THE ART OF BOOKS SINCE 1949

115 West 18th Street
New York, NY 10011
www.abramsbooks.com

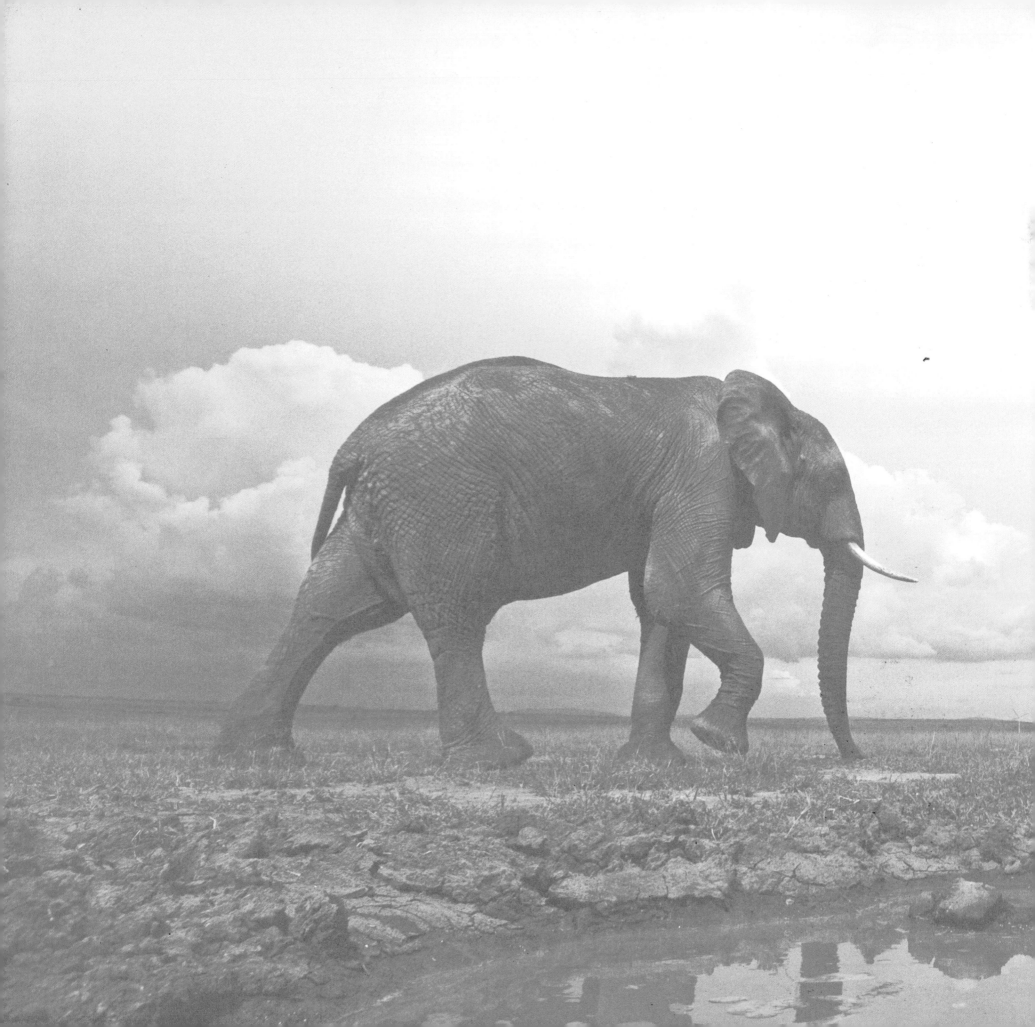